Photography and
the American Civil War

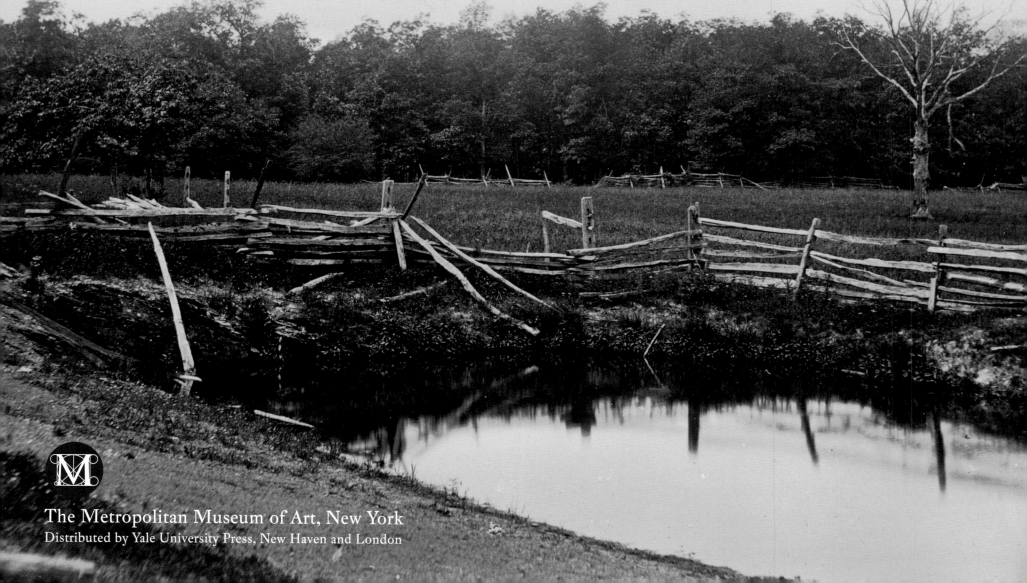

Photography and
the American Civil War

Jeff L. Rosenheim

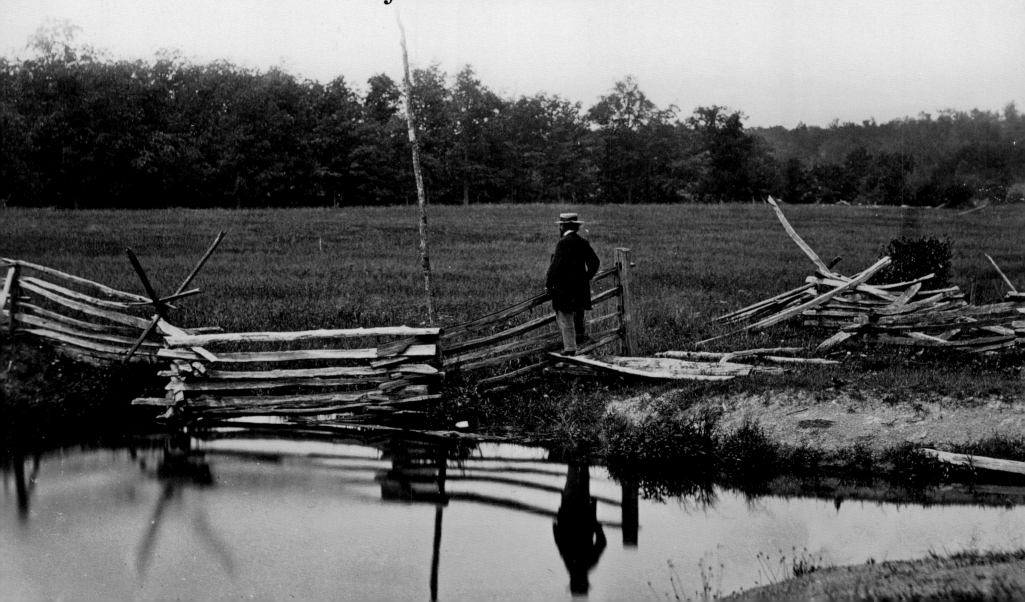

This catalogue is published in conjunction with "Photography and the American Civil War" on view at The Metropolitan Museum of Art, New York, from April 2 through September 2, 2013; the Gibbes Museum of Art, Charleston, S.C., from September 27, 2013, through January 5, 2014; and the New Orleans Museum of Art, from January 31 through May 4, 2014.

The exhibition is made possible by The Horace W. Goldsmith Foundation.

This catalogue is made possible by the Roswell L. Gilpatric Publications Fund.

Published by The Metropolitan Museum of Art, New York
Mark Polizzotti, Publisher and Editor in Chief
Gwen Roginsky, Associate Publisher and General Manager of Publications
Peter Antony, Chief Production Manager
Michael Sittenfeld, Managing Editor
Robert Weisberg, Senior Project Manager

Edited by Anna Jardine
Designed by Laura Lindgren
Production by Douglas Malicki
Bibliography by Jean Wagner

Unless otherwise noted, photographs of works in the Metropolitan Museum's collection as well as private collections are by Eileen Travell, The Photograph Studio, The Metropolitan Museum of Art.

Digital Image © The Museum of Modern Art/Licensed by SCALA / Art Resource, NY: pp. 84, 101, 107, 108, 201, 202, 204–8, 211, 217. Photographs of works in the David Wynn Vaughan and the David Wynn Vaughan Jr. collections are by Jack Melton.

Typeset in Fleischman and Source Sans
Printed on Phoenix Motion Xantur
Separations, printing, and binding by Trifolio S.r.l., Verona

Jacket illustrations: front, Unknown artist, *Captain Charles A. and Sergeant John M. Hawkins, Company E, "Tom Cobb Infantry," Thirty-eighth Regiment, Georgia Volunteer Infantry*, 1861–62 (pl. 123); back, Alexander Gardner, *The President [Abraham Lincoln], Major General John A. McClernand [right], and E. J. Allen [Allan Pinkerton, left], Chief of the Secret Service of the United States, at Secret Service Department, Headquarters Army of the Potomac, near Antietam*, October 4, 1862 (pl. 14)

Frontispiece: Mathew B. Brady, *Wheat-Field in Which General Reynolds Was Shot*, July 1863 (pl. 93)

The Metropolitan Museum of Art
1000 Fifth Avenue
New York, New York 10028
metmuseum.org

Distributed by
Yale University Press, New Haven and London
yalebooks.com/art
yalebooks.co.uk

Cataloging-in-Publication Data is available from the Library of Congress.
ISBN 978-1-58839-486-6 (The Metropolitan Museum of Art)
ISBN 978-0-300-19180-6 (Yale University Press)

CONTENTS

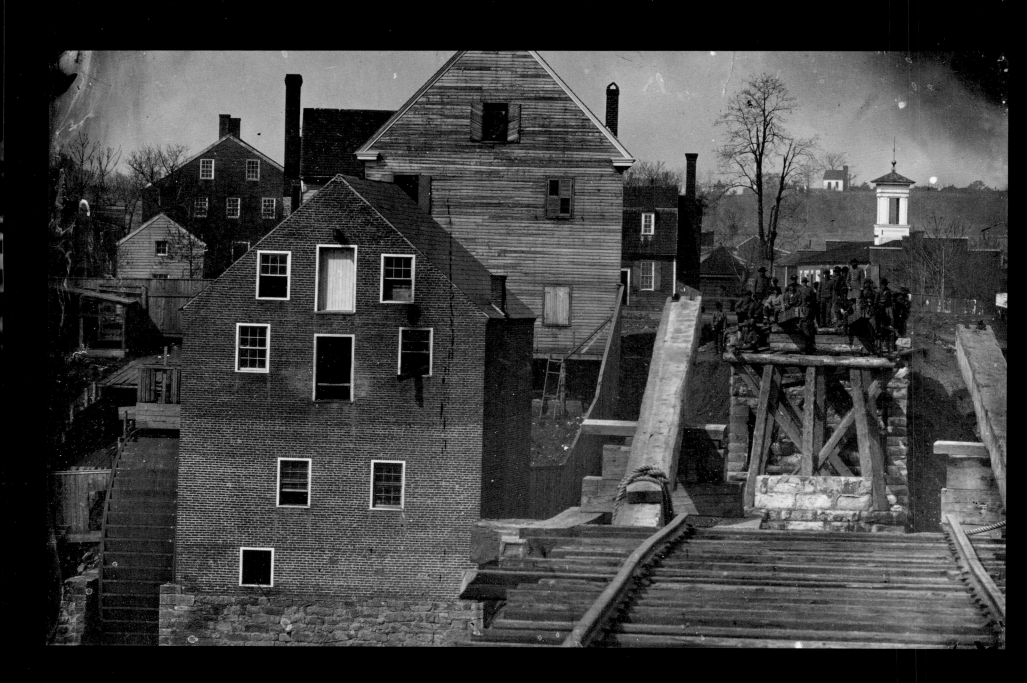

DIRECTOR'S FOREWORD

Photography has occupied a prominent place at The Metropolitan Museum of Art for nearly a century. The inaugural acquisition of photographs as independent works of art came in 1928, with the gift of twenty-two photographs by Alfred Stieglitz. Five years later, the Museum made its first purchase: a suite of 418 Civil War photographs attributed at the time to Mathew B. Brady and acquired from the Massachusetts division of the Military Order of the Loyal Legion of the United States, a veterans' organization founded in 1868. This early acquisition is the nucleus of *Photography and the American Civil War*.

As Jeff L. Rosenheim, Curator in Charge of the Department of Photographs, makes clear in his analysis of many of the finest and most important photographs from the Civil War, the camera played an exceptionally complex and diverse role during one of the most cataclysmic periods in American history. From the moment the first photographs of the war appeared in the public sphere, their authority and visual power shaped the direction of American art. The dramatic events documented so effectively by the camera moved Frederic Church, Albert Bierstadt, Eastman Johnson, and other painters of the era to use an even more symbolic vocabulary. This in turn freed photography to focus on physical realities—the facts of life and death—that define the human experience. By the early decades of the twentieth century, when most of the combatants were dead, the photographs of the Civil War had developed a potent resonance that would last for years. Walker Evans, Robert Frank, Lee Friedlander, William Eggleston, and many others sharpened their observational and interpretive skills by looking at photographs by Brady, Alexander Gardner, Timothy H. O'Sullivan, and Andrew Joseph Russell.

The images by these four photographers and all the others featured in this book remain a vibrant tradition for artists working today.

This exhibition comprises more than two hundred photographs, among them thirteen from the Museum's 1933 acquisition and thirty-two acquired in 2005 from the renowned holdings of the Gilman Paper Company. This second major purchase of Civil War photographs included a mint-condition copy of America's first photographic anthology, *Gardner's Photographic Sketch Book of the War*, from 1866. Together with George N. Barnard's *Photographic Views of Sherman's Campaign*, from the same year, purchased by the Metropolitan in 1970, Gardner's two-volume masterpiece forms the foundation of the Metropolitan's celebrated collection of nineteenth-century American photographs. For this exhibition, we are pleased to supplement this core group with extraordinary pictures held in private and public collections.

Photography and the American Civil War commemorates the 150th anniversary of Gettysburg, the three-day battle in Pennsylvania that most historians see as a turning point in the brutal war in which some three-quarters of a million Americans died. Along with the exhibition's curator, and on behalf of our colleagues at the Gibbes Museum of Art in Charleston and the New Orleans Museum of Art, I am honored to have the trust of every lender to this timely show. We are also grateful to The Horace W. Goldsmith Foundation for its broad support of the Met's Department of Photographs and of this project, and to the Roswell L. Gilpatric Publications Fund for its generous commitment toward this catalogue.

Thomas P. Campbell
Director
The Metropolitan Museum of Art

1 Andrew Joseph Russell, *End of the Bridge after Burnside's Attack, Fredericksburg, Virginia*, 1863. Albumen silver print

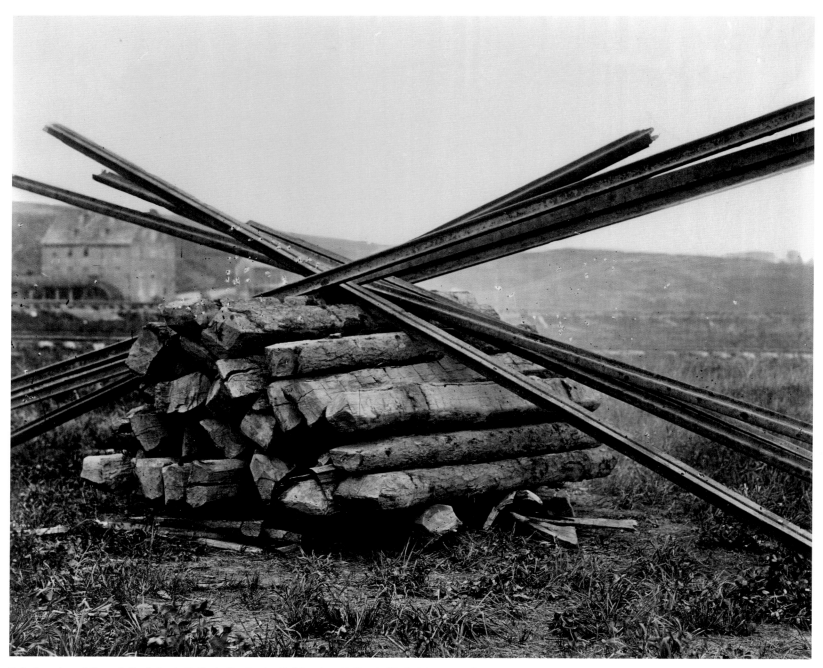

2 Andrew Joseph Russell, *Confederate Method of Destroying Rail Roads at McCloud Mill, Virginia*, 1863. Albumen silver print

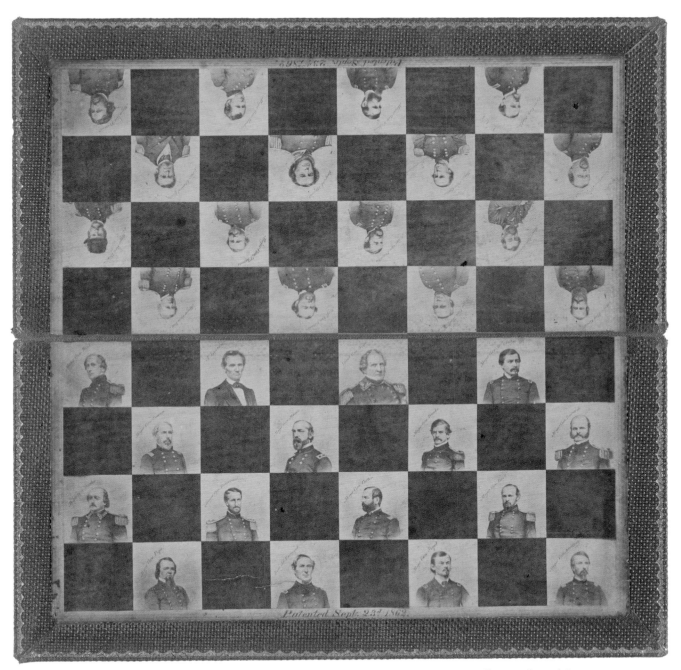

3 Unknown maker, Game Board with Portraits of President Abraham Lincoln and Union Generals, 1862. Albumen silver print

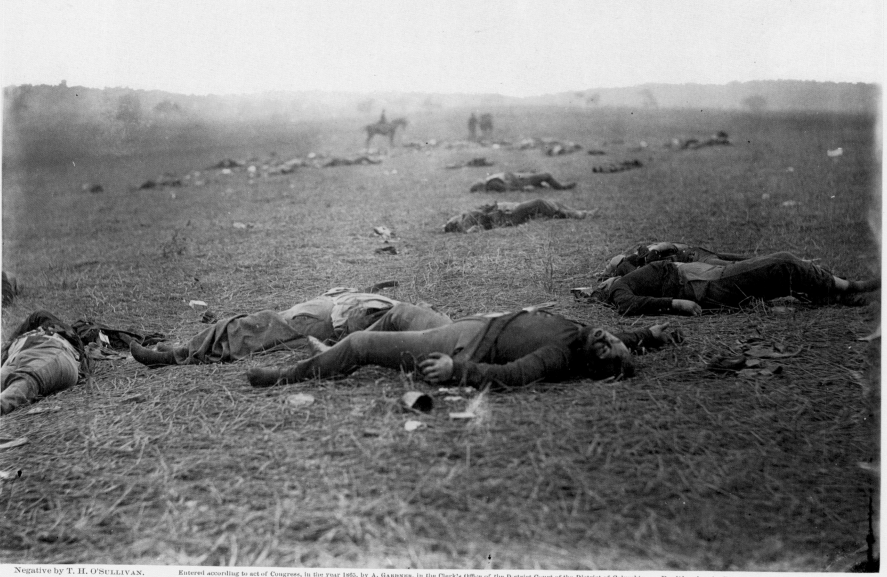

Incidents of the War.

A HARVEST OF DEATH.

PROLOGUE
Shadows of Ourselves

First, a warning shot from the battlefield. This book is not a history of the Civil War, but rather an exploration of the role of the camera at a watershed moment in American culture. During the war years (1861–65), the medium of photography matured and flourished in surprising and unexpected ways, and what survives from the period in vintage albumen silver prints and original collodion-on-glass-plate negatives, in cased ambrotypes and tintypes, in albums of large-format views and miniature carte-de-visite portraits, and in stereographic scenes is a rich legacy of stunning complexity. Approximately a thousand photographers worked separately and in teams to produce hundreds of thousands of portraits and views that were actively collected during the period (and for the past 150 years) by Americans of all ages and social classes. In a direct expression of the nation's changing vision of itself, the camera documented the four-year war and also mediated it by memorializing the brutal events of the battlefield as well as the consequent toll on the home front. And in the creation of this vast treasury of photographs—a national visual library of sorts—the camera performed a key role the opposing armies and their leaders could not: it defined and perhaps even helped unify the nation through an unrehearsed and unscripted act of collective memory-making.

Photography and the American Civil War and the exhibition it accompanies temper the well-known and oft-reproduced views of battlefields, cannons, defensive works, bridges, and equipment with more common but seldom seen portraits (pls. 5, 17, 18) of individual soldiers, Confederates and Unionists, whose names are generally lost but whose eyes, body language, and personal belongings reflect much of the pathos

4 Timothy H. O'Sullivan, *A Harvest of Death, Gettysburg*, July 1863. Albumen silver print

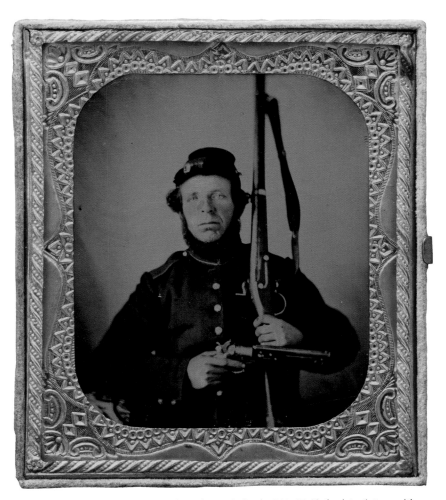

5 Unknown artist, Union Private with Musket and Pistol, 1861–65. Sixth-plate tintype with applied color

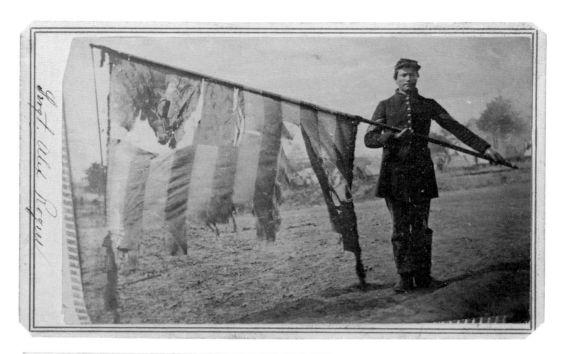

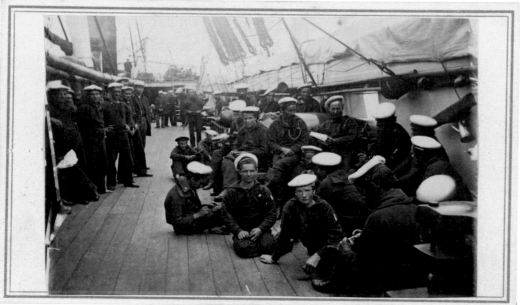

6 Unknown artist, *Sergeant Alex Rogers with Battle Flag, Eighty-third Pennsylvania Volunteers, Third Brigade, First Division, Fifth Corps, Army of the Potomac*, ca. 1863. Albumen silver print (carte de visite)

7 McPherson & Oliver, *Sailors on the USS Hartford*, 1864. Albumen silver print (carte de visite)

and poignancy of the war itself. Even the most simple and graphically formulaic of these small wartime portraits—intimate shadows of ourselves in ambrotypes and tintypes and cartes de visite—are as spectacular in their own way as the most searing image of a fallen soldier lying bloated with mouth agape in a scarred field (pl. 4). Produced simultaneously and examined together here, these landscapes and likenesses offer a revelatory way to see, to represent, and to understand photography and the Civil War—by all accounts, the crucible of American history.

The past quarter-century has been a dynamic period for everyone interested in the history of photography, especially of the American Civil War. Intense and often collaborative research has provided historians, independent scholars, collectors, dedicated amateurs, and members of the general public with frequent changes to the titles, image dates, and attributions for many of the thousands of photographs of the era. Through the continuing effort to properly identify which pictures were made by which

artists, and in what order, this publication takes full advantage of recent and dramatic discoveries in the exciting field of Civil War iconography.

The reader will notice that in certain instances even the most widely published photographs with seemingly secure historical attributions have in these pages new or different (or unknown) picture makers associated with them. These changes reflect current understanding and up-to-date scholarship. Most revisions have been gleaned from the ever-expanding field and the immense bibliography of the war; a few are based on direct observations and research by this author. Scholarship in the field is now so active that it is anticipated that before the exhibition to which this catalogue is pendant opens to the public, it will be necessary to revise the wall labels. In this rapidly growing area of photographic history, what is new becomes old almost before the ink dries.

Regrettably, the many reattributions in this publication may be confusing, even to those individuals most devoted to the study of

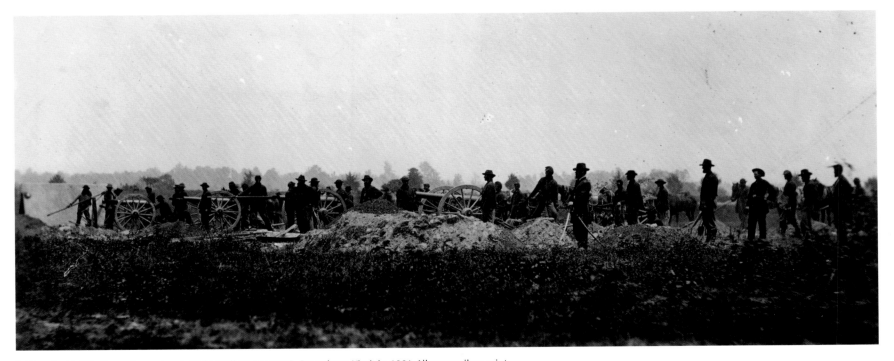

8 Timothy H. O'Sullivan, *Pennsylvania Light Artillery, Battery B, Petersburg, Virginia*, 1864. Albumen silver print

Civil War arcana and familiar with the many online war forums and blogs and the innumerable electronic and print magazines that specialize in the subject. The reasons are twofold: online access to high-resolution digital images of photographic prints and negatives offers daily reproductions of photographs previously hidden in large and small archives across the country; and similarly, scans of textual records of almost every regiment and division that fought for the Union and the Confederacy reveal new details about soldier movement from the start of the war through its end and into the Reconstruction period. With access to this information come confirmations of, but also corrections to, what we thought we knew about the war and the role photography played in it.

The result of all this fresh research can at times be overwhelming to an author (and a reader) seeking to understand what we know about Civil War photography, and what we do not. With so much in flux, it is difficult to determine where to begin such a study. Chronologically, at the start of the war in April 1861, with the Confederate attack on Fort Sumter, an island in the port of Charleston, South Carolina? At the first land battle, Bull Run (called First Manassas by the Confederates), along a creek in northern Virginia just twenty-five miles from the nation's capital? Or perhaps at its close, four years later, at Appomattox Court House, also in Virginia, where Confederate General Robert E. Lee surrendered to Union General Ulysses S. Grant, to end the war? More important for this study, should the book begin on the field or in a portrait studio? Conveniently, one location in October 1862 presents an opportunity to do both: Mathew B. Brady's "National Gallery," situated at the corner of Broadway and Tenth Street in New York City.

9 Andrew Joseph Russell, *Bridge on Orange and Alexandria Rail Road, as Repaired by Army Engineers under Colonel Herman Haupt*, 1865. Albumen silver print

Note

DAGUERREOTYPES, AMBROTYPES, AND TINTYPES

Plate sizes are as follows:

Whole plate: 8½ × 6½ inches
Half plate: 5½ × 4¼ inches
Quarter plate: 4¼ × 3¼ inches
Sixth plate: 3¼ × 2¾ inches
Ninth plate: 2½ × 2 inches

PAPER PRINTS

All albumen silver prints reproduced in this publication are from glass negatives unless indicated otherwise.

The Dead of Antietam

On October 6, 1862, *The New York Times* reported under the headline "Antietam Reproduced" that Mathew B. Brady (1823/24–1896), arguably the most famous photographer working in the United States, had in his portrait studio a timely exhibition of photographs made in Sharpsburg, Maryland, where one day three weeks earlier, along Antietam Creek, some 26,000 Confederate and Union soldiers were killed, wounded, or captured, or went missing (pl. 10).[1] What no one knew then was that September 17, 1862, would be the bloodiest single day of the Civil War, and, for American troops, of any war in which the United States has ever been engaged.

Brady's exhibition would be the first public presentation of photography from what was not yet known as the Civil War, the "War of the Rebellion," the "War for Southern Independence," the "War Between the States," or still to many living in the South today, the "War of Northern Aggression." The unsigned *Times* commentary makes note of two facts: Brady's photographs were graphically brutal, and curiously, they were available for immediate purchase, conveniently sized for easy insertion into the period's ubiquitous portrait albums:

> If our readers wish to know the horrors of the battle-field, let them go to BRADY'S Gallery, and see the fearful reproductions which he has on exhibition, and for sale. In all the literal repulsiveness of nature, lie the naked corpses of our dead soldiers side by side in the quiet impassiveness of rest. Blackened faces, distorted features, expressions most agonizing, and details of absolute verity, teach us a lesson which it is well for us to learn. The enterprise, the perseverance and courage, physical and pecuniary, which suggest to and encourage an artist in such work as this, establish for him forever a reputation such as no flattery, no claptrap can secure. The pictures, of a size convenient for albums, can be seen and bought at the National Gallery, corner of Broadway and Tenth-street.[2]

Why Brady believed the public would want to purchase photographs, "fearful reproductions" that showed "the literal repulsiveness of nature," is unknown. Nonetheless, a few things are quite clear: the press adored the exhibition, and the gallery sold photographs (pl. 11). And just as the prescient columnist had predicted, Brady's name remains permanently affixed to these early images of Antietam—perhaps to almost every image of the Civil War. In reality, however, Brady did not dirty his boots on the killing fields at Antietam, nor did he likely ever see or photograph a single dead soldier on any battlefield during the war. He left this work to the artists he employed (pl. 13).

By the time of the fall of Fort Sumter, Brady was less a photographer than an entrepreneur who managed what we would call today a picture agency, which operated much like the Associated Press. He hired the best photographers, worked all the picture outlets (newspapers and magazines), and hobnobbed with influential politicians and the social elite (pl. 12). In his New York exhibition in October 1862, the photographs Brady placed on view (and received credit for in the press) were actually executed by his employee Alexander Gardner (1821–1882), the talented manager of Brady's Washington, D.C., gallery since it had opened in 1858, and by Gardner's assistant James F. Gibson (b. 1828/29).[3] As William A. Frassanito, the now legendary expert on the photographic documentation

10 Unknown artist, *Corporal Hiram Warner, Company C, Second United States Sharpshooters,* 1861–62. Sixth-plate tintype with applied color

11 Alexander Gardner, *Confederate Soldier [on the Battlefield at Antietam]*, September 1862. Albumen silver print

BRADY'S ALBUM GALLERY.
No. 554.

CONFEDERATE SOLDIER,

Who, after being wounded, had dragged himself to a little ravine on the hill-side, where he died.

The Photographs of this series were taken directly from nature, at considerable cost. Warning is therefore given that legal proceedings will be at once instituted against any party infringing the copyright.

of the war, wrote in 1978: "The views these men produced at Antietam included scenes that would open the country's eyes and highlight a new era in the visual documentation of war."[4]

Brady marketed the small, 4 × 2½-inch card-mounted photographs known by the French description *cartes de visite* as ready-made war relics. They were easy and inexpensive to collect, easy to house (Brady sold picture albums as well), and even easy to interpret. The last matter was conveniently managed by the inclusion of interpretative labels affixed on each print's verso. Brady offered the following caption for this study (pl. 11) of a dead soldier moldering on the ground: "BRADY'S ALBUM GALLERY. No. 554. CONFEDERATE SOLDIER, Who, after being wounded, had dragged himself to a little ravine on the hill-side, where he died." From all surviving evidence, it is certain that Brady (and perhaps Gardner as well) believed that these startling photographs required titles and narrative captions. The intended role of the latter was to relieve the viewer from the gruesome, graphic charge of the image itself, and thus make it more marketable. Ironically, the raw animal power Gardner worked so hard to capture with the camera has been diminished for modern viewers by the blatant

romanticism of the caption, which adds the softening gauze of fiction to an otherwise unfiltered view of the facts of life and death during war. Gardner's title for the contemporaneous stereograph of the same image, made from the same negative, places an even more opaque scrim between the subject and the viewer's possible interpretation of it: "He Sleeps His Last Sleep. A Confederate soldier being wounded had evidently dragged himself to a little ravine on the hillside, where he died."

Brady's exhibition "The Dead of Antietam" struck a chord in New York City, especially with the press. Two weeks after the initial *Times* notice, the newspaper reviewed the show again.[5] This second unsigned article, published on October 20, 1862, is the most effective and thorough newspaper commentary about photography during the war.[6] The relevant section is the second paragraph, and the beginning of the third:

We recognize the battle-field as a reality, but it stands as a remote one. It is like a funeral next door. The crape on the bell-pull tells there is death in the house, and in the closed carriage that rolls away with muffled wheels you know there

rides a woman to whom the world is very dark now. But you only see the mourners in the last of the long line of carriages—they ride very jollily and at their ease, smoking cigars in a furtive and discursive manner, perhaps, and, were it not for the black gloves they wear, which the deceased was wise and liberal enough to furnish, it might be a wedding for all the world would know. It attracts your attention, but does not enlist your sympathy. But it is very different when the hearse stops at your own door, and the corpse is carried out over your own threshold—you know whether it is a wedding or a funeral then, without looking at the color of gloves worn. Those who lose friends in battle know what battle-fields are, and our Marylanders, with their door-yards strewed with the dead and dying, and their houses turned into hospitals for the wounded, know what battle-fields are.

Mr. BRADY has done something to bring home to us the terrible reality and earnestness of war. If he has not brought bodies and laid them in our door-yards and along the streets, he has done something very like it. At the door of his gallery hangs a little placard, "The Dead of Antietam."[7]

— ✦⁊✦ —

One of those who died in action at Antietam was Corporal Hiram Warner (pl. 10). He was born on January 1, 1833, in New York state, but raised in Wilcox, Pennsylvania, and with three of his brothers, Horace, Robert, and William, he fought in the Civil War.[8] Warner was twenty-eight years old and unmarried when he enlisted on April 24, 1861, for three months' service in Company I of the Eighth Pennsylvania Infantry, after which he reenlisted as a private in Company C, Second United States Sharpshooters. He soon became a corporal and fought at Antietam with the sharpshooters in Colonel Walter Phelps Jr.'s brigade of the First Division. After dawn on September 17, 1862, Warner was killed in action along the Hagerstown Pike

Brady, Washington.

12 Mathew B. Brady, *Self-Portrait*, ca. 1860. Albumen silver print (carte de visite)

1862

Antietam

Horse killed with his rider, a rebel colonel.

After the battle.

13 Alexander Gardner, *Antietam*, September 19, 1862. Albumen silver prints in *A Photographic Album of the Civil War*

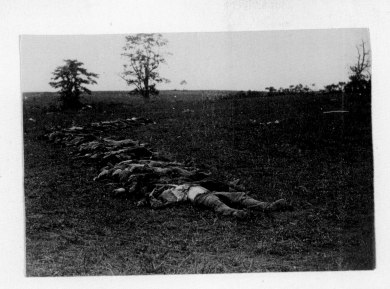

Collected for burial.

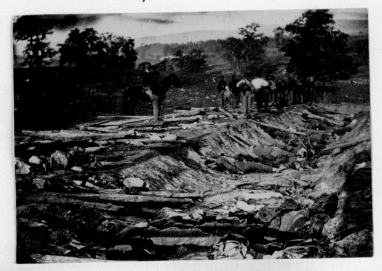

Ditch used as a rifle-pit during the battle.

in fierce fighting against the Second Louisiana Brigade led by Brigadier General William E. Starke (who also died that day). What resonates in this sixth-plate tintype by an unknown artist is the sitter's direct stare at the camera and the simplicity of the composition. There is no embellishment in pose, no prop, no painted backdrop, not even a hat or marking on the soldier's sleeves to distract the viewer's attention. Warner's slightly tinted, "sunburned" cheeks and vacant look—as if he has been to the abyss and back—strongly suggest that he has already witnessed firsthand the killing fields. In period jargon, he has "seen the elephant."

The same week that Brady celebrated the success of the nation's first "spot news" war photography exhibition, Alexander Gardner was following another story, back at Antietam. He had learned from sources in Washington that President Abraham Lincoln was planning to visit the

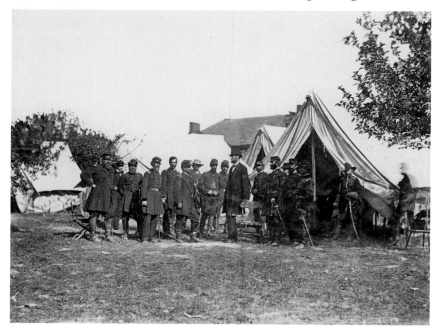

Fig. 1 Alexander Gardner, *President Lincoln on Battle-field of Antietam*, October 3, 1862. Albumen silver print. The Metropolitan Museum of Art, Gilman Collection, Purchase, Ann Tenenbaum and Thomas H. Lee Gift, 2005 (2005.100.502.1)

battlefield, meet with the commander of the Union army, General George B. McClellan, and pay his respects to the wounded on both sides. Gardner and James F. Gibson had already returned to Washington after four exhausting, malodorous days (September 19–22), during which they had exposed some seventy plates of decaying soldiers and animals awaiting burial. Albumen silver prints of these negatives were what Brady exhibited in his New York gallery. When Gardner returned to the site on October 3, he made twenty-five more photographs, mostly portraits of a strained meeting between the president and General McClellan. The photograph of Lincoln at the headquarters of the Fifth Corps of the Army of the Potomac (fig. 1) seems to record not just the dramatic size difference between the tall, top-hatted president and his short field commander, but also the palpable tension between Lincoln and "Little Mac," as the general's soldiers affectionately called him. For months McClellan (seen fourth from the president's right) had rebuffed Lincoln's requests that he advance on the enemy and engage General Robert E. Lee. Before his visit to Antietam, Lincoln, a savvy pundit, purportedly commented to his intimates: "If General McClellan isn't going to use his army, I'd like to borrow it for a time." He had sent a telegram to his wife from Harpers Ferry on October 2, just before the trip to Maryland: "General McClellan and myself are to be photographed tomorrow A.M. by Mr. Gardner if we can be still long enough. I feel Gen. M. should have no problem on his end but I may sway in the breeze a bit."[9]

Gardner would use this image as plate 23 in his 1866 landmark of American photography: the two-volume, one-hundred-picture opus *Gardner's Photographic Sketch Book of the War*. In the extended typeset picture analysis that precedes this plate (an explanatory text accompanied every photograph), Gardner wrote: "It is said, that when the President alluded to the complaints that were being made of the slowness of the General's movements, General McClellan replied, 'You may find those that will go faster than I, Mr. President; but it is very doubtful if you will find

14 Alexander Gardner, *The President [Abraham Lincoln], Major General John A. McClernand [right], and E. J. Allen [Allan Pinkerton, left], Chief of the Secret Service of the United States, at Secret Service Department, Headquarters Army of the Potomac, near Antietam*, October 4, 1862. Albumen silver print

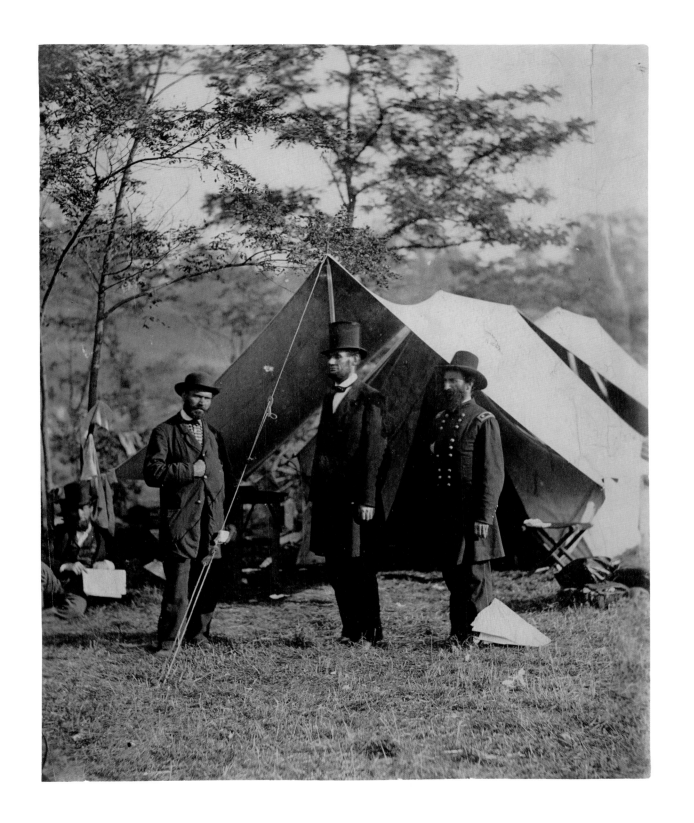

many who will go further.' ”[10] A month after visiting Antietam, Lincoln relieved McClellan of his command; two years later Lincoln would defeat him in the 1864 presidential election and win a second term in office.

The day after the important meeting that generated the large group portrait that Gardner used in the *Sketch Book*, he made field portraits of Lincoln posed with Allan Pinkerton and General John McClernand (pl. 14). Flanked by his secret service chief (left) and one of McClellan's lead generals, Lincoln seems much more comfortable in his body than he does in earlier photographs: he stands the part and understands the role the camera requires him to play. Unfortunately, Pinkerton (founder in 1850 of the eponymous detective agency) proved to be a particularly poor gatherer of military intelligence in his advisory role to the Army of the Potomac. According to Frassanito, he "significantly overestimated the strength of Lee's army—a factor that in turn contributed to McClellan's extreme caution."[11]

After posing for these last field portraits, Lincoln and his entourage returned to Washington; so, too, did Gardner with his cache of glass negatives from Antietam. Both men would make significant changes in the next few months. The president replaced McClellan with Brigadier General Ambrose E. Burnside in early November, and Gardner would leave his employer, Mathew Brady, to open his own competing business just a few blocks away. When Gardner left Brady, he seems to have taken with him most of the war negatives (or copies thereof) in the gallery's possession, along with many of the photographers he had hired when Brady opened the gallery four years earlier. Although the precise departure date remains unknown, the critical rupture between Gardner and Brady may have happened even before Brady's exhibition of Gardner's photographs in New York City. Regardless, once free of Brady, Gardner accepted an important commission as a photographic copyist of maps and documents for the Army of the Potomac. For this work he received the honorary rank of captain— the first photographer in the war to receive an official military post.[12]

So ends this brief connected interlude in early October 1862, when the first views of the Civil War were shown and critiqued in a public exhibition. Eighteen months into the war, the camera and its product, the photograph, had found a secure position in the army with Captain Gardner, the world's first official war journalist; a home in the hands of the press: "Here [in the photographs in Brady's New York gallery] lie men who have not hesitated to seal and stamp their convictions with their blood,— men who have flung themselves in the great gulf of the unknown to teach the world that there are truths dearer than life, wrongs and shames more to be dreaded than death";[13] and a special place in the hearts and homes of thousands of Americans who began collecting in simple albums pictures of the raging conflict between North and South. The war was far from over, but the photographic portraits and views already in mass circulation by the autumn of 1862 had changed the medium and American society. What twenty-three years earlier had been a specialty invention was now the preeminent form of visual communication. In ways this publication intends to explicate, the modern era had begun, with "The Dead of Antietam." Yet the seeds of this transformation had been sown over the previous two decades; a brief survey of the image materials used by American photographers in the 1840s and 1850s is in order.

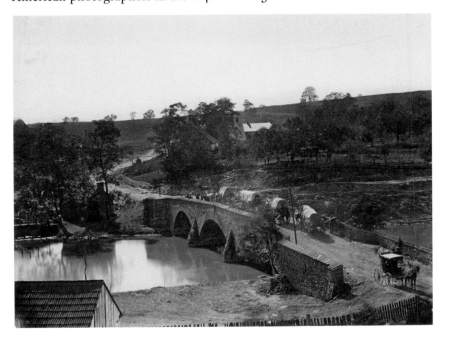

15 Unknown artist, Copying Maps, Photographic Headquarters, Petersburg, Virginia, March 1865. Albumen silver print

16 Alexander Gardner, *Antietam Bridge, Maryland*, September 1862. Albumen silver print

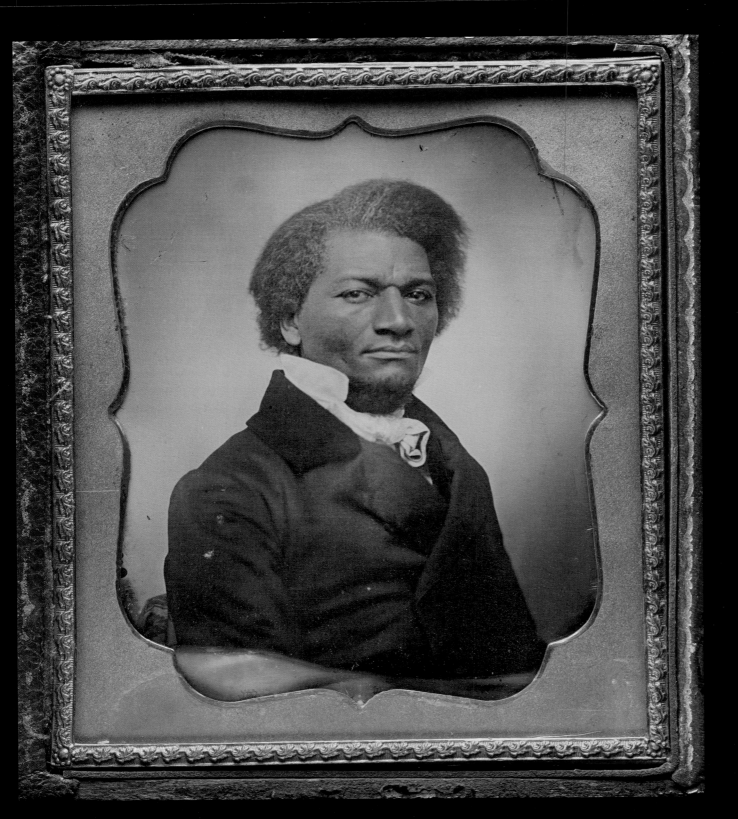

Photography before the War

At the start of the Civil War, the nation's picture galleries and image purveyors were overflowing with lists of goods and services. On offer were photographs of all kinds and sizes: miniature portraits made on thin sheets of copper (daguerreotypes), glass (ambrotypes), or iron (ferrotypes or tintypes) that were housed in decorative leather cases, and large "painting-size" likenesses on paper embellished with sometimes careful, sometimes crude handwork in India ink, watercolor, and oil. For sale in most bookshops and stationers were vast quantities of photographic portraits on paper of the nation's leading statesmen, artists, and members of the stage, as well as stereographic views, on colorful numbered card mounts, of notable scenery from New York City to Niagara Falls to the canals of Venice. Viewed in a stereopticon, these paired images gave the sensation of three-dimensionality and the charming pleasure of traveling the world in one's own armchair.

Daguerreotypes
Present in even the most humble of homes from rural Vermont to the gold fields near San Francisco, daguerreotypes recorded the features not only of poets and industrial tycoons, but also of soldiers, abolitionists, urban laborers, mothers, infants, and the recently deceased. This sixth-plate daguerreotype of Frederick Douglass (fig. 2) by an unknown maker from about 1855 is an excellent example of portraiture from the prewar period. Born into slavery, Douglass (1817–1895) was the son of a white man and a slave woman. He escaped his bondage in 1838 and became the nation's most persuasive orator for the cause of abolition.

Fig. 2 Unknown artist, *Frederick Douglass*, ca. 1855. Sixth-plate daguerreotype.
The Metropolitan Museum of Art, The Rubel Collection, Gift of William Rubel, 2001 (2001.756)

As early as 1843, one prophetic critic wrote that "it will soon be as difficult to find a man who has not his likeness done by the sun . . . as it was, before the *rain* of portrait painters, to find one without a profile cut in black. . . . The immortality of this generation is as sure, at least, as the duration of a metallic plate."[14] The plate was a daguerreotype: a sheet of copper, silver-plated and buffed to a mirrorlike finish, upon which the action of light, focused through a lens, formed a highly detailed and nearly indelible image—the world's first viable form of photography. Named for its French inventor, Louis-Jacques-Mandé Daguerre (1787–1851), the daguerreotype was immensely popular in the United States for fifteen years, until about 1855. No one knows exactly how many daguerreotypes were made in the 1840s and 1850s, but the number is more than 25 million. Characterized by remarkable clarity of description—"realness"—and an uncanny dimensionality, the daguerreotype was one of the wonders of the age. It was, as the celebrated portrait painter, inventor, and photographer Samuel F. B. Morse described, "Rembrandt perfected."[15]

Mathew Brady opened his first daguerreotype portrait studio on lower Broadway in New York in 1844.[16] From the start, he distinguished himself from his competitors by making, collecting from others, and displaying, in his "Daguerrean Miniature Gallery," portraits of the country's most noted citizens.[17] This effort to preserve the faces of his time led to the publication, in 1850, of *The Gallery of Illustrious Americans*, in which Brady's daguerreotypes were copied in lithography by the skilled French-born printer Francis D'Avignon and complemented by extensive biographical texts set in letterpress.[18] While smartly conceived and printed, the publication proved to be ahead of its time. Brady's fellow artists may have appreciated the finesse of the portfolio and the care with which he selected and posed his subjects—John Calhoun,

Fig. 3 Francis D'Avignon, *John James Audubon*, 1850, from *The Gallery of Illustrious Americans* (1850). Lithograph after daguerreotype by Mathew B. Brady. The Metropolitan Museum of Art, Bequest of Charles Allen Munn, 1924 (24.90.576)

Daniel Webster, John James Audubon (fig. 3), among others—but the general public was reluctant to own the prints, or at least to pay a premium for them. Far more interesting to most Americans were the extraordinary entertainments presented by Phineas T. Barnum, the impresario working directly across Broadway from Brady's gallery. There was no bigger star in the era than Barnum's discovery Tom Thumb (born Charles Stratton), seen standing at about age ten on a simple side chair in this early sixth-plate daguerreotype (fig. 4). Rather than collect the illustrious, the majority of Americans preferred images of the not-yet-famous or the infamous, and thus were willing to buy pictures of themselves or of folks less fortunate, if more famous, than they were.

But all was not a loss for Brady. An oil portrait of the photographer from the late 1850s (fig. 5) by the New York society painter Charles Loring Elliott (1812–1868) is a good indicator of how quickly Brady himself had become one of the more illustrious men of his time, managing a network of artists, politicians, and patrons who frequented his galleries in New York City. The former jewelry-case maker from Ireland (he claimed that he was from upstate New York) had learned much from the

Fig. 4 Unknown artist, *Tom Thumb*, ca. 1848. Sixth-plate daguerreotype. The Metropolitan Museum of Art, Purchase, W. Bruce and Delaney H. Lundberg Gift and Gilman Collection, Purchase, The Howard Gilman Foundation Gift, 2008 (2008.14.1)

production, marketing, and ultimate commercial failure of *Illustrious Americans*.[19] The lessons would serve him well soon after the Confederate attack on Fort Sumter in April 1861.

Ambrotypes
Although for years his gallery offered only daguerreotypes, Brady, like most photographers across America, eventually augmented his photographic offerings of cased portraits with newer techniques. In December 1852, he purchased a right from John Adams Whipple to make crystallotypes (salted paper prints from glass negatives), and in 1855 he introduced the ambrotype.

Fig. 5 Charles Loring Elliott, *Mathew B. Brady*, 1857. Oil on canvas. The Metropolitan Museum of Art, Gift of the Friends of Mathew Brady, 1896 (96.24)

Fig. 6 Mathew B. Brady, *Grenville Kane*, late 1850s. Half-plate ambrotype with applied color. The Metropolitan Museum of Art, The Rubel Collection, Purchase, Lila Acheson Wallace Gift, 1997 (1997.382.48)

Cheaper to make than a daguerreotype, an ambrotype is a unique image produced on a silver-coated sheet of glass. Set into a decorative miniature case outfitted just as for a daguerreotype, it is somewhat easier to view but also somewhat less mysterious than its predecessor. This half-plate portrait of young Grenville Kane (fig. 6) resting his feet on a Gothic Revival studio chair is a good example of the Brady studio's technical finesse with the medium and the proprietor's celebrated skill posing his sitters. Popular for less than ten years, the ambrotype eventually replaced the daguerreotype and, in turn, by the early years of the Civil War, was itself supplanted by paper photography from glass negatives. Still, in both the North and the South it was a popular medium, and many surviving portraits of Union and Confederate soldiers are ambrotypes (pls. 17, 18).

Imperial Portraits on Paper

Sometime in 1856, Brady welcomed into his business the services of Alexander Gardner, an émigré Scotsman skilled in the use of both glass negatives and the paper-print process with which he and his employer would soon transform the field. With Gardner in his employ, Brady grew less engaged in the manipulation of plates and chemicals, preferring to assign to Gardner the mechanical aspects of the process. Instead of occupying himself with technique, the studio founder—who had already begun to lose his eyesight—focused his attention on the arrangement of the sitters, their physical and psychological comfort, and, perhaps most important, the promotion of his business. By January 1858, Brady was operating two separate portrait studios in New York; as of January 26, 1858, Gardner would manage a third gallery for him in Washington, D.C.[20]

As the decade neared its close, Brady and other top photographers in New York, Boston, and Philadelphia sought to distinguish themselves from newcomers to the field, whom they dismissed as "mere practitioners," not artists. One way to do so was by offering their patrons large-format photographic portraits on paper that were often heavily retouched with ink, crayon, and oil intended to flatter the wealthy sitters, something not possible with daguerreotypes or ambrotypes. The prints made from Gardner's oversize collodion glass negatives, such as a portrait of the eighth president of the United States, Martin Van Buren (fig. 7), Brady dubbed "Imperials." Depending on the amount of handwork requested,

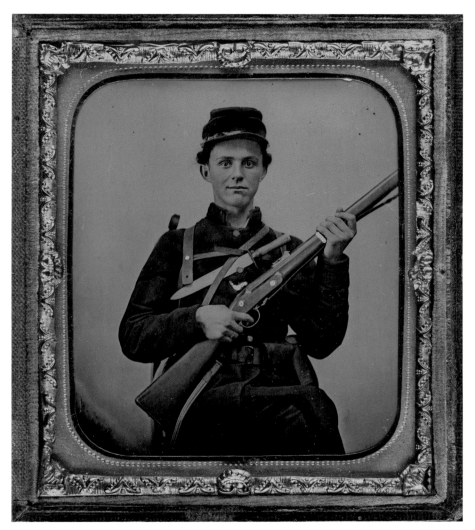

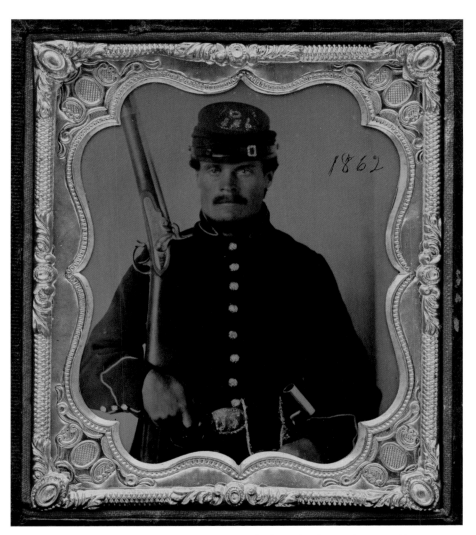

17 Unknown artist, Confederate Corporal (?) with British Rifle Musket and Bowie Knife, Likely from Georgia, 1861–62 (?). Sixth-plate ambrotype with applied color

18 Unknown artist, Union Soldier with Rifle, 1862. Sixth-plate ruby glass ambrotype with applied color

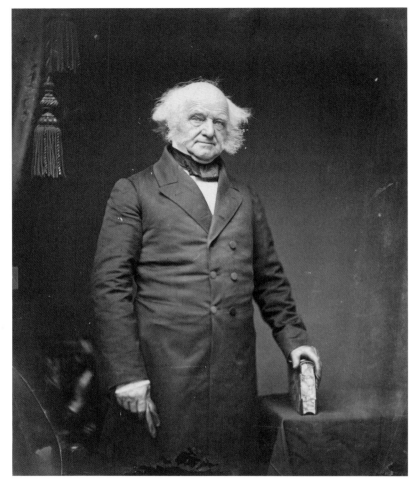

Fig. 7 Mathew B. Brady, *President Martin Van Buren*, 1855–58. Salted paper print from glass negative. The Metropolitan Museum of Art, David Hunter McAlpin Fund, 1956 (56.517.4)

Tintypes

It seems that the only major photographic process of the era never used by Brady or Gardner was the Melainotype, patented in 1856, and more commonly known as the ferrotype or tintype. Like both of its predecessors, the tintype was a direct-positive technique. Rather than copper or glass, the picture support was a thin sheet of iron that was japanned black. Among its selling attributes were its sturdiness, its light weight, and the ease with which it could be sent in the mail and incorporated into jewelry, generally pins and medals. An 1860 presidential election pin (pl. 19) with a tintype portrait of Lincoln set in a brass medallion with red, white, and blue ribbons is an extremely rare survivor from the nation's first political campaign that saw buttons featuring original photographic likenesses of all the candidates. Copied for mass distribution, the source image of the beardless Lincoln is an 1859 ambrotype portrait by H. H. Cole of Peoria, Illinois.

More than its pliability, it was the price point that greatly contributed to the tintype's ultimate success during the Civil War and

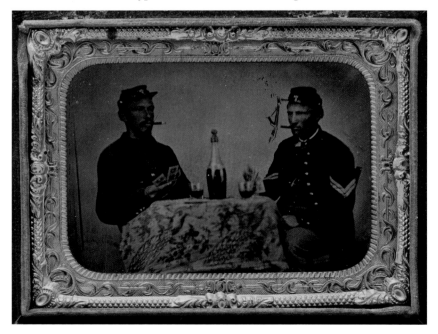

Fig. 8 Unknown artist, *Union Soldiers at Table, Playing Cards and Smoking Cigars*, 1861–65. Quarter-plate tintype with applied color. Brian D. Caplan Collection

he and Gardner sold these grand 17 × 21-inch portraits for the substantial sum of $50 to $500. The glass negatives combined the exquisite clarity of the daguerreotype with the endless reproducibility of the negative-positive process and paper-print photography. They were stable (if unwieldy) and could be printed repeatedly—a significant boon to the commercial application of the new medium.

for the following three decades. The tintype failed in only two areas: reproducibility and beauty. The process did not generate a negative, and thus a tintype could not be used to produce another example. If the sitter wanted a second image, it had to be copied by the photographer. This was easily done but, again, left no residue for the photographer to capitalize on later in the season, or long in the future—certainly one of the reasons Brady and Gardner kept their distance from the technology. The other was the inherent flatness of tone characteristic of the photographic description. No matter how hard they tried, even the most professional and diligent practitioners found it difficult to generate pleasing and dynamic natural contrasts of highlights and shadows. But if the tintype had its technical limitations, its many advantages—including versatility and cheapness—soon proved worthy of the moment. Once the war began, hundreds of itinerant tintypists began following the armies into the field and providing soldiers North and South with cheap portraits often distinguished by playfulness—a contribution of the young subjects—and pictorial invention—courtesy of the image makers (fig. 8).

Cartes de Visite
The demise of the daguerreotype and the ambrotype resulted primarily not from the introduction of the inexpensive tintype or the highbrow Imperial salted paper print portrait (with its impressive wall power that attempted to compete with painted portraits), but from the immediate success of another type of paper image—the carte de visite. Brought to the United States from France in the summer of 1859, the carte de visite was a miniature albumen silver print mounted on a thick paper card often bearing the photography studio's name on the verso, and at times on the recto as well. It was made from a collodion glass negative and measured approximately 4 × 2½ inches, and was usually sold by portrait studios with "collector" albums that could house and display from a dozen to several hundred card photographs.

There are conflicting opinions about who introduced this novelty in the United States, but a New York City photographer, Charles DeForest Fredricks (1823–1894), is usually given the credit

19 Unknown artist, *Abraham Lincoln Campaign Pin*, 1860. Red, white, and blue silk with tintype set inside stamped brass button

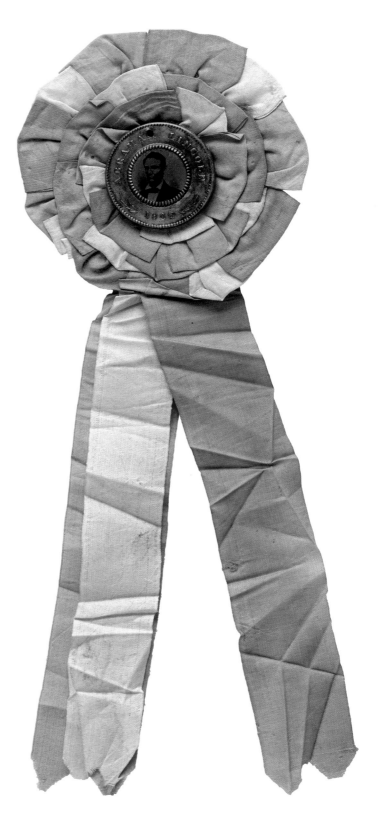

Fig. 9 André-Adolphe-Eugène Disdéri, *Prince Lobkowitz*, 1858. Albumen silver print. The Metropolitan Museum of Art, Purchase, The Horace W. Goldsmith Foundation Gift, through Joyce and Robert Menschel, 1995 (1995.170.1)

(see figure 17).[21] Using a special camera apparatus that produced from four to eight consecutive images on a single 8 × 10-inch glass plate, photographers were able to make inexpensive portraits, which could then be freely distributed by the sitter just like a visiting or calling card. Figure 9 is an example by the inventor of the process, André-Adolphe-Eugène Disdéri (1819–1889), of a print never cut apart or mounted. The subject is Prince Lobkowitz, in various poses and degrees of undress. Wildly popular as a means of self-representation, the carte de visite became an international collectible; there were few financial or technical barriers to the low-cost production and distribution (by post) of multiple copies of popular images. By the early 1860s the fashion for collecting cartes de visite was widespread—a phenomenon that captivated folks in Litchfield and Louisville, Lisbon and London. Queen Victoria kept albums of them and was so zealous it was reported she "could be bought, and sold for a Photograph!" Mary Todd Lincoln and the president began their own collection in early 1861.[22]

Views in Multiple Media
From the beginning of the photographic era in America, the increasing demand for portraiture fueled the proliferation of the medium. Eventually, though, the public started to take an interest in seeing pictures of their contemporary built environment—views of small towns and large cities—as well as studies of nature unmolested by man. As early as 1851, the taste for landscapes was well established; the New York press celebrated Robert H. Vance's panoramic daguerreotypes of California—"three hundred full plate views . . . of the principal cities

Fig. 10 Jay Dearborn Edwards, New Orleans Levee with Steamer *Magnolia*, 1857–60. Salted paper print from glass negative. The Historic New Orleans Collection

Fig. 11 Samuel Masury, Landscape, Pride's Crossing, Beverly, Massachusetts, 1859. Salted paper print from paper negative. The Metropolitan Museum of Art, Gilman Collection, Museum Purchase, 2005 (2005.100.869)

and most conspicuous places in the land of gold."[23] In many ways the daguerreotype (like all successor techniques) was well suited to the task: static and sunlit, monuments of architecture required no gentle coaxing or rigid head clamps to sit for a long camera exposure. But workers plying their trades on city streets were another matter. Their activity most often appears as an enticing blur, like the one in the central foreground of this study from 1857–60 of men loading or unloading cotton bales in the busy port of New Orleans (fig. 10). Astonishing early American daguerreotypes and salted paper prints of street scenes in San Francisco, St. Louis, and New York, among many other cities, also survive. They have one thing in common: unlike the period's printed views—wood engravings and lithographs, which were drawn for clarity and filled with drafting-table anecdote—these photographs reveal their cities as inelegant places filled with traffic, commercial signs, awnings, and pedestrians.

If American cities appeared somewhat chaotic in early photographic views, the landscape surrounding the urban centers must have seemed, by contrast, Edenic. An 1859 nature study made near Beverly, Massachusetts, by Samuel Masury (ca. 1818–1874) reveals a sense of graphic discovery that must have enchanted the era's viewers (fig. 11). Looking directly into the sun on a summer day along the Massachusetts coast, Masury, another Boston-based daguerreotypist who started experimenting with paper photography in the early 1850s, took pleasure in the comparison between the foreground's deep tonal shadows and the radiant expanse of sea and sky. In this, one of the earliest pure landscapes on paper in American photography, the strong feeling of repose recalls the sultry qualities found in oil paintings by Masury's contemporary John F. Kensett.

Far more common in the period than large albumen print (or salted paper print) views are stereoscopic images executed as daguerreotypes,

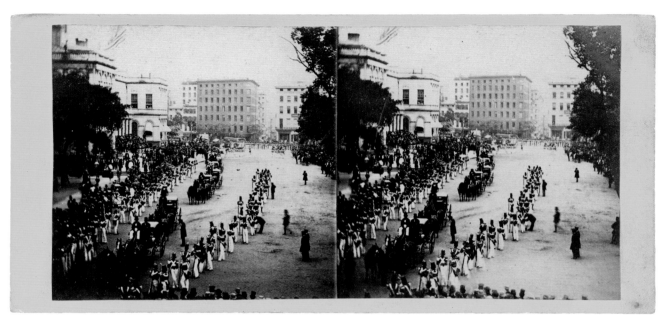

Fig. 12 Unknown artist, *Return of the Japanese Embassy from City Hall*, 1860. Albumen silver print (stereograph). The Metropolitan Museum of Art, Herbert Mitchell Collection, 2007 (2007.457.3626)

20 Porter Photographic Parlors, Young Woman with Beckers Tabletop Stereoscope, 1864–66. Albumen silver print (carte de visite)

glass positives, and paper prints. These paired photographs, seen in a special viewer, give the illusion of three-dimensionality. From redwoods in Yosemite Valley, California, to a parade of members of the visiting Japanese embassy near New York's City Hall (fig. 12), virtually every aspect of the American experience found its way into the hands of itinerant photographers looking to sell images to the era's stock picture dealers. By the start of the war, the stereograph, like the carte de visite, had become a popular collectible and a major source of revenue for photographers as well as the nation's premier publishers, including Brady's close friend and business associate Edward Anthony (1819–1888).

Such were the conditions that defined the medium of photography at the start of the Civil War. To understand the remarkable state of the art at this heady and exciting time, one need only consider for a moment the wealth of advertising covering the two facades of the Washington, D.C., gallery of Alexander Gardner, Brady's former chief operator, who in the autumn of 1862 had left to start his own portrait gallery (pl. 21). A view of his corner business at 7th and D streets in Washington—which operated in direct competition to Brady's—shows a four-story building festooned with signs for virtually every type of image available at the time, except the tintype: cartes de visite, stereographs, album cards, Imperial photographs (plain, colored, and retouched), ambrotypes, hallotypes, and ivorytypes.[24] The largest sign reads "Views of the War."

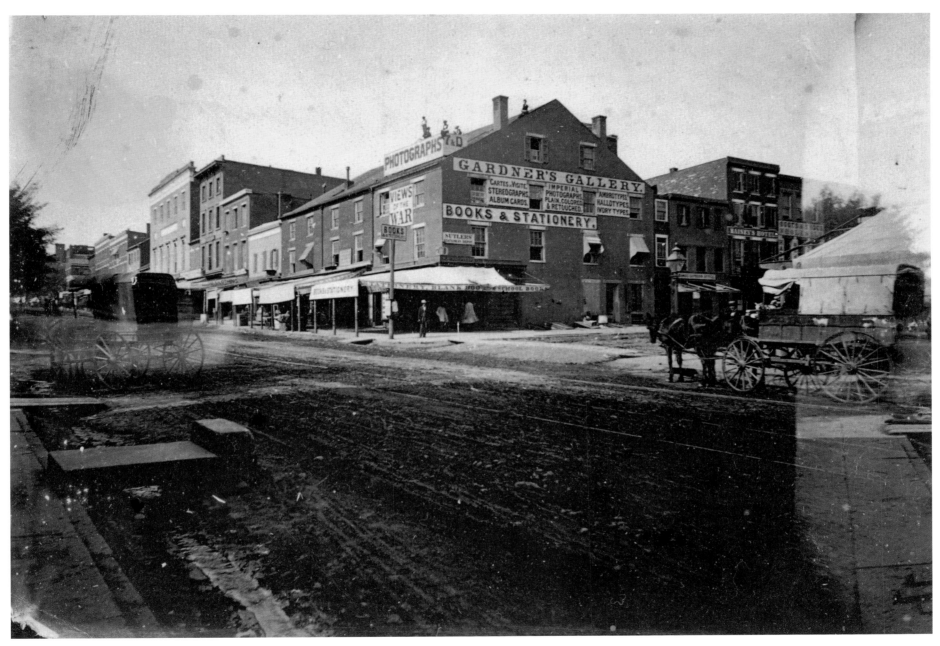

21 Alexander Gardner, *Gardner's Gallery, 7th and D Streets, Washington, D.C.*, 1864. Albumen silver print

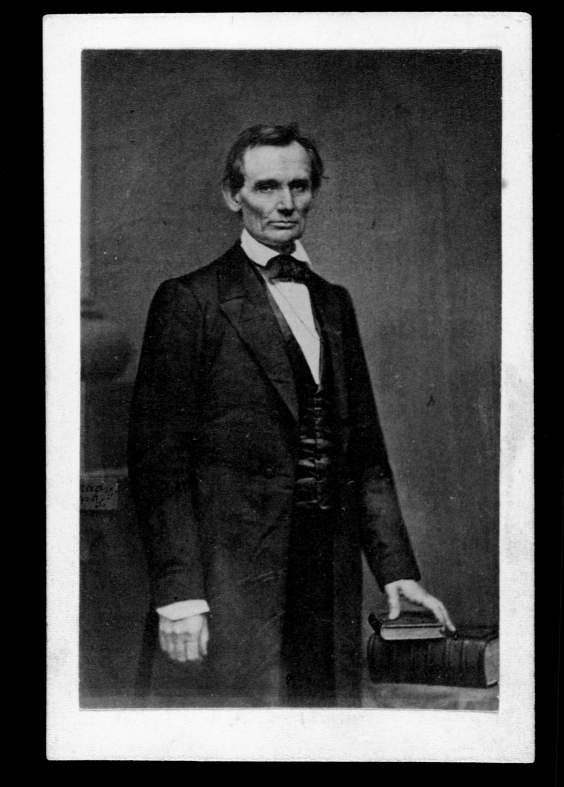

Lincoln and the 1860 Presidential Election

In the late spring of 1858, a prairie lawyer from Kentucky and former Illinois congressman made the decision to run for the United States Senate against a formidable incumbent Democrat, Stephen A. Douglas. Abraham Lincoln would lose the election but gain valuable moxie for what would come two years later. Lincoln and Douglas had long been political rivals: Douglas advocated for "popular sovereignty," his belief that citizens in Kansas and the other western territories should be allowed to make their own judgments regarding the expansion of slavery; Lincoln believed that slavery was wrong, and he set out to fight Douglas for the Senate seat on the platform that he and his party were against any expansion of human bondage in the United States. Lincoln formally launched his campaign on June 16, when he accepted the nomination at the Republican Party convention in Springfield, Illinois. His "house divided" speech delivered on the occasion was read and debated through the vibrant newspaper culture of the day:

A house divided against itself cannot stand. I believe this government cannot endure, permanently half slave and half free. I do not expect the Union to be dissolved—I do not expect the house to fall—but I do expect it will cease to be divided. It will become all one thing, or all the other. Either the opponents of slavery, will arrest the further spread of it, and place it where the public mind shall rest in the belief that it is in course of ultimate extinction; or its advocates will push it forward, till it shall become alike lawful in all the States, old as well as new—North as well as South.[25]

22 Mathew B. Brady, *Abraham Lincoln*, February 27, 1860. Albumen silver print (carte de visite)

Lincoln may have failed to win the Senate election, but after seven extraordinary campaign debates with Douglas he had built a national reputation that would in due time propel him as a candidate for the nation's highest office.[26]

To succeed, Lincoln had to make himself known to Americans across the country, and in 1859 he embarked on a Midwestern tour, giving talks in Illinois, Indiana, Ohio, Wisconsin, and Kansas. In early 1860 he came East, stopping in New York City on February 27, 1860, to give a speech at the Cooper Institute (now the Cooper Union for the Advancement of Science and Art), in the Italianate brownstone structure that still stands in Manhattan east of Broadway at Seventh Street.[27] Lincoln's powerful antislavery lecture was considered by many as his most important to date. The closing words spurred his audience, and the country at large: "Let us have faith that right makes might, and in that faith, let us, to the end, dare to do our duty as we understand it."[28]

With these words, Lincoln made as strong a statement of personal identity as he had made earlier in the day. Sometime in the morning before heading to the Cooper Institute, he made an impromptu visit to sit for his likeness at a popular photography studio (pl. 22). Mathew Brady's gallery at Broadway and Tenth Street was just a few blocks from the lecture hall, and the proprietor happened to be on the premises when Lincoln arrived. Although his visit to the studio could not have lasted long, the result of this first of many portrait sessions with Brady was a simple but powerful image that would alter the visual landscape during the upcoming election. In a single exposure on a silver-coated sheet of glass, Brady captured the odd physiognomy of the man who would change the course of American history.

The photograph Brady made that day of Lincoln, the "Cooper Union portrait," would soon be engraved and lithographed, to appear in

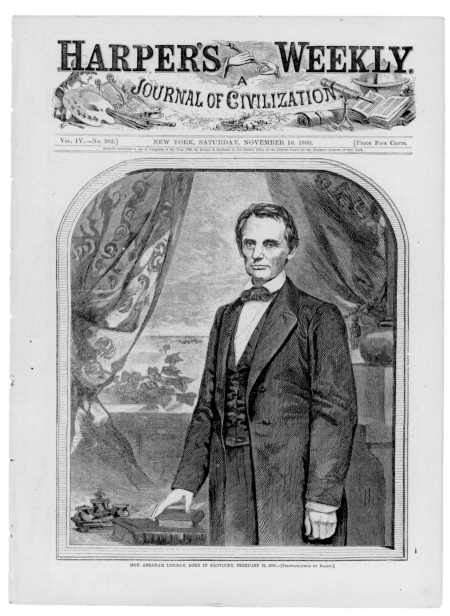

23 Front page of *Harper's Weekly*, November 10, 1860. Newspaper with wood engraving after carte de visite by Mathew B. Brady

24 Unknown artist, Presidential Campaign Medal with Portraits of Abraham Lincoln and Hannibal Hamlin, 1860. Tintypes in stamped brass medallion

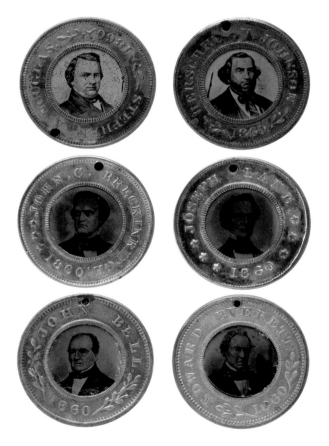

25 Unknown artists, Presidential Campaign Medals with Portraits of Stephen A. Douglas and Herschel V. Johnson, John C. Breckinridge and Joseph Lane, John Bell and Edward Everett, 1860. Tintypes in stamped brass medallions

newspapers and magazines (pl. 23), on campaign broadsides and banners, and printed as cartes de visite by Brady and his chief picture wholesaler, Edward Anthony.[29] Perhaps the best-known photographic portrait of the era, it would be photographically copied (likely without the artist's approval) as a miniature tintype for the world's first political campaign photo medallion, or button (pl. 24). Late in his life, the photographer told all who inquired that this portrait had made Lincoln president.[30] Lincoln himself conceded that Brady had "got my shadow, and can multiply copies indefinitely."[31] That he did.

In the most common of several extant Lincoln campaign photo buttons produced for the 1860 election, Brady's original portrait of the candidate is both laterally reversed and slightly blurred. Surprisingly, the flaws in the duplication process proved to have been a boon to the Kentucky "Rail Splitter." As his strong features softened, Lincoln became more classically handsome and less rough-hewn; more like James Stewart in *Rear Window* than the wild man found in period descriptions. William Howard Russell, a London *Times* journalist, met Lincoln in the Executive Mansion in March 1862 and composed the following prose portrait:

> The impression produced by the size of his extremities, and by his flapping and wide projecting ears, may be removed by the appearance of kindliness, sagacity, and the awkward bonhomie of his face; the mouth is absolutely prodigious; the lips straggling . . . are only kept in order by two deep furrows from the nostril to the chin; the nose itself—a prominent organ—stands out from the face, with an inquiring, anxious air, as though it were sniffing for some good thing in the wind.[32]

Curiously, the same softening effect seems not to have afforded the other candidates the bounce it gave Lincoln. Even a cursory examination of the surviving campaign medals of Stephen Douglas and Herschel V. Johnson, John C. Breckinridge and Joseph Lane, and John Bell and Edward Everett (pl. 25) reveals more about the crudeness of the photographic materials than the quality of the human countenance.

The straightforward pose Brady would ask Lincoln to adopt—standing, three-quarter profile, hand placed on a stack of books to stabilize the body and evoke a seriousness of purpose—was one the photographer had mastered years earlier, and used often. With but a minor variation in the angle of the shoulders and the direction of the eyes, the pose duplicates Brady's portrait of Jefferson Davis, the aristocratic Mississippi planter, Mexican-American War hero, and United States senator soon to become president of the Confederate States of America (pl. 26). Brady's likeness of Davis would be duplicated by photographers for various purposes in the North and South, including the production of a rare, perhaps unique, piece of patriotic Confederate jewelry (pl. 27). Constructed of thirteen carved vegetable ivory (tagua nut) disks, the necklace is inset with miniature albumen silver print portraits of Davis and two members of his Confederate cabinet: Vice President Alexander H. Stephens and the secretary of war, General John C. Breckinridge.[33] Who would have worn this extraordinary piece of war ephemera is not known. Likely commissioned in 1865 by a high-ranking member of the Confederacy as a special gift to a woman of means, the necklace would have been even more striking when it was first made: the carved beads would have been pure ivory-white, not light brown as they appear today.

Back in Illinois after a productive trip to the east coast, Lincoln worked further on his candidacy. He received the nomination for president at the National Convention of the Republican Party on May 18, 1860.[34] Almost immediately there was an outcry for photographs of the

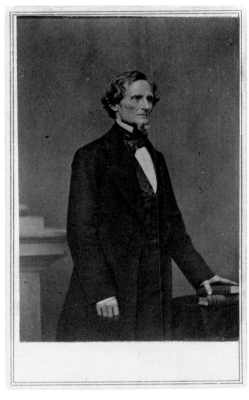

26 Mathew B. Brady, *Jefferson Davis*, 1858–60. Albumen silver print (carte de visite)

candidate now officially running for the nation's highest office. Lincoln complied with the wishes of the party organizers yet chose not to distribute Brady's carte-de-visite portrait. At this point in his political career, he admired the New York photographer but felt little brand loyalty. Instead of using solely the Cooper Union picture, Lincoln sat for a likeness immediately after the party convention in Chicago (pl. 28). One of five portraits by William Marsh of Springfield, Illinois, it was executed at the request of Marcus L. Ward, a delegate from Newark, New Jersey. In the photograph, the candidate appears younger than his fifty-one years, innocent of the great toll the presidency would take on him.

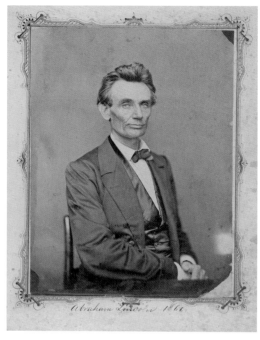

28 William Marsh, *Abraham Lincoln*, May 20, 1860. Salted paper print from glass negative

Marsh presents the handsome, rugged face of a man who two years after the photograph was made would write the Emancipation Proclamation (September 22, 1862; signed January 1, 1863), and who, in his second inaugural address, on March 4, 1865, would speak of reconstructing a vital, new country from the ashes of the South, "with malice toward none; with charity for all."[35]

If this portrait (so, too, the Cooper Union image by Brady) does not resonate with most viewers' standard mental image of the president, it is perhaps because Lincoln is not wearing his signature stovepipe hat or his characteristic beard. Despite repeated requests from the media consultants of the day—his party's election committee—that he grow a beard to hide his gaunt face, Lincoln was loath to do so until a few weeks before the election, when he received a letter from an eleven-year-old girl:

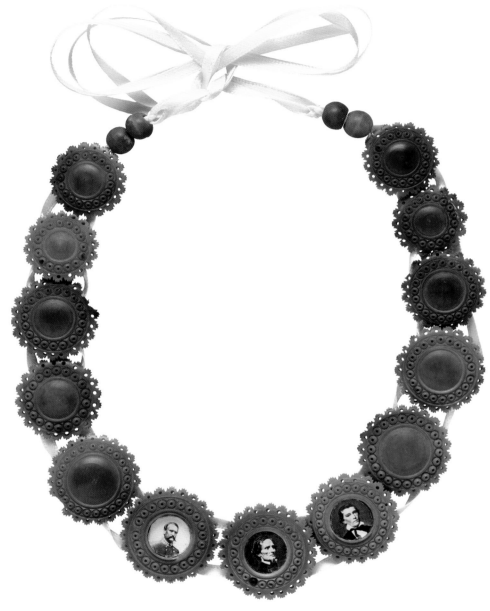

27 Unknown maker, Political Necklace with Portraits of Confederate President Jefferson Davis (center), Vice President Alexander H. Stephens (right), and Secretary of War John C. Breckinridge (left), 1861–65. Albumen silver prints set in carved vegetable ivory

October 15, 1860

Dear Sir,

My father has just home [*sic*] from the fair and brought home your picture and Mr. Hamlin's. I am a little girl only eleven years old, but want you should be President of the United States very much so I hope you wont think me very bold to write to such a great man as you are. Have you any little girls about as large as I am if so give them my love and tell her to write to me if you cannot answer this letter. I have got 4 brother's and part of them will vote for you any way and if you let your whiskers grow I will try and get the rest of them to vote for you you would look a great deal better for your face is so thin. All the ladies like whiskers and they would tease their husband's to vote for you and then you would be President. My father is a going to vote for you and if I was a man I would vote for you to but I will try and get every one to vote for you that I can I think that rail fence around your picture makes it look very pretty I have got a little baby sister she is nine weeks old and is just as cunning as can be. When you direct your letter direct to Grace Bedell Westfield Chatauque County New York

I must not write any more answer this letter right off Good bye

Grace Bedell[36]

Upon receipt of the note, Lincoln responded to the young New Yorker that he had three sons but no daughters: "As to the whiskers, having never worn any, do you not think people would call it a piece of silly affection if I were to begin it now?"[37] After the election, Lincoln stopped shaving, and by the time of the inauguration, March 4, 1861, he had become the first American president to wear a beard. (See plate 14 for an 1862 field portrait of the bearded Lincoln.)

This contemplative carte-de-visite portrait of Lincoln (fig. 13) was the first made after his arrival in Washington, D.C., to assume his role as the sixteenth president of the United States. Alexander Gardner made the photograph on Sunday, February 24, 1861, on Lincoln's extremely busy first day in the nation's capital. After attending morning services at St. John's Episcopal Church with New York Senator William Seward, his future secretary of state, and before an evening meeting with outgoing Vice President John Breckinridge, the president-elect took time to visit Brady's gallery to sit for a likeness sporting his new whiskers. Gardner posed Lincoln in an armchair, seated erect, and beside a table set only with an inkwell. Perhaps musing on the content, tone, and significance of his unfinished inaugural address, Lincoln appears lost in thought and tired from his twelve-day rail journey to Washington. He wears on his face the expression that John G. Nicolay, his private secretary, described as "that serious, far-away look that with prophetic intuitions beheld the awful panorama of war, and heard the cry of oppression and suffering."[38]

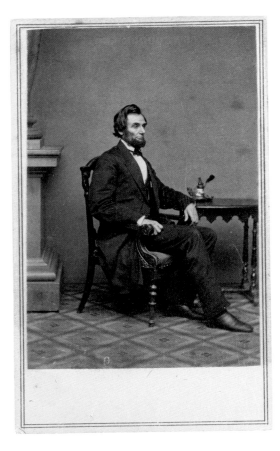

Fig. 13 Alexander Gardner for Brady & Company, *President-Elect Abraham Lincoln*, February 24, 1861. Albumen silver print (carte de visite). Thomas Harris Collection

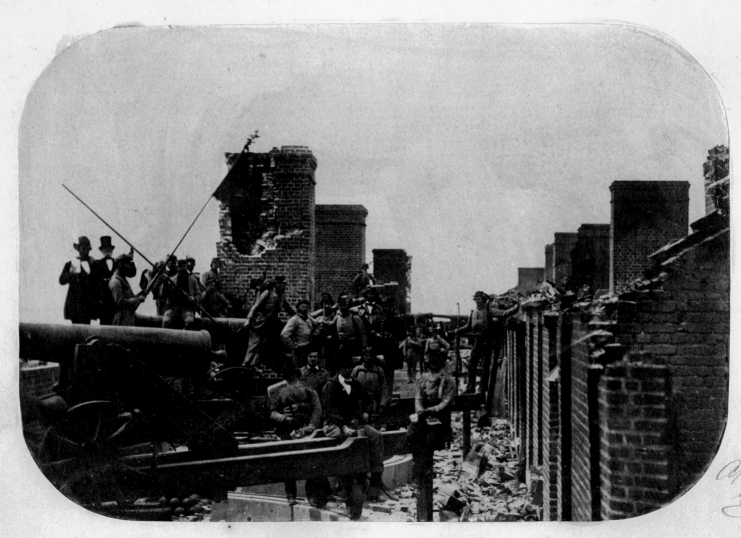

Terre-plein of the Gorge; showing the guns en barbette

Approved
G.T. Beauregard
Brigadier Gen'l

No 12

Charleston Harbour } Fort Sumter
S.C. } April 15 1861

Secession and Fort Sumter

Lincoln won the November 6, 1860, election, defeating his chief rival, Stephen Douglas, by 500,000 popular votes, and winning fifty-seven more electoral college votes than the other three candidates combined. The vote was essentially split along the North–South divisions of free and slave states. The Republican Party victory and its antislavery policy instantly set the stage for the outbreak of the Civil War. The first Southern state to react to the election was South Carolina, which seceded from the Union on December 20.[39] Almost immediately its governor, William Henry Gist, demanded that President James Buchanan abandon all the federal forts guarding Charleston Harbor, including Fort Sumter, which had been under construction by the federal government since 1829.

Cadets at The Citadel, the Military College of South Carolina, fired the first shots of the war on January 9, 1861, effectively stopping the USS *Star of the West* from resupplying United States Army Major Robert Anderson and the soldiers of the First United States Artillery garrisoned on Fort Sumter. Isolated on an inhospitable rock slab in the middle of the harbor, Anderson was protected from a land invasion but had no food supplies or means to procure them on the mainland. To provide relief, the new president sent a flotilla in support of Anderson, who had wired Washington that he would soon run out of food. Despite the imminent (April 11) arrival in Charleston Harbor of the first federal ships, Confederate Brigadier General Pierre G. T. Beauregard sent three aides to demand Anderson's total surrender. It would be one of many ironies of the war. Twenty-five years earlier, while he was a cadet at the United States Military Academy at West Point, New York, Beauregard's

favorite instructor was his artillery professor, Robert Anderson. When Anderson refused to leave the fort and pull down the huge American flag flying above it, Beauregard instructed his men, about five hundred soldiers, to begin firing every artillery weapon in the Confederate arsenal on Anderson's troops, some eighty men, at the fort. The bombardment would last for two days; the war it began, for four years. When it ended, more than 750,000 Americans would be dead, two percent of the nation's population, and approximately one of every five combatants.

On the early afternoon of April 14, 1861, Major Anderson removed the thirty-three-star United States garrison flag that had flown above Fort Sumter and with his men evacuated the severely damaged fortress. He and the First United States Artillery had survived the first military action of the Civil War—some thirty-three hours of nearly constant shelling from at least seventy cannons and mortars, and raging fires within the fort itself.[40] The following day, while Anderson was steaming north for New York City as rapidly as possible on the USS *Baltic*, a much smaller vessel was slowly heading toward Fort Sumter.[41] On board was an enterprising Charleston photographer named Alma A. Pelot (b. 1840?) and a pile of gear including his wooden glass-plate camera and tripod, a dark tent for sensitizing and developing his plates, and all the chemicals he would need to make what most historians believe are the first photographic images of the Civil War.[42]

The editors of *The Charleston Daily Courier* found space in the newspaper on April 16 to report with evident pride on this small but important part of the story of the Confederate States of America's first battle victory:

By special permission of General Beauregard, our young native artist, Mr. Alma A. Pelot, assistant to Jesse H. Bolles,

29 Attributed to Alma A. Pelot, *Terre-plein off the Gorge, Fort Sumter*, April 15, 1861. Albumen silver print

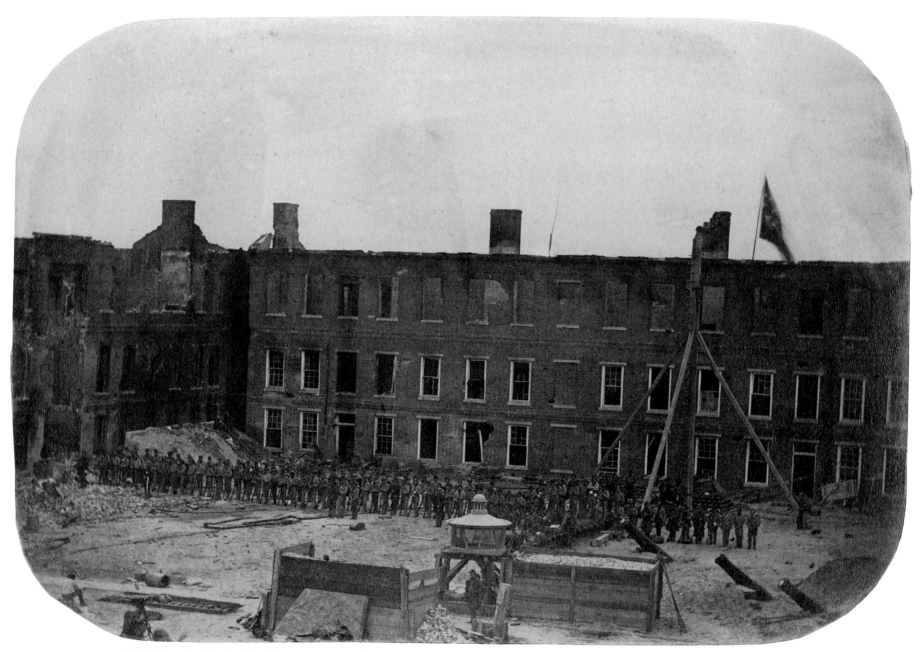

30 Attributed to Alma A. Pelot, *Western Barracks and Parade, Fort Sumter*, April 15, 1861. Albumen silver print

has taken full and perfect representations of the internal appearance of Fort Sumter, on the morning after the surrender. These pictures for the time will afford appropriate ornaments for our Drawing Rooms, Scrap Books and Albums, and a most acceptable present to distant and anxious friends.[43]

The Charleston Mercury reported that Pelot had returned from Fort Sumter with negatives made from "five different points of view."[44] Pelot or other assistants at Bolles's gallery quickly printed the negatives, mounted the albumen silver prints on fine cotton-rag board, and began the preparations for an exhibition of these and another eleven views made in the following days at Fort Sumter and at Fort Moultrie, one of the batteries from which Beauregard had trained his guns on Anderson.[45] The gallery also made a special presentation set, which it offered to Beauregard for his approval. Four of these first five battle views of the Civil War survive in the collection of the New-York Historical Society; each is signed and inscribed by Beauregard, dated April 15, 1861, and annotated with full period captions. Perhaps the most dramatic is *Terre-plein off the Gorge* (pl. 29), a dynamic study of armed Confederate soldiers and top-hatted civilians celebrating the South's victory by draping themselves over the huge pivot guns Beauregard had silenced at Fort Sumter.

Given that Pelot was a young studio portraitist with little field experience, these modest-size prints with their rounded corners and mature balance of architectural description and human incident are extraordinary (pls. 30, 32, 33). Collectively they reveal a natural understanding of the historical moment, a graphic appreciation for the harsh beauty of a ruin, and an eye for the symbolic. In *Western Barracks and Parade*, one of the two views of Fort Sumter's parade ground, Pelot maintains just the right camera height so that the new flag of the Confederacy, the "Stars and Bars," would not only fly above the parade of about a hundred marshaled soldiers, but also wave in the breeze against the open sky atop the fort's battered walls. This is the first known photograph of the Confederate flag in military use.[46] The flag, which had been adopted by the Confederate Congress seven weeks earlier, is difficult to see without magnification; it is composed of a circular field of seven white stars set into a dark blue canton,

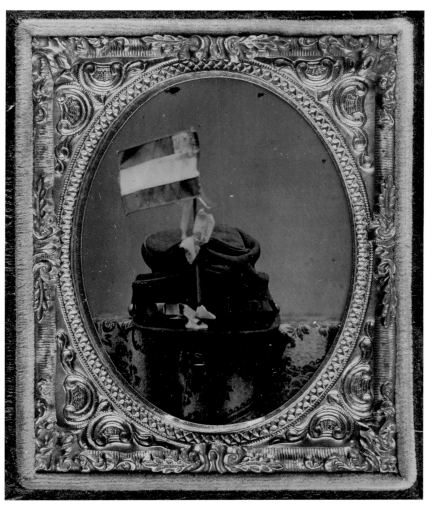

31 Unknown artist, Soldier's Kepi with First National Flag of the Confederacy, April 1861. Ninth-plate ruby glass ambrotype with applied color

alongside three horizontal stripes, two red, one white. The basic design of the First National Flag of the Confederacy is seen much more clearly in a ninth-plate ambrotype of a Southern soldier's kepi (military cap) resting on the photographer's studio table (pl. 31). The unknown artist added to the still-life composition a bit of ribbon and a dogwood flower that helps

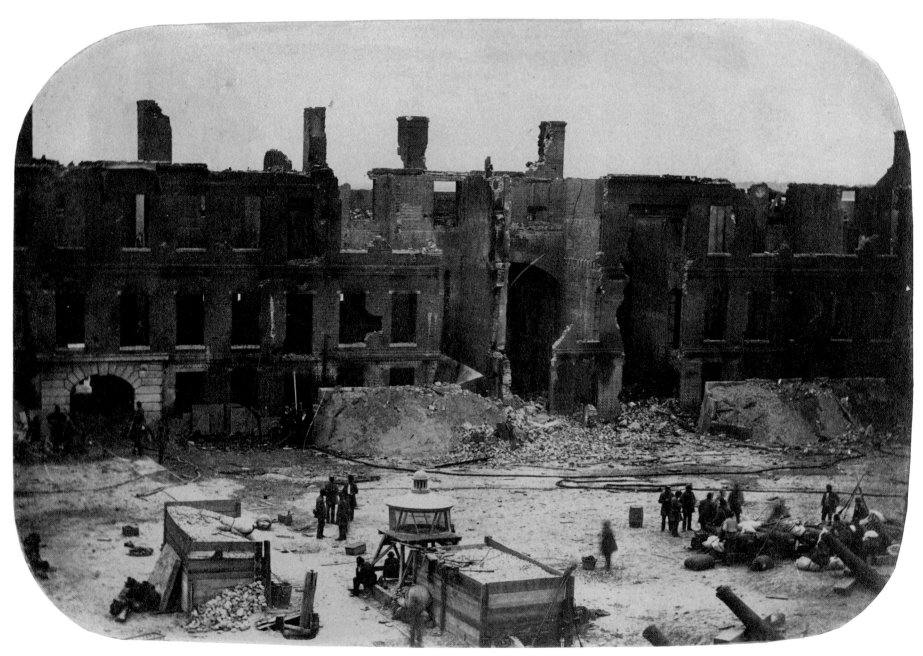

32 Attributed to Alma A. Pelot, *Interior Face of Gorge, Fort Sumter*, April 15, 1861. Albumen silver print

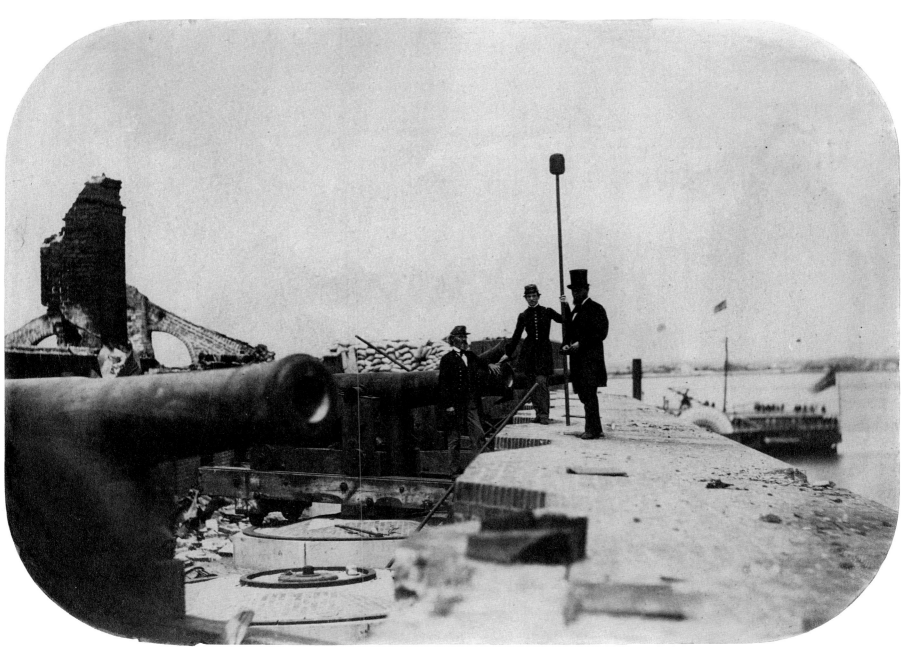

33 Attributed to Alma A. Pelot, *Terre-plein and Parapet, Fort Sumter*, April 15, 1861. Albumen silver print

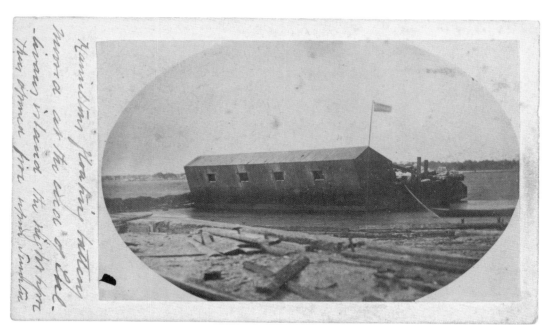

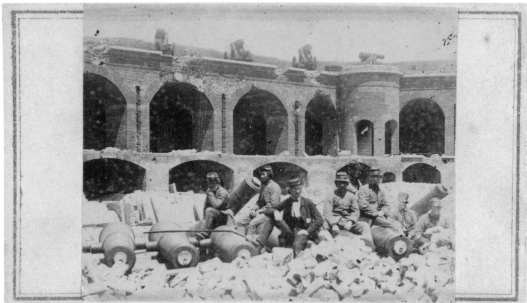

34 Attributed to Alma A. Pelot and Jesse H. Bolles, *Hamilton's Floating Battery Moored at the End of Sullivan's Island the Night Before They Opened Fire upon Fort Sumter*, April 1861. Albumen silver print (carte de visite)

35 Osborn's Gallery, *Salient with North-west Casemates, Fort Sumter*, April 1861. Albumen silver print (carte de visite)

date the 1861 photograph to April, when the characteristically Southern tree blossoms.

Alma Pelot was not the only Charleston photographer to see an immediate opportunity to profit from the city's proximity to the seat of war and to celebrate the South's first victory. A small carte-de-visite-format album hand-inscribed "The Evacuation of Fort Sumter" and given in 1862 as a gift to a "Mrs. Crawford Washington" includes sixteen cartes de visite of Fort Sumter and the other batteries lining Charleston Harbor (pls. 34, 35). On the inside front cover is a period inscription: "These photographs were taken immediately after the evacuation of Fort Sumter by the U.S. Troops under Anderson, April 1861." Two of the cartes de visite—including a study of Confederate soldiers sitting in the rubble of the fort—feature the backmark of Osborn's Gallery, which was located on the same Charleston corner as Jesse H. Bolles's studio. All the others, including a view of Beauregard's "floating battery" that is generally attributed to Pelot and Bolles, are on E. Anthony mounts.[47]

J. M. Osborn, a partner of the firm of Osborn and Durbec's Southern Stereoscopic and Photographic Depot, received permission to photograph at Fort Sumter, as *The Charleston Daily Courier* reported on April 23.[48] Together with those by Pelot, Osborn's photographs, exhibited in Charleston and sold as loose prints, cartes de visite, and stereographs, constitute "the largest known group of Confederate images of the war . . . as well as one of the most complete contemporary photographic records ever made of the site of a Civil War engagement."[49] It is thus disconcerting to consider that there are no large sets of extant field photographs (battlefield studies) made by Southern artists between April 1861 and August 1864, when A. J. Riddle (ca. 1829–1897) left his Macon, Georgia, portrait studio to document the squalid conditions in the prison for Union soldiers at Andersonville, Georgia (pls. 170, 171).[50] The result is that virtually all the other known views of the Civil War are by Northern photographers, even those made in the Deep South (pls. 37, 38). The primary reason was the greatly diminished availability of photographic supplies, due to the Union's successful blockade of almost every Confederate-held port. What few materials were available to Southern photographers were evidently reserved for their core business: portraiture (pl. 36).

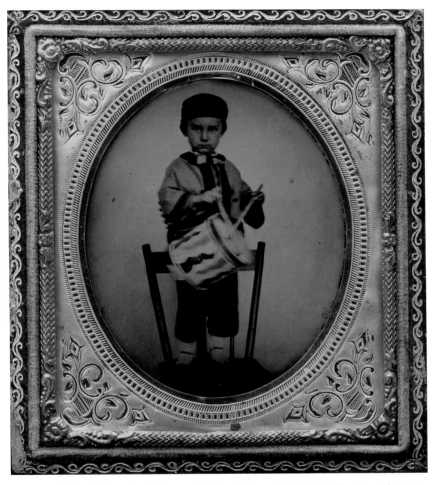

36 George S. Cook, Young Boy in Zouave Outfit, with Drum, 1861–65. Sixth-plate ambrotype with applied color

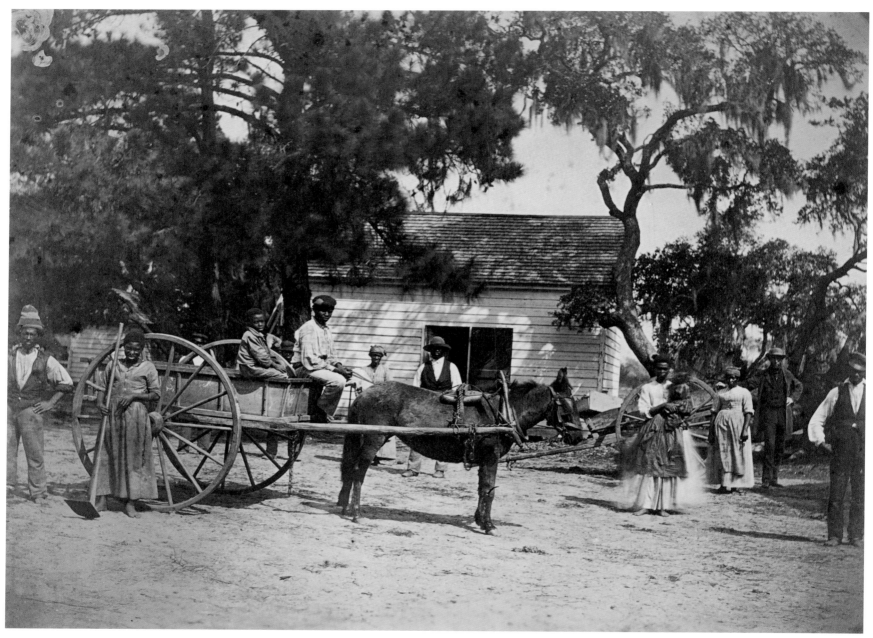

37 Henry P. Moore, *Negroes (Gwine to de Field), Hopkinson's Plantation, Edisto Island, South Carolina*, 1862. Albumen silver print

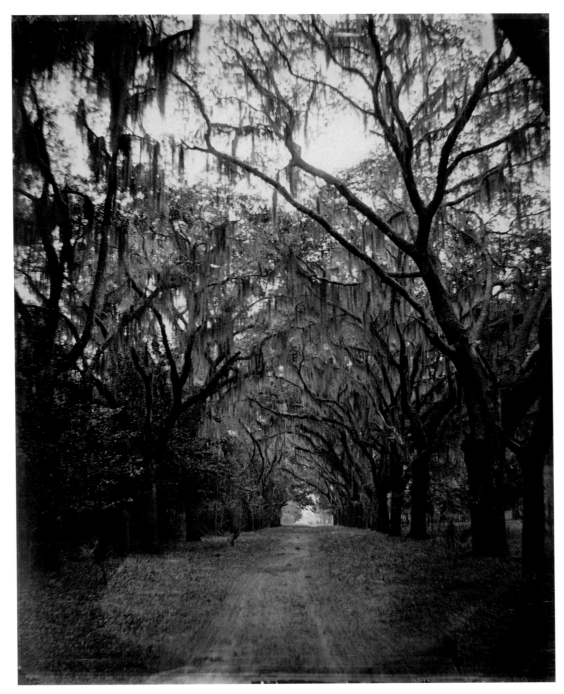

38 George N. Barnard, *Bonaventure Cemetery, Four Miles from Savannah*, 1866. Albumen silver print

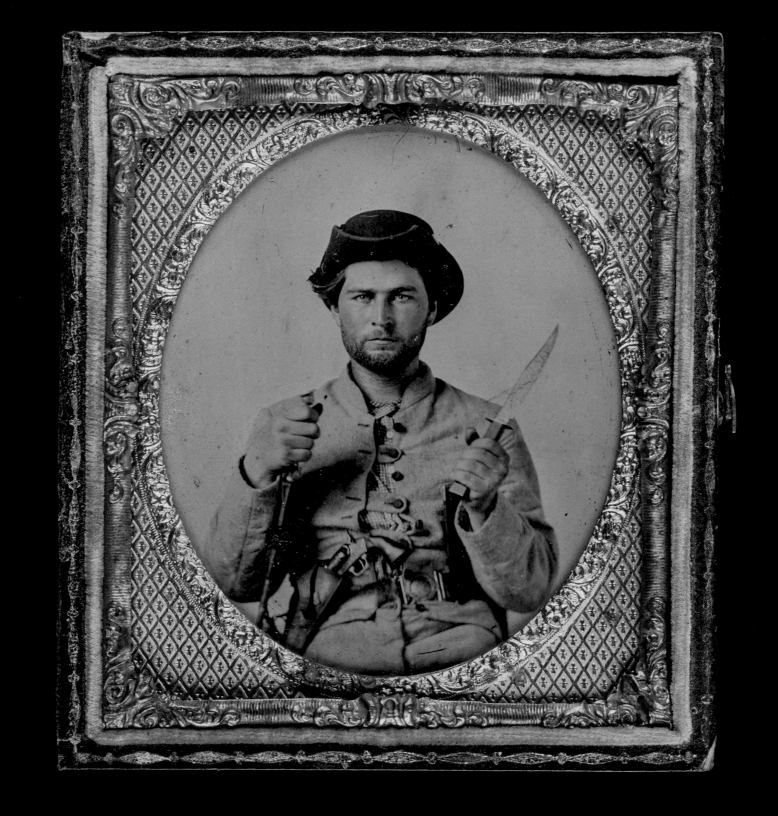

Early War Portraits

General Beauregard's dramatic capture of Fort Sumter prompted an immediate response from President Lincoln: a clarion call for "the militia of the several States of the Union, to the aggregate number of seventy-five thousand, in order to suppress said combinations [essentially the new Confederate States of America, then comprising South Carolina, Mississippi, Florida, Alabama, Georgia, Louisiana, and Texas], and to cause the laws to be duly executed."[51] The request for troops to come to Washington to help quell the insurrection triggered four more Southern states to secede: first Virginia, then Arkansas, North Carolina, and Tennessee.[52] As the historian James M. McPherson writes, "Secession was a counterrevolution by slaveholders against the ideology of freedom, the dignity of labor, and the chance for upward mobility for workingmen represented by Lincoln's Republican Party."[53]

Lincoln's order for militia to protect and preserve the United States government was heeded across the North (pls. 60, 61), and was a boon to photographers from Massachusetts to Michigan. Similarly, in the South it was a catalyst for Confederate militiamen (pl. 39) to seek their portraits before heading off to serve their equally new leader, Jefferson Davis. The result of this military activity was the creation of an unparalleled mass national photographic portrait of men and women of all means, of large and small families, and of groups of soldiers. The name and personal narrative of the gangly Union soldier wearing a wide-brimmed slouch hat who was " 'mustered in' for 30 days" may well remain unknown (fig. 14), but Confederate Private Abram Beach Reading's story is fully recorded (pl. 40). He would die in action at the Battle of Savage's

Station in Henrico County, Virginia, on June 29, 1862. The long and bloody war defined an era when, almost single-handedly, photography transformed portraiture from a luxury good into a necessity: at ten cents to two dollars an image, a portrait of oneself and one's friends, of regimental commanders, even of one's fellow combatants, was affordable for virtually every citizen North and South, from the farmer to the railroad magnate, from the ticket taker to the congressman.

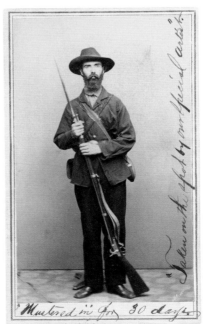 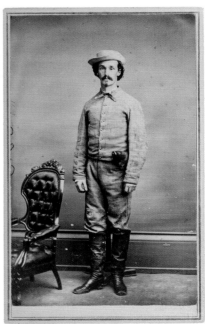

Fig. 14 John Goldin & Company, *"Mustered in" for 30 Days*, 1861 (?). Albumen silver print (carte de visite). Thomas Harris Collection

40 Herrick & Dirr, *Private Abram Beach Reading, Company A, "Vicksburg Southrons," Twenty-first Mississippi Infantry*, 1861–62. Albumen silver print (carte de visite)

39 Unknown artist, *Private James House, Sixteenth Georgia Cavalry Battalion, Army of Tennessee*, 1861–62 (?). Sixth-plate ruby glass ambrotype

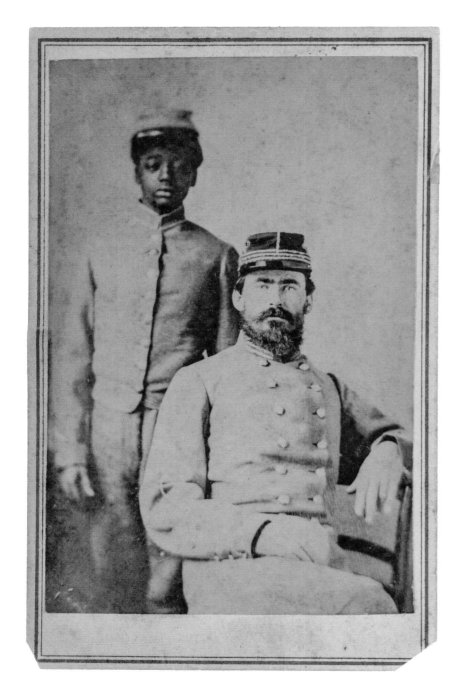

Moreover, this national portrait being created by individuals across America for a host of different reasons and purposes would help delineate the lives of the country's most disenfranchised, those most invisible in the cultural record: African-Americans (pl. 41). In a July 4, 1861, message presented to Congress on the anniversary of the country's independence, Lincoln affirmed his understanding that the American government was responsible, and the contest was being fought, for the rights of all men, black and white: "This is essentially a People's contest . . . to elevate the condition of men—to lift artificial weights from all shoulders—to clear the paths of laudable pursuit for all—to afford all, an unfettered start, and a fair chance, in the race of life."[54] The medium of photography, in very real ways, would serve this noble cause.

The low price and relatively high quality of the images, however, cannot alone explain the saturation into the culture of the carte de visite, the ambrotype, and the tintype. The very fact of the war and the real threat of severe injury—or death, for one in five soldiers—drew tens of thousands of men and their families to portrait studios. At times, ambitious photographers used the volatility of the moment to add to the societal anxiety and promote their bottom line. The darkly affecting carte de visite of a soldier embracing his young children (fig. 15) is actually an early advertising image. The proprietors at Evans' Photographic Parlors (location unknown) suggest the grave risk should any soldier leave town without a new portrait of himself with his family, because "this may be my 'last visit home.'"

Photography studios thus accommodated and also took advantage of a wounded populace seeking solace and an escape from the threat caused by what the cultural historian Andrea Volpe calls "the turmoil of secessionist politics and the instabilities of the Civil War."[55] What is uncertain is whether the desire to sit for a portrait was driven primarily by hope that the little photograph might help the subject and his family survive the war, or by fear that the sitter and his relatives would not live through the next battle. Regardless, the belief in the power of the photographic image during this period, in both field pictures and portraits, is astounding. And it comes through in the faces of privates

41 A. J. Riddle, Confederate Captain and Manservant, 1864. Albumen silver print (carte de visite)

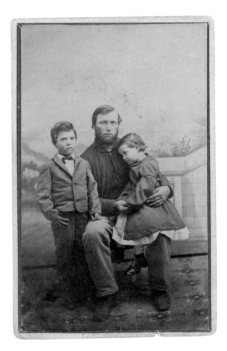

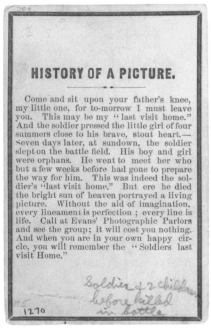

Fig. 15 Evans' Photographic Parlors, *History of a Picture,* 1861–65. Albumen silver print (carte de visite). Thomas Harris Collection

and officers alike, Confederates and Unionists, men and women. In plate 59, a sixth-plate tintype, a young woman physically embraces a pair of quarter-plate soldier portraits—silver likenesses of her loved ones, who may never come home. In figure 16, a tintype missing its case but with a contemporary note inscribed on its verso, another anonymous young woman seems to have given the picture's owner the required strength (or luck) needed to survive the hell that General William Tecumseh Sherman said was war's essential quality.

In these and other early wartime portraits, seen in plates 42–59, a picture of American society emerges—an entire nation of faces searching for identity and looking at the camera to find its way there. This act of democratic self-representation is where the pathos and poignancy of Civil War photography come through most clearly: in the seemingly straightforward, transparent, and affecting stare of Johnny Reb and Billy

Yank. In plate 42, a Union private holds his rifle musket fixed with its bayonet and poses standing at attention against a blank studio wall. He wears a new government-issue four-button sack coat and a kepi; a leather waist belt with bayonet scabbard and pouch for carrying percussion caps (used for igniting musket cartridges); and a shoulder belt from which hangs a cartridge box that holds forty rounds of ammunition. The circular medallion on the shoulder strap has an eagle insignia rarely visible in photographs because of the light reflected off its metallic surface. Far easier to see are the two oval plates with "US" in relief, on both the waist belt (serving as a buckle) and on the cartridge box (used as a weight to hold down the flap). Both insignias are laterally reversed, because ambrotypes and tintypes, created without a negative, are mirror images of their subjects. This effect greatly bothered some observant officers, including a Lieutenant Griswold, who sent home a letter with a new portrait from Fairfax Court House, Virginia: "Enclosed I send you my ambrotype taken at this place. I cannot get any photographs [cartes de visite] but you can take the plate and get it photographed, which will bring the sword on the side it ought to be."[56]

The soldier in plate 42 honors the occasion by paying a bit extra for the color applied to the surface of the sixth-plate tintype (a dash of rouge on the cheeks), and even more for the embossed patriotic brass mat heralding "CONSTITUTION" and "UNION."[57] Patriotic mats with

Fig. 16 Unknown artist, Woman with Brooch, 1861. Ninth-plate tintype with applied color. Jane Van N. Turano-Thompson Collection

Union motifs were not uncommon during the Civil War and appear on a good number of cased ambrotypes and tintypes, especially in thermoplastic cases as seen here and in plates 53 and 56. For Confederate cased portraits, there is no true equivalent of the decorative "patriotic" mat. In the South, the design, production, and manufacture of such a luxury, factory-produced item during wartime was simply not possible. In fact, after the war entered its second year, it was difficult for most Southern photographers to acquire any type of brass mat or even cases for ambrotypes and tintypes. They had an equally hard time finding vendors who sold albumen silver paper, used to print cartes de visite and larger-

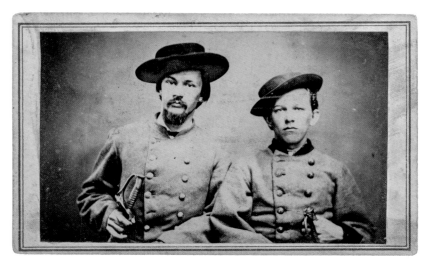

43 Unknown artist, *Thomas Mickleberry Merritt and Unknown Fellow Officer, Company G, Second Georgia Cavalry Regiment*, 1862–63. Albumen silver print (carte de visite)

format negatives. This helps explain why, numerically, there are far fewer Confederate-made cartes de visite and large-format paper prints (pl. 43). Most photographers active in the South at the start of the war closed shop completely. To make do, the remaining photographers collected and reused materials that had previously housed existing daguerreotypes or other cased images. At least one or more resourceful photographers made components of their own cases and mats with textile remnants, colored papers, or printed wallpaper (pls. 44, 45, 54, 55).

One especially clever artist, Charles Henry Lanneau, even went to the trouble of inserting his own ruby glass ambrotype portrait of Private Ezekiel Taylor Bray of the Sixteenth Regiment, Georgia Volunteer Infantry, into an old sixth-plate daguerreotype case stamped on the brass preserver mat "JEFFERS" (pl. 44).[58] Lanneau presumably removed an original portrait by George A. Jeffers, a photographer operating in the 1850s in North and South Carolina, but kept the original photographer's name; he then hand-embossed his own patriotic sentiment on the dark

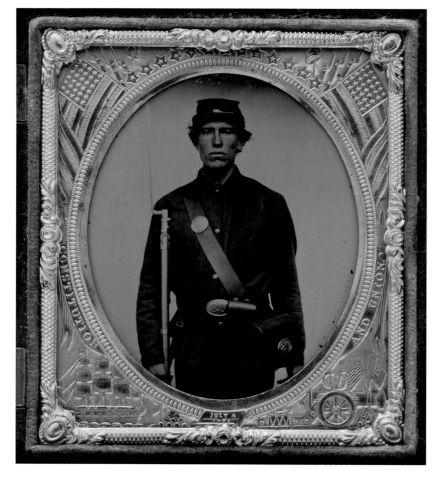

42 Unknown artist, Union Private, Standing, with Rifle Musket, 1861–65. Sixth-plate tintype with applied color

and town. Some may have believed, as General Sherman noted in his memoirs, what many Southern orators had expressed at the time, "that there would be no war, and that a lady's thimble would hold all the blood to be shed."[60] This was, of course, a significant misreading of the political realities, and from April to June 1861 the two armies prepared themselves for war.

Brady's Washington gallery had been doing blockbuster business from the moment President Lincoln took office. Located on Pennsylvania Avenue, it was well situated, politically and geographically, to provide to the new and older congressman fine Imperial portraits as well as less expensive

44 Charles Henry Lanneau, *Private Ezekiel Taylor Bray, Company A, "Madison County Greys," Sixteenth Regiment, Georgia Volunteer Infantry, Army of Northern Virginia*, 1863. Sixth-plate ruby glass ambrotype

red velvet pad on the inside front cover of the otherwise plain case. The line reads "CONFEDERATE CASES," a gesture of Rebel defiance to Yankee photographic manufacturing. This type of hinged daguerreotype case, made of thermoplastic and produced in Connecticut beginning in the early 1850s, would have been described in simplest terms in a photographer's standard product catalogue as a "Union Case."[59]

—+·✦·+—

In the first few months of the war, almost every Union militiaman garrisoned in his home state or on the way to the seat of war was mustered out without ever firing a shot at the enemy. Most of the soldiers had signed up for only thirty days; they drilled, fired their weapons, tried to keep their uniforms fresh, wrote family letters, and sat for photographs in field

45 Charles Henry Lanneau, *Fincher Brothers, Company I, "Zollicoffer Rifles," Forty-third Regiment, Georgia Volunteer Infantry, Army of Tennessee*, 1863. Sixth-plate ambrotype with applied color

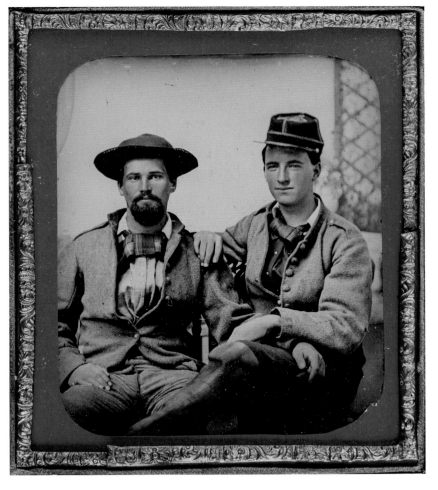

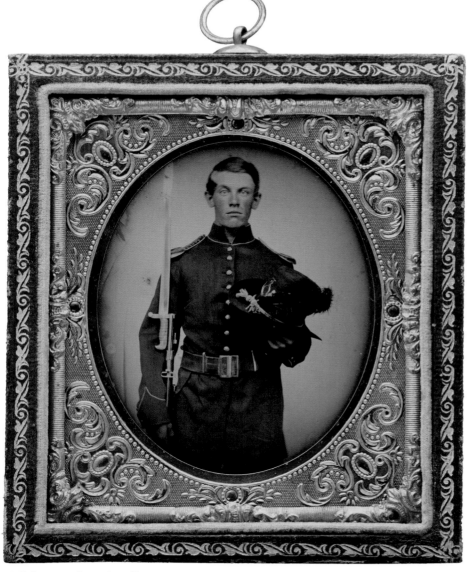

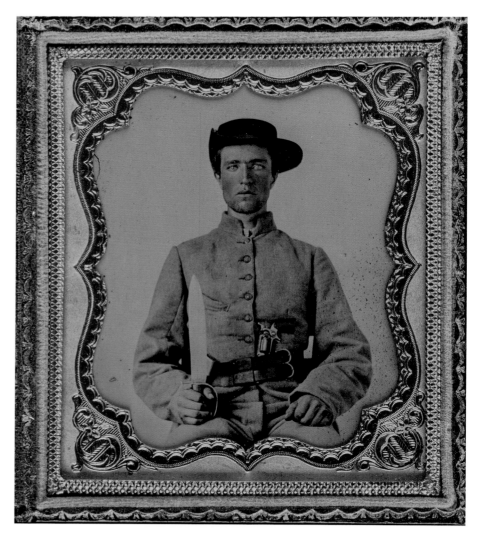

46 Unknown artist, Union Officer in Dress Coat and Plumed Hat, with Rifle and Sword
Bayonet, 1861–65. Sixth-plate ambrotype with applied color

47 Unknown artist, Confederate Soldier with Handgun in Belt, Holding Bowie Knife, 1861–62.
Sixth-plate ruby glass ambrotype with applied color

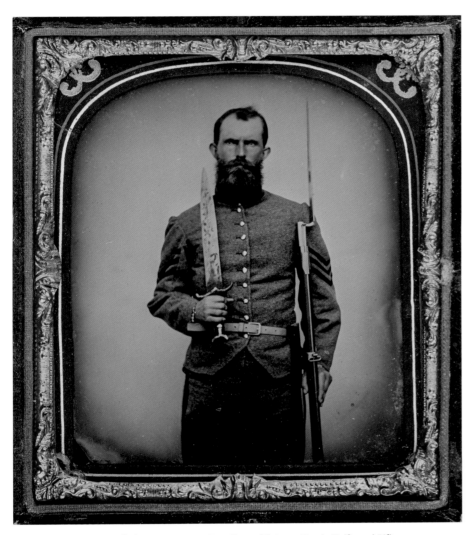

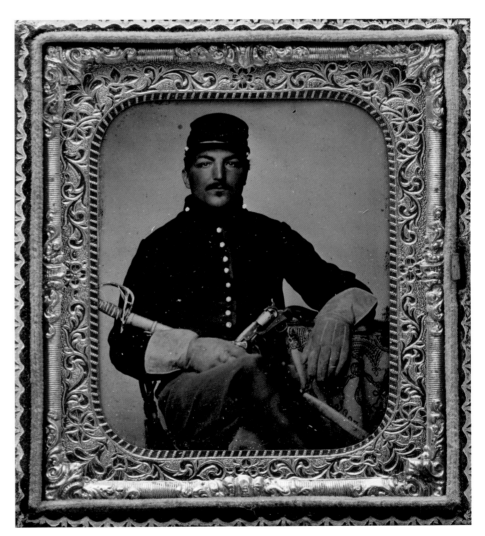

48 Unknown artist, Confederate Sergeant, Standing, with Large Bowie Knife and Rifle, 1861–65. Sixth-plate ruby glass ambrotype with applied color

49 Unknown artist, Union Cavalry Soldier, Seated, with Sword and Handgun, 1861–65. Sixth-plate tintype with applied color

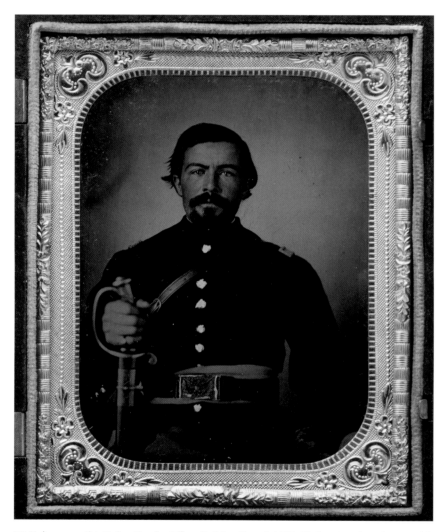

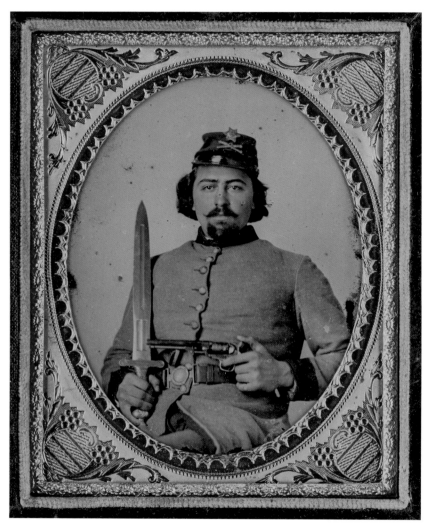

50 Unknown artist, Union Cavalry Officer Holding Sword, 1861–65. Quarter-plate tintype with applied color

51 Unknown artist, *Private Benjamin Franklin Ammons, Company L, First Tennessee Regiment Heavy Artillery*, 1861–63. Quarter-plate ambrotype with applied color

52 Unknown artist, Confederate Sergeant in Slouch Hat, 1861–62. Sixth-plate ambrotype with applied color

53 Unknown artist, Union Infantry Soldier, Seated, with Handgun in Belt, 1861–65. Sixth-plate tintype with applied color

54 Unknown artist, Confederate Private in Double-breasted Jacket, 1861–65. Ninth-plate ambrotype with applied color

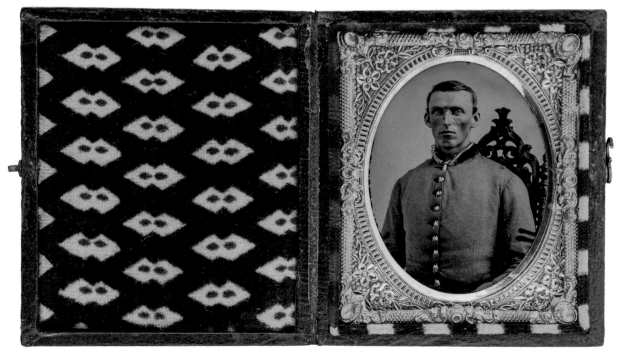

55 Unknown artist, Confederate Corporal, Seated in Gothic Revival Chair, 1861–65. Ninth-plate ruby glass ambrotype with applied color

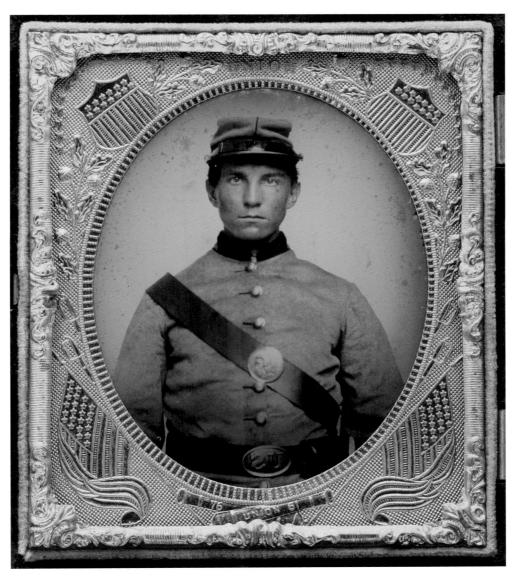

56 Unknown artist, Union Soldier with Black Collar, 1861–65. Sixth-plate ruby glass ambrotype with applied color

57 Unknown artist, Union Officer Standing at Attention, 1861–65. Quarter-plate ruby glass ambrotype with applied color

58 Unknown artist, Union Soldier Holding Rifle, with Photographer's Posing Stand, 1861–65. Quarter-plate ruby glass ambrotype with applied color

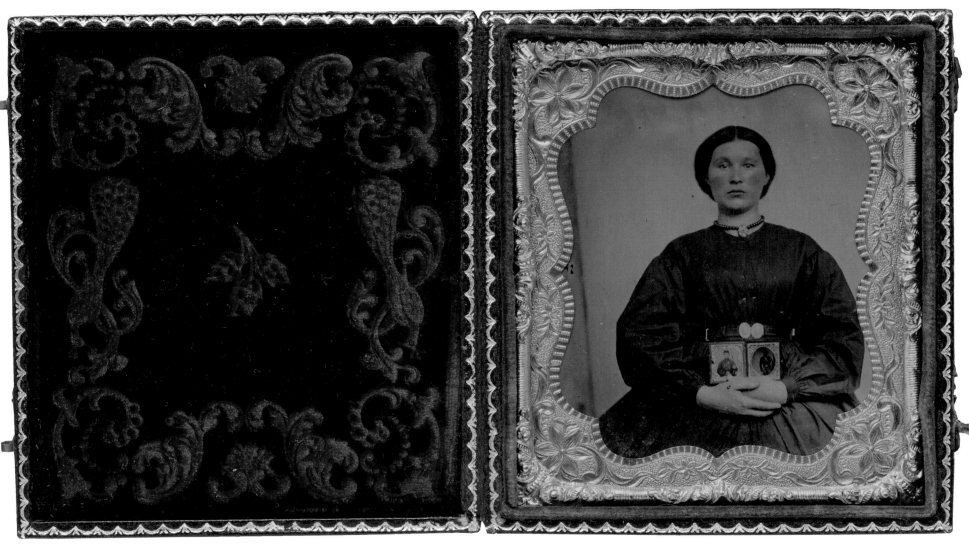

59 Unknown artist, Woman Holding Cased Portraits of Civil War Soldiers, 1861–65.
Sixth-plate tintype with applied color

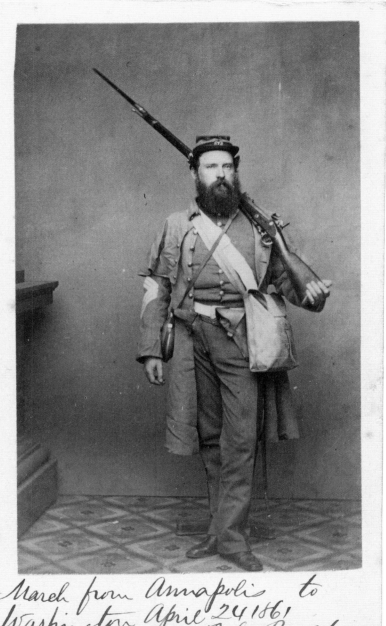

NOTICE

WAR! WAR! WAR!

GEN'L SCROGGS,

And other prominent speakers will address the citizens of ALDEN, on

SATURDAY EVENING, APRIL 20, 1861.

For the purpose of forming a Military Company.

COME ONE! COME ALL!!

60 Unknown maker, *War! War! War!*, April 1861. Ink on paper (broadside)

cartes de visite. Alexander Gardner, Brady's Washington studio manager and partner, immediately made duplicate plates of the new portraits, which he then licensed to Edward Anthony in New York to wholesale. The culture of photographic portraiture thrived before the crisis in Charleston, and even more so afterward, as regiment after regiment arrived in Washington to serve their country. To satisfy their own sense of self, and the national press, the soldiers soon began their assault on the city's portrait studios, especially Brady's "National Photographic Art Gallery."

Among the first militia groups to leave for Washington after Lincoln's call to arms were the Sixth and Eighth Massachusetts Regiments, and the Seventh Regiment, New York State Militia.[61] In or near Annapolis, Maryland, en route to the nation's capital, Sergeant Major Robert C. Rathbone (1825–1915), a member of the Seventh Regiment, posed for his carte-de-visite portrait (pl. 61).

61 Unknown artist, *March from Annapolis to Washington, Robert C. Rathbone, Sergeant Major, Seventh Regiment, New York State Militia*, April 24, 1861. Albumen silver print (carte de visite)

Fig. 17 Charles DeForest Fredricks, *Soldier, New York State Militia*, 1861. Albumen silver print (carte de visite). Thomas Harris Collection

Fig. 18 Unknown artist, *Commissary Patten*, 1861. Albumen silver print (carte de visite). Michael J. McAfee Collection

Fig. 19 Unknown artist, *Commissary Patten as a Spy*, 1861. Albumen silver print (carte de visite). Michael J. McAfee Collection

Although the card mount is not imprinted with an artist's name, the sitter annotated his likeness with enough information to suggest that this image might be the first photograph (identifiable as such) of a Union soldier made after the fall of Fort Sumter. The narrative text inscribed on the mount is resolute, the pose straightforward and optimistic. Eyes directed at the camera, Rathbone shoulders his weapon and stands at attention with two holstered handguns, a canteen, and a light-colored haversack used to hold his rations and other personal gear. Representative of tens of thousands of similar Union portraits (fig. 17), this honest study of an officer seen against a blank studio wall with just the narrowest hint of a studio column is typical of the graphic simplicity of the earliest war pictures.

Whenever possible, photographers and sitters in these early moments of the war did look for interesting ways to collaborate and add a bit of drama to their pictures. In figures 18 and 19, William Patten, also an officer in the Seventh Regiment, poses twice for the camera: first in his military coat as "Commissary Patten," then in civilian clothes as "Commissary Patten as a spy."[62] Patten was not an actual spy, but rather a scout in civilian clothes, and the title on the latter portrait seems to have been inscribed to add levity to the occasion. In due time, ambitious photographers would experiment with props and more playful, less military poses; they also began commissioning local artists to paint special patriotic scenes to be used as backdrops (pls. 122, 153).

Patten and Rathbone's regiment, the Seventh New York, was a militia unit from New York composed of businessmen from the city's most prominent families. The soldiers arrived in Washington on April 25, headed directly to the Executive Mansion, and were personally welcomed by President Lincoln. Initially, the militia camped indoors, within the chambers of the House of Representatives. One member of the unit, young Private Robert Gould Shaw, wrote on April 26 to his mother in Staten Island: "We marched up to the Capitol, and were quartered in the House of Representatives, where we each have a desk, and easy-chair to sleep in, but generally prefer the floor and our blankets, as the last eight days' experience has accustomed us to hard beds. The Capitol is

"I wish I was in Dixie."

Entered according to Act of Congress, in the year 1863, by Charles Wheeler, in the Clerk's Office of the District Court of the United States for the Southern District of New York.

a magnificent building, and the men all take the greatest pains not to harm anything. Jeff Davis shan't get it without trouble."[63] Shaw's precise sentiment about the Confederate president is found in graphic form on a mailing envelope designed and sold in the North for wartime use (pl. 64). An artist working for the Philadelphia publisher A. C. Kline suggests with a wry sense of humor that the only possible way Davis might "take" the capital is as a photographer with a large-view camera.

In the year before the war's inevitable outbreak, stationery shops and printing houses satisfied the nation's partisan spirit by offering their customers mailing envelopes imprinted with humorous motifs. The collecting and use of what came to be known as "patriotic covers" quickly developed into a passion. Even today there is a notable market for Civil War covers, particularly those with Confederate themes, which are much rarer, because of significant paper shortages in the South beginning in late 1862. Most covers are printed in one color and exhibit a gallows humor expressed in crude, cartoonlike drawings. Among many other subjects, the

62 Charles Wheeler, *"I wish I was in Dixie,"* 1863. Albumen silver print (carte de visite)

63 Kellogg Brothers, *"How do You Like it, Jefferson D.?,"* 1865. Albumen silver print (carte de visite)

envelopes lampoon Abraham Lincoln and Ulysses S. Grant in the North, and Jefferson Davis and P. G. T. Beauregard in the South.[64]

By 1863, photographers realized that they could have a share of this large market, and they developed a successful business producing and selling satirical composite portraits in the carte-de-visite format: General McClellan, "Dear Little Mac," rides a hobbyhorse while standing immobile, as usual; Lincoln plays a banjo and sings, "I wish I was in Dixie" (pl. 62); and Jefferson Davis wears a hoopskirt as he tries to escape capture at war's end (pl. 63). The Civil War era was a time of great trauma, but the abundance of farcical images found in newspapers (wood engravings) and in cartes de visite confirms that citizens North and South appreciated caricature.

The extraordinary events relating to the capture of Jefferson Davis by the Fourth Michigan Cavalry at war's end, on May 10, 1865, generated countless news stories—some loosely based on fact, most others wholly fabricated—and also a large number of engravings and photographs. The fact that there were no sketch artists or photographers present at the scene contributes to the astounding variety of accounts. The most common images of Davis are those that mix drawing and photography and show the president of the Confederacy dressed humiliatingly as a woman. Fed by the rumor mill, the Northern public seems to have had an insatiable desire to collect these photographic collages.[65] On May 14, 1865, *The New York Times* was among the first papers to report the news: "Jeff. Davis Captured"; the next day the banner headline read: "Cowardly behavior of the head of the southern chivalry. He puts on his wife's petticoats and tries to sneak into the woods. Not having changed his boots, the brogans betray him."[66] Many graphic satires embellished the story, adding a hoopskirt and/or crinoline, as did P. T. Barnum, who offered to his New York City audience a nightly representation of Davis, dressed in his wife's clothes, resisting arrest by the Michigan cavalry. Civil War photographers produced more than fifty different versions of the petticoated rebel in boots, including plate 63 by Kellogg Brothers of Hartford, Connecticut. An editorial in *Harper's Weekly* noted, and the proliferation and mass distribution of the cartes de visite ensured, that Davis "will go down to posterity, cowering under a petticoat, the object of mingled horror and derision."[67]

Missing the Picture, Bull Run, 1861–62

In the days that followed their arrival in Washington in April 1861, soldiers and officers of the Seventh New York stopped at the National Photographic Art Gallery for new photographs to satisfy the requests of their families, the press, and their old New York friend, Mathew Brady.[68] Even before the men of the "Gallant Seventh" saw any action, they were already war heroes, having been given a parade down Broadway on the day of their departure from New York City.[69] After other militia units found their way to Washington, the men of the Seventh New York left their unconventional lodgings in the House of Representatives and moved two miles away, to Camp Cameron, on Meridian Hill overlooking the Potomac River. There they set up hundreds of tents to accommodate 1,200 soldiers and officers. Among their first visitors were Major Robert Anderson, President Lincoln (who visited three times in May), and George N. Barnard (1819–1902), an extremely talented photographer who had an illustrious career in the 1850s as a daguerreotypist in upstate New York and who periodically worked for Brady.

It is not known precisely when Barnard and Brady met, but it could have been as early as the late 1840s, when they each established their first daguerreian portrait studios. They were certainly well acquainted by 1860, when Brady hired Barnard and a small team of other photographers to make carte-de-visite-format copy negatives of all the distinguished people Brady had photographed on daguerreotype plates during his fifteen years in business. The purpose was to exploit a lucrative contract that Alexander Gardner had negotiated with Edward Anthony, which paid the Brady studio the phenomenal sum of $4,000 per year for rights to publish and sell, over Anthony's imprint and Brady's name, cartes de

visite of illustrious Americans. The job eventually required Barnard to do additional copy work at Brady's Washington, D.C., studio, which Gardner managed. After Lincoln's inauguration on March 4, 1861, Barnard left New York for the District of Columbia; a month later the nation would be at war, and Barnard—as much by luck as by anything else—was in the right place at the right time.

With the assistance of an artist named C. O. Bostwick, Barnard would produce among the first field portraits of the war: soldiers and officers in formal yet relaxed poses before tidy rows of tents. Although his base of operations in Washington was Brady's gallery, Barnard was likely employed directly by Anthony, whose stereograph No. 814, *Gymnastic Field Sports of the Gallant Seventh, A Four-Story Pile of Men*, from May 1861, is typical of the earliest photographs from the war: an image of a pyramid of fourteen men, optimistic, playful, and in the popular new stereographic format (fig. 20; pls. 67, 68).[70] The first seven stereographs in Anthony's inaugural "800 series" (the numbering begins with 811) are by Barnard and Bostwick; all are group portraits of the Seventh Regiment at Camp Cameron. The soldiers are generally well posed and carefree but seemingly ready for action.[71]

Brady, Gardner, and their trained Washington-based team of photographers (including Barnard) were fully prepared to record the events at the war's first land battle on July 21, 1861. But despite all their best intentions, not a single photograph survives from the First Battle of Bull Run, in Virginia. Remarkably, this embarrassing failure did not stop Brady and his "photographs" of Bull Run from receiving on September 1 a rave review in *Humphrey's Journal*, a photography trade publication. The vainglorious text is pure business promotion and invention, written probably by Brady himself or someone working in his gallery. Nonetheless, the article, "Photographs of War Scenes," accurately reveals

65 George N. Barnard, *Ruins of Mrs. Henry's House, Battlefield of Bull Run*, March 1862. Albumen silver print

Fig. 20 George N. Barnard and C. O. Bostwick, *Gymnastic Field Sports of the Gallant Seventh. A Four-Story Pile of Men*, May 1861. Albumen silver print (stereograph). Private collection

Of the approximately 68,000 combatants at Bull Run, there were 5,000 casualties—3,000 Union, 2,000 Confederate—counting killed, wounded, and captured or missing. In the confusion that followed the rout of General Irvin McDowell's army by the Confederates under Generals Beauregard, Joseph E. Johnston, and Thomas J. "Stonewall" Jackson, Brady had to abandon his photography wagons temporarily during the retreat of the Union army, and of the spectators who had traveled from Washington to picnic and watch Jefferson Davis's armies be defeated once and for all. As Brady stated in 1891: "I went to the first Battle of Bull Run with two wagons from Washington. My personal companions were Dick McCormick, then a newspaper writer, Ned House, and Al [Alfred R. Waud], the sketch artist. We stayed all night at Centreville; we got as far as Blackburne's [*sic*] Ford; we made pictures and expected to be in Richmond next day, but it was not so, and our apparatus was a good deal damaged on the way back to Washington; yet we reached the city."[73]

Brady's ambitions for the documentation of the war, if not his actual achievement in the field:

> The public are indebted to Brady, of Broadway, for numerous excellent views of "grim-visaged war." He has been in Virginia with his camera, and many and spirited are the pictures he has taken. His are the only reliable records of the fight at Bull's Run [*sic*]. The correspondents of the rebel newspapers are sheer falsifiers, the correspondents of the Northern journals are not to be depended upon, and the correspondents of the English press are altogether worse than either; but Brady never misrepresents. He is to the campaigns of the republic what Vandermeulen was to the wars of Louis XIV. His pictures, though perhaps not as lasting as the battle pieces on the pyramids, will not the less immortalize those introduced in them.[72]

Brady's failure to return from Bull Run with even a single photograph, combined with the demoralizing defeat of the Union army, motivated the photographer to renew his commitment to record at any cost, and for however long it took, the events of the Civil War. To do so, Brady leaned on his creditors and partners for funds, equipment, and expertise, and on his many political connections for tips about where the next battleground would be, and then for special access to restricted army encampments when he and/or his field operators found their way there. Brady knew from the start that his expenses would be sizable: "My wife and my most conservative friends had looked unfavorably upon this departure from commercial business to pictorial war correspondence,

Brady, July 16th 1861 Washington.

and I can only describe the destiny that overruled me by saying that, like [Euphorion], I felt that I had to go. A spirit in my feet said, 'Go,' and I went. After that I had men in all parts of the army, like a rich newspaper. . . . I spent over $100,000 in my war enterprises."[74]

While not made anywhere near the Bull Run battlefield, plate 66 is noteworthy because it records a group of Union soldiers in their camp right before the battle. The portrait by the Brady studio is dated July 16, 1861, and shows some ten members of Company C of the Eighth New York State Militia, known as the "Washington Greys." The men already seem exhausted and resigned to their fate: one shoulders an ax, another his bedroll; a single soldier sits cross-legged on the ground surrounded by his fellow combatants who await their next orders. For almost three months, the Greys had posed for portraits in Washington studios and beside their tents at Arlington Heights. One soldier, Charles A. During, annotated the print's verso with the names of his tent mates and, surprisingly, the exact hour in the day when the photograph was taken: "half an hour before the start at 3 o'clock to Fairfax Courthouse, Virginia." The tenderness of this quiet if bittersweet moment just before the deafening guns of war exploded is not lost after 150 years.[75]

In early summer 1861, the Brady studio began offering soldiers stationed at Union facilities near Washington a new type of outdoor portrait mounted on specially designed imprinted cards. These small albumen silver prints were larger than typical carte-de-visite-format prints and did not fit in standard portrait albums. As in the study of the soldiers outside their tents at Arlington Heights, they feature the gallery's name and location imprinted below the image. This author's recent examination of the field suggests that such portraits are quite rare. Scarcer still, but in the same oversize carte-de-visite format, are camp portraits and scenes that include on the mounts the series title "Illustrations of Camp Life." The studio released "Camp Life" portraits with at least two different typographical styles: one in all capital letters, the other capital and lowercase (figs. 21, 22).[76] Plate 70 is a superb example of Brady's dedicated effort to record the distinctive physiognomies of the nation's

66 Mathew B. Brady, *Arlington Heights, Virginia*, July 16, 1861. Albumen silver print

67 Unknown artist, *Scene in the Fortifications at Camp Essex [Maryland]*, 1861. Albumen silver print (stereograph)

68 Attributed to George Stacy, *Camp Hamilton, near Fortress Monroe, Virginia*, 1861 (?). Albumen silver print (stereograph)

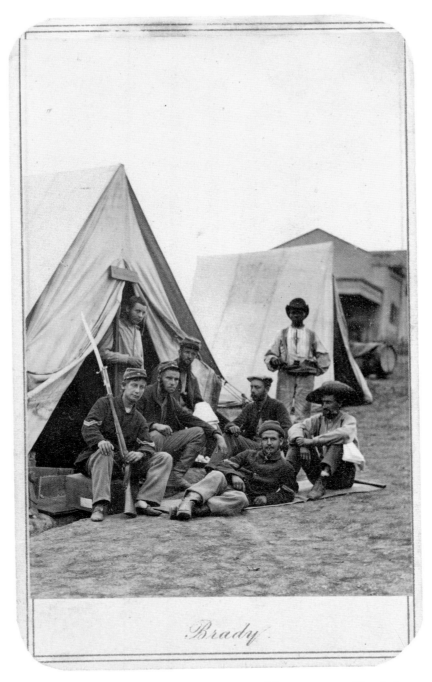

Brady

69　Mathew B. Brady, Camp Scene with Soldiers of the Twenty-second New York State Militia, Harpers Ferry, Virginia, 1862. Albumen silver print (carte de visite)

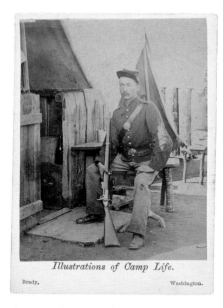

Fig. 21 Mathew B. Brady, New York Soldier on Stool, Fort Runyon, Virginia, 1861. Albumen silver print. Michael J. McAfee Collection

Fig. 22 Mathew B. Brady, Soldier in the Fifty-fifth New York Infantry, Fort Gaines, Maryland, 1861. Albumen silver print. Michael J. McAfee Collection

soldiers before they had seen battle. As Michael J. McAfee, curator of history at the West Point Museum at the United States Military Academy, has written, Richard L. Cramer, from Company I of the Fourth Michigan Volunteer Infantry, is "the quintessential raw recruit of the Civil War . . . a symbol for a nation blundering into four years of bloody chaos."[77]

Outfitted in a smart plaid shirt and a necktie, Cramer leans against a tree wearing fresh federal-issue dark blue trousers, not the gray jacket and pants and fatigue cap he wore when he and his regiment, the "Wolverines," began their long journey from Adrian, in southwestern Michigan, to the District of Columbia. This dates the photograph to later than June 20, 1861, when Cramer was mustered into service, and before the company's departure for Bull Run in mid-July. From the card's

70 Mathew B. Brady, *Richard L. Cramer, Company I, Fourth Michigan Volunteer Infantry*, 1861. Albumen silver print

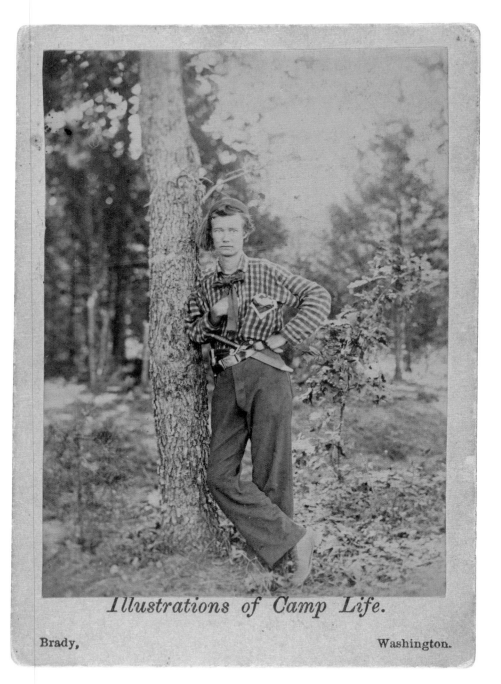

verso we learn the soldier's name, company, regiment, and even the price of the carte de visite: "30 cents Pd." What is conveyed by the other side, the recto, is even more important—what McAfee terms the pathos of "youth and inexperience." Brady has captured a boy of eighteen at ease. This comes through in the naturalness of the pose, the innocence of the half-smile, and the jaunty, hand-on-hip stance. Even the soldier's knife is nicely placed through the belt, crossing the body with equipoise. Notwithstanding his youthful appearance and his nonchalance, Cramer would serve with his regiment for almost two years, until February 16, 1863, when he was discharged for disability. He died thirty-one years later, in 1894, and is buried in Oxford, Michigan, approximately one hundred miles from where he enlisted in the Union army.

It is not known how long Brady offered these oversize cartes de visite on the "Camp Life" mounts or when the firm switched to a standard-size mount and dropped the series title for a script "Brady" centered beneath the image on the cards' front margin (pl. 69; figs. 23, 24). Despite their simplicity, the outdoor portrait mounts are distinct from the gallery's contemporaneous standard carte mounts with the "Brady, Washington" imprint. (See plates 144 and 146, Brady studio cartes de visite of Grant and George Armstrong Custer, for example.)

A large proportion of these images date from the autumn of 1862 and show members of the Twenty-second New York State Militia in outdoor settings at Harpers Ferry, Virginia.[78] The portraits—as much like traditional genre scenes as any produced during the Civil War—are among the most carefully composed field photographs that survive. Almost all feature two or more soldiers conversing, playing cards, sitting on folding stools at their mess, or visiting with their wives. The intelligence of the posing is extended to the clever ways in which the photographer used the characteristic shapes of different-style army tents to create a lively tableau against which to set the foreground drama. Whichever operator produced this series (likely Alexander Gardner), he understood the mechanics of photographic narrative as well as pictorial composition; most interesting, he also seems to have appreciated the many textural pleasures of the army tent—the soldier's portable home.

—✢✢✢—

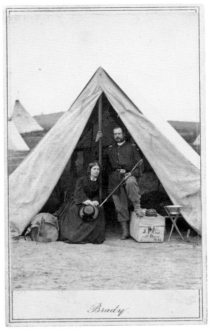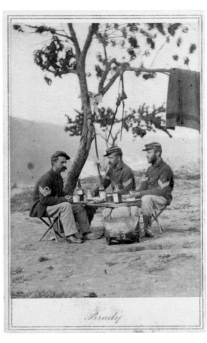

Fig. 23 Mathew B. Brady, Captain J. F. Cox and Wife in the Camp of the Twenty-second New York State Militia, Harpers Ferry, Virginia, 1862. Albumen silver print (carte de visite). Thomas Harris Collection

Fig. 24 Mathew B. Brady, Three Officers in the Camp of the Twenty-second New York State Militia, Harpers Ferry, Virginia, 1862. Albumen silver print (carte de visite). Thomas Harris Collection

At the same time that Brady and Gardner were conducting their camp portraiture carte-de-visite business, they were constructing a massive archive of large-format group portraits and landscape views of the war. In the summer of 1861, Brady started releasing to the public oversize photographs on rag-board mounts with the series title "Brady's Incidents of the War" set in letterpress along with each picture's full caption (pl. 71; fig. 25). These albumen silver prints, made from negatives as large as 12 × 15 inches, were expensive, and were conceived by Brady to appeal to a small but wealthy audience; they constitute the first intentionally produced collectible series of photographs in American photography.[79] One of the earliest that Brady registered for copyright protection, on

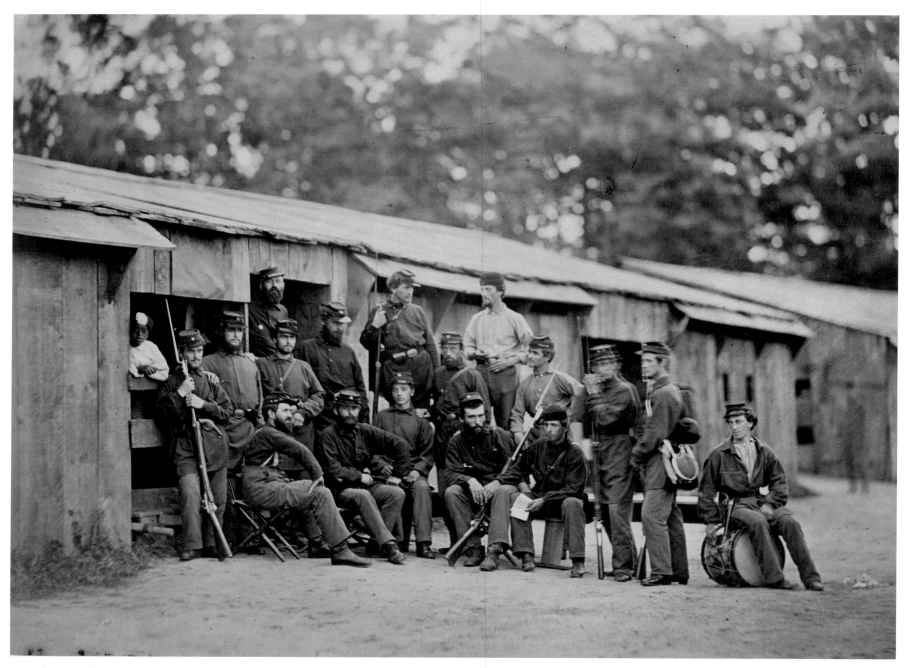

71 Mathew B. Brady, *Camp Sprague. First Rhode Island Regiment. Company D [Washington, D.C.]*, 1861. Albumen silver print

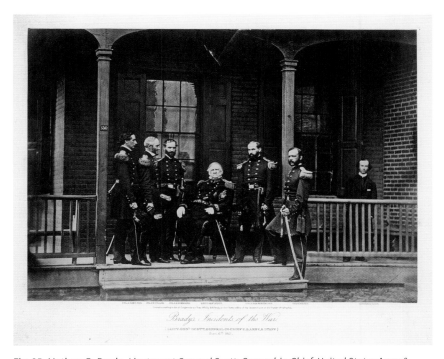

Fig. 25 Mathew B. Brady, *Lieutenant General Scott, General-in-Chief, United States Army & Staff*, September 6, 1861. Albumen silver print. The Metropolitan Museum of Art, Gilman Collection, Museum Purchase, 2005 (2005.100.1108)

July 11, 1861, and among the finest in the series, is the elegant field portrait of members of the First Rhode Island Regiment (pl. 71) at Camp Sprague, a defensive facility built to protect the nation's capital after the fall of Fort Sumter. Between an African-American mess cook and a drummer seated on his snare, sixteen soldiers resonate like musical notes on a staff. Within a week's time the regiment would cross the Potomac for their first taste of battle. Sadly, but inevitably, this harmony was short-lived. Twenty-five of the regiment's men were lost in the Battle of Bull Run: one officer and sixteen enlisted men killed, and eight others dead from disease.

Another example of a photograph released by the Brady studio in the "Incidents of the War" series is this portrait, No. 212 (fig. 26), attributed to Alexander Gardner, of the infamous Confederate spy Rose O'Neal Greenhow in prison with her daughter Rose. Gardner and

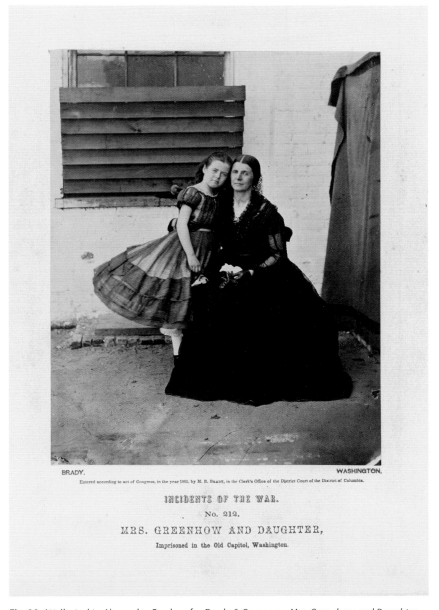

Fig. 26 Attributed to Alexander Gardner for Brady & Company, *Mrs. Greenhow and Daughter, Imprisoned in the Old Capitol, Washington*, 1862. Albumen silver print. The Metropolitan Museum of Art, Gift of Mrs. A. Hyatt Mayor, 1981 (1981.1158.2)

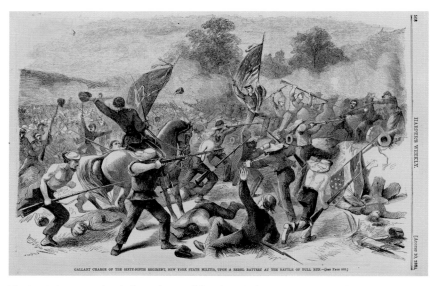

Fig. 27 Unknown Artist, *Gallant Charge of the Sixty-ninth Regiment, New York State Militia, upon a Rebel Battery at the Battle of Bull Run*, July 21, 1861. Wood engraving from *Harper's Weekly*, August 10, 1861. Private collection

Brady released the image in multiple formats over an 1862 "M. B. Brady" copyright notice. Greenhow was a Washington socialite (and the widow of a Confederate sympathizer) who was accused by the federal government of passing information about Union troop movements to the enemy just before the Battle of Bull Run. Originally put under house arrest, she was later jailed and held for nearly a year in the Old Capitol Prison. Eventually, Greenhow was released and deported to Richmond, Virginia, where she had become a minor heroine. In 1863, while in London attempting to gather support for the Confederate cause, she wrote and published a memoir. She was on her way back to the Confederate States in October 1864 when the blockade-runner *Condor*, on which she was traveling, ran aground near Wilmington, North Carolina, while trying to flee Union pursuit. Greenhow escaped from the *Condor*, but drowned when her rowboat capsized.

— ✦❖✦ —

After the Battle of Bull Run, Confederate General Robert E. Lee and his armies maintained control of all the surrounding area—Manassas

Junction, Centreville, and Fairfax Court House. For eight months, it was dangerous if not impossible for Northern photographers to gain access to the battlefields to document the terrain where this first land battle had been fought and lost by the Union armies. For completely different reasons, Southern photographers chose not to photograph the site of their grand victory, and in March 1862, Lee withdrew his troops. Soon thereafter, along with the Union army, came the first photographers. In the interim, curious for news of the battle, the nation had to rely on the many published stories in the press that analyzed the North's failure and the South's resounding success. These articles were illustrated by wood engravings printed from drawings made by sketch artists who may or may not have been present on the battlefield (fig. 27). The first photographs of Bull Run were released in 1862 by both Brady and Anthony and were credited jointly to George N. Barnard and James F. Gibson. These views appear among the earliest photographs in Alexander Gardner's *Sketch Book* (pl. 75)—a strong indication that Barnard (and possibly Gibson) joined Gardner when he opened his own business in late fall 1862.[80]

Barnard and Gibson worked together with a large-format 8 × 10-inch field camera and a stereo camera, producing photographs that could be sold by their employers to the widest possible range of customers. Brady promptly added these scenes to his "Incidents of the War" series, which he no longer branded with his name. These views, like the portrait of Rose Greenhow, appear on 11 × 14-inch mounts and were sold to collectors of historical materials in handsome tooled-leather portfolios like the one seen in figure 28, which

Fig. 28 Mathew B. Brady, Portfolio for "Incidents of the War," 1862. Cloth over board with leather trim. The Metropolitan Museum of Art, Gilman Collection, Museum Purchase, 2005 (2005.100.854)

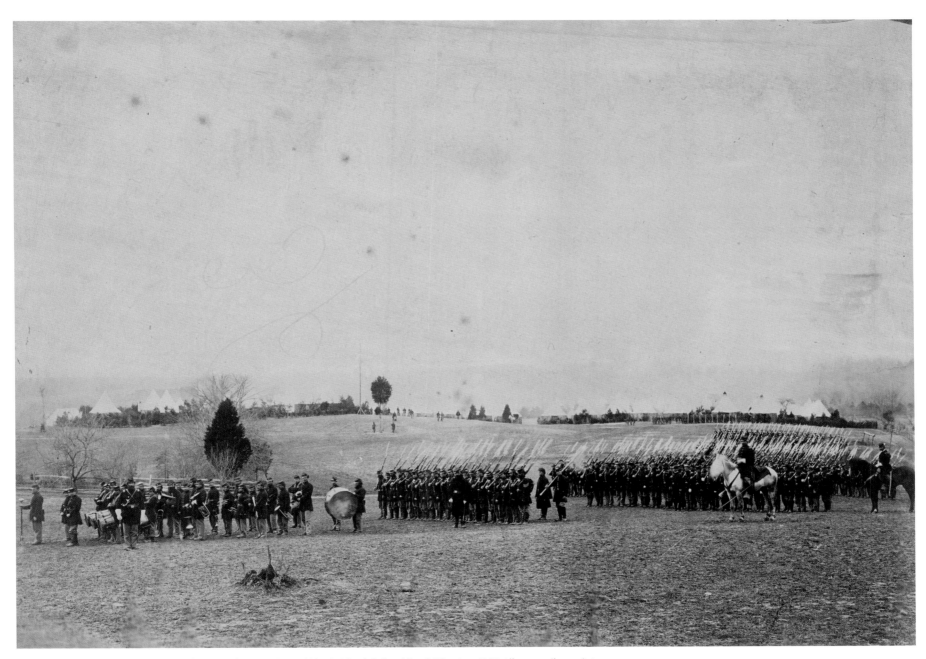

72 Mathew B. Brady, *Camp Brightwood near Washington. Second Rhode Island. Colonel Frank Wheaton*, 1862. Albumen silver print

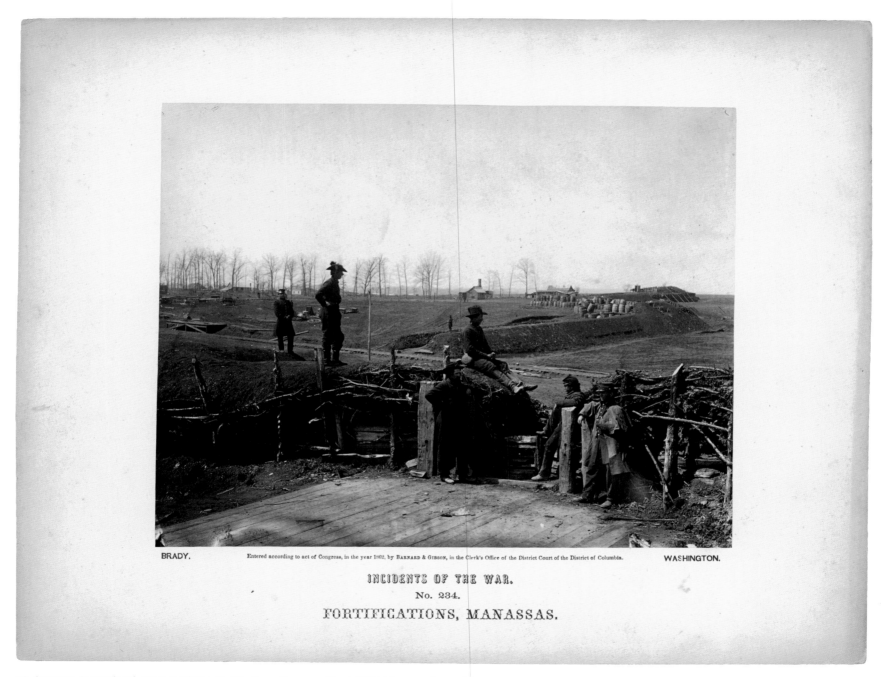

BRADY. Entered according to act of Congress, in the year 1862, by BARNARD & GIBSON, in the Clerk's Office of the District Court of the District of Columbia. WASHINGTON.

INCIDENTS OF THE WAR.

No. 234.

FORTIFICATIONS, MANASSAS.

73 George N. Barnard and James F. Gibson, *Fortifications, Manassas*, March 1862. Albumen silver print

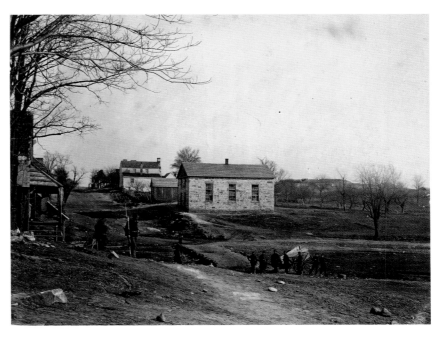

74 George N. Barnard and James F. Gibson, *Stone Church, Centreville, Virginia*, March 1862. Albumen silver print (album card)

75 George N. Barnard and James F. Gibson, *Stone Church, Centreville, Virginia*, March 1862. Albumen silver print

housed at least four mounted prints now in The Metropolitan Museum of Art's collection, including plate 73. The printed mounts credit "Brady, Washington" as the de facto publisher and Barnard and Gibson as the artists and copyright holders. The identical credit formulation appears on the small mounts of Brady's less expensive series, "Brady's Album Gallery," made of the same subjects from half-stereo negatives.[81] A close comparison of prints from the two formats (8 × 10-inch and stereo) shows that the photographers exposed their negatives almost simultaneously and from virtually the same vantage point. In many cases, the two cameras must have been standing side by side on their folding tripods. These March 1862 views of Centreville, near Bull Run (pls. 74, 75), have an odd feel that may even have been recognized at the time—a vacancy or artificiality that seems to confirm their status as documents of old news, studies of places where something has happened but where neither the causes nor the effects of the actions are revealed. Barnard and Gibson provide in-depth if dispassionate visual descriptions of rutted streets, the ruins of railroad terminuses, miles of earthworks built by Confederates long gone, and the

ruins of Judith Henry's farmhouse (pl. 65).[82] According to contemporary reports, Mrs. Henry was an invalid octogenarian widow who because of her infirmities was unable to leave the site of the battle that took place surrounding her home along Bull Run. By removing her to a gully nearby, her children helped her survive the first charge. But when the fighting increased in ferocity, they returned her to her residence, where she was later found dead with bullet wounds.

The contemplative landscape by Barnard and Gibson of the ruins of the Henry house is perhaps the most successful of the lot; the artists figured out how to use what they found at Bull Run to create a potent image of war, not just of the impressive Confederate engineering. That is, they had learned how to use the emptiness and temporal distance from the heat of battle as an element of a pictorial composition worthy of the medium. Surrounding the ruins of the farmhouse are boards from the home itself and from the property's missing fences, and leafless trees that stand like shattered men. The cornerstone of the composition is a human figure placed inside what remains of the house. The individual, a stand-in

Alexander Gardner and James F. Gibson, *Peninsular Campaign*, May 1862. Albumen silver prints in *A Photographic Album of the Civil War*

Head-quarters of Gen. McClellan. Camp Winfield Scott

Yorktown. May. 1862

Whole army, 25 miles long.

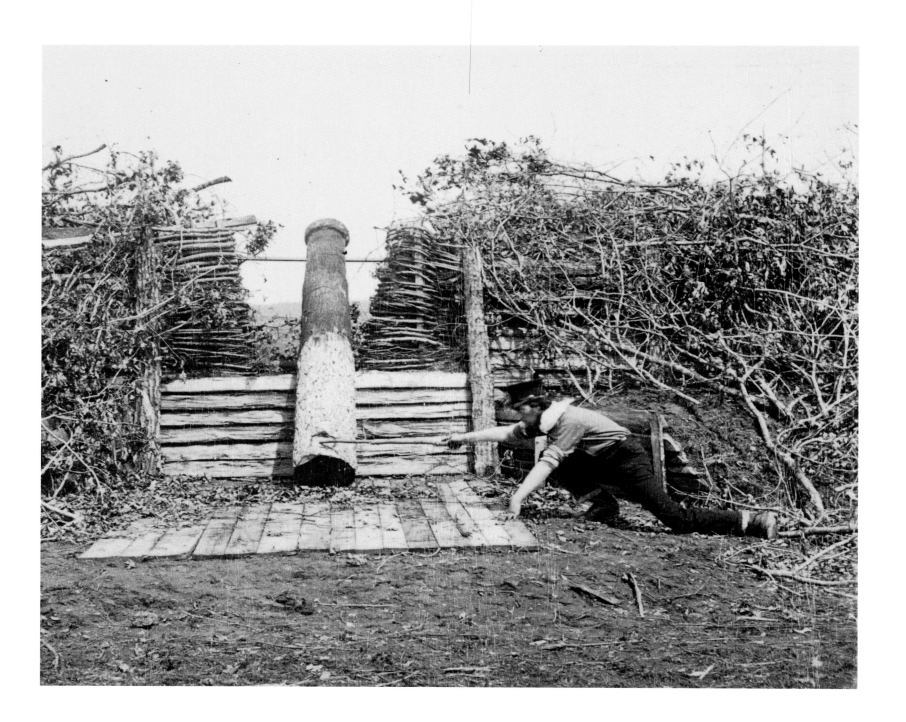

for the viewer, and possibly Barnard himself, peers into the distance and studies the scene and its tragic sublimity. The camera position is restrained and low, curious and respectful—a composition that recalls those by the German Romantic painter Caspar David Friedrich.

With a dash of humor and a dose of irony, Barnard found yet another novel way to interpret the passage of time between the past, the July 1861 battle, and the present, March 1862.[83] In *Quaker Gun, Centreville, Virginia* (pl. 77), the subject is a tree trunk expertly carved and painted by the Confederates to look like a massive cast-iron cannon. Barnard's assistant stretches to fire the weapon known by all as a "Quaker gun" (it can never be fired, no one gets hurt). The photograph offers wry commentary on the nature of war and on the art of deception. At Centreville, General George McClellan (pl. 78) had been fully deceived by the Confederate fortifications and row upon row of "large guns" seen from a distance through the lenses of his ever-present binoculars. General Lee had far fewer weapons than the Union army, but he had outsmarted his counterpart by designing and building his fortifications to appear at a distance far stronger and more dangerous than they actually were. Tricked by Lee's ploy, McClellan moved his entire army miles down the Potomac, farther from Richmond, to begin an ineffective offensive that could have started right in Centreville (pl. 76).

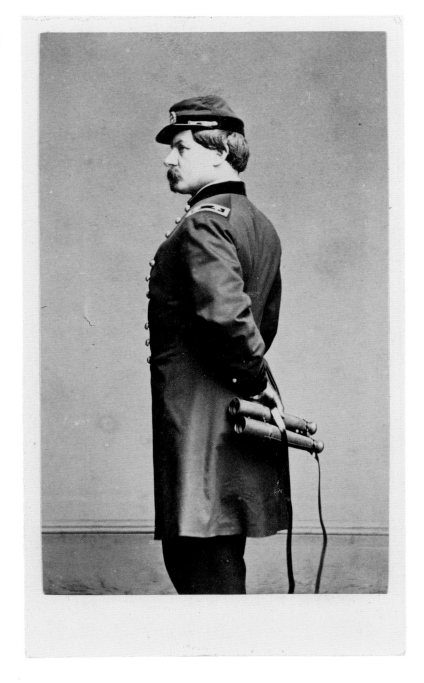

77 George N. Barnard, *Quaker Gun, Centreville, Virginia*, March 1862 (?). Albumen silver print

78 Charles DeForest Fredricks, *General George McClellan*, 1862 (?). Albumen silver print (carte de visite)

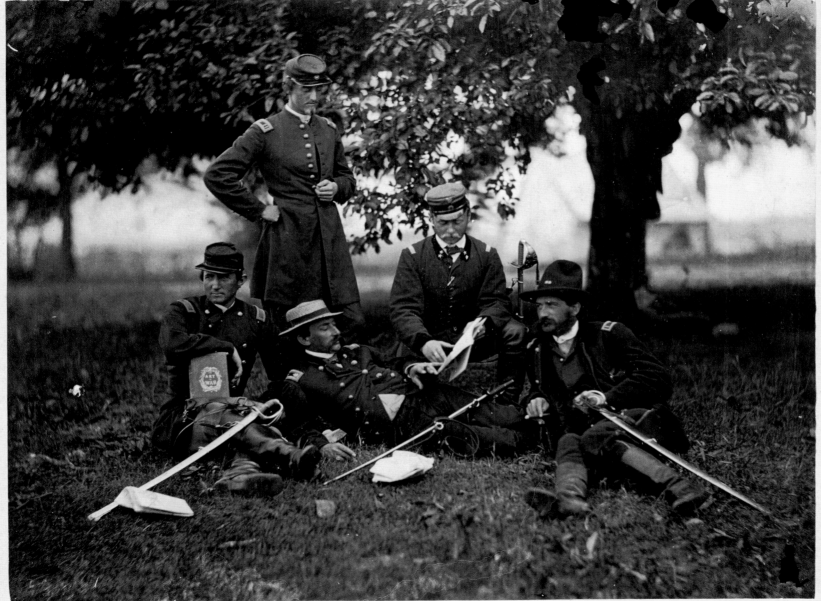

Gardner and His Photographic Sketch Book

In late fall 1862, Alexander Gardner left Mathew Brady to establish his own gallery business at 511 7th Street, at the corner of D Street in Washington, D.C. (pl. 21).[84] This was after he had completed his groundbreaking series of photographs of the dead at Antietam in mid-September; after his former employer's exhibition of these same pictures in New York in October; and after a short stint as a semiofficial photographer for General George McClellan and the Army of the Potomac that ended in early November, when Lincoln relieved the general of his duties. Gardner was forty-one years old and arguably the most talented and ambitious photographer working in America. If Brady had perhaps conceived the grand idea of an epic documentation of the Civil War, it was Gardner who actually executed it, both before and after the two gallerists separated.

Gardner took with him—likely to settle debts as part of a negotiated agreement with Brady—all of his own glass negatives and most of his assistants' plates as well.[85] According to financial reports by R. G. Dun & Company, Brady's credit was weak, and he may have been unable to pay Gardner and the gallery's other photographers for their services.[86] In due time, almost all Brady's Washington-based artists would work for Gardner. These included his brother James (b. 1829) and, among many others, George N. Barnard, James F. Gibson, and the young and daring picture-maker Timothy H. O'Sullivan (1840?–1882).[87] In plate 80, O'Sullivan attempts with an 8 × 10-inch field camera an unposed street scene before the Provost Marshal's Office at Aquia Creek on the Potomac River. The new board-and-batten office (through which the military and all civilians had to pass) serves as a backdrop for the natural drama of soldiers and peddlers, officers and African-American teamsters, everyone anxiously awaiting the arrival of the Washington-bound steamer. As Gardner wrote in the caption for this plate, "Soldiers or citizens who had business with the army in those days will not readily forget how limited was the time between the arrival of the long train of cars from the front and the departure of the Washington boat; nor how often, after successfully elbowing a way in the motley crowd, and getting the pass vised, the end of the dock would be only reached in time to see the steamer moving swiftly down the creek to the Potomac."[88]

As he had done on Brady's behalf, Gardner sent his growing team of photographers to follow the Union armies and to harvest pictures for the gallery. By the end of the war, he had amassed a collection of nearly three thousand glass negatives, from which he would select and print one hundred for his 1866 publication, *Gardner's Photographic Sketch Book of the War*, by all accounts America's first book of photographs. The *Sketch Book*'s introduction establishes individual sacrifice and cultural memory (in the guise of great picture-making) as its twin themes:

> As mementoes of the fearful struggle through which the country has just passed, it is confidently hoped that . . . [the photographs in the book] will possess an enduring interest. Localities that would scarcely have been known, and probably never remembered, save in their immediate vicinity, have become celebrated, and will ever be held sacred as memorable fields, where thousands of brave men yielded up their lives a willing sacrifice for the cause they had espoused.[89]

79 Alexander Gardner, *Studying the Art of War, Fairfax Court-House [Virginia]*, June 1863. Albumen silver print

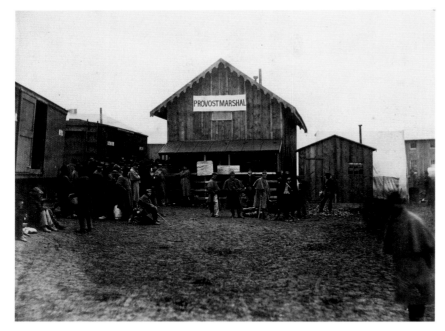

80 Timothy H. O'Sullivan, *Provost Marshal's Office, Aquia Creek, Virginia*, February 1863. Albumen silver print

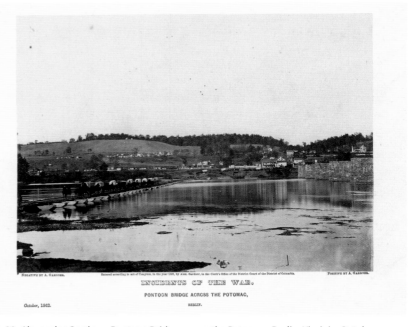

Fig. 29 Alexander Gardner, *Pontoon Bridge across the Potomac, Berlin, Virginia*, October 1862. Albumen silver print. The Metropolitan Museum of Art, Purchase, Florance Waterbury Bequest, 1970 (1970.537.16)

Ninety years later, William Faulkner, the novelist from Oxford, Mississippi, described in similar terms his understanding of the role of the artist in society: "The aim of every artist is to arrest motion, which is life, by artificial means and hold it fixed so that a hundred years later, when a stranger looks at it, it moves again since it is life. Since man is mortal, the only immortality possible for him is to leave something behind him that is immortal since it will always move. This is the artist's way of scribbling 'Kilroy was here' on the wall of the final and irrevocable oblivion through which he must someday pass."[90]

After opening his own gallery, one of Gardner's first business activities was the preparation of his *Catalogue of Photographic Incidents of the War*, printed in Washington by Henry Polkinhorn Jr. and released in September 1863. The publication is essentially a long list of picture titles and reference numbers that today is a useful guide for Civil War historians in dating and identifying photographs. The "Incidents of the War" title Gardner chose for his catalogue and for the imprinted mounts of his concurrently released large-format albumen silver prints (fig. 29) was identical to Brady's series title and likely intended to create association and confusion in the marketplace.[91] Gardner would use the series imprint "Incidents of the War" until the war's end, when he changed it to "Memories of the War."[92]

One of the distinguishing features of Gardner's "Incidents of the War" mounts, and thereafter the mounts in the *Sketch Book*, was his egalitarian commitment to crediting each artist for the negatives made in the field. No other gallerist or publisher in the country—not Brady or Anthony, or D. Appleton, another stereo-view vendor in New York—gave credit to the individual field operators who witnessed the carnage, slogged through the mud, and lived in their carriages and tents to get

the pictures. In the *Sketch Book*, Gardner featured the work of eleven artists: Timothy H. O'Sullivan, who made almost half of the total number of photographs (forty-five); Gardner himself (sixteen); James Gardner (ten); the team of George N. Barnard and James F. Gibson (eight); John Reekie (seven); the team of John Wood and James F. Gibson (five); David Knox (four); William R. Pywell (three); David Woodbury (one); and W. Morris Smith (one). Imprinted on each and every mount, just below the photograph at the left edge, is the text "Negative by ____," and at the right edge, "Positive by A. Gardner" (pl. 4). This progressive, inclusionary act seems to have generated intense loyalty within his team of field photographers.

In other ways, however, the format and graphic design of the *Sketch Book* are typical of the period. A survey of a dozen sets indicates that the covers are in full or half morocco (leather) in brown, green, red, or blue. The title page for each of the two volumes is a multiscene lithograph drawn by Alfred R. Waud (1828–1891), the sketch artist who worked for *Harper's Weekly* during the war (fig. 30). The letterset typography Gardner selected for the *Sketch Book* mounts includes multiple font styles and type designs that vary from set to set in only one way: The earlier releases have an 1865 copyright printed on the mounts and the series title "Incidents of the War" centered below the photographs and directly above the plate title. Sets released later have an 1866 copyright and a slightly more uniform type font. The *Sketch Book* plates copyrighted 1866 have the plate numbers imprinted on the mounts but do not feature the series title. Why Gardner changed the copyright, added the plate numbers, and removed the "Incidents" series title remains a matter of speculation. It is far easier to understand why there is variation from set to set in the plates themselves. Because of breakage rather than artistic reconsideration, Gardner had to retire some negatives before he completed the entire print run for the edition, believed to be about two hundred copies. The differences are minor, affecting *Sketch Book* plates 21, 22, and 65, and were not significant enough to require a change of the printed titles or the narrative captions that precede each photograph.[93]

The organization of the *Sketch Book* is essentially chronological. Gardner opens the two-volume publication with an architectural study

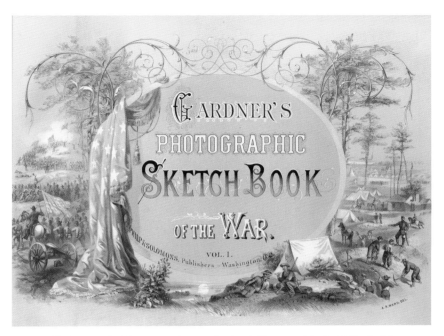

Fig. 30 Alfred R. Waud, Title Page, Volume 1, *Gardner's Photographic Sketch Book of the War* (1866). Lithograph. The Metropolitan Museum of Art, Gilman Collection, Purchase, Ann Tenenbaum and Thomas H. Lee Gift, 2005 (2005.100.502.1)

of the Marshall House in Alexandria, Virginia, where Lincoln's friend Colonel Elmer Ellsworth, of the New York Fire Zouaves, was shot and killed by the inn's proprietor on May 24, 1861, at the commencement of the war; and he closes it with a postwar view from June 10, 1865, of family members and soldiers dedicating a twenty-seven-foot-high sandstone monument to those who died on the battlefield at Bull Run. Neither photograph fully manages to introduce the drama of the war, or to reflect upon it, yet to his credit Gardner felt obliged to include these historical markers to tell the broadest possible story.[94] He had neither the means nor the negatives to document the start of the war, but he was witness to its end and offers his readers a fully nuanced report of the final two months. The concluding twenty-two photographs in the *Sketch Book* are from April and May 1865 (pl. 81), after the last historic events of the war: Confederate President Davis's evacuation from Richmond and

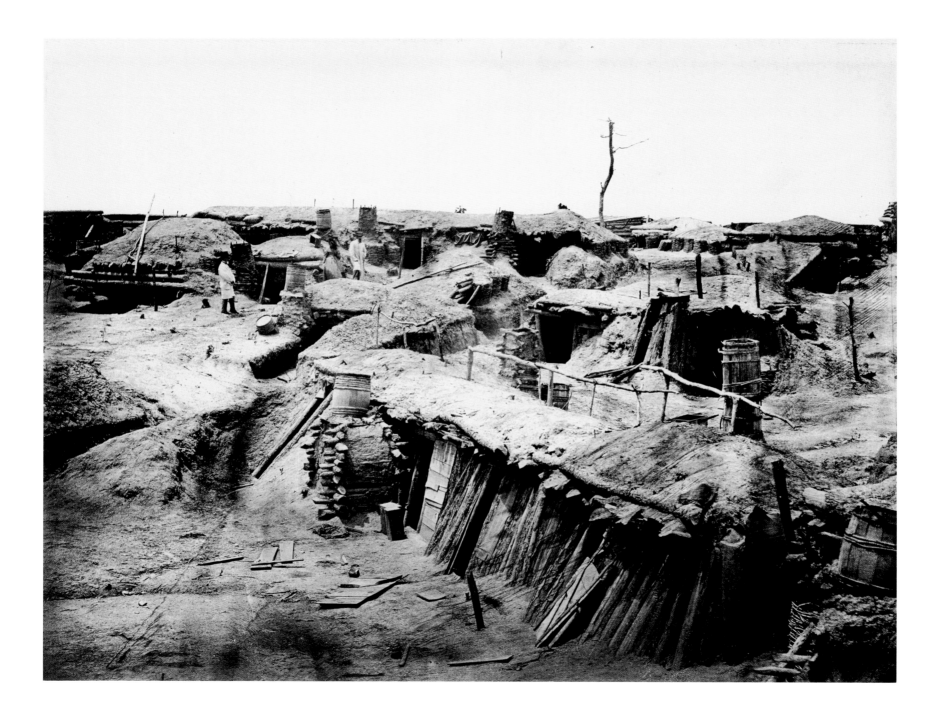

the burning of the city; General Lee's surrender to General Grant at Appomattox; and John Wilkes Booth's assassination of President Lincoln on April 14, 1865.

— ⊹✦⊹ —

In *Slave Pen, Alexandria, Virginia*, plate 2 of the *Sketch Book*, Gardner presents what to him was the ethical center over which the war was fought: slavery and the immorality of human bondage. As the only known eulogist of Gardner's life noted, he was "a lover of liberty, he was an abolitionist from the earliest recollection, and remained an enemy of slavery until it was destroyed."[95] Figure 31, by William R. Pywell (1843–1887), shows one of the many establishments in the South for the confinement and sale of slaves.[96] Painted on the brick facade, just barely visible beneath the business's name, is "DEALERS IN SLAVES." As Gardner noted in his caption:

> Auction sales were regularly held, at which Virginia farmers disposed of their servants to cotton and sugar planters from the Gulf States. If a slave-owner needed money which he could not easily procure, he sold one of his slaves; and the threat of being sent South was constantly held over the servants as security for faithful labor and good behavior.[97]

In the 1830s, during the height of the American cotton market, the District of Columbia (which then included Alexandria, Virginia) was considered the seat of the American slave trade. At the time, the most active firm in the capital was Franklin & Armfield, which eventually sold out to George Kephart, one of its former agents. Although slavery was outlawed in the District in 1850, it flourished across the Potomac in Alexandria. In 1859, Kephart joined William Birch, J. C. Cook, and C. M. Price and conducted business under the name seen here. The partnership dissolved in 1859, but Kephart continued operating his slave pen until Union troops seized the city in the spring of 1861. If the photograph's raw subject is powerful,

81 Timothy H. O'Sullivan, *Quarters of Men in Fort Sedgwick, Generally Known as Fort Hell*, May 1865. Albumen silver print

Fig. 31 William R. Pywell, *Slave Pen, Alexandria, Virginia*, August 1863. Albumen silver print. The Metropolitan Museum of Art, Gilman Collection, Purchase, Ann Tenenbaum and Thomas H. Lee Gift, 2005 (2005.100.502.1)

Pywell's picture of it leaves much to be desired. The dramatic signage on the building—where three to four hundred slaves were regularly kept in heavily locked cells—is just too far from the camera to elicit a sense of compassion and empathy. Other, more seasoned photographers who were not members of Gardner's team would record the same site with far greater success.

Price, Birch & Co. appears in at least two other wartime photographs: a stereo view by an unknown maker published by E. & H. T. Anthony over the Brady imprint, and a large-format study by Andrew Joseph Russell (pls. 82, 83). Better known for his later views commissioned by the Union Pacific Railroad, A. J. Russell (1830–1902) was a captain in the 141st New York Infantry Volunteers. He was one of the few Civil War photographers who was also a soldier. As a photographer-engineer for the United States Military Railroad Construction Corps,

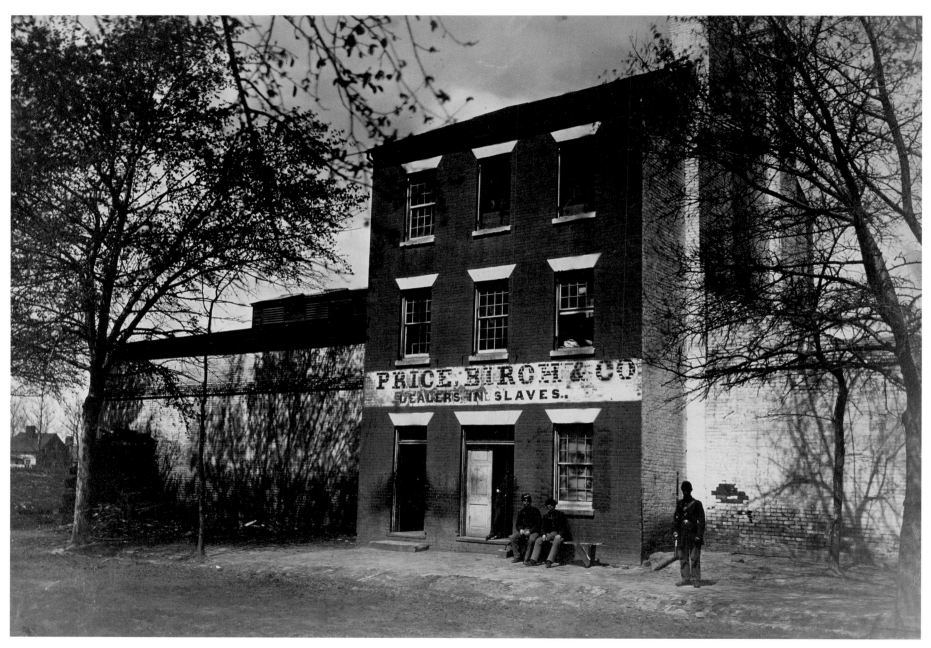

82 Andrew Joseph Russell, *Slave Pen, Alexandria, Virginia*, 1863. Albumen silver print

Russell produced extraordinary large-format photographs, primarily in Virginia, of the technical accomplishments of General Herman Haupt's engineers (pls. 84–87).[98]

As in all his work with the camera, Russell focused closely on the important details of the subject and exploited the full descriptive potential of the 12 × 15-inch glass plate, the largest size used by Civil War photographers in the field.[99] His 1863 view of the Alexandria slave pen, guarded, ironically, by Union officers, shows Russell at his most perceptive; the pen had recently been converted by the army into a prison for captured Confederate soldiers. Both Russell's and Gardner's photographs are in fundamental ways studies of the new American landscape after President Lincoln's Emancipation Proclamation of January 1, 1863. With the inspiring words "All persons held as slaves within any State or designated part of a State . . . in rebellion against the United States, shall be then, thenceforward, and forever free," Lincoln had given liberty and hope to some four million enslaved Americans.[100] In time, some 200,000 former slaves would don Union jackets and fight for the Union cause and their own freedom.

In the *Sketch Book*, Gardner follows the Alexandria slave pen with a study by O'Sullivan of the Fairfax Courthouse and then a series of eight views by Barnard and Gibson from March 1862 of the Confederate earthwork fortifications, Quaker guns, redoubts, and rifle pits from Manassas Junction to Centreville, Virginia. These photographs, shown previously and in plate 88, gave Gardner the opportunity to use his extended picture captions to reconstruct the events of the day and to comment on what was not visible in the images: the military actions that led to the devastating defeat of the Union

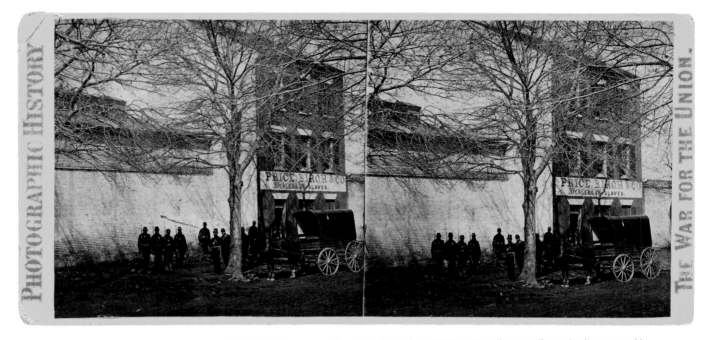

83 Brady & Company, *Slave Pen, Alexandria, Virginia*, 1862. Albumen silver print (stereograph)

forces at the Battle of Bull Run. In the caption for *Sketch Book* plate 7, Gardner reports:

The country at that time was densely wooded, and the entire portion shown in the sketch occupied by the Confederates. . . . The fighting had nearly ceased, and [Union Major] Gen. McDowell was expressing his thanks to some of his officers for their services, when [Confederate General Joseph] Johnston's reinforcements from [the nearby town of] Winchester suddenly appeared in rear of our right, and threw our lines into utter confusion. A feeble attempt was made to repulse the attack, but the regiments rapidly broke to pieces, and forming a mass of terror-stricken fugitives, rushed from the field down across the bridge, which soon became obstructed by wagons, and to prevent pursuit by the enemy was destroyed.[101]

84 Andrew Joseph Russell, *Rebel Caisson Destroyed by Federal Shells*, May 3, 1863. Albumen silver print

85 Andrew Joseph Russell, *Wood Choppers' Huts in a Virginia Forest*, ca. 1863. Albumen silver print

86 Andrew Joseph Russell, *Street Scene, Culpeper [Virginia]*, March 1864. Albumen silver print

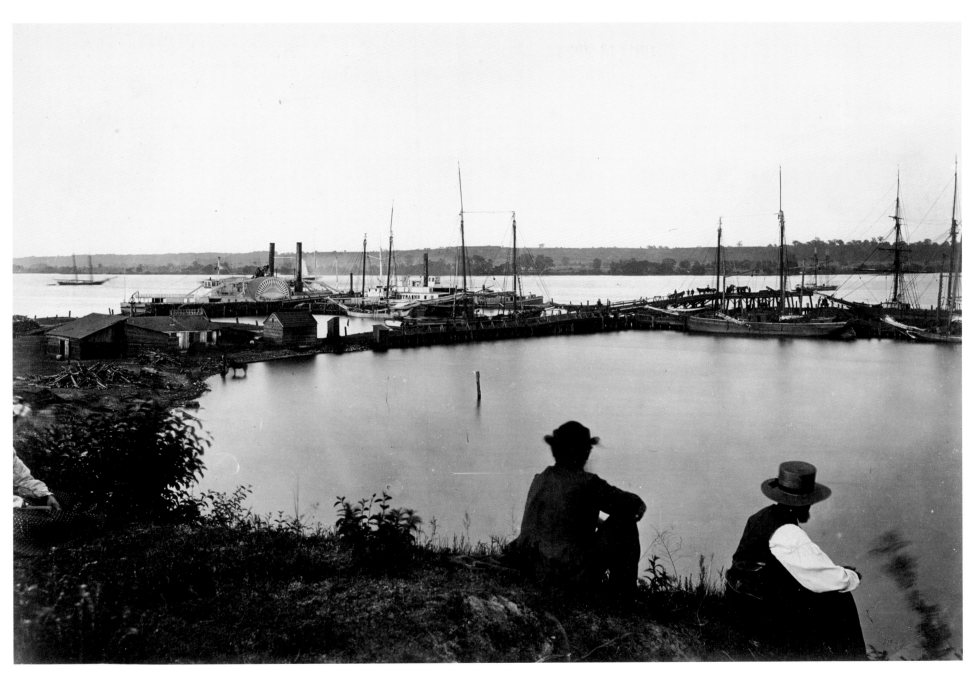

87 Andrew Joseph Russell, *Government Coal Wharf, Alexandria, Virginia*, ca. 1863. Albumen silver print

88 George N. Barnard and James F. Gibson, *Ruins of Stone Bridge, Bull Run, Virginia*, March 1862. Albumen silver print

Fig. 32 Timothy H. O'Sullivan, *Battery D, Fifth United States Artillery, in Action, Fredericksburg, Virginia*, 1863. Albumen silver print. The Metropolitan Museum of Art, Gilman Collection, Purchase, Ann Tenenbaum and Thomas H. Lee Gift, 2005 (2005.100.502.1)

As E. F. Bleiler writes in the 1959 Dover reprint of the *Sketch Book*, Gardner's text is generally "brisk, colorful, and journalistic," and this allows the reader to examine the pictures while learning from an expert, "a man who was personally and emotionally identified with the scenes illustrated."[102] But as Bleiler notes, Gardner penned an inherently biased text that cannot be separated from his belief that all Confederates were rebels and that "death was their just desert."[103] The Barnard and Gibson photograph of Bull Run (as opposed to its caption) is, in itself, far more contemplative and neutral. A figure, perhaps Barnard or Gibson, sits in the sun on the edge of the masonry bridge. Silhouetted against the deforested hillside, he connects near and far, North and South, Rebels and Yankees.

Over the course of one hundred views (including a few superb field portraits), the *Sketch Book* follows the general story of the war and

exploits the depth of Gardner's negative archive of field photographs in an attempt to understand what the camera could and could not record. As seen in figure 32, action shots, for example, were more or less impracticable because of the long times required to properly expose a collodion glass negative. Gardner also realized that the medium was not especially suitable for showing causes and effects or the range of emotions connected to military success or failure. These were abstractions at which written language excelled and which Gardner explored in the captions. He knew, though, from years of work that photography was extremely effective at chronicling things that did not move: batteries and mortars like the one seen in David Knox's terrific portrait of the 17,720-pound "monster mortar" known as the Dictator (pl. 106); and of course, bridges, buildings, and ruins, subjects that photographers had so successfully documented since the medium's birth (pl. 89). One of

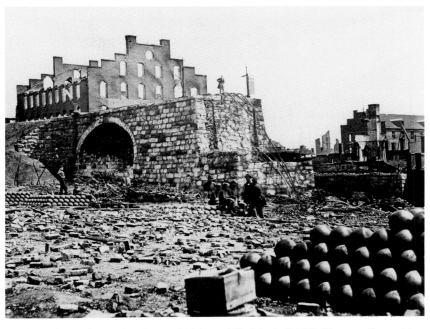

89 Timothy H. O'Sullivan, *View on the Appomattox River, near Campbell's Bridge, Petersburg, Virginia*, May 1865. Albumen silver print

90 Alexander Gardner, *Ruins of Arsenal, Richmond, Virginia*, April 1865. Albumen silver print

the last plates in volume 2 of the *Sketch Book* is Gardner's own study of the decimated Confederate arsenal in Richmond (pl. 90). A neat pile of eleven-inch shells (cannonballs) marks the foreground; a small cleanup crew takes a work break in the picture's midsection where the arsenal once stood; behind them looms the broken-down masonry foundation for the once elevated Richmond and Petersburg Railroad, whose steel rails now hang down like strands of hair.

Under perfect conditions in the field and with receptive subjects, Gardner was even able to harness the medium as a means of portraiture, a tool that could memorialize—just as it did in a studio setting—the weary and the fresh, the snap and pull of uniforms and accoutrements, and the characteristic body language of men at war. Gardner's elegant field portrait near the end of volume 1, *Studying the Art of War*, *Fairfax Court-House* (pl. 79), was made just before the Battle of Gettysburg. Major D. S.

Ludlow sits on the ground to the right of Colonel Ulric Dahlgren (standing), who would die during a failed attempt in March 1864 to free Union soldiers held in Confederate prisons in Richmond.[104]

Without a trace of irony, Ludlow holds for the camera a copy of the 1862 translation of *The Art of War*, Antoine-Henri Jomini's definitive treatise on warfare and military strategy, used as a standard reference by both Union and Confederate generals. Military historians today believe that Baron de Jomini's theories led to massive casualties during the Civil War. Napoleon's lauded general understood conflict in the context of pre-industrial society, but this was the first industrial war with efficient and rapid replacement of soldiers and weapons courtesy of the railroad. In his portrait, Gardner stage-directs each of the five officers. They focus their attention away from the camera while *The Art of War* faces it. And seems to wink at Gardner.

Gardner knew from direct experience at Antietam that beyond its capacity to fix for the record searing portraits and astonishing views of batteries and buildings in ruin, the camera was truly splendid at revealing the dead (pl. 91).

—·✧✦✧·—

For three days, July 1 through July 3, 1863, the Union and Confederate forces of, respectively, Generals George Meade and Robert E. Lee fought each other on the rolling fields and steep, rocky ridges of Adams County, Pennsylvania, surrounding the town of Gettysburg. It was the Confederacy's second significant attack on the North, a battle involving some 160,000 combatants that was, most historians believe, the turning point of the war. At the end of the third day, each side had lost more than 20,000 men—killed, wounded, captured, or missing—and Lee began his retreat to Virginia. Two nights later, on July 5, Timothy H. O'Sullivan, Alexander Gardner, and James F. Gibson were on the scene with their large-format and stereo-view cameras, chemicals, and boxes of glass plates. Mathew Brady, assisted by David Woodbury and Anthony Berger, would also make the eighty-mile trip from Washington but would not begin to

photograph until ten days after Gardner, by which time all the dead had been buried. The negatives these two teams exposed at Gettysburg are unquestionably the most often reproduced images of the war (pls. 92, 93, 99–102). They are quite different in style and subject matter, and they remain among the most powerful and controversial war pictures ever made.

Gardner and his crew made at least eighty-seven photographs at Gettysburg (thirty-five 8 × 10-inch plates and fifty-two stereos); Brady produced less than half as many (sixteen large plates, and twenty stereos (pls. 92, 93).[105] But as Bob Zeller has written, for more than a century after they were taken, "no distinction was made between the Gettysburg photographs of Gardner and those of Brady. Usually Brady received the credit for all the battlefield images."[106] It must have rankled Gardner that his former employer, now his rival, was last on the field at Gettysburg yet still won the publicity contest. *Harper's Weekly* released the first major graphic coverage of the battle on August 22, 1863. The newspaper converted eleven photographs to wood engravings, and all the photographs were by Brady. The engravings ran with the caption "From photographs by Brady."[107]

The *Sketch Book* features ten plates of Gettysburg, eight by O'Sullivan and two by Gardner himself. After a sweeping view by O'Sullivan that Gardner uses to set the scene, he presents two stunning photographs of dead soldiers by O'Sullivan that he titles "A Harvest of Death, Gettysburg" and "Field Where General Reynolds Fell, Gettysburg" (pls. 99, 100). Gardner's extended caption for the former, *Sketch Book* plate 36, makes it clear he wants the viewer to believe that the dead are Southerners. They are not. In fact, they are Union soldiers and Gardner likely knew so. Oddly, it is here that the author's partisan voice rings loudest as he lionizes the heroic federals and damns the treasonous Confederates:

> The rebels represented in the photograph are without shoes. These were always removed from the feet of the dead on account of the pressing need of the survivors. The pockets turned inside out also show that appropriation did not cease

91 Alexander Gardner or Timothy H. O'Sullivan, *Unfit for Service at the Battle-field of Gettysburg*, July 6, 1863. Albumen silver print

with the coverings of the feet. . . . Killed in the frantic efforts to break the steady lines of an army of patriots, whose heroism only excelled theirs in motive, they paid with life the price of their treason, and when the wicked strife was finished, found nameless graves, far from home and kindred.[108]

From an interpretative point of view, this problem of misidentification is noteworthy—especially considering the issues related to the following plate in the *Sketch Book* and the natural contradictions they present to historians and the general public.

Sketch Book plate 37 (pl. 100) shows the same bodies as in *Sketch Book* plate 36, but here Gardner describes them as "our own men." Indeed, they are Union dead: the soldier in the left background of the second image appears in the central foreground of the preceding one. O'Sullivan has simply moved his camera to view the decaying corpses from a different perspective. In his text, Gardner offers a kind of benediction to the Union dead that he does not bestow on their Confederate counterparts (actually them) in *A Harvest of Death, Gettysburg*, his plate 36:

> Some of the dead presented an aspect which showed that they had suffered severely just previous to dissolution, but these were few in number compared with those who wore a calm and resigned expression, as though they had passed away in the act of prayer. Others had a smile on their faces, and looked as if they were in the act of speaking. Some lay stretched on their backs, as if friendly hands had prepared them for burial.[109]

What is there to be said about this descriptive predicament and Gardner's odd embroidery? It is remotely possible that he made a notational error

92 Brady & Company, *Rebel Prisoners, Gettysburg*, July 1863. Albumen silver print (stereograph)

in Washington that was perpetuated on all future negative lists and then in his *Sketch Book*. Yet most historians think that the confusion was intentional, calculated by Gardner to create a pair of marketable pictures (one Confederate, one Union) to rival those recently published by Brady as engravings in *Harper's Weekly*.[110]

More than perhaps any other Civil War photographer, Gardner would have known a Rebel from a Yankee, dead or alive. He also would have been advised by O'Sullivan that his negatives had been made nowhere near the field (or actually the woods) "where General Reynolds fell." Nonetheless, after the battle and the publication in *Harper's Weekly* of a wood engraving made from Brady's two-negative panoramic photograph (pl. 93) that the newspaper titled "Wheat-field in which General Reynolds was Shot," John F. Reynolds became a martyr. Gardner simply played a bit more with the facts, used a dramatic picture by O'Sullivan, and released it to the public to satisfy the demand his former employer had helped create. The two photographs (O'Sullivan's and Brady's) could not be more different. In one, the rotting dead, likely

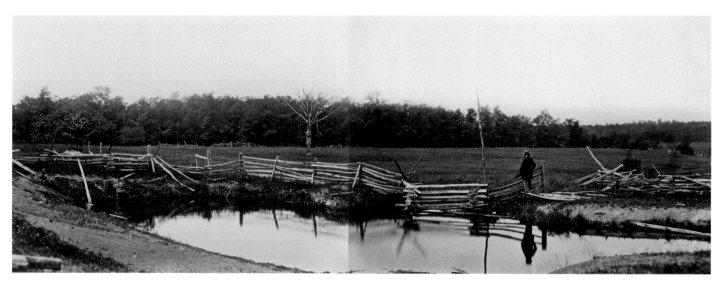

93 Mathew B. Brady, *Wheat-Field in Which General Reynolds Was Shot*, July 1863 [Mathew B. Brady Looking toward McPherson's Woods, from the Wheatfield, Gettysburg, Pennsylvania]. Albumen silver prints

all enlisted men, are present and accounted for. They await burial and lie there just as regimental historian Sergeant Thomas Marbaker of the Eleventh New Jersey Infantry recalled: "Some, with faces bloated and blackened beyond recognition, lay with glassy eyes staring up at the blazing summer sun . . . and over all, hugging the earth like a fog, poisoning every breath, the pestilential stench of decaying humanity."[III] In the other photograph, there are no dead, just a bit of self-reflection. Two separate plates merge to form a single pastoral scene, a panorama in which Brady himself plays the lead role. He stands alone and contemplates the beautiful Pennsylvania landscape where in the distance an officer may have been shot in the woods. If the photograph evokes the heavenly sublime, it does so by intentionally avoiding the hellish reality.

—✦✦✦—

Stretching the truth and constructing a false title for a battlefield photograph for sales purposes may have been a good business decision, but it is bad form. And somewhat foolish. Transforming the Union dead

into Confederates, picking their pockets, and calling them traitors are disrespectful acts. And betray Gardner's recklessness with the facts. Dragging a dead Confederate soldier seventy-two yards from where he died to make a more elegiac photograph is an even more shocking breach. Yet that is precisely what most Civil War historians believe Alexander Gardner did on July 6 or 7, 1863.[112] He faked a photograph. Perhaps two.

Sketch Book plates 40 and 41 (pls. 101, 102) are among the most recognized and intensely evaluated photographs of the Civil War.[113] They document the same Confederate soldier in dramatically different environments—a fact Gardner purges from his extended captions. Moreover, as he had done with O'Sullivan's pair of pictures a few plates earlier, Gardner subtly suggests that one sharpshooter might be a Yankee; the other is a Rebel, as he makes clear with his title. In the rocky locale at Gettysburg aptly known as "Devil's Den," Gardner, O'Sullivan, and Gibson had spent the day of July 6 or 7 exposing about two dozen negatives, mostly of Confederate and Union corpses. They seem to have worked as a team, using both stereo and 8 × 10-inch view cameras. These soldiers were among the last to die during the three-day battle, and the photographers had to work as fast as they could to stay ahead of bands of laborers on burial detail whose job it was to inter the bodies as quickly as possible. It was summertime, almost ninety degrees.

In the first of the two photographs, "A Sharpshooter's Last Sleep," *Sketch Book* plate 40, Gardner reprises his brutal study of a lone, dead, rot-faced soldier at Antietam (pl. 11), the stereo view of which he had titled "He Sleeps his Last Sleep." But here at Gettysburg, the corpse is much fresher and the face lifelike. Gardner described the scene in his caption: "His cap and gun were evidently thrown behind him by the

violence of the shock [from the bullet that killed him], and the blanket, partly shown, indicates that he had selected this as a permanent position from which to annoy the enemy."[114] With his large-view camera Gardner focuses in closely and, rhetoric to the contrary, provides the soldier with his musket—a prop rifle he and O'Sullivan had used before in other photographs, and would use again. The weapon is not a specialty marksman's rifle and would not have been useful to a real sharpshooter, who, according to Gardner's text, "could snuff a candle at a hundred yards."[115] No matter: at the time, the fallen soldier was just a dead Union infantryman.[116] Or at least he would be, until Gardner moved the body and turned him into a Confederate sharpshooter.

On the ground surrounding the corpse is a collection of typical soldier gear—a kepi, a tin cup, a haversack, a glass bottle, a blanket. These items would quietly move around the body in the four glass plates (one large-format, three stereo views) that Gardner and O'Sullivan exposed. So far, so good. The problems begin with what happens next. Possibly with the assistance of members of a nearby burial detail, the photographers transported the body uphill to a more intimate and visually attractive location, that of the now controversial *Home of a Rebel Sharpshooter, Gettysburg*, plate 41 of the *Sketch Book* (pl. 102). Between two massive granite boulders bridged by a short wall of fieldstones rests a dead Confederate sharpshooter, or so the caption states. His weapon (the same musket seen in *Sketch Book* plate 40) is positioned theatrically against the wall, just below his right leg. Gardner or O'Sullivan scatters a few objects beside him, props up the soldier's head with a knapsack, then turns the young face toward the camera for his cameo. O'Sullivan first exposed a single stereo view that shows the blanket the men may have used to transport the body; then, without the blanket, Gardner would make a single large-format negative.[117] To complete the picture he would compose, two years later, the most far-fetched tale in Civil War photography:

On the nineteenth of November [1863], the artist attended the consecration of the Gettysburg Cemetery, and again visited the "Sharpshooter's Home." The musket, rusted by many storms, still leaned against the rock, and the skeleton of the soldier lay undisturbed within the mouldering uniform, as did the cold form of the dead four months before. None of those who went up and down the fields to bury the fallen, had found him. "Missing," was all that could have been known of him at home, and some mother may yet be patiently watching for the return of her boy, whose bones lie bleaching, unrecognized and alone, between the rocks at Gettysburg.[118]

Of this dramatic text, the historian William Frassanito notes that the lengthy caption was "an obvious case of fiction. . . . The body would have been long since buried, and the rifle would have been picked up by Union forces or relic hunters."[119]

Today, *Home of a Rebel Sharpshooter, Gettysburg* is the most famous of Gardner's field photographs, partly because it has become the focus of an almost fifty-year debate about documentary ethics and photographic credibility. What remains unresolved is the question of evidence: Why do most forensic historians believe that the body was moved from the open field to the stone wall, not vice versa? And why do the photographers themselves have to be the impetus for causing the corpse to be moved? To this author it is just as plausible that after Gardner and O'Sullivan made the two photographs at the "sharpshooter's home," one of the many burial parties working in the area removed the body and deposited it for interment in the lower field, where it was subsequently photographed four more times. If the photographers did not move the body but simply documented it at two different locations, the ethical issue of fakery is diminished, if not fully resolved.

In the history of photography, there is a long and established tradition of manipulated documentary: Roger Fenton, the photographer of the Crimean War, seems to have added a few cannonballs to make his 1855 landscape *Valley of the Shadow of Death* even more lush. And in 1936, Walker Evans moved an Alabama sharecropper's bed away from the wall to make a celebrated picture for what became *Let Us Now Praise Famous Men*, Evans and James Agee's Depression-era masterpiece of lyric documentary photography and writing.[120] Photography in the

Civil War era was no different. As the cultural critic Susan Sontag wrote in *Regarding the Pain of Others*:

> The frankness of the most memorable pictures in *Gardner's Photographic Sketch Book of the War* (1866) did not mean that he and his colleagues had necessarily photographed their subjects as they found them. To photograph was to compose (with living subjects, to pose), and the desire to arrange elements in the picture did not vanish because the subject was immobilized, or immobile.[121]

It is true that Gardner and other artists may have added a prop or two to improve the formal qualities of their pictures; and they all certainly posed living soldiers and officers for field portraits. But neither Gardner nor O'Sullivan is known to have moved any other corpses during the war. Perhaps they did not wish to; perhaps they simply did not have any other opportunities? The matter seems to end here. At least for now.

—◆◆◆—

In many ways, Gettysburg is the centerpiece of Gardner's *Sketch Book*, just as it is of the Civil War itself. And what comes thereafter at the end of volume 1 and in volume 2 is a series of extraordinary photographs of camp life, not the battlefield. To many, these scenes of the war in Virginia cannot compete with the emotional intensity of the dead of Antietam and Gettysburg. On July 9, after their work at Devil's Den, and exhausted from the heat and psychic trauma caused by the human carnage at Gettysburg, Gardner, O'Sullivan, and Gibson left town. Gardner directed O'Sullivan and Gibson to follow the Army of the Potomac; he would return to the Washington gallery with the team's precious war treasure: fragile glass plates chronicling one of America's darkest moments. Back at home, he would add the titles of the new negatives to his lengthy inventory list soon to be published, and then return to the business of managing his portrait gallery. Evidence shows that he would not work in the field again until the last two months of the war (pl. 90).[122]

As reflected in this catalogue, the vast majority of photographs Gardner presents in volume 2 of the *Sketch Book* are by O'Sullivan, who contributed twenty-four views of camp headquarters and camp architecture, and scenes of the army's commissary, telegraph construction corps, wagon repair shop, and forts (pls. 103, 104). Yet none has the tragic sadness of *A Burial Party, Cold Harbor, Virginia* (pl. 108). It is one of the seven photographs Gardner included by the obscure John Reekie (1830?–1880s). A shocking field study made after the Confederacy's evacuation of Richmond on April 3, 1865, and Lee's surrender to Grant at Appomattox six days later (and probably after President Lincoln's assassination), it is the only photograph in the second volume that shows corpses, here being collected by African-American soldiers. The dead were casualties from two intense battles fought on the same ground: Gaines's Mill (June 27, 1862), with 11,000 men killed, wounded, captured, or missing, and Cold Harbor (June 3, 1864), with 7,000 Union soldiers and 1,500 Confederates killed or wounded in less than an hour of fighting. The latter battle was one of General Grant's greatest military failures against Lee or any other general; late in life he wrote: "I have always regretted that the last assault at Cold Harbor was ever made."[123]

In *A Burial Party*, plate 94 of the *Sketch Book*, Reekie composes a photograph that tells a complex story about the experiences of African-Americans in the Union army. Four soldiers with shovels work in the background; in the foreground, a single soldier in a knit cap sits crouched behind a bier that holds the lower right leg of a dead soldier and five skulls—one for each member of the living work crew. Reekie's atypical low vantage point and tight composition ensure that the foreground soldier's head is precisely the same size as the bleached white skulls, and that the head of one of the workers rests in the sky above the distant tree line.[124] It is a macabre and chilling portrait—literally a study of black and white—that is as memorable as any made during the war. But what does it reveal? Does it present what the art historian Anthony W. Lee suggests is a view not of heroes but of survivors, "not a cause for celebration [the war was over] but, with strange aptness, an awareness through photography that antinarrative and antiheroism, forms of fracture and the impossibility of exultation, were what lay in store in the modern world"?[125] Perhaps, but it meant something entirely different to Gardner, whose caption focuses not on the living, or the dead, but on the absent local residents who failed to honor those lost on both sides:

It speaks ill of the residents of that part of Virginia, that they allowed even the remains of those they considered enemies, to decay unnoticed where they fell. The soldiers, to whom commonly falls the task of burying the dead, may possibly have been called away before the task was completed. At such times the native dwellers of the neighborhood would usually come forward and provide sepulture for such as had been left uncovered. Cold Harbor, however, was not the only place where Union men were left unburied.[126]

As it did to almost everyone in the country, Abraham Lincoln's assassination must have seemed to Gardner an unfathomable act of evil. It affected him personally, and it is likely he conceived of the *Sketch Book* as an effort to honor the tragic history of the war and simultaneously to offer a lasting tribute in photographs to his revered dead president.[127] The two volumes were not intended to be a comprehensive history of every regiment in every battle in every state, but they would try, Gardner wrote, to elucidate "the Titanic contest that recently shook our continents."[128] After serving as the exclusive photographer of the July 7, 1865, hanging of the Lincoln conspirators (pl. 94)—pictures of the dead he chose not to include in the *Sketch Book*—Gardner would work in late summer and fall designing, sequencing, and printing the photographs for the publication, and then composing and editing the narrative captions that precede each image.

Unfortunately, the timing for the book's release was not auspicious, for the nation was in the middle of an acrimonious political debate about the future of the former Confederate states and how they might best be readmitted into the Union. The first announcement for the publication appeared in the July 22 issue of *Harper's Weekly*, in an article stating that Gardner would soon release a book about the war to be titled "Memories of the Rebellion."[129] Perhaps because many in the country, North and South, wanted to move on with their shattered lives and leave their memories of the war behind them, Gardner changed the title to *Gardner's Photographic Sketch Book of the War*. Philp & Solomons produced and

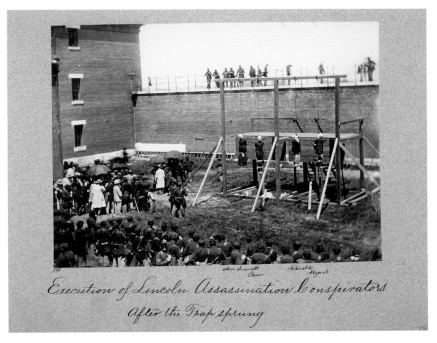

94 Alexander Gardner, *Execution of Lincoln Assassination Conspirators, After the Trap Sprung*, July 7, 1865. Albumen silver print

sold to the public in early 1866 approximately two hundred sets of the two-volume book. The price was $150, which works out to the same price per plate that Gardner charged for loose prints in his "Incidents of the War" series.[130] There are no known critical reviews, but the first listing of the completed work appears on January 28, 1866, in Washington's *Sunday Morning Chronicle*, followed by one in April in *The Art-Journal* (London). Since only sixty-seven complete sets are known today, it is not certain that all two hundred were actually printed and released to the public as bound volumes. What is known is that *Gardner's Photographic Sketch Book of the War* is the publication from which all other photographically illustrated books in America are descended, and against which they are judged. And it is the foundation of any important Civil War collection.

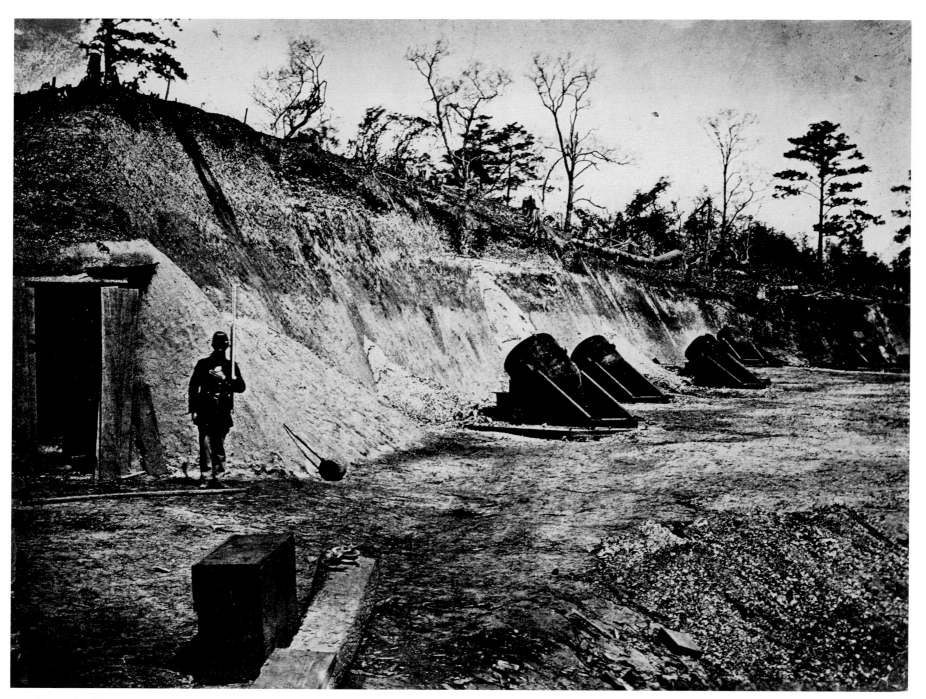

95 John Wood and James F. Gibson, *Battery No. 4, near Yorktown, Virginia*, May 1862. Albumen silver print

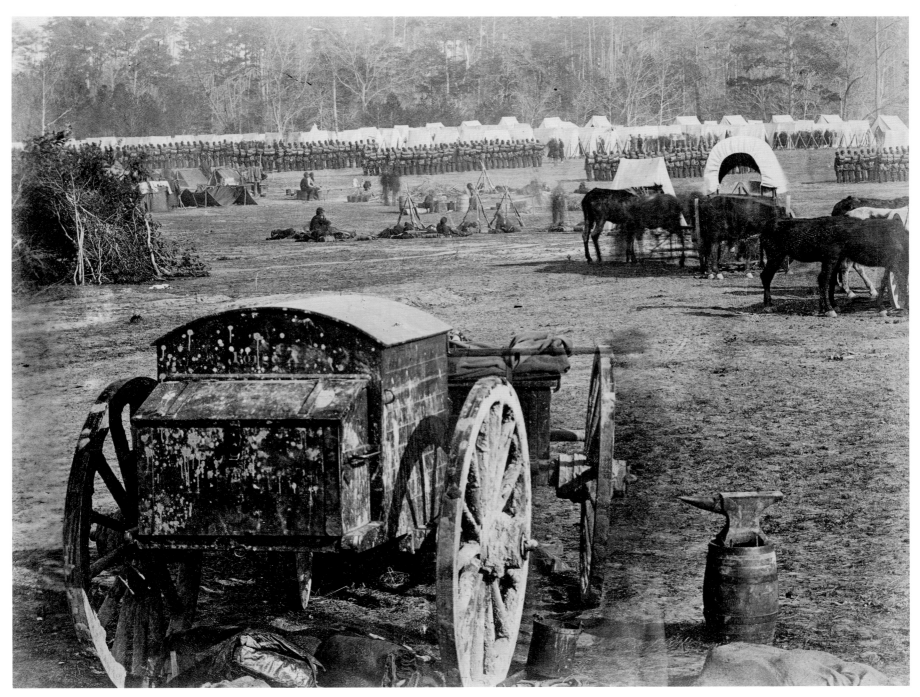

96 John Wood and James F. Gibson, *Inspection of Troops at Cumberland Landing, Pamunkey, Virginia*, May 1862. Albumen silver print

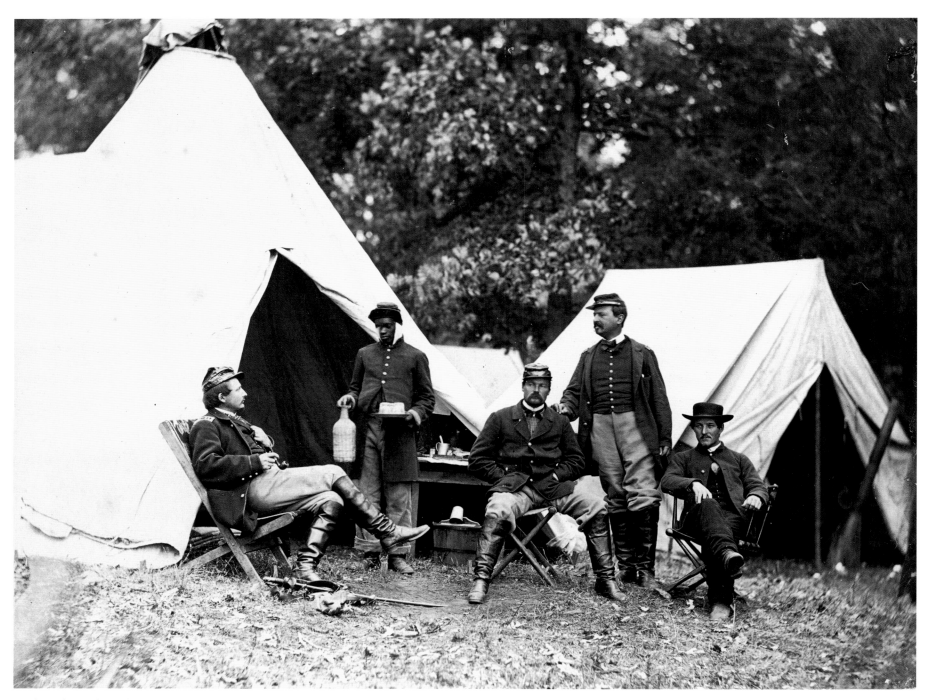

97 Alexander Gardner, *What Do I Want, John Henry? Warrenton, Virginia*, November 1862. Albumen silver print

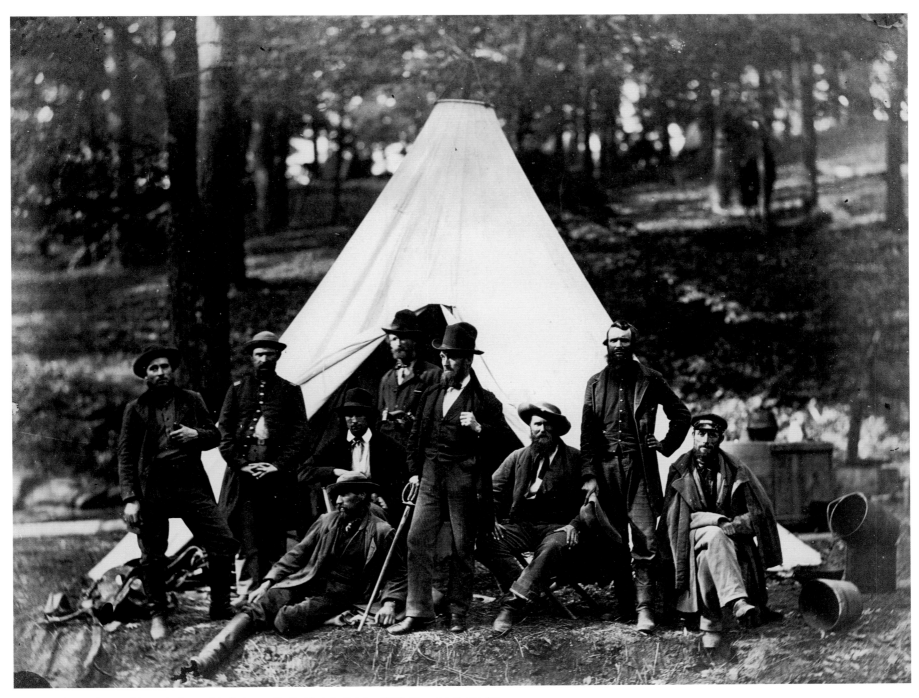

98 Alexander Gardner, *Guides to the Army of the Potomac, Berlin, Virginia*, October 1862. Albumen silver print

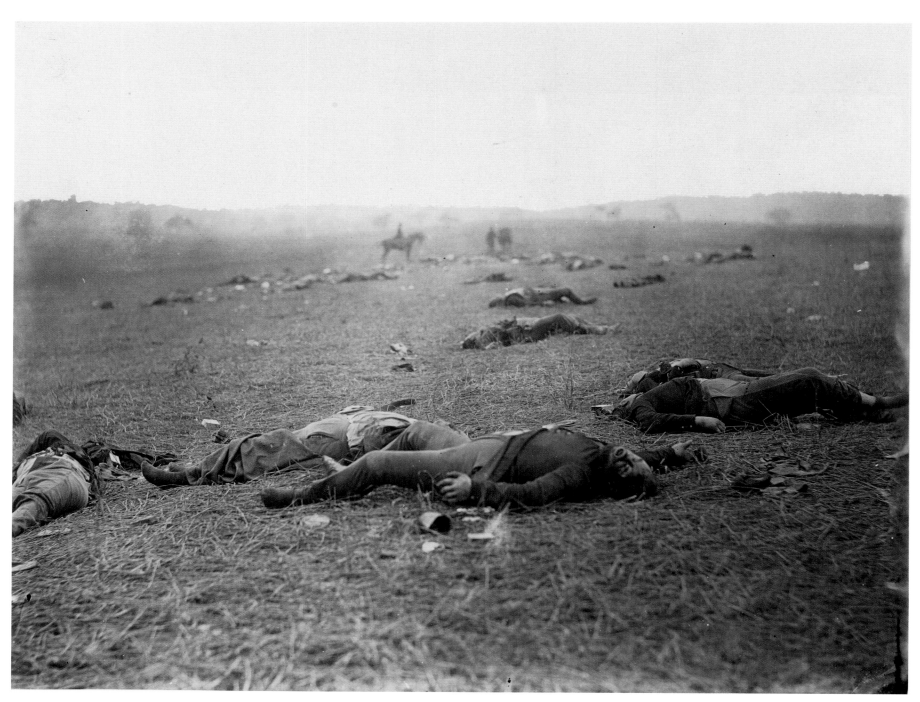

99 Timothy H. O'Sullivan, *A Harvest of Death, Gettysburg*, July 1863. Albumen silver print

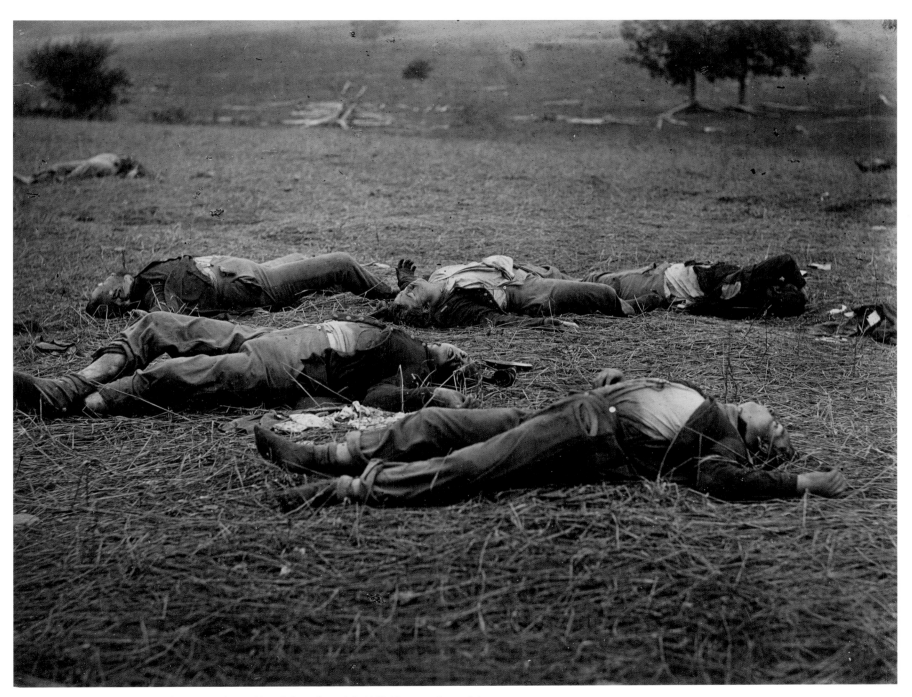

100 Timothy H. O'Sullivan, *Field Where General Reynolds Fell, Gettysburg*, July 1863. Albumen silver print

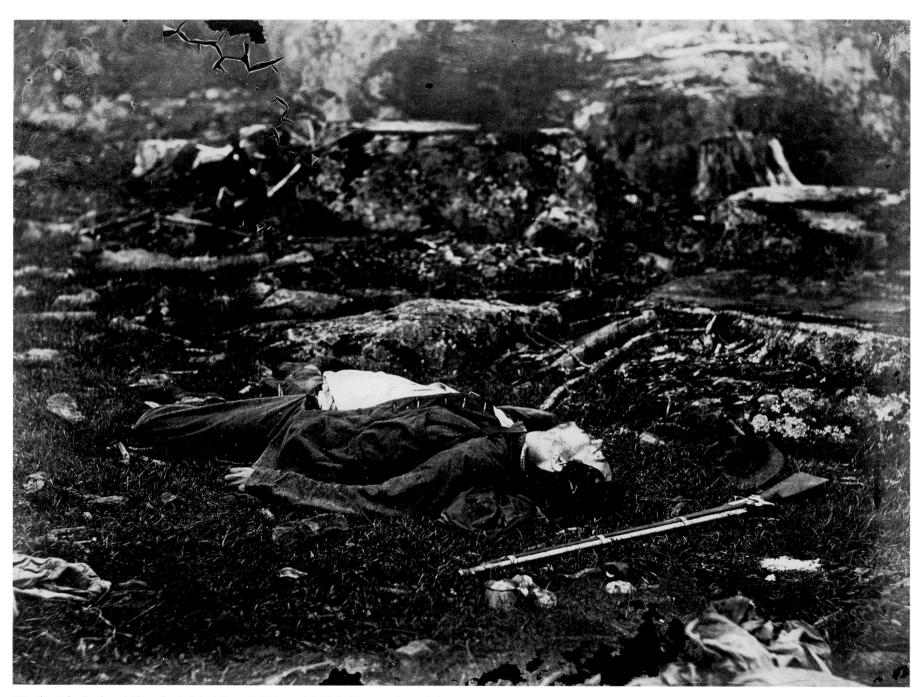

101 Alexander Gardner, *A Sharpshooter's Last Sleep, Gettysburg*, July 1863. Albumen silver print

102 Alexander Gardner, *Home of a Rebel Sharpshooter, Gettysburg*, July 1863. Albumen silver print

103 Timothy H. O'Sullivan, *Pontoon Boat*, February 1864. Albumen silver print

104 Timothy H. O'Sullivan, *Chesterfield Bridge, North Anna, Virginia*, May 1864. Albumen silver print

105 David Knox, *Battery Wagon, Front of Petersburg*, September 1864. Albumen silver print

106 David Knox, *Mortar Dictator, Front of Petersburg*, October 1864. Albumen silver print

107　John Reekie, *Extreme Line of Confederate Works, Cold Harbor, Virginia*, April 1865. Albumen silver print

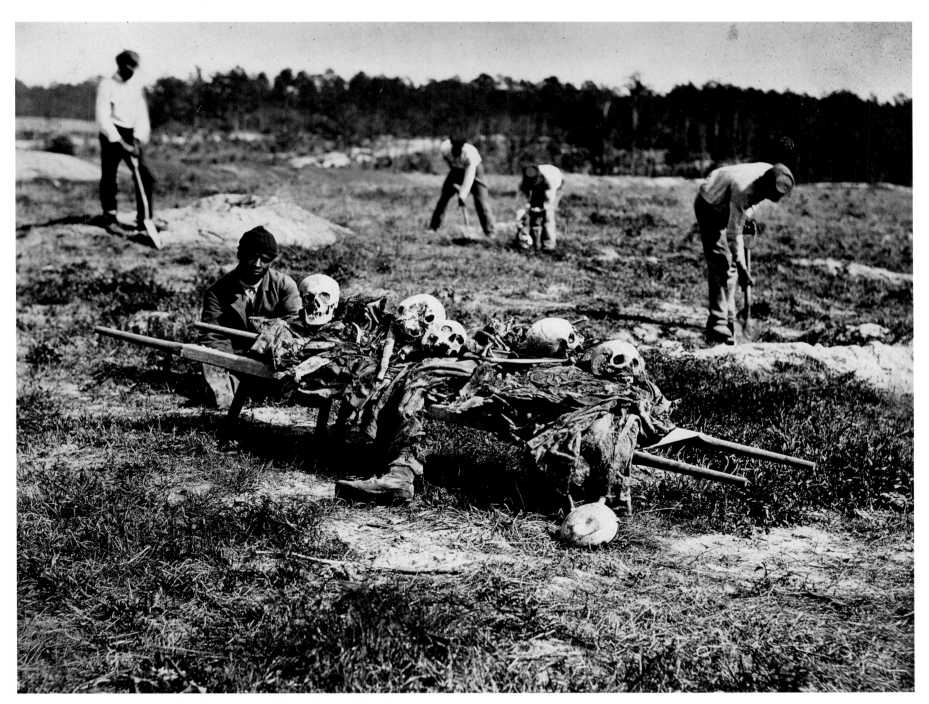

108 John Reekie, *A Burial Party, Cold Harbor, Virginia*, April 1865. Albumen silver print

Ambrotypes and Tintypes

Landscapes and likenesses, people and places. While Gardner and Brady and their teams of field photographers were following the Union armies and recording the body of war, hundreds of others were recording the face of it. Some portrait galleries were located on the top floors of brick-and-mortar buildings; others, like Bonsall & Gibson, whose skylighted tent is seen in plate 109, traveled with mobile studios. They followed the armies, and set up their businesses wherever customers could be found. In this quarter-plate ambrotype, a customer has just emerged from the "Pictures" tent and examines his portrait. Regrettably, ambrotypes and tintypes often do not reveal their makers; the photographers' names rarely appear on the hinged cases (pls. 110, 111). Their subjects are known because of the images' ancestral value as treasured family keepsakes passed down from generation to generation. Seen one at a time or in a private collection or vast public archive, these small, handheld likenesses of the men and women who served in the war or were caught up in it are masterpieces of vernacular picture-making. Collectively they form an essential portrait of American culture (pls. 110–36).

Communication to and from the war front and the camps supporting the Union and Confederate armies was very much a part of the Civil War experience. Newspapers and small packages with food (dried fruit, cakes) and clothing (socks), and of course private letters from family members, arrived weekly. During the winter, when both North and South retired for the season, the mail was delivered almost daily. Among the most valued items ferried to and from the armies were photographs, cased objects as well as cartes de visite. Most were portraits, for the production and the sale of views and stereos was reserved for the consumption of individuals not near the front lines of battle. In the field, North and South, the refrain was similar from soldier to soldier:

> I have been trying to find time to get to the city to find a daguerreian room, but have not yet. Hope to soon.
>
> You want me to send my likeness. That I cannot do just now for we can't have them taken here now.
>
> Send me Willy's face.[131]

Sergeant William Charles of the 154th New York Volunteer Infantry asked his wife, Ann, to send him portraits of her and of their children, Thomas and Frances. He wrote home from Fairfax Court House, Virginia, in 1862: "I tell you I wish you could send me your likeness, and the children. . . . I will send you money to pay for them. . . . I should like very much to hear and see Tommy blow his horn. I wish you could go and have his likeness taken with his horn in his hand. . . . You can send it in a letter. . . . Not only send me his picture but of you all."[132] By June 1864, he was requesting a new set of portraits: "The pictures I have of yourself and children are all worn out. As soon as you have time you will please have them taken again & send them to me."[133] Private James D. Quilliam, also of the 154th New York, wrote to his wife, Rhoda, from Stafford Court House, Virginia:

> I have on the dress that I wear every day except the straps. Them I do not wear, only when on duty. That yellow spot on my shoulder strap is a brass eagle, but the man spoiled it by gilding it. I stand just as I should if an officer should give the command [illegible].[134]

— ❖ —

109 Bonsall & Gibson, *"Headquarters for Photographs,"* ca. 1863. Quarter-plate ambrotype

110 Unknown artist, Union Drummer with Drum and Sticks, 1861–65. Sixth-plate ambrotype with applied color

111 Unknown artist, Union Soldiers, Seated, with Handguns, 1861–65. Sixth-plate tintype with applied color

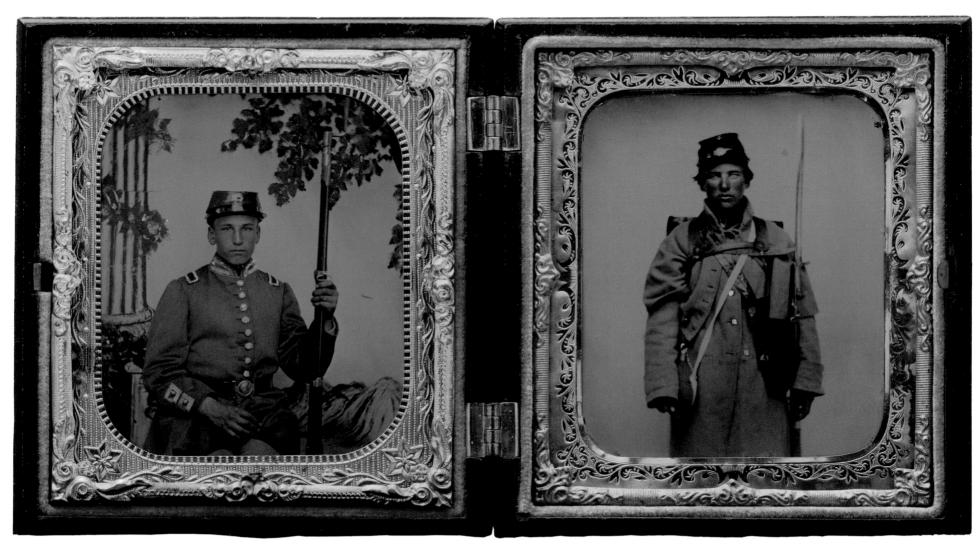

112 Unknown artists. Union Soldier in Dress Coat, Seated, before Painted Backdrop, 1861–65. Sixth-plate ruby glass ambrotype with applied color.
Union Soldier in Winter Overcoat, Standing, in Full Marching Order, 1861–65. Sixth-plate tintype with applied color

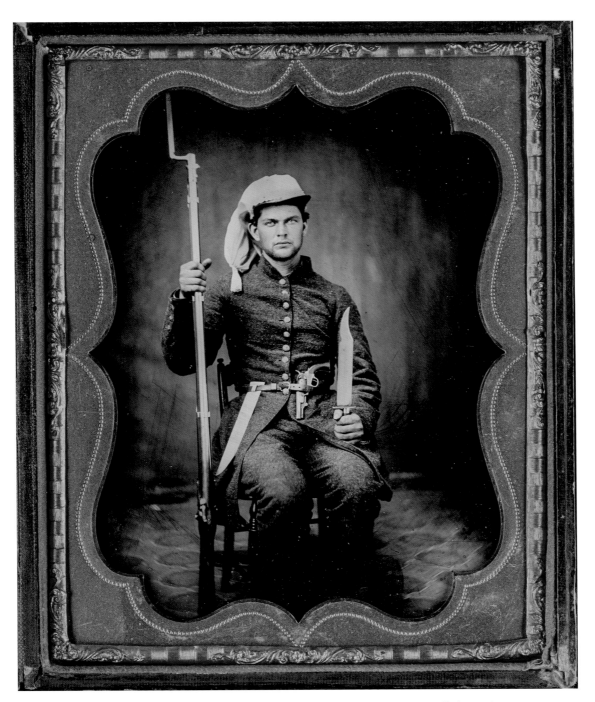

113 Unknown artist, *William Houston House, Cavalry Battalion, Army of Tennessee*, 1862–65. Half-plate ambrotype

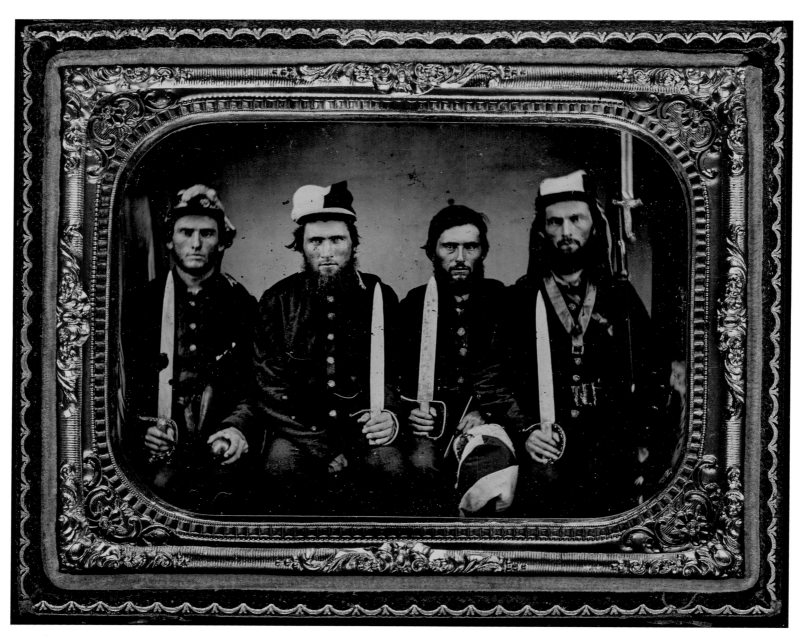

114 Unknown artist, *The Pattillo Brothers, Company K, "Henry Volunteers," Twenty-second Regiment, Georgia Volunteer Infantry*, 1861–63. Quarter-plate ruby glass ambrotype with applied color

On New Year's Day, 1862, *Humphrey's Journal*, an unabashedly partisan publication issued in New York City, reported on the status of photographic practice in the country during the war. It acknowledged in a rather gloating manner two regrets: "Hundreds are now mourning the loss of husband, brother, or dear friend! The number of such is happily much less than we had a right to fear it would be by this time." And:

> The Photographic art down South has completely died out in consequence of the war. The miserable rebels are shut up like a rat in a hole. A mighty power is compressing them on all sides, and they will soon be obliged to "give it up." . . . The Photographic art here at the North is flourishing finely.[135]

While exaggerated and tinged with schadenfreude, the journal's report was essentially accurate. Most Civil War portraits made in the South date from the first year or so of the conflict, from the attack on Fort Sumter in April 1861 to the end of 1862. The demand likely existed for far more than were made, but by midsummer 1862, with the Union blockade of the largest Southern ports, it had become exceedingly difficult for Confederate artists to find photographic chemicals and materials with which to work. Nevertheless, what these mostly anonymous photographers produced is a testament to their craft and to the seriousness and urgency of the situation that brought sitters to their studios and field tents. Even the finest of these portraits are seldom seen—especially the cased images that rival any made at the time anywhere in the United States. A sampling of portraits from Georgia offers an excellent overview of the graphic quality and range of expression found in Confederate portraiture from early in the war.[136]

Private Thomas Gaston Wood, a drummer in the Eleventh Regiment, Georgia Infantry, sits for his portrait against a blank wall in a photographer's studio (pl. 116). He is sixteen years old and will not see seventeen. An orphan, he joined Company H in the town of Social Circle, Georgia, on July 3, 1861, and before the end of the year died of pneumonia in a Richmond hospital.[137] Shortly thereafter, on January 11, 1862, the Augusta, Georgia, *Daily Constitutionalist* published a letter about Wood written by the Reverend William Monroe Crumley, who had visited him in the hospital in Richmond:

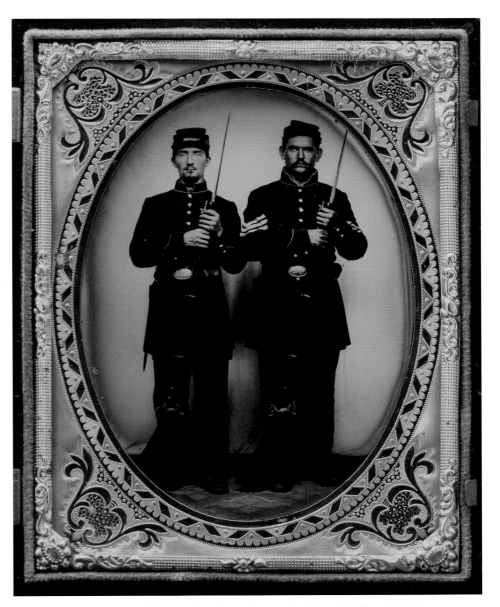

115 Unknown artist, *Union Infantry Soldiers in Frock Coats, Standing, with Rifles*, 1861–65. Quarter-plate ruby glass ambrotype with applied color

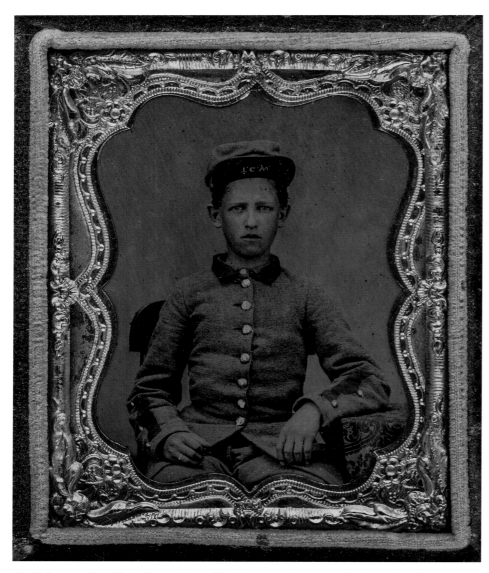

116 Unknown artist, *Private Thomas Gaston Wood, Drummer, Company H, "Walton Infantry,"*
Eleventh Regiment, Georgia Volunteer Infantry, 1861. Ninth-plate tintype with applied color

Young Wood was the pet and idol of his regiment. And he is struggling with pneumonia, that terrible scourge of the camp and the hospital. When asked whether he was afraid to die, he calmly answered: "No; I joined the church when but eight years of age; my father and mother are both in heaven, and I would rather go and bee [*sic*] with them there, than to stay and suffer here."[138]

In the photograph, Wood seems proud of his seven-button, single-breasted shell jacket and especially his kepi, which he has dutifully marked under the brim with his initials, "T.G.W." The photographer tipped up the cap to reveal the sitter's handiwork, but in this tintype he could not prevent the letters' lateral reversal. One wonders to whom the photograph was given, or whether Wood had it with him when he died. As a musician, he poses without any prop other than his uniform, whose buttons the photographer touched with gold. The minimalist composition is an exception; almost all portraits of Civil War soldiers, Confederate and Union, furnish their sitters with one or more weapons: a rifle, with or without a fixed bayonet; a sword; a pistol or two; a fighting knife.

A sixth-plate ambrotype of Private James House of the Sixteenth Georgia Cavalry Battalion is a fine example of a well-armed Confederate soldier (pl. 39). House wears a slouch hat and a checked battle shirt seen through the gap in an interestingly modified woolen shell jacket with tabbed button closures. The cavalryman menacingly brandishes his fighting knife and for quick use has half removed from its belted holster a pocket revolver. Yet the most frightening weapons in House's personal arsenal may be his focused stare and his set jaw.

Except in large-format studies of officers before their tents (pls. 97, 98), the vast majority of war portraits, either cased images or cartes de visite, are of individual soldiers. Group portraits in smaller formats are much rarer and challenged the field photographer (as well as the studio gallerist) to conceive and execute an image that would honor the occasion and be desirable—sellable—to multiple sitters. For the patient photographer, this created interesting compositional problems and an excellent opportunity to make memorable group portraits of brothers, friends, and even members of different regiments. As the Civil War author and collector Ronald S.

Coddington writes, "We know from letters, journals, and other first-hand accounts that bands of brothers were linked by strong bonds and esprit de corps due to their pre-war connections, patriotism, sense of duty, and shared military experience."[139] In a quarter-plate ambrotype (pl. 123), Captain Charles Hawkins of the Thirty-eighth Regiment, Georgia Volunteer Infantry, on the left, sits for his portrait with his brother John, a sergeant in the same regiment. They address the camera—one with a well-rehearsed "Don't move an inch" expression—and draw their fighting knives from scabbards. Charles (born in 1842) would die on June 13, 1863, in the Shenandoah Valley during General Lee's second invasion of the North. John, wounded at the Battle of Gaines's Mill in June 1862, would survive the war, fighting with his company until its surrender at Appomattox.[140]

Plate 117 is a tinted sixth-plate ambrotype of Private George M. Harper, who enlisted in Americus, Georgia, on September 10, 1861. He served in the Eleventh Battalion of the Georgia Volunteer Artillery. Harper was wounded in May 1864, but after his recuperation in a Richmond hospital he rejoined his company and, like Sergeant Hawkins, was present at the Appomattox surrender in April 1865. The endearing portrait, however, is a good example of a soldier who poses in a borrowed uniform and with a weapon he does not own. Private Harper stands at attention in an ill-fitting gray-blue jacket with sergeant's stripes; he holds a militia officer's sword; and the pin (crossed cannons) on the top of his kepi is crooked and improperly affixed to the cap. Everything the soldier wears or holds is a prop lent to him by a buddy or the photographer. As with Gardner's and O'Sullivan's photographs of the dead sharpshooter at Gettysburg, the fictional or aestheticizing aspects, the "fakery," and how it is to be interpreted, call for a serious analysis of all war portraits—something not easily accomplished when the sitters' names and military careers are often lost to historians. The baseline questions are: How often did the portraitists' aesthetic practices undermine their sitters' desires (if they had any) for factual accuracy, and how should historians interpret these photographic tapestries? To many Civil War experts, only a perfectly accoutered, by-the-book uniformed soldier or officer merits attention and has true historical value; to others, perhaps with less elitist standards, these constructed portraits are even more nuanced, complex, and beautiful. Still, they are as definitive of the historical moment as those that may be more factually accurate.

—⟶ ✦ ⟵—

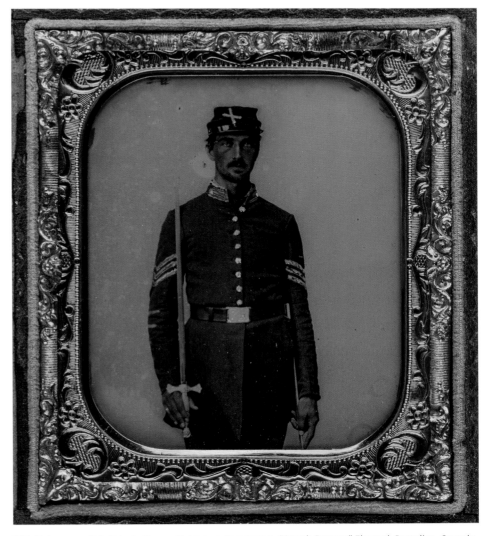

117 Unknown artist, *Private George M. Harper, Company A, "Cutts's Battery," Eleventh Battalion, Georgia Volunteer Artillery*, 1861–62. Sixth-plate ambrotype with applied color

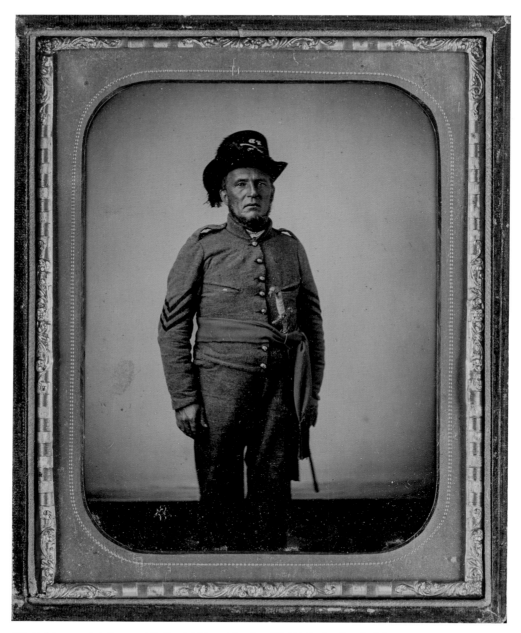

118 Unknown artist, *Sergeant Nathaniel Edward Gardner, "Cobb's Legion Cavalry," Company B,*
"Fulton Dragoons," Army of Tennessee, 1861–65. Half-plate ambrotype with applied color

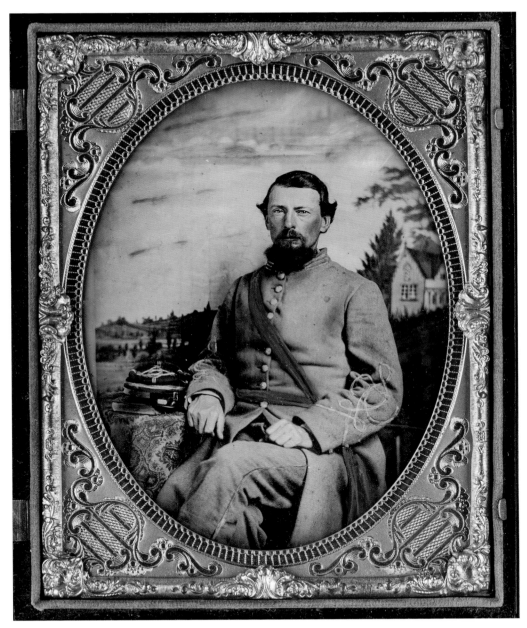

119 Unknown artist, *James A. Holeman, Company A, "Roxboro Grays," Twenty-fourth North Carolina Infantry Regiment, Army of Northern Virginia*, 1861–62. Half-plate ambrotype with applied color

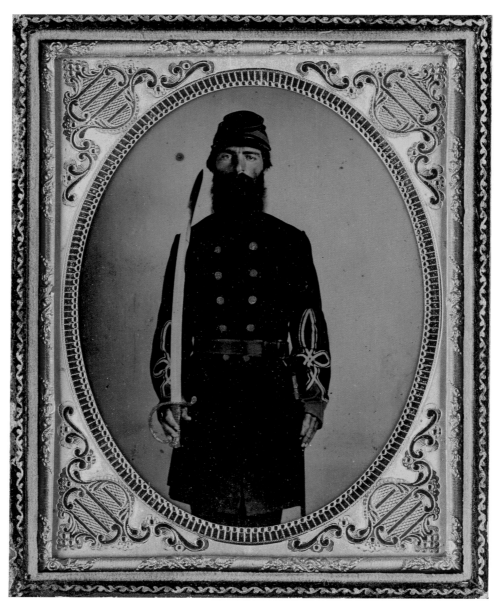

120 Unknown artist, *Lieutenant William O. Fontaine, Company I, Twentieth Texas Infantry*, 1862–65.
Half-plate tintype with applied color

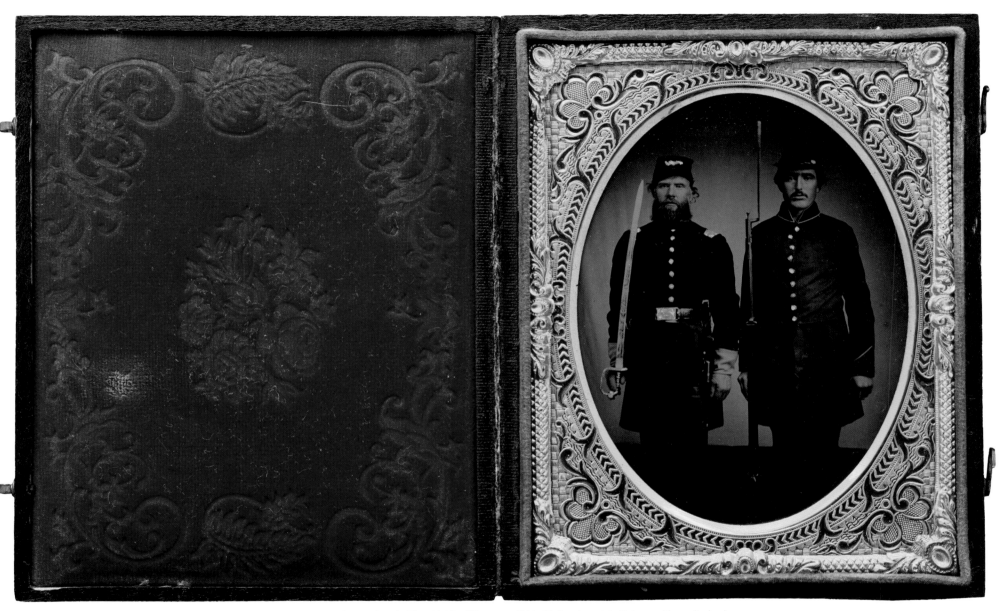

121 Unknown artist, Union Officer and Private, Standing at Attention, with Sword and Rifle with Fixed Bayonet, 1861–65. Quarter-plate tintype with applied color

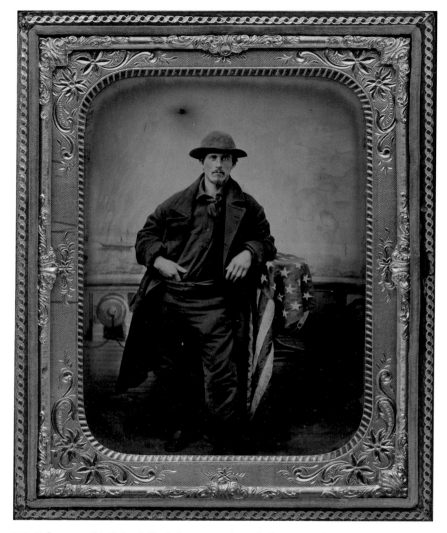

122 Unknown artist, Union Sailor in Peacoat and Hat, before Nautical Backdrop, 1861–65. Half-plate tintype with applied color

Union photographers, more than their Confederate counterparts, had the means to offer their patrons a variety of pictorial conventions through the use of patriotic painted backdrops. Plate 122 is a half-plate tintype of an unidentified Union sailor who leans on a table draped with the United States flag. Behind him is a painted backdrop of a nautical scene complete with two cannons and a steam frigate on the water. Some 118,000 men served in the Union navy, about five percent of the number who fought in the army, and thus ambrotype and tintype portraits of "bluejackets," as Union sailors were called, are necessarily rare. Their blue uniforms appear dark (practically black) in photographs, as do their pullover shirts worn with a black neckerchief, and usually a cap, often a flat beret with a dangling ribbon. This sailor wears a regulation overcoat (a peacoat) and a slouch hat. Since sailors were not normally armed, photographers had fewer props to incorporate into their compositions. Most made do by posing sailors with one or both hands tucked into the front of their trousers, like revolvers—an interesting modification of the Napoleon pose.[141]

Along with the general setting, most Union soldiers were furnished with a few props, so "the fierce-looking Civil Warrior who appears in an ambrotype armed to the teeth may not have owned a single weapon with which he is pictured."[142] The clearest examples of the borrowing of militariana are the many photographs of privates with officers' swords (pl. 117), Confederates from the same regiments posed with identical D-guard bowie knives, and Union infantrymen with no holsters but large revolvers. Figure 33 is a typical studio portrait of a quadruple-armed Union private. He sports two revolvers (no holsters), a battle knife, and a musket with a fixed bayonet. The awkward young soldier yet to see action in this sixth-plate tintype probably owned none of the weapons other than the musket. The rest came from the prop room of the gallery.

In some parts of the country, certain varieties of props were sold as easy moneymakers by enterprising photographers. Valerius C. Giles, a Fourth Texas Infantry soldier, recalled in his memoir a visit to a local photography studio after members of his regiment received their uniforms in early 1861: "While Bridges [sic] was placing me in position for this ambrotype, he suggested that I would look more fierce and military if I would pin one side of my hat back with a star. He had a supply of stars on hand, which he sold for a dollar apiece. . . . The star was bought, and

one side of the hat was pinned back."[143] Private Thomas Holeman, of the Tennessee Infantry, may have succumbed to a similar suggestion for a half-plate tintype (pl. 124). A resident of Shelbyville, Tennessee, he wears a reddish-brown uniform with light blue trim, likely homemade, and sports a black felt Hardee hat with an ostrich plume and a large gold star pin like that described by the Texas infantryman.

In the hands of an enterprising portraitist, almost anything could be a useful prop to render a memorable likeness that would stand out from all the others: a canteen with a Union soldier's initials stenciled on the woolen cover (pl. 125); the striped bow tie worn with panache by Union Sergeant John Emery (pl. 126); a bench, a deck of cards, and a few cigars (pl. 127); or simply raingear and a cape (pls. 129, 130). Confederate Private James Malcolm Hart of Captain William G. Crenshaw's Virginia Battery wears a shiny oilcloth poncho and rubberized head and neck gear, whose intense effect must have been unsettling even to the sitter. So, too, the Union infantry soldier who poses in a light-colored overcoat and short cape. In the sixth-plate ambrotype, he crosses his arms and gives a look to the camera that is filled with pain and emptiness. It recalls a frequently cited passage from Walt Whitman's collection of wartime essays, *Specimen Days*:

Future years will never know the seething hell and the black infernal background of countless minor scenes and interiors, (not the official surface-courteousness of the Generals, not the few great battles) of the Secession war; and it is best they should not—*the real war will never get in the books. . . .* The actual soldier of 1862–'65, North and South, with all his ways, his incredible dauntlessness, habits, practices, tastes, language, his fierce friendship, his appetite, rankness, his superb strength and animality, lawless gait, and a hundred unnamed lights and shades of camp, I say, will never be written—perhaps must not and should not be.[144]

Perhaps not. Yet it does seem to be lurking in the photographs, in the hollow stares of James Malcolm Hart and an anonymous caped Yankee, and in the faces found on thousands of tintype lockets that Union soldiers left behind with their families when they departed for the front (pl. 131).

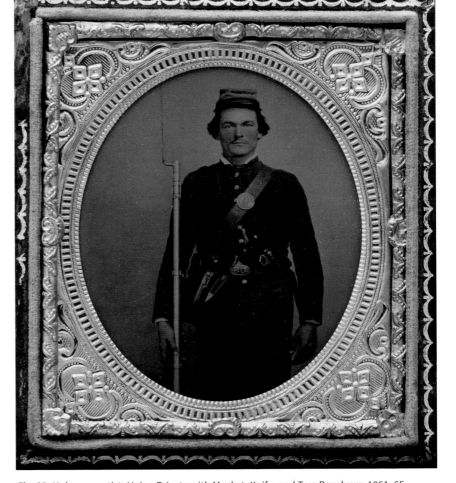

Fig. 33 Unknown artist, *Union Private with Musket, Knife, and Two Revolvers*, 1861–65. Sixth-plate tintype with applied color. Brian D. Caplan Collection

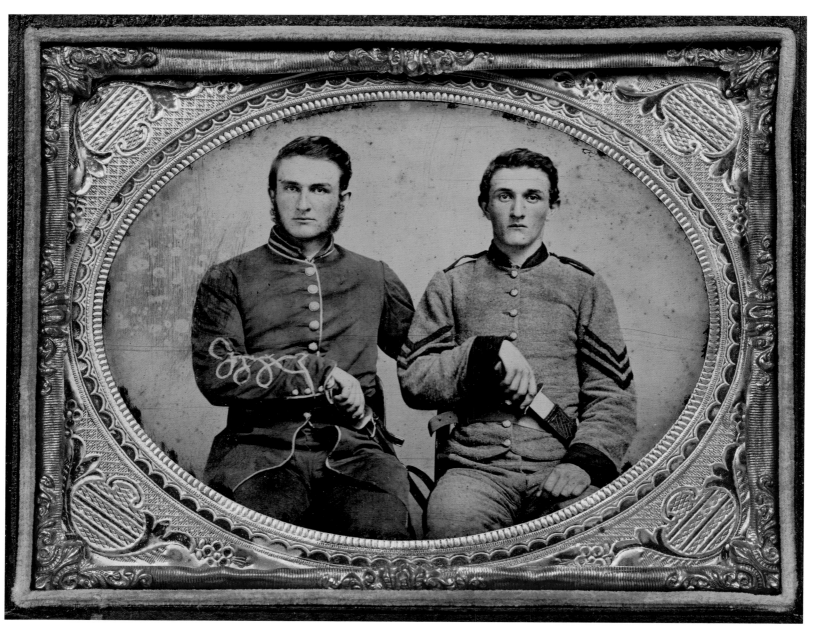

123 Unknown artist, *Captain Charles A. and Sergeant John M. Hawkins, Company E, "Tom Cobb Infantry,"*
Thirty-eighth Regiment, Georgia Volunteer Infantry, 1861–62. Quarter-plate ambrotype with applied color

124 Unknown artist, *Private Thomas Holeman, Company C, "The Secession Guards," Thirteenth Tennessee Infantry*, 1861–62. Half-plate tintype with applied color

125 Unknown artist, Union Private with Stenciled Canteen, 1861–65. Ninth-plate ruby glass ambrotype
with applied color

126 Unknown artist, *Union Sergeant John Emery*, 1861–65. Sixth-plate tintype with applied color

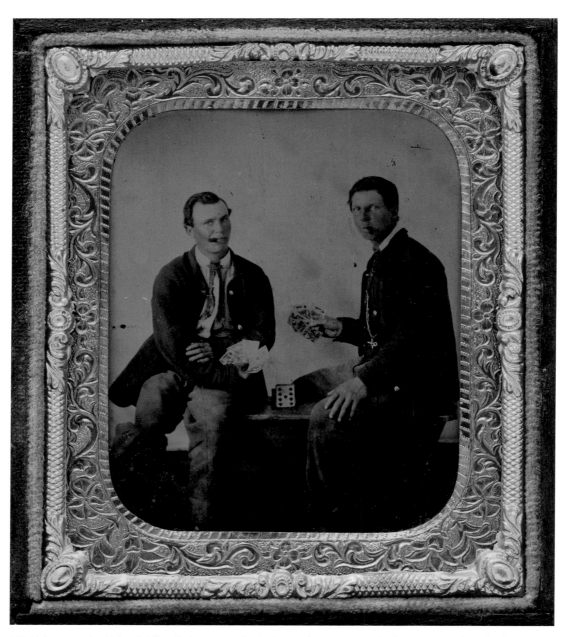

127 Unknown artist, Union Soldiers Sitting on Bench, Playing Cards, 1861–65. Sixth-plate tintype with applied color

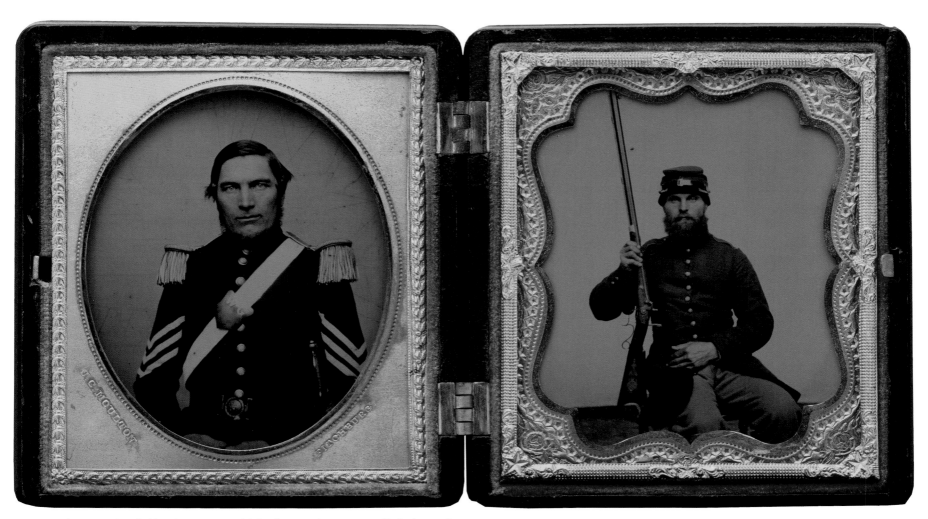

128 Joseph Carr Moulton (left), Union Sergeant with "WG" Breastplate, 1861–65. Sixth-plate ambrotype
Unknown artist, Union Private with Musket, 1861–65. Sixth-plate ambrotype with applied color

129 Unknown artist, *Private James Malcolm Hart, Crenshaw's Virginia Battery*, 1862–65. Sixth-plate ruby glass ambrotype with applied color

130 Unknown artist, Union Infantry Soldier Wearing Light-Colored Overcoat with Short Cape, 1861–65. Sixth-plate ambrotype with applied color

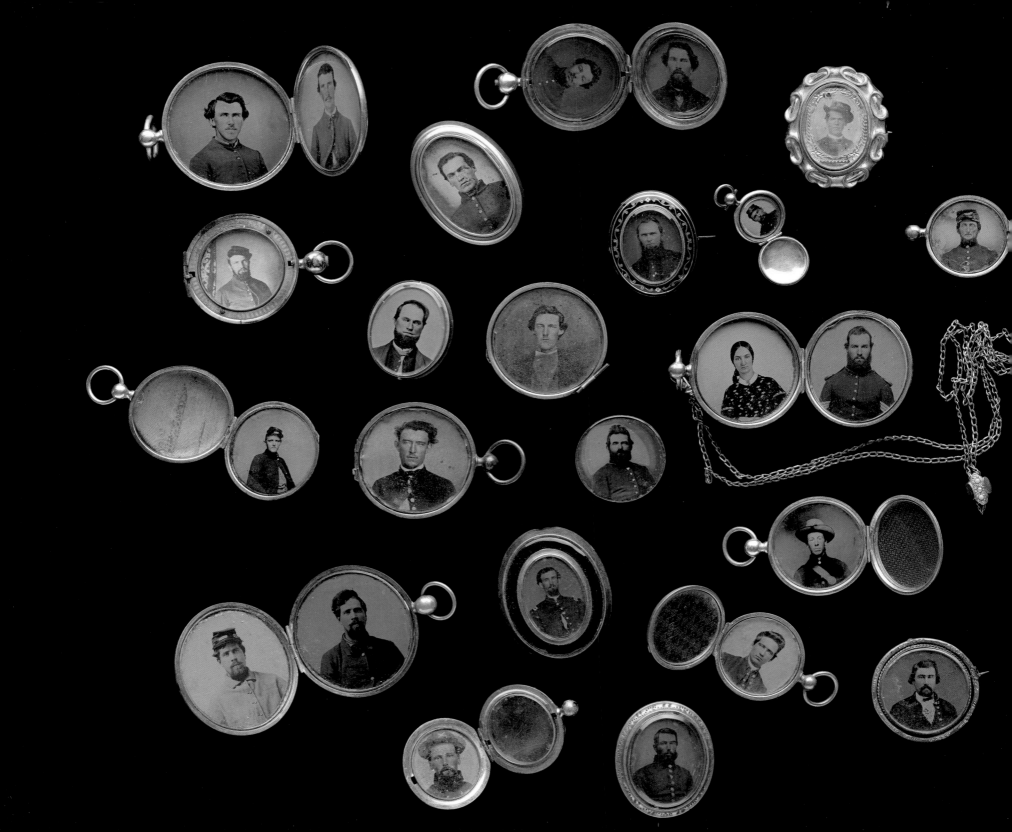

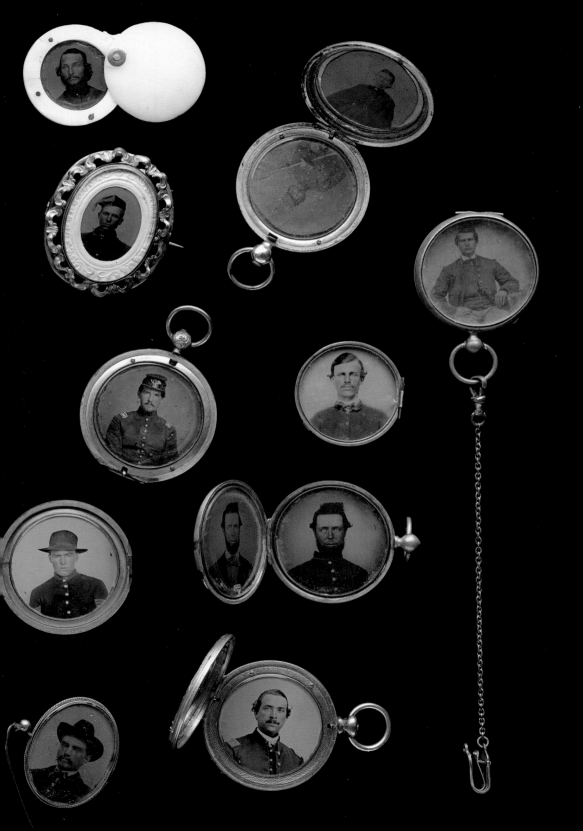

131 Unknown makers, Civil War Portrait Lockets, 1860s. Tintypes and albumen silver prints in brass, glass, and shell enclosures

From the start of the war, photographers in the North and South developed a thriving business making studio portraits of children wearing patriotic attire. Parents dressed their sons in miniature copies of soldier uniforms and then headed to the closest gallery for a picture or two (pl. 132). The most desired costume, it seems, was the colorful Zouave outfit adapted by American militia groups in the late 1850s from the French army, which had borrowed the style from North African troops in Algeria (fig. 34). Complete with fez headgear, short jackets, sashes, and pantaloons in bright blues and reds often decorated with fancifully patterned swirls, the uniforms varied from company to company but were always visually arresting and distinctive. Popularized by Colonel Elmer Ellsworth and his touring drill team, the United States Zouave Cadets, volunteer Zouave companies (and related Chasseur regiments) sprang up across the country after Fort Sumter (pl. 134).[145] *The Baltimore Sun* covered a pro-Union parade in August 1861 and noted that the soldiers were preceded by a drum corps composed of children: "The Franklin Zouaves executed all the intricacies of the Zouave drill. The dress and equipment of the Franklin Corps is in the full Zouave style—red pants, cap, with knapsack, and harmless musket and bayonet. The ages of the lads . . . range between nine and fourteen."[146]

Despite the fun of dressing up in Daddy's clothes, the children's often serious expressions and erect postures confirm their effort to honor

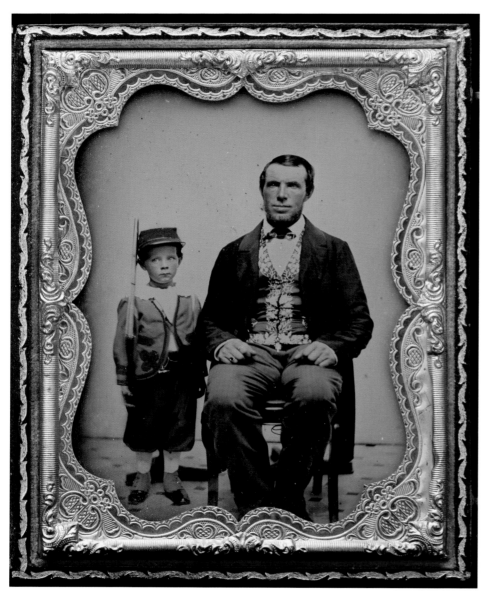

132 Unknown artist, Young Boy Dressed in Zouave Outfit, with Father, 1861–65. Quarter-plate ambrotype with applied color

133 Unknown maker, *Attention!! Recruits Wanted to Fill Up Company C. Col. D. B. Birney's Zouave Regiment*, 1861. Ink on paper (broadside)

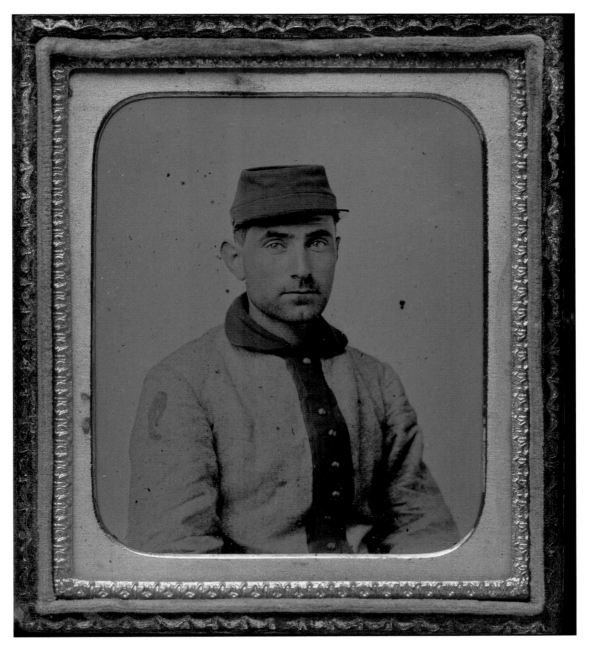

134 Unknown artist, Union Private, Eleventh New York Infantry (First Fire Zouaves), May–June 1861.
Sixth-plate ruby glass ambrotype with applied color

the photographers' and their parents' stern warnings: "Hold as still as you can, and don't move a muscle." These ambrotype and tintype portraits of junior "combatants" are among the most collectible likenesses of the era; the rarest are those where parents appear with their costumed children. If the father in plate 132 looks marginally like a more robust Abraham Lincoln, the boy recalls Thomas (Tad), the president's fourth son, who posed for photographs wearing his own miniature Zouave uniform. Tad Lincoln's hero was Elmer Ellsworth, his father's friend, and one of the first casualties of the war.

Even scarcer than father-son Zouave portraits are scenes of Zouave soldiers drilling in the field. In this dynamic sixth-plate tintype (pl. 136), Zouaves in the foreground are at the ready, deployed in skirmish formation on one knee and addressing the camera; behind them, silhouetted against the sky, a comrade stands and aims his rifle at a distant enemy combatant. It is a posed scene, not a true snapshot of soldier life, yet it is nonetheless descriptive of the theater of war.[147] These Zouaves, likely from the Ninety-fifth Pennsylvania, would soon see their share of suffering, with 112 men

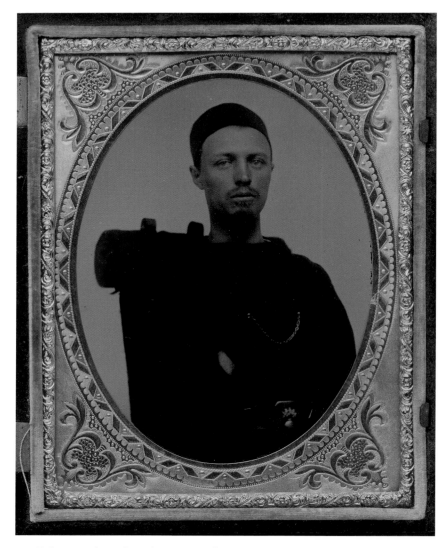

135 Unknown artist, Union Private, New York Zouaves, Wearing Knapsack with Blanket Roll, 1860–61. Quarter-plate ambrotype with applied color

Fig. 34 Gustave Le Gray, Zouaves, Camp de Châlons, near Paris, 1857. Albumen silver print. The Metropolitan Museum of Art, Gilman Collection, Purchase, Mrs. Walter Annenberg and The Annenberg Foundation Gift, 2005 (2005.100.965)

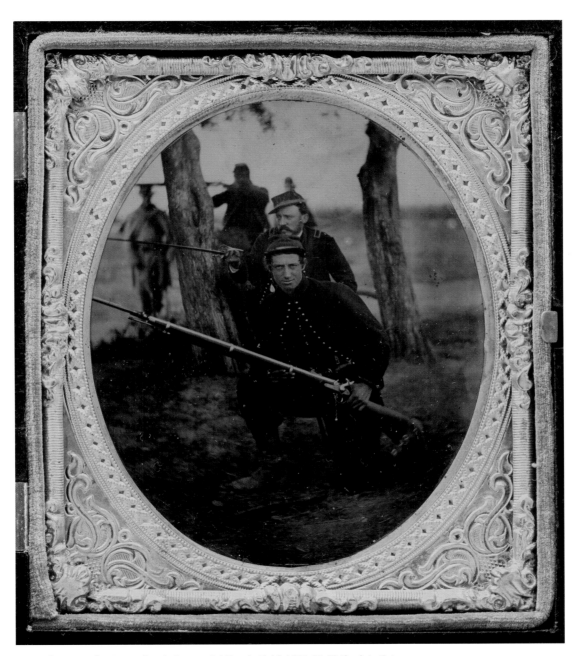

136 Unknown artist, Pennsylvania Zouave Soldiers in Field, 1861–65. Sixth-plate tintype

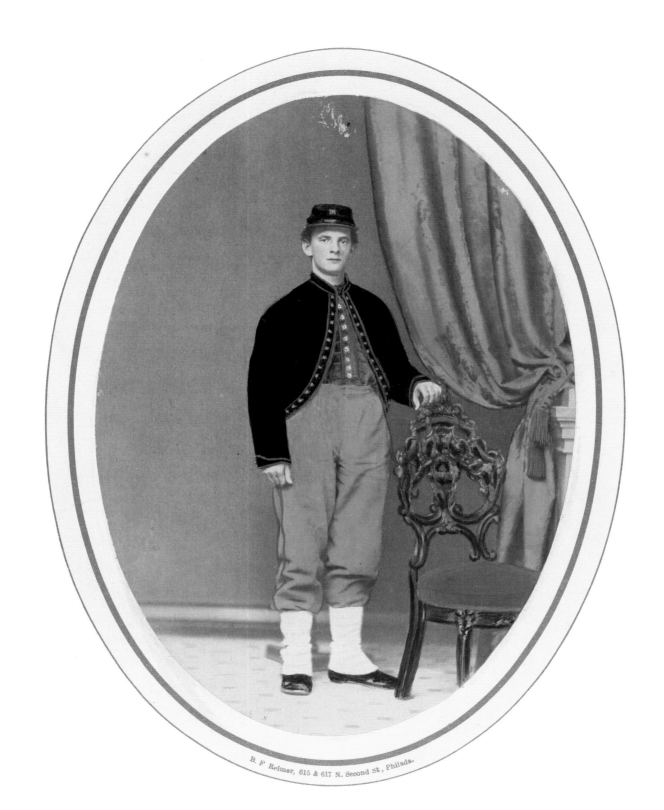

killed or wounded at the Battle of Gaines's Mill on June 27, 1862. Also rare, but far more common than photographs in the field, are cased portraits of Zouaves in studio settings. Plates 134 and 135, both ambrotypes, show a moderate amount of color applied to the plates, which added a hint of chromatic contrast to the soldiers' distinctive uniforms. Plate 134 records a melancholy private in the Eleventh New York Volunteer Infantry, also known as the First Fire Zouaves, the regiment Colonel Ellsworth recruited in May 1861 from New York City's volunteer firefighting companies. In plate 135, a private in the New York Zouaves, also known as "Hawkins's Zouaves," proudly displays his unusual belt buckle featuring a motif of an exploding bomb. He wears his knapsack and blanket roll and seems ready to serve his regiment, which entered service on April 23, 1861, just a week after the fall of Fort Sumter. A survey of the field suggests, however, that most Zouaves wanted not cased portraits but large albumen silver prints, even if they cost twice as much as ambrotypes or tintypes (pls. 137, 138). The reason is clear: paper prints could be far more skillfully painted with oils, thereby showing off the uniforms' fancy embroidery and the soldiers' stylish flair—the theater of war.[148]

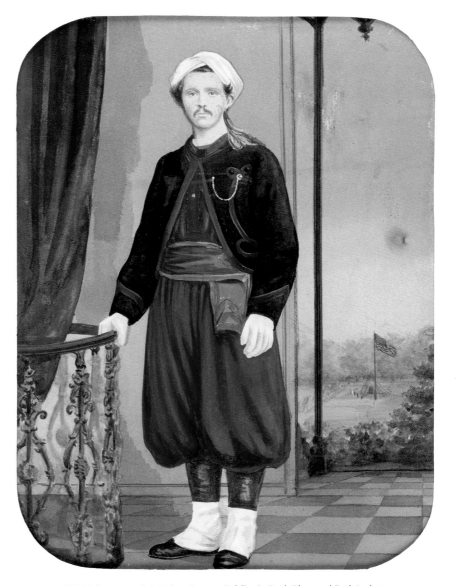

138 Unknown artist, *Union Zouave Soldier in Dark Blue and Red Jacket, and Red Pants*, 1861–65. Albumen silver print with applied color

137 Benjamin F. Reimer, *Union Zouave Soldier in Dark Blue Jacket and Light Blue Pants*, 1861–65. Albumen silver print with applied color

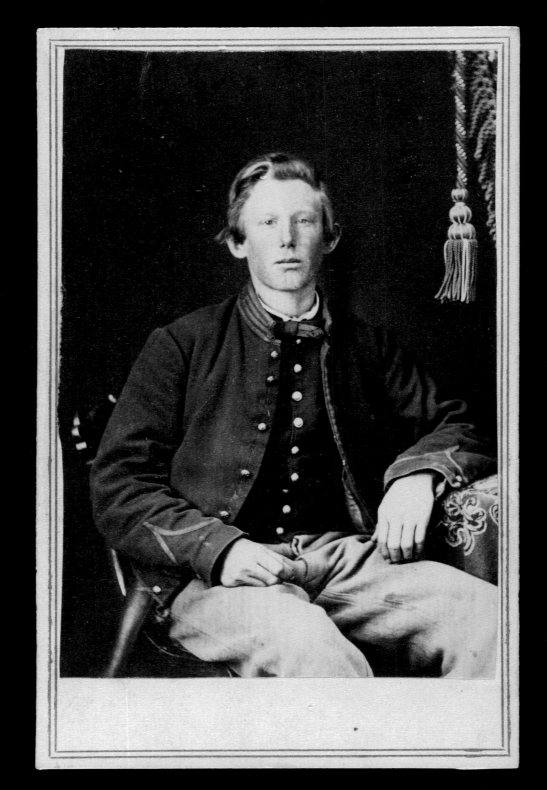

Cartes de Visite and Other Paper Prints

It was a matter of practicalities more than aesthetics. If a soldier had the cash and wanted only a single picture, he paid for an ambrotype or a tintype and within a few minutes departed the studio, near camp or in town, with a handsome cased image; if he wanted multiple examples of his portrait, or had lost most of his cash the night before in the last hand of poker, he bought a carte de visite or a dozen copies thereof. If he chose the carte de visite, he had to return to the picture gallery later in the day, or on the next day, since the photographer had to print the negative in the sun and then mount the miniature portrait on card stock. The next stop for the soldier often was the post office.

During the war years, photography studios across the country generated hundreds of thousands of carte-de-visite portraits. As *The Times* of London reported on August 30, 1862:

America swarms with the members of the mighty tribe of cameristas, and the civil war has developed their business in the same way that it has given an impetus to the manufacturers of metallic air-tight coffins and embalmers of the dead. The young Volunteer rushes off at once to the studio when he puts on his uniform, and the soldier of a year's campaign sends home his likeness that the absent ones may see what changes have been produced in him by war's alarms. In every glade and by the roadsides of the camp may be seen all kinds of covered carts and portable sheds for the worker in metal acid and sun-ray—Washington has burst out into signboards of ambrotypists and collodionists, and

the "professors" of New York, Boston, and Philadelphia send their representatives to pick up whatever is left, and to follow the camps as well as they can.[149]

The portraits generated by all these photographers were prized by the soldiers, and their families, and were usually stored in decorative pressed-paper and tooled-leather albums, thousands of which survive intact today (fig. 35; pl. 143).[150] In many ways, the immense quantity of existing portraits and carte-de-visite-format views (pl. 140) is as much a testament to the protection and stability offered by these period albums as it is to the nation's now enduring obsession with the war. One has to examine only a few examples to feel their authority. Private William Henry Lord, a cavalryman,

139 George W. Wertz, *Private William Henry Lord, Company I, Eleventh Kansas Volunteer Cavalry*, 1863–65. Albumen silver print (carte de visite)

140 Attributed to McPherson & Oliver, *Iron Clad* Essex*, Baton Rouge, Louisiana*, May 1863. Albumen silver print (carte de visite)

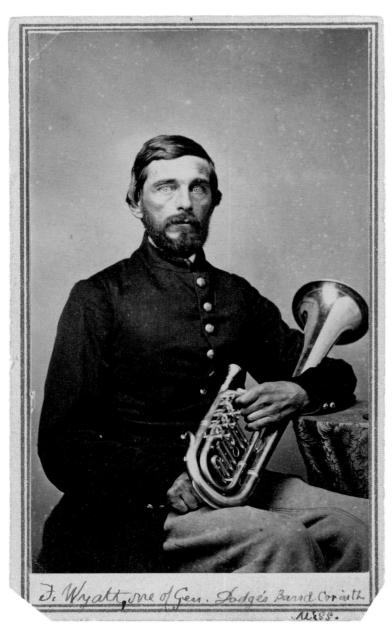

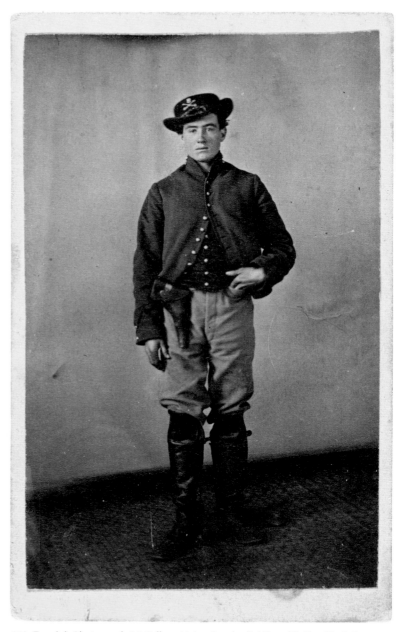

141 George W. Armstead, *Frank Wyatt, One of General Dodge's Band, Corinth, Mississippi*, September 18, 1863. Albumen silver print (carte de visite)

142 Tappin's Photograph Art Gallery, *Union Cavalry Soldier with Pistol in Holster*, 1861–65. Albumen silver print (carte de visite)

143 Unknown makers, Civil War Pocket Photograph Albums, 1861–65. Paper-and-leather cases housing cartes de visite

Fig. 35 Advertisement for Charles Hughes Photograph Albums, 1860s. Ink on paper. Michael J. McAfee Collection

sits alert and ready for the next ride in a portrait made in Kansas City, Missouri (pl. 139). A yet unmuddied enlistee from the far western region of the war—from "Bleeding Kansas," the last state to enter the Union before Fort Sumter—Lord was in the Eleventh Kansas Volunteer Cavalry; he was wounded in the shoulder in October 1864 but rejoined his company and was mustered out in September 1865. Also on the war's western frontier, in Corinth, Mississippi, a federal stronghold in the northeast corner of the state, Frank Wyatt cradles his gleaming saxhorn, an essential component of any military brass band (pl. 141). Wyatt notes on the recto of the carte de visite that he was a member of Brigadier General Grenville M. Dodge's band, and on the verso that he plays second E-flat alto. A resident of Grinnell, he had joined the band of the Second Iowa Volunteer Infantry on August 22, 1862. Thirteen months into his service, at age thirty-nine, Wyatt looks proud but rather wearied, even for a musician. He was one of the older members of the company; most Union soldiers were between eighteen and twenty-nine years old.[151]

Paper-print portraiture in the Civil War era gave ordinary Americans, and the picture makers who courted them, an unprecedented amount of graphic and political freedom. The result, iconographically, is an image of the times with more diverse types of men and women than had ever been depicted in any medium (pls. 139–61). In addition to gallant, if classical, portraits of Civil War elite such as Generals Grant, Lee, Sherman, and Custer and Admiral David Farragut, and of course Presidents Lincoln and Davis, one finds in the same albums exhausted soldiers whose names we will never know (pl. 147); twelve-year-old soldier drummer boys (pl. 149); wounded veterans who sold their portraits during and after the war to support themselves and their families (pl. 150); and women, like Frances Clalin Clayton, who fought in the armies dressed as men (pl. 151). Clayton poses here suggestively holding the handle of a cavalry sword between her crossed legs.[152] Some subjects saw the medium as form of self-revelation, others as a tool of change and personal empowerment.

—◦◦◦—

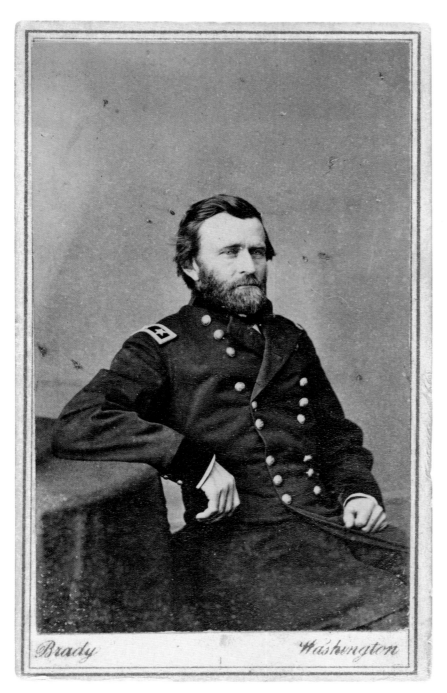

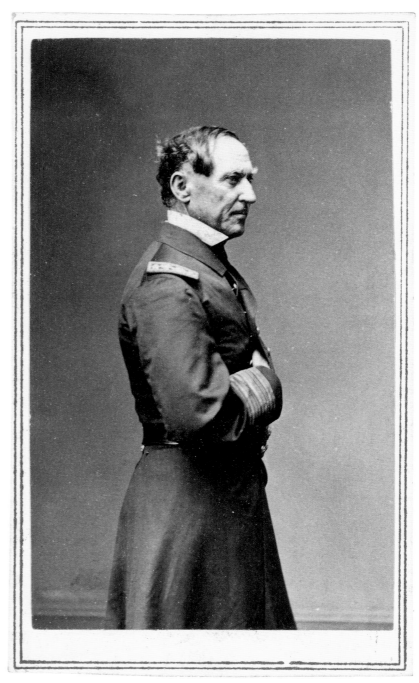

144 Brady & Company, *General Ulysses S. Grant*, ca. 1864. Albumen silver print (carte de visite)

145 Charles DeForest Fredricks, *Rear Admiral David Farragut*, 1864. Albumen silver print (carte de visite)

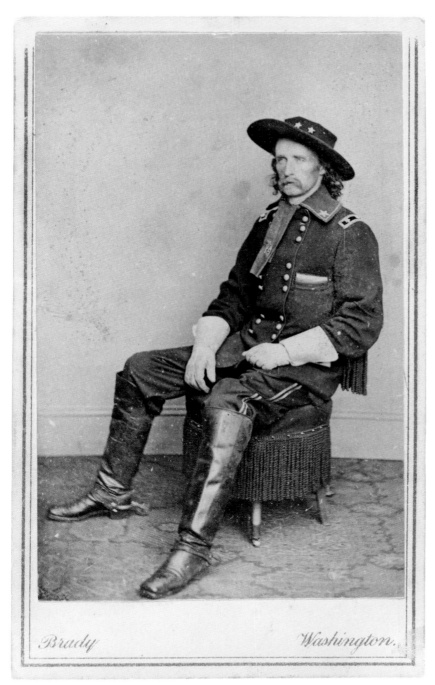

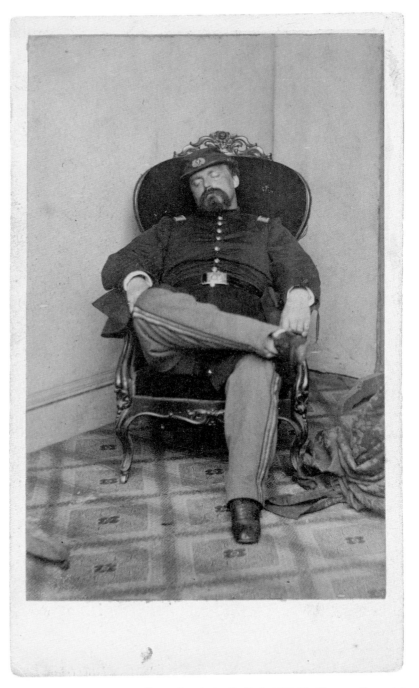

146 Brady & Company, *General George Custer*, 1864–66. Albumen silver print (carte de visite)

147 Unknown artist, Union Officer Asleep in Studio Chair, 1861–65. Albumen silver print (carte de visite)

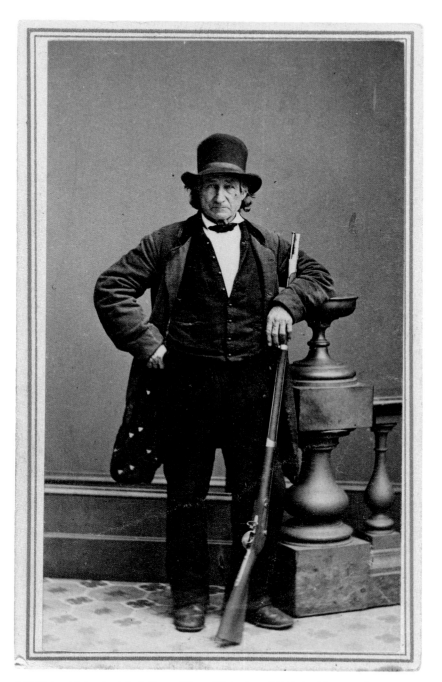

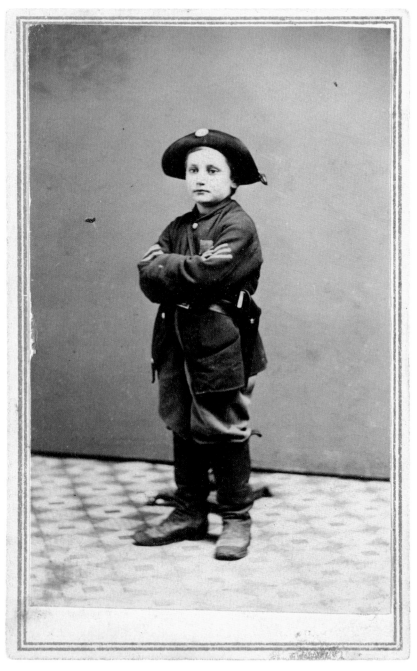

148 Richard A. Lewis, *John L. Burns, "Hero of Gettysburg,"* 1863–65. Albumen silver print (carte de visite)

149 Morse & Peaslee, *Sergeant John Lincoln Clem, the Drummer Boy of Chickamauga*, ca. 1864. Albumen silver print (carte de visite)

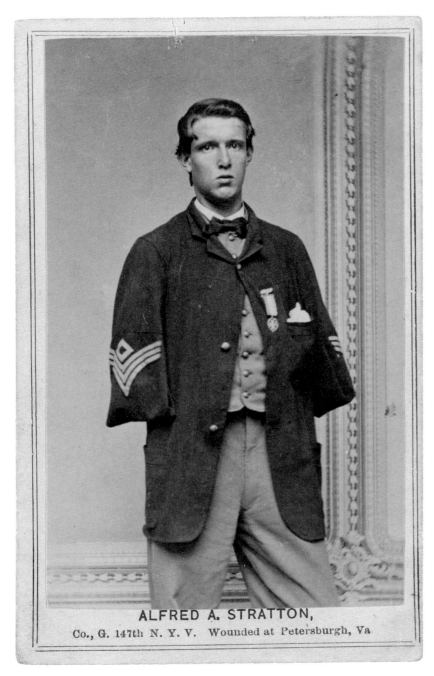

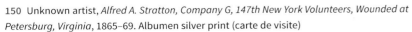

ALFRED A. STRATTON,

Co., G. 147th N. Y. V. Wounded at Petersburgh, Va.

150 Unknown artist, *Alfred A. Stratton, Company G, 147th New York Volunteers, Wounded at Petersburg, Virginia*, 1865–69. Albumen silver print (carte de visite)

151 Samuel Masury, *Frances Clalin Clayton*, 1864–66. Albumen silver print (carte de visite)

152 Hall & Company, *Alonzo H. Sterrett, Late Adjutant, Fortieth U.S. Infantry,* July 27, 1865.
Albumen silver print (carte de visite)

153 N. A. & R. A. Moore, Union Soldier with Rifle, Standing before Painted Backdrop with Tented Encampment, 1862–65. Albumen silver print (carte de visite)

154 N. A. & R. A. Moore, Union Soldier, Standing before Painted Backdrop with Tented Encampment, 1862–65. Albumen silver print (carte de visite) with applied color

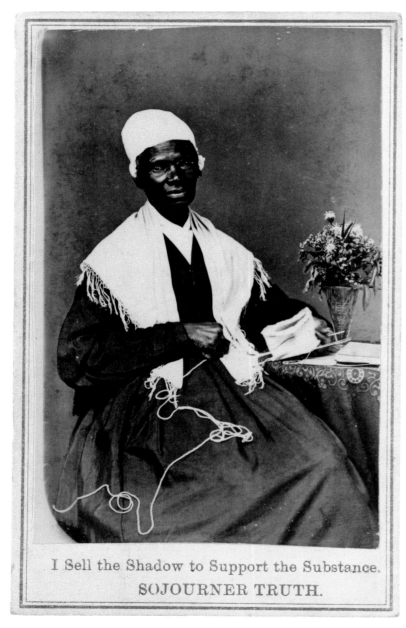

155 Unknown artist, *Sojourner Truth, "I Sell the Shadow to Support the Substance,"* 1864. Albumen silver print (carte de visite)

Born Isabella Baumfree to a family of slaves in Ulster County, New York, Sojourner Truth (ca. 1797–1883) sits for one of the war's most iconic portraits in an anonymous photographer's studio, likely in Detroit (pl. 155). The sixty-seven-year-old abolitionist who never learned to read or write pauses from her knitting and looks pensively at the camera. She was not only an antislavery activist and colleague of Frederick Douglass, but also a memoirist and a committed feminist who shows herself engaged in the dignity of women's work.[153] More than most sitters, Sojourner Truth is both the actor in the picture's drama and its author, and she used the card mount to promote and raise money for her many causes: "I Sell the Shadow to Support the Substance. SOJOURNER TRUTH." The imprint on the card's verso tells another truth. Rather than a photographer's advertisement, the carte de visite features in bright red ink the activist sitter's own statement, as well as a Michigan 1864 copyright in her name. By owning control of her image, her "shadow," Sojourner Truth could sell it. In so doing she became one of the era's most progressive advocates for slaves and freedmen after Emancipation, for women's suffrage, and for the medium of photography. At a human rights convention, Sojourner Truth commented that she "used to be sold for other people's benefit, but now she sold herself for her own."[154]

Gordon, a runaway slave seen with severe whipping scars in plate 156, is one of the many African-Americans whose lives Sojourner Truth endeavored to better. But while she controlled the circulation of her own image, Gordon did not have the same power. One of the most famous of all known photographs of slaves, the carte de visite is attributed to McPherson & Oliver, a Louisiana firm that was active in Baton Rouge and New Orleans in the early 1860s (pls. 140, 166). The photograph dates from March or April 1863 and was made in a camp of Union soldiers along the Mississippi River where Gordon took refuge after escaping his bondage in a nearby Mississippi plantation. He was under the care of Union medical officers from Massachusetts who engaged a local photographer after the escaped slave showed them his scourged back—which gave another common title for the image. The officers subsequently sent copies of the photograph to dedicated abolitionists in New England. On Saturday, July 4, 1863, this haunting image and two other portraits of Gordon appeared as wood engravings in a special Independence Day feature in *Harper's Weekly*.[155]

"A Typical Negro" tells the story of the former slave's flight to freedom and explains that he was, at the time of the article, a newly enlisted soldier in the United States Army. Of the three wood engravings—"Gordon as He Entered Our Lines," "Gordon Under Medical Inspection," and "Gordon in his Uniform as a U.S. Soldier"— only the second portrait is known to exist as a photograph.[156] Like much of Alexander Gardner's writing in his *Sketch Book*, the text in *Harper's Weekly* is entertaining but not necessarily factual, particularly as it relates to Gordon's escape from his master: "In order to foil the scent of the blood-hounds who were chasing him he took from his plantation onions, which he carried in his pockets. After crossing each creek or swamp he rubbed his body freely with these onions, and thus, no doubt, frequently threw the dogs off the scent."[157] McPherson & Oliver's portrait and Gordon's narrative were extremely popular, and photography studios throughout the North (including Mathew Brady's) duplicated and sold prints of *The Scourged Back*. Within months, the carte de visite had secured its place as an early example of the wide dissemination of ideologically abolitionist photographs. Although the image began its life in an army camp, its transmission to the public was orchestrated privately. Government-sponsored photography to educate the public about the facts of slavery would begin some months later, also in Louisiana.

In December 1863, almost a year after Lincoln's Emancipation Proclamation, an unusual group of adults and children, military personnel and civilians, left Union-occupied New Orleans for the North with the express purpose of visiting photography studios in Philadelphia, New York, and other major cities. Colonel George Hanks of the Eighteenth Infantry, Corps d'Afrique (composed of African-Americans), accompanied eight emancipated slaves from New Orleans on the publicity campaign. Major General Nathaniel Prentice Banks, commander of the Department of the Gulf, together with the American Missionary Association and the National Freedman's Relief Association, coordinated and promoted the tour.[158] The intent was to raise money to build schools and hire capable teachers to educate former slaves in Louisiana, which was still partially held by the Confederacy. Since at least 1830, it had been a violation of Louisiana law to teach a slave to read or write, and the federal government had resolved to make education for emancipated slaves a priority in the state.[159]

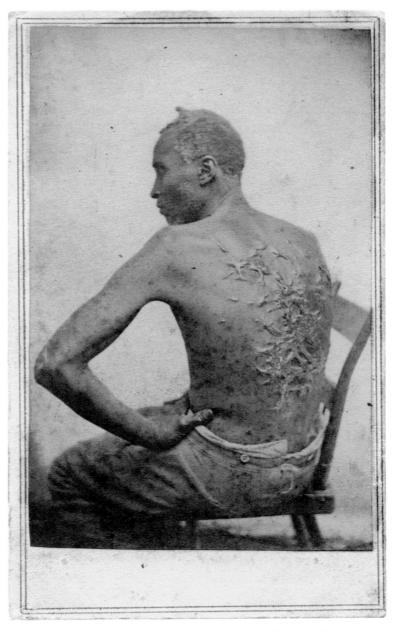

156 Attributed to McPherson & Oliver, *Gordon, a Runaway Mississippi Slave*, or "*The Scourged Back*," March–April 1863. Albumen silver print (carte de visite)

The eight former slaves sat in New York City for a single large-format group portrait (pl. 157), and numerous individual cartes de visite by Myron H. Kimball, a Broadway gallerist and later a prominent member of the Freedmen's Bureau. Another sympathetic New York photographer, Charles Paxson, produced a numbered set of more than ten cartes de visite that with the Kimball "family picture" endure as among the most heartrending portraits of African-Americans from the period (pls. 158–61).[160] All were for sale: one dollar for the large picture and twenty-five cents for each of the smaller cartes de visite. On the verso of the cards was the statement: "The nett proceeds from the sale of these Photographs will be devoted to the education of colored people in the department of the Gulf, now under the command of Maj. Gen. Banks."

Soon after the entourage returned to Louisiana, the National Freedman's Relief Association (which managed publicity for the tour) submitted the group photograph to *Harper's Weekly*. On January 30, 1864, the newspaper published a wood engraving of the image over the caption "Emancipated Slaves, White and Colored," with short biographies of the eight sitters to fan the abolitionist cause. Among them were:

AUGUSTA BROUJEY is nine years old. Her mother, who is almost white, was owned by her half-brother, named Solamon, who still retains two of her children.

WILSON CHINN is about 60 years old. He was "raised" by Isaac Howard of Woodford County, Kentucky. When 21 years old he was taken down the river and sold to Volsey B. Marmillion, a sugar planter about 45 miles above New Orleans. This man was accustomed to brand his negroes, and Wilson has on his forehead the letters "V. B. M." Of the 210 slaves on this plantation 105 left at one time and came into the Union camp. Thirty of them had been branded like cattle with a hot iron, four of them on the forehead, and the others on the breast or arm.[161]

Inspection of Wilson Chinn's forehead reveals the brand and another harsh reality. To make the marks more visible to viewers, Kimball added

a bit of unintended insult to injury: he retouched the initials on the original negative to make them appear even more visible in the albumen silver print.

A letter to the editor published in the newspaper explained that copies of the photograph were for sale at the rooms of the National Freedman's Relief Association, at No. 1 Mercer Street, New York, and that the "profits go to the support of the schools in Louisiana."[162] That only one of the five emancipated slave children appears to be African-American was not lost on the editors at *Harper's Weekly* or on the general public who might have read the paper or wandered into the National Freedman's Relief Association offices in New York. Evidently this organization, the American Missionary Association, and even the federal government realized that their supporters, albeit abolitionists, were not necessarily advocates of "Negro suffrage." The tour organizers believed that by showing Northerners photographs of "white" children who were emancipated slaves, they would stir the emotions of viewers against the cruelty of the slave system and thus appeal to the widest possible audience. The photographs then and now promote a judicious reading of the "one-drop rule" and the 1662 Virginia law of *partus sequitur ventrem*, which provided that the status (slave or free) of any child was determined solely by the condition of the mother. A child born of a slave mother was by law a slave, even if his father was white, even if his father was a free man of color. From long before the Civil War through the 1960s civil rights era, this law was used in the South to establish strict racial divisions and to buttress the Jim Crow system of segregation.

The photographs were copyrighted on behalf of the National Freedman's Relief Association, and the actual photographers took no credit for the camera work other than by their names. Paxson posed the sitters in simple constructed tableaux, often with flags; the association then sentimentalized the images with imprinted titles such as "Oh! How I Love the Old Flag" and "Our Protection" (pls. 160, 161). The most effective portraits in the series are those that hold to the essential purpose of the fund-raising effort, such as Paxson No. 6, *Learning Is Wealth*, which features the adult Wilson Chinn reading books with three children, Charley, Rebecca, and Rosa (pl. 158). Paxson No. 8, *Wilson, Branded Slave from New Orleans* (pl. 159), is among the most difficult to

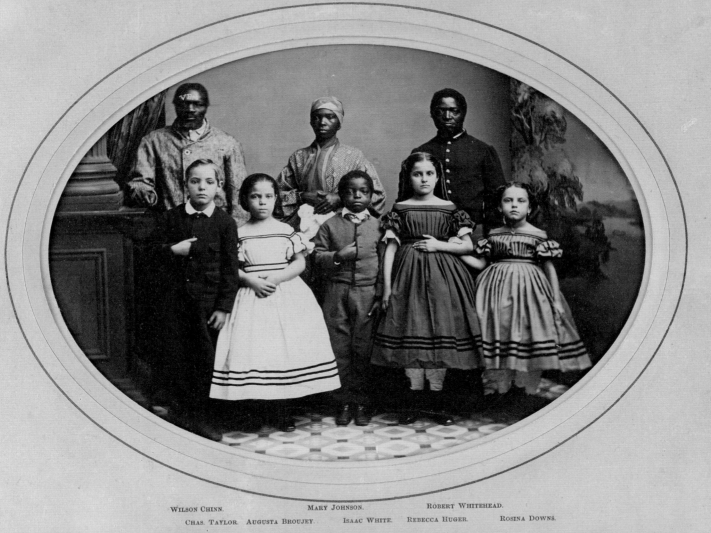

EMANCIPATED SLAVES BROUGHT FROM LOUISIANA BY COL. GEORGE H. HANKS.

The Children are from the Schools established by order of Maj. Gen. Banks.

WILSON CHINN. MARY JOHNSON. ROBERT WHITEHEAD.

CHAS. TAYLOR. AUGUSTA BROUJEY. ISAAC WHITE. REBECCA HUGER. ROSINA DOWNS.

Entered according to Act of Congress, in the year 1863, by GEO. H. HANKS, in the Clerk's Office of the United States for the Southern District of New-York.

Photographed by M. H. Kimball, 477 Broadway.

157 Myron H. Kimball, *Emancipated Slaves Brought from Louisiana by Colonel George H. Hanks*, December 1863. Albumen silver print

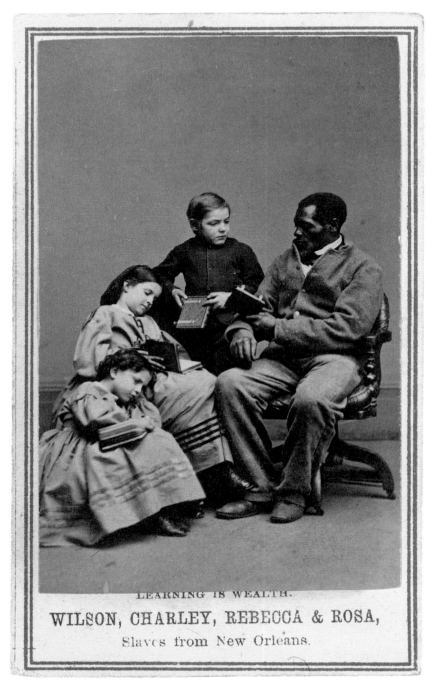

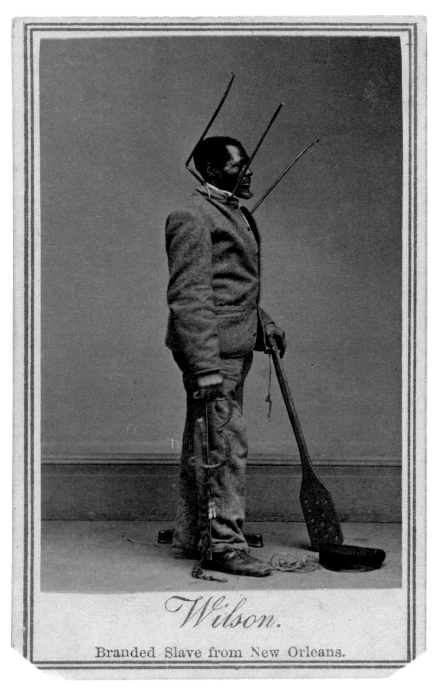

158 Charles Paxson, *Learning Is Wealth. Wilson, Charley, Rebecca & Rosa, Slaves from New Orleans*, 1863. Albumen silver print (carte de visite)

159 Charles Paxson, *Wilson. Branded Slave from New Orleans*, 1863. Albumen silver print (carte de visite)

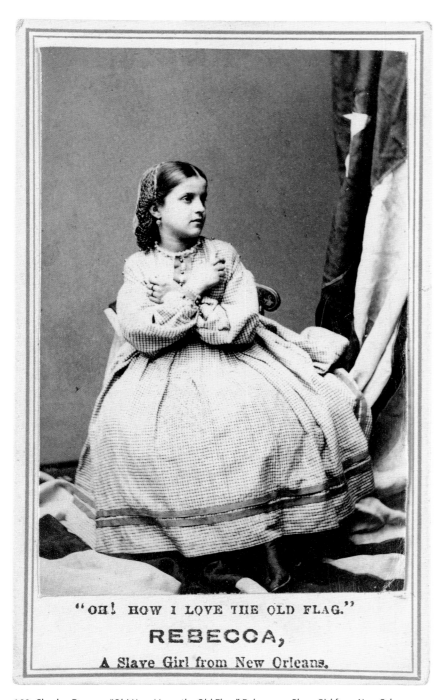

"OH! HOW I LOVE THE OLD FLAG."

REBECCA,

A Slave Girl from New Orleans.

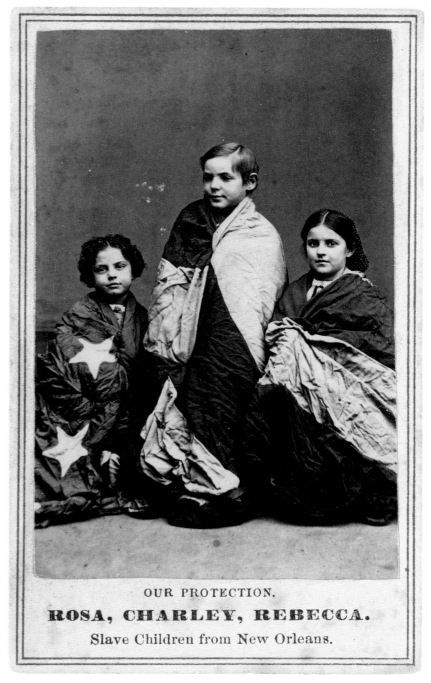

OUR PROTECTION.

ROSA, CHARLEY, REBECCA.

Slave Children from New Orleans.

160 Charles Paxson, *"Oh! How I Love the Old Flag." Rebecca, a Slave Girl from New Orleans*, 1863. Albumen silver print (carte de visite)

161 Charles Paxson, *Our Protection. Rosa, Charley, Rebecca. Slave Children from New Orleans*, 1863. Albumen silver print (carte de visite)

interpret—a study of an emancipated slave required to hold a nail-studded whipping paddle and to wear for his portrait a spiked collar and leg irons, cruel instruments of slavery that the Union army must have brought North from Louisiana. It is a bewildering instance of Civil War photographic marketing that asks as many questions about the individuals who commissioned the portraits as it does about those who would purchase or collect these images. The large quantity of surviving cartes de visite from the "Slaves from New Orleans" series suggests that several thousand were sold. It seems that the organizers had read the situation correctly and that more money could be raised to support their efforts if sympathetic Northerners could see through the window of photography the actual faces of some of the first emancipated slaves studying in Louisiana schools.[163]

After every Civil War battle, burial details combed the fields and searched the corpses looking for any form of identification with which to match a body and a name. Only a small number of soldiers wore ID badges, like dog tags, stamped with their names and companies. A few sewed their names inside their jackets or, like Confederate Private Thomas Wood, marked their hats with their initials (pl. 116). One day after the Battle of Gettysburg, a Union soldier was discovered with no form of identification other than an ambrotype of three children clutched in his hands (pl. 162).[164] This simple portrait and how it made its way via newspaper articles and photography galleries through the currents of American culture reflect yet another interesting facet of the enormous popularity of photography during the Civil War.

Part of the implausible story of the "Children of the Battle Field" carte-de-visite portrait is introduced by its verso inscription.[165]

> "THE CHILDREN OF THE BATTLE FIELD." This is a copy of the Ambrotype found in the hands of Sergeant Humiston of the 154th N.Y. Volunteers as he lay dead on the Battlefield of Gettysburg. *The proceeds of the sale of the copies are appropriated to the support and education of the Orphan Children.*

After the Battle of Gettysburg, J. Francis Bourns, a Philadelphia physician, saw in a tavern near Gettysburg the ambrotype of three children that had been found with an otherwise unidentified dead Union soldier. He acquired the photograph with the intention of locating the soldier's family, and brought the matter to the attention of *The Philadelphia Inquirer.* An article titled "Whose Father Was He?" appeared on October 19, 1863, and in it the editors attempted with some difficulty to describe the simple portrait's salient details:

> The children, two boys and a girl, are, apparently, nine, seven and five years of age, the boys being respectively the oldest and youngest of the three. . . . The eldest boy's jacket is made from the same material as his sister's dress. These are the most prominent features of the group. It is earnestly desired that all the papers in the country will draw attention to the discovery of this picture and its attendant circumstances, so that, if possible, the family of the dead hero may come into possession of it. Of what inestimable value will it be to these children, proving, as it does, that the last thoughts of their dying father was [*sic*] for them, and them only.[166]

Newspapers and magazines throughout the North republished the article, and ultimately it was seen by Philinda Humiston, a mother of three who had not heard from her husband, Amos, a soldier in the 154th New York Volunteer Infantry, since before Gettysburg. With the help of the town postmaster, Humiston wrote to Bourns, who replied in November enclosing a carte-de-visite copy of the ambrotype, which she identified positively. Despite reports to the contrary, Bourns seems never to have sent the original ambrotype to Philinda Humiston, but from charitable gifts and the proceeds of carte-de-visite sales, he raised enough money to open, in October 1866, the National Homestead at Gettysburg, a widows' and orphans' home. Humiston moved with her children to Gettysburg and lived there for three years, until she remarried and relocated to Massachusetts with her children, Frank, Frederick, and Alice, and her new husband.

FRANK, FREDERICK & ALICE.

A federal statute of 1792 that remained unchanged until 1862 prohibited African-Americans from serving in the United States military. As a result, few fought in any American armies until the Civil War, when more than 186,000 served in segregated divisions of the Union army: 7,122 officers and 178,975 enlisted men.[167] Remarkably, it was not until after World War II that the American military was desegregated. The most well-known African-American military hero before the Civil War is Crispus Attucks. A former slave, he was a civilian seaman who died of gunshot wounds to the chest on March 5, 1770, beside a small mob of fellow citizens who challenged British rule during the Boston Massacre. Born into slavery in Framingham, Massachusetts, Attucks became an icon of the antislavery movement and was often used by Frederick Douglass and others as an inspiration for African-Americans to join the Union army and fight against slavery. At the war's start, President Lincoln expressed no interest in arming free men of color, or former or runaway slaves, in the effort to defend the Union and defeat the Confederacy. African-Americans were welcome to serve the federal army in other ways, but not as combatants. The photographic record shows that African-Americans in the North and South played numerous roles in camps: as menservants to officers, as cooks, farriers, and dockworkers (pls. 163–66).

In July 1862, with General Lee gaining momentum, the War Department in Washington made an about-face in policy. Lincoln's own military strategists and Douglass persuaded the president to accept the enlistment of African-American soldiers to join the fight to free other African-Americans. And join they did, especially in the New England states, such as Massachusetts, which soon outfitted the celebrated Fifty-fourth Regiment, led by Colonel Robert Gould Shaw and memorialized later in a dramatic sculpture by Augustus Saint-Gaudens and Stanford White (1897) and, eventually, in the film *Glory* (1989). African-Americans received $10 per month of service, $3 of that in the form of clothing.[168] By the end of 1863, some 37,000 African-Americans had enlisted in the Union army, in fifty-eight segregated regiments known as the United States Colored Troops. Another 3,200 served in the Union navy on fully

162 Wenderoth, Taylor & Brown, *Frank, Frederick & Alice. "The Children of the Battle Field,"* 1863. Albumen silver print (carte de visite)

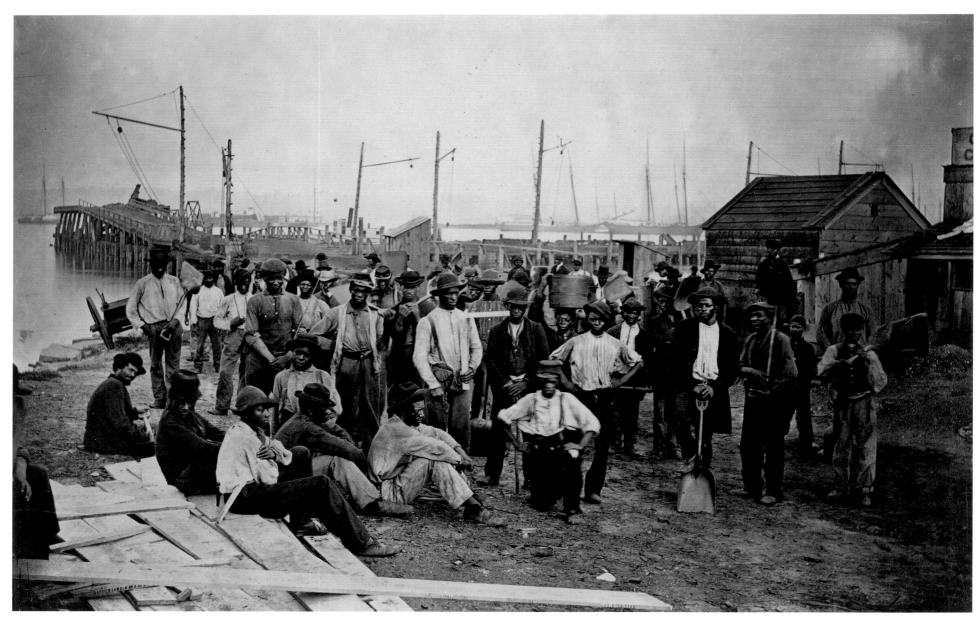

163 Attributed to Andrew Joseph Russell, Laborers at Quartermaster's Wharf, Alexandria, Virginia, 1863–65. Albumen silver print

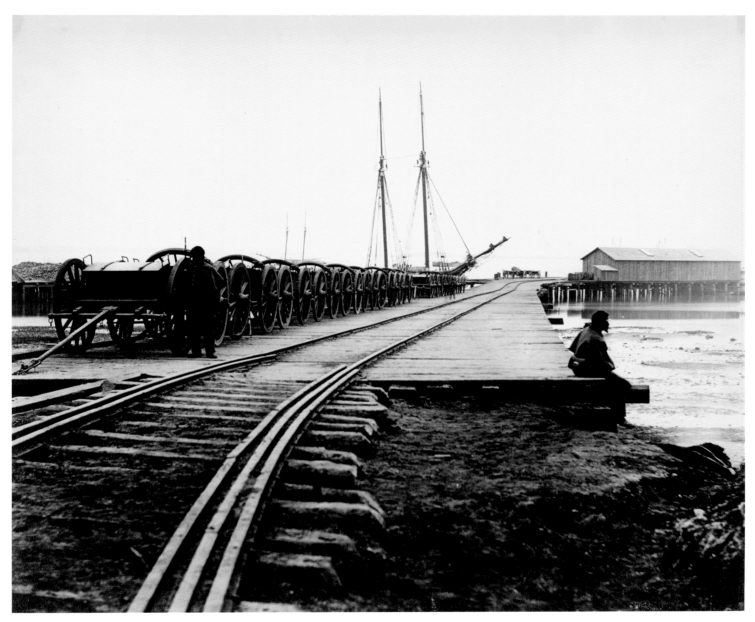

164 Thomas C. Roche, *Ordnance Wharf, City Point, Virginia*, 1865. Albumen silver print

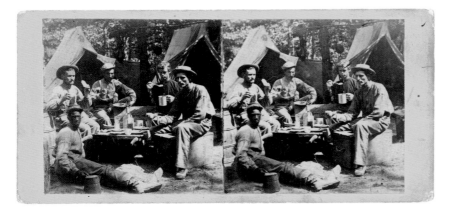

165 Thomas C. Roche, *Camp Dinner*, 1861–65. Albumen silver print (stereograph)

integrated warships. In three years of combat and supporting duties, approximately one in five of the African-Americans who fought lost their lives for the nation.

Perhaps heeding what Frederick Douglass had espoused in 1848, that "every blow of the sledge hammer, wielded by a sable arm, is a powerful blow in support of our cause," the three armed men in plates 167–69 joined the 108th United States Colored Troops in 1864 when it was organized in Louisville, Kentucky.[169] It remains unknown whether they were free men of color or emancipated slaves. The members of the 108th did not see combat and spent their time performing "garrison and guard duty in Kentucky, Illinois, and the Department of Mississippi until it was mustered out in March of 1866."[170] According to Michael McAfee, the soldiers' uniforms and weapons are "the standard 1858 . . . coat, sky blue kersey trousers, and forage cap of any enlisted soldier."[171] After the Battle of Gettysburg, the federal government constructed Rock Island Prison, a massive facility for Confederate soldiers located on a swampy island in the Mississippi River between Davenport, Iowa, and Rock Island, Illinois. These three soldiers are among the many who guarded Rock Island, often called the "Andersonville of the North," where 1,964 Confederate prisoners died.[172] Built to hold 10,000 inmates, it had no hospital; early on, the prison population suffered major outbreaks of smallpox, pneumonia, and dysentery, which affected the inmates as well as their guards.[173]

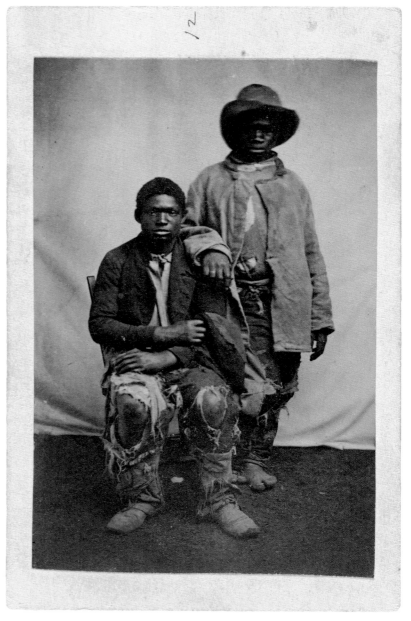

166 Attributed to McPherson & Oliver, *Our Scouts and Guides in 1863 in Baton Rouge, Louisiana*, 1863. Albumen silver print (carte de visite)

The respectful, straightforward carte-de-visite portraits by the Rock Island, Illinois, studio Gayford & Speidel are extremely rare: each is carefully inscribed on the verso with the subject's name, rank, and division. On that of Louis Troutman (pl. 169), an unknown commentator—likely his commanding officer—adds a generous note on the quality of the soldier: "Received $500—bounty—which he put into the Bank—Sharp & will soon be a non-commissioned officer." Also on the verso is an orange two-cent revenue stamp that helps date and price the photograph. To support the Northern war effort, on June 30, 1864, Congress began taxing the sale of all types of documents and goods, including patent medicines, perfumes, matches, playing cards, and photographs.[174] The costs were borne by the purchaser as follows: two cents for photographs retailed for twenty-five cents or less; three cents for photographs costing more than twenty-five and less than fifty cents; five cents for photographs retailing between fifty cents and a dollar; and another five cents for each additional dollar or fraction thereof. Between July 1, 1864, and the date of the repeal of the tax, on August 1, 1866, the federal government raised $11 million from the sale of photographs.[175]

As it is today, the camera during the Civil War was frequently drafted to document prison life, recording guards, as well as inmates during their incarceration and, at times, upon their release. Known by the Confederates as Camp Sumter, Andersonville Prison, seen here in plates 170 and 171, was the most notorious Confederate facility for captured Union soldiers and officers. Its commandant, Captain Henry Wirz, was the only Confederate to be tried and put to death for war crimes after Appomattox.[176] An open-air stockade without wooden barracks for the prisoners, with little food or potable water, and with no medical facilities, the prison was severely overcrowded from the moment it opened. The exceptional images by A. J. Riddle—some of the few surviving landscape views from during the war by a Confederate photographer—were made for unknown purposes. Copyrighted in New York and sold by the artist at the end of the war, they articulate the cruel circumstances that some 45,000 soldiers suffered through in Andersonville's fourteen months of existence. Thirteen thousand died there.

Many who survived Andersonville were marked for life. Plate 172 is a carte-de-visite portrait of an unidentified former prisoner. It would be another eighty years, at the end of World War II, before anyone would see comparable pictures of man's inhumanity to man. In April or May 1865,

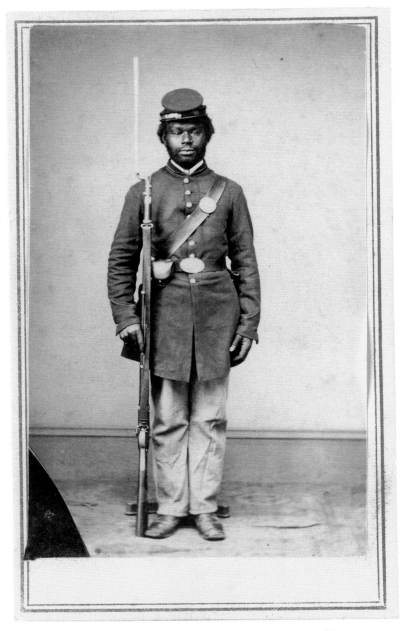

167 Gayford & Speidel, *Private Christopher Anderson, Company F, 108th Regiment, U.S. Colored Infantry*, January–May 1865. Albumen silver print (carte de visite)

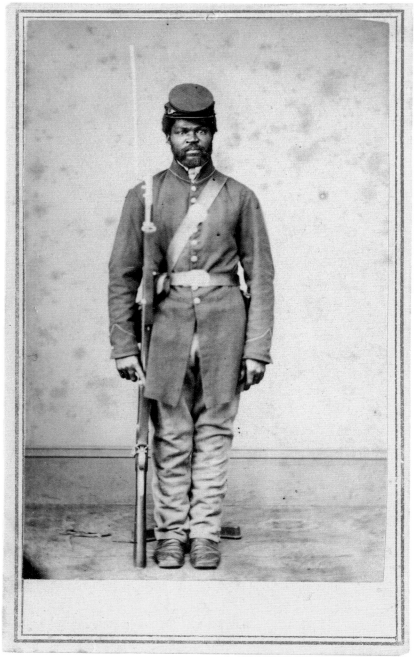

Gid. White.
Pvt. Co. F. 108. U.S.C.I.
Neat & good soldier.

GAYFORD & SPEIDEL
PHOTOGRAPHERS
ROCK ISLAND, ILLS

All Negatives preserved and duplicates can be had any time.

168 Gayford & Speidel, *Private Gid White, Company F, 108th Regiment,*
U.S. Colored Infantry, January–May 1865. Albumen silver print (carte de visite)

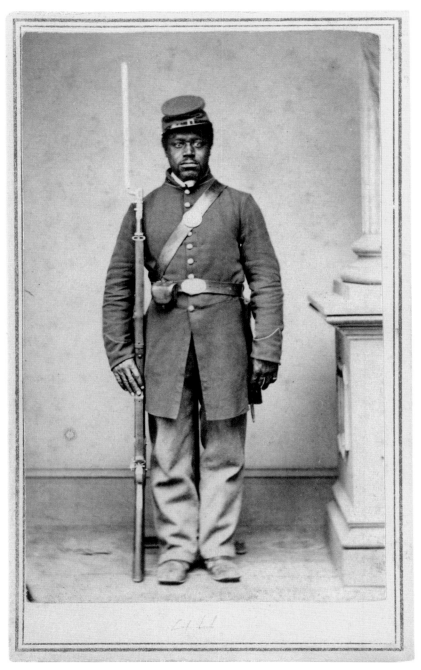

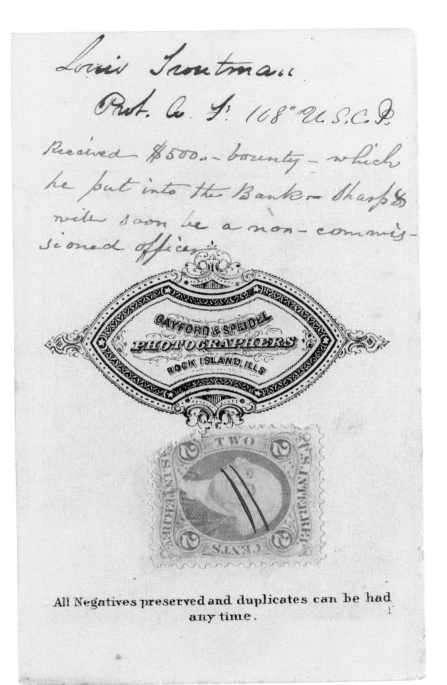

169 Gayford & Speidel, *Private Louis Troutman, Company F, 108th Regiment,*
U.S. Colored Infantry, January–May 1865. Albumen silver print (carte de visite)

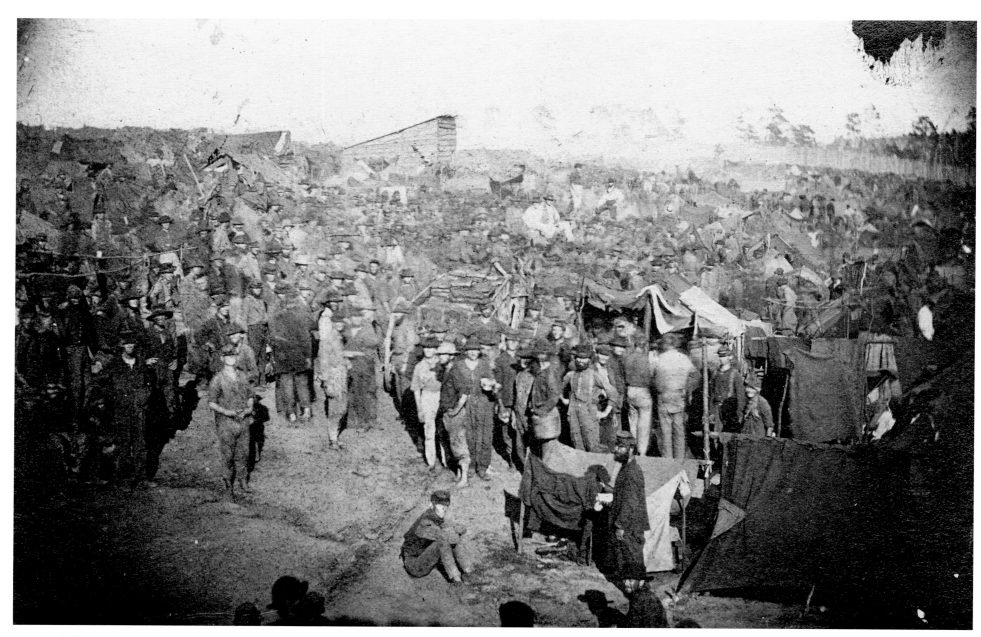

170 A. J. Riddle, *Issuing Rations to Thirty-three Thousand Prisoners. View from the Main Gate, Andersonville Prison, Georgia*, August 17, 1864. Albumen silver print

171 A. J. Riddle, *Thirty-three Thousand Prisoners in Bastile. South-west View of Stockade, Showing the Dead Line, Andersonville Prison, Georgia*, August 17, 1864. Albumen silver print

Walt Whitman saw a number of the released Union prisoners who after Appomattox had begun to make their way from the South to Washington hospitals for treatment. The writer did not hold back his emotions:

> The sight is worse than any sight of battle-fields, or any collection of wounded, even the bloodiest. There was, (as a sample,) one large boat load, of several hundreds, brought . . . to Annapolis; and out of the whole number only three individuals were able to walk from the boat. The rest were carried ashore and laid down in one place or another. Can those be *men*—those little livid brown, ash-streak'd, monkey-looking dwarfs?—are they really not mummied, dwindled corpses? They lay there, most of them, quite still, but with a horrible look in their eyes and skinny lips (often with not enough flesh on the lips to cover their teeth.) Probably no more appalling sight was ever seen on this earth. (There are deeds, crimes, that may be forgiven; but this is not among them. . . .)[177]

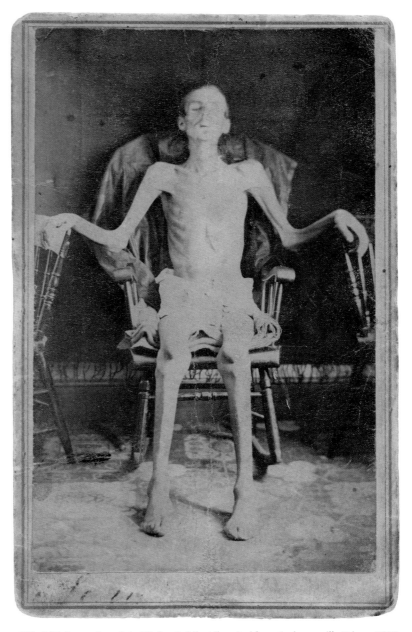

172 J. W. Jones, *Emaciated Union Soldier Liberated from Andersonville Prison*, 1865. Albumen silver print (carte de visite)

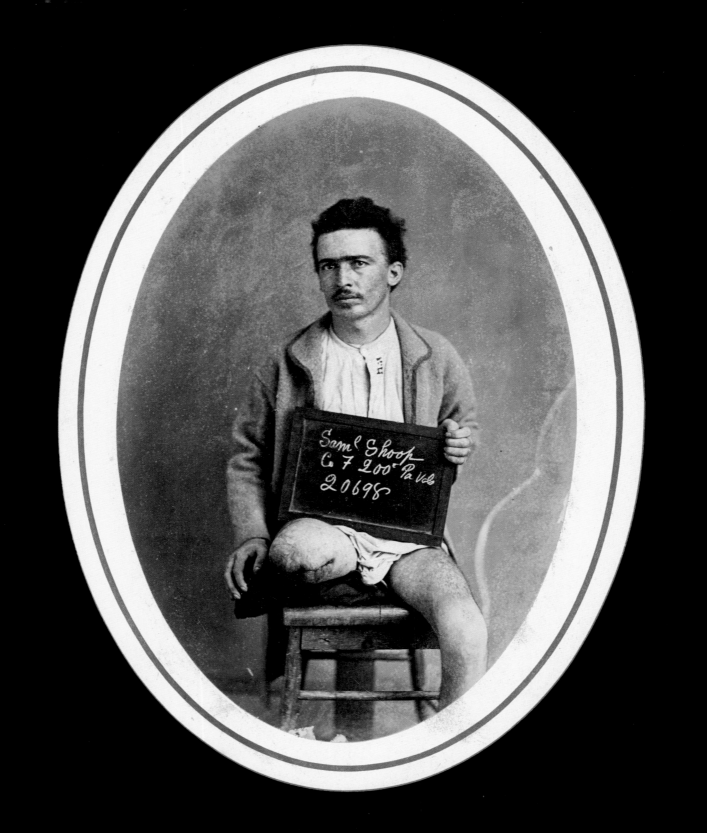

Collecting the Wounded

Social customs in the 1860s greatly restricted the number of public roles for women in American society, and the photographic record bears this out. Among the rarest Civil War occupational portraits are those of nurses, such as Anna Etheridge, who served in the Second and Third Regiments of the Michigan Volunteer Infantry (pl. 174). Known as "Michigan Annie" or "Gentle Anna," she enlisted as a nurse in 1861 and was present at Bull Run, Gettysburg, and thirty other battles.[178] Daniel G. Crotty, the color sergeant of the Third Regiment, described her as "the heroine and daughter of our regiment. . . . She is along with us through storm and sunshine, in the heat of the battle caring for the wounded, and in the camp looking after the poor sick soldier."[179] Beloved by all who saw her on the battlefield retrieving the wounded even while under enemy fire, Etheridge poses for her portrait wearing her "work clothes" and a feathered hat. Pinned to her blouse is the Kearny Medal, a Union combat decoration awarded to soldiers for "overwhelming bravery," which she received on May 27, 1863. Unfortunately, it took Congress until 1887 to recognize her meritorious service and award her a standard veteran's pension. Etheridge lived until 1913 and is buried in Arlington National Cemetery.

"Gentle Anna" was, however, an exception; few women gained access to the battlefield or frontline hospitals, for fear that they could not abide the sight of blood and diseased flesh. But behind the front lines, many women devoted themselves to humanitarian or charity work with wounded soldiers, widows, and orphaned children. They also converted their homes into small "factories" filled with like-minded needleworkers who dedicated themselves to producing quilts, blankets, and socks for their local regiments. Outside the home—often at a distance from their own families—many women in the North worked in armories, ammunition factories where they occupied the majority of the jobs rolling and filling paper cartridges with gunpowder for pistols, revolvers, rifles, and muskets.

Working out of the nation's capital, Clara Barton, a former Massachusetts schoolteacher and former United States Patent Office clerk and later first president of the American Red Cross, organized in 1861 the first team of women dedicated to the efficient distribution of medical supplies, food, and humanitarian care to wounded soldiers.[180] At the close of the war, she organized the first bureau of records to aid families in the search for missing men. Barton directed the Office of Correspondence with Friends of the Missing Men of the United States Army, or Office of Missing Soldiers, and provided answers to families searching for lost sons and fathers. In four years she and her team of volunteers answered 63,000 letters and identified more than 22,000 missing men.[181]

In connection with this work, Barton marked the graves of more than 12,000 soldiers in the National Cemetery at Andersonville, Georgia.

173 Reed Brockway Bontecou, *Private Samuel Shoop, Company F, 200th Pennsylvania Infantry*, April–May 1865. Albumen silver print

174 Unknown artist, *Anna Etheridge*, 1863–65. Albumen silver print (carte de visite)

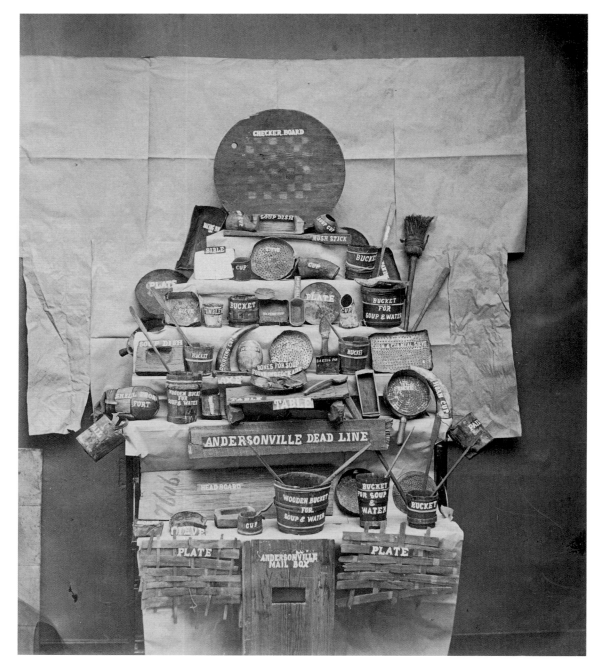

175 Brady & Company, *Relics of Andersonville Prison*, June 1866. Albumen silver print

176 Unknown artist, Patriotic Young Woman Holding Flag, 1861–65. Albumen silver print (carte de visite)

To support her effort for proper burial of the Andersonville dead and to raise money for veteran relief in general, she displayed and sold Andersonville souvenirs at events like the June 1866 fair for the benefit of the National Home for Soldiers' and Sailors' Orphans, held in Washington. As early as 1866, the year plate 175 was copyrighted by Brady, Barton saw that veterans were already collecting relics of the war, including photographs. Identified by descriptive labels and placed on a crudely built stepped display, the artifacts in the photograph are a heinous spectacle, a brutal tableau composed for the camera, intended to elicit alms from survivors. The largest item for sale was a portion of the grim "Dead Line," a wooden fence that Andersonville prisoners were prohibited from crossing, on pain of death.

As the Civil War costume historian Juanita Leisch has written, women contributed to the war effort in important ways, "mainly through . . . logistics like food, shelter and clothing for soldiers and through social, spiritual, medical, monetary, and moral support of the war. These efforts and the difference they made in the war [were] acknowledged at the time, if [they have] sometimes been overlooked since."[182] Right after Secession, in the euphoria of the moment, women in the South added buttons to their garments and bright cockades in red and white to show their support for the Confederacy. In the North,

women wore similar patriotic adornments, often incorporating stars and stripes and the colors of the national flag (pl. 176). Many women joined philanthropic organizations such as the United States Sanitary Commission and the United States Christian Commission. And they were the leading force behind such fund-raising efforts as the popular sanitary fairs that were held in cities from Chicago to Boston.

Organized in June 1861 and conceived and managed primarily by women volunteers, the privately funded United States Sanitary Commission was modeled on civilian activity during the Crimean War. It helped soldiers with back pay and other logistical needs related to their convalescence, but mostly it raised money and distributed supplies to battlefield and camp hospitals (fig. 36), through voluntary donations and the hosting of sanitary fairs. If this view of the field operations seems appropriately modest, the commission's fund-raising fairs were just the opposite: they were extravagant showcases for industrial machines, fine art, militariana, and even live tableaux. The first such fair took place in Chicago in October 1863. The strategy was to move the burden of philanthropy for the cause from the nation's elite to the

Fig. 36 Unknown artist, Sanitary Commission Office, Convalescent Camp, Alexandria, Virginia, ca. 1863. Albumen silver print. The Metropolitan Museum of Art, Harris Brisbane Dick Fund, 1933 (33.65.121)

Fig. 37 Unknown artist, *The Department of Arms and Trophies at the Great Metropolitan Sanitary Fair*, April 1864. Albumen silver print (stereograph). Private collection

general public. Individuals donated homemade clothing and preserves, and manufacturers demonstrated new machinery. Even President Lincoln made a contribution. He gave the commission a draft of the Emancipation Proclamation that was auctioned for $3,000. The buyer later donated the manuscript to the Chicago Soldiers' Home.[183] Some five thousand people a day paid seventy-five cents each to see the fair, and the commission raised the remarkable sum of $100,000 during the two-week run of the show. Soon other large cities including New York planned their own sanitary fairs.

The April 1864 New York Metropolitan Fair in support of the Sanitary Commission was even more popular, raising at least $178,000, and featuring among dozens of other displays two extremely popular exhibitions: the Department of Arms and Trophies, and the Picture Gallery. In the former (fig. 37), visitors beheld an extensive presentation of recently captured Confederate weapons and battle flags intermixed with suits of armor and trophies from the Mexican-American War. The

claustrophobic arrangement and visual intensity are captured in one of the many stereo views of the fair sold by Anthony and possibly made by the Brady studio in New York. The Picture Gallery was less chaotic but equally dynamic. It featured loans of paintings and sculptures from the city's finest collections, as well as works commissioned from Albert Bierstadt, Asher B. Durand, and John F. Kensett, among the most important artists of the era. The centerpiece of the gallery was *Washington Crossing the Delaware*, the massive twenty-one-foot-wide 1851 oil by Emanuel Leutze, in an impressive military-inspired gilded frame, made especially for the exhibition, with crossed cannons and a war eagle perched on a nest of pikes, guns, and other weapons.[184]

In what must have been a first, the organizers of the art committee invited the still-emerging field of photography to appear alongside the traditional arts, and even gave two positions on the organizing committee to leaders of the city's photography community, an artist and a merchant. Joining Kensett, who served as chairman, and the painters Eastman Johnson, Bierstadt, and Leutze, were Mathew Brady and Edward Anthony. It is thus surprising to learn that one of Brady's main competitors in New York City, Jeremiah Gurney (1812–1895), opened a portrait studio inside the fair and was making photographs and selling them to the thousands of visitors who paid a dollar to participate in this great cultural event.[185] On April 9, *The New York Times* reported at length on Gurney's business and charitable activity:

Messrs. GURNEY & SON have fitted up a very neat and comfortable gallery in the building, and are prepared to take the pictures of all who wish them at $5 per dozen, the

Gurney & Son Photo N.Y.

proceeds to be given to the fund of the Fair. The Messrs. GURNEY have taken great trouble in this matter, have built a light which is equal to, if not superior to the one they have at their regular gallery, and can take pictures at the fair which are not to be excelled in the City. . . . They have also taken pictures of several of the stands in the fair, among which are the fire department stand, the New-Jersey stand, several views from the department of arms and trophies and the art gallery. These pictures are all on exhibition at their gallery at the fair, and duplicates of them are for sale. To the ladies in particular the novelty of having a picture taken at the fair is very attractive, and they in consequence fill the gallery during the entire day. All the visitors from out of town who wish a remembrance of the fair, will also have their pictures taken, and this feature will, doubtless, be one of the best paying of the fair.[186]

Some visitors chose to support the patriotic cause in an even more direct way by purchasing from Gurney carte-de-visite portraits of wounded soldiers who posed during the fair as part of a living tableau. The three Union soldiers in plate 177 were survivor-representatives of "the blank horror and reality of war, in opposition to its pageantry," as Gardner observed of the corpses in O'Sullivan's photograph *A Harvest of Death*.[187] In the center of Gurney's composition sits William McNulty, who lost his right arm serving in the Tenth New York Infantry, also known as the National Guard Zouaves. On his left stands Sergeant Thomas Plunkett of Company E of the Twenty-first Massachusetts Volunteer Infantry; he lost both arms while carrying the flag of his regiment on December 13, 1862, at Fredericksburg, Virginia. The blind man, William R. Mudge, Second Massachusetts Infantry, was shot through the head and lost both eyes at the Battle of Chancellorsville, Virginia, on May 3, 1863. In Lynn, Massachusetts, before the war, he had been a photographer.[188]

177 J. Gurney & Son, Disabled Union Soldiers Posed in Aid of the U.S. Sanitary Commission at the New York Metropolitan Fair, April 1864. Albumen silver print (carte de visite)

On December 13, 1862, Captain George Washington Whitman, of Company K of the Fifty-first New York Volunteers, was wounded in the face by a fragmented shell at the Battle of Fredericksburg. Concerned for his younger brother's well-being, Walt Whitman, known for his unconventional volume of poems, *Leaves of Grass*, left New York to search for him in one of the capital's hospitals. After days of looking, he found George convalescing in an army camp near Fredericksburg and immediately wrote home to reassure his family. Near the end of a long letter, Whitman recalled for his mother, Louise, an experience that would change the course of his life:

> Dear, Dear Mother . . . I succeeded in reaching the camp of the 51st New York, and found George alive and well. . . . I have lived for eight or nine days amid such scenes as the camps furnish. . . . One of the first things that met my eyes in camp was a heap of feet, arms, legs, etc., under a tree in front of a hospital, the Lacy house.[189]

Witnessing the dedicated and at times miraculous work of the surgeons in the Lacy House, and possibly seeing Clara Barton attending to the suffering Union soldiers, seems to have moved Whitman to spend most of the next three years visiting the wounded and dying in Washington hospitals—"this great army of the sick," he wrote.[190] It also encouraged him to keep "note-books for impromptu jottings in pencil to refresh my memory of names and circumstances, and what was specially wanted, &c. In these I brief'd cases, persons, sights, occurrences in camp, by the bedside, and not seldom by the corpses of the dead."[191] Whitman was a poet, not a nurse, but he comforted the wounded and sick soldiers in the way he knew best: he read to them from books and newspapers; he wrote letters home to their families; and he performed myriad other acts of kindness that included sourcing hard candy, or brandy, for those who needed it most.

Whitman's complex reflections on what he observed in the hospitals, later published as *Memoranda During the War* (1875–76),

help frame an understanding of perhaps the most extraordinary of all late Civil War photography on paper: Dr. Reed Brockway Bontecou's medical portraits and patient histories of the wounded and sick from the war's last battles. *A Morning's Work* (pl. 178) is a carte de visite by a surgeon-photographer that rivals for pathos O'Sullivan's *A Harvest of Death*. It does a bit more as well. It confirms that Whitman did not exaggerate but accurately recorded in his field notes what he had seen at the makeshift hospital near Fredericksburg: piles of limbs cut off soldiers to save their lives. The photograph is one of more than 570 cartes de visite found in a unique medical teaching album assembled between 1864 and 1865 by Dr. Bontecou from fourteen months of photographing his patients at Harewood U.S. Army General Hospital in Washington, D.C. (pls. 178–84).[192] By any terms, the portraits in the album are visually devastating—shocking for their humanity, and their aesthetics (pl. 180), through which these seemingly straightforward documents of wounded soldiers become "eloquent works of art that offer unflinching testimony to the suffering caused by America's bloodiest war."[193] Whitman wrote that war was not "a quadrille in a ball-room. Its interior history will not only never be written—its practicality, minutiæ of deeds and passions, will never be even suggested."[194] Bontecou offers a glimpse of what the bard thought was not possible.

178 Reed Brockway Bontecou, *A Morning's Work*, 1865. Albumen silver print (carte de visite)

An army physician, Reed Brockway Bontecou was mustered into service on May 14, 1861, in the Second New York Infantry in Troy, New York. He was thirty-seven years old and since 1849 had been a commissioned surgeon in the New York State Militia. By September 1861, he had been promoted to brigade surgeon of United States Volunteers and director of Hygeia General Hospital at Fortress Monroe, Virginia. He was soon sent to the Department of the South and placed in charge of U.S. Army Hospital No. 1 in Beaufort, South Carolina. By May 1863 he was in charge of the hospital ship *Cosmopolitan*, and in October he accepted the appointment, from which he retired in June 1866, as head of Harewood General in Washington.[195] It was here that he made his mark on the history of photography and medicine.

In May 1864, Bontecou started to photograph his patients with a carte-de-visite-format camera when they arrived from the field, before and after their surgeries, and upon recovery or the opposite. He also meticulously recorded complete patient histories of all the soldiers he photographed. As the medical historian Dr. Stanley B. Burns writes, "Bontecou introduced the application of photography for clinical purposes . . . the concept of photographing soldiers' wounds and the post-operative healed state. The images became a major educational device to help surgeons learn routine procedures and the expected results."[196]

There is no precedent for these intense portraits of a patient's and a doctor's shared inner sanctum. A photograph such as that of Private John Parmenter, unconscious from anesthesia, on an operating table with his severed foot (pl. 179), astounds us today after a century and a half of subsequent medical photography because it seems to transmit the physical and emotional connection between an ailing patient barely holding on to life and a benevolent doctor who may just have the tools to return it to him. Because of our modern doctor-patient confidentiality laws, it is unlikely that the general public will ever again see such an intimate and honest expression— the rich psychic atmosphere—of professional medical care.

Whitman scrawled a solemn note in his diary on June 25, 1863: "As I sit writing this paragraph I see a train of about thirty huge four-horse wagons, used as ambulances, fill'd with wounded, passing up Fourteenth street, on their way, probably to Columbian, Carver, and Mount Pleasant Hospitals. This is the way the men come in now, seldom in small numbers, but almost always in these long, sad processions."[197] Elsewhere Whitman commented that after large battles it was not uncommon for Washington hospitals to receive for treatment

180 Reed Brockway Bontecou, *Amputated Leg of Private George S. Shelton, Company J, Thirty-sixth Wisconsin Volunteers*, 1864–65. Albumen silver print (carte de visite)

179 Reed Brockway Bontecou, *Union Private John Parmenter, Company G, Sixty-seventh Pennsylvania Volunteers*, June 21, 1865. Albumen silver print (carte de visite)

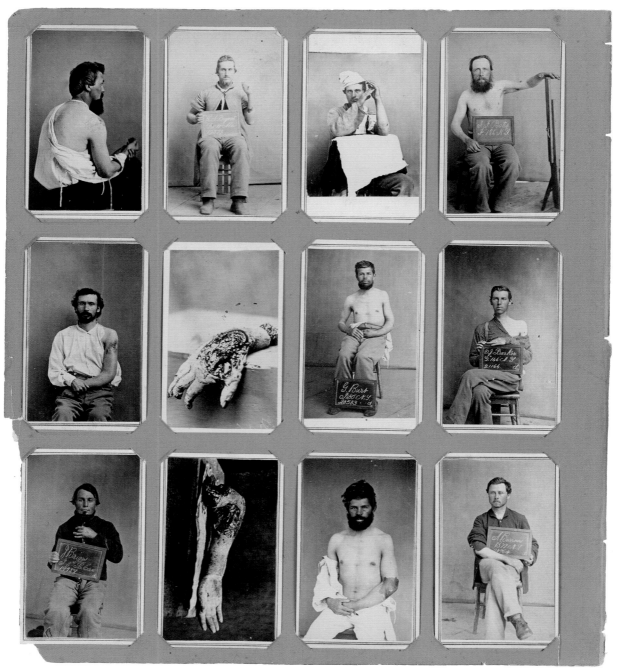

181 Reed Brockway Bontecou, Page from Dr. Bontecou's Private Teaching Album of Wounded Civil War Soldiers, 1864–65. Albumen silver prints (cartes de visite)

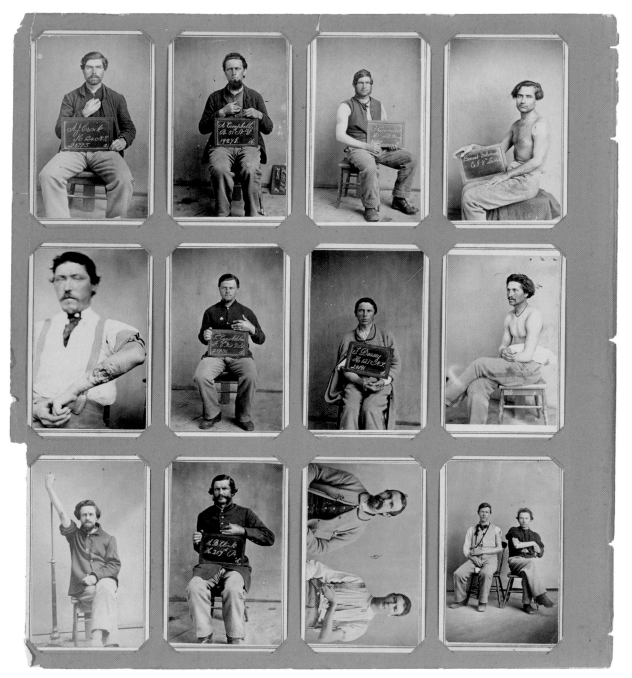

182 Reed Brockway Bontecou, Page from Dr. Bontecou's Private Teaching Album of Wounded Civil War Soldiers, 1864–65. Albumen silver prints (cartes de visite)

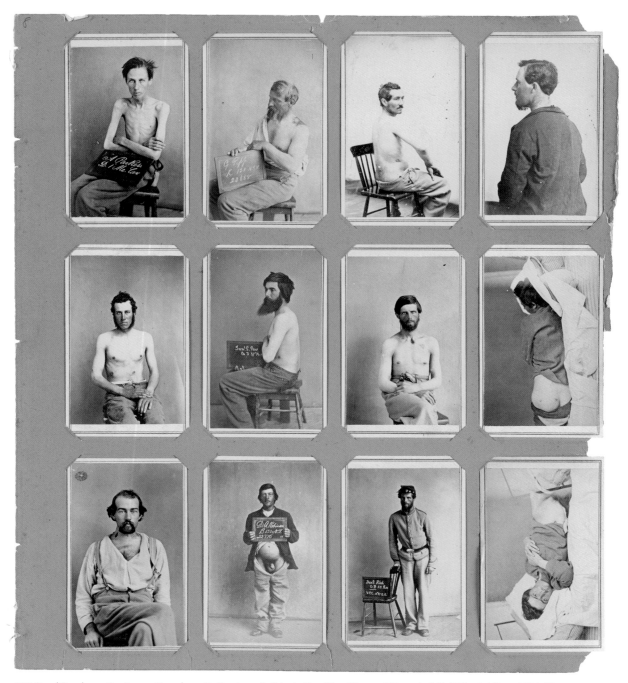

183 Reed Brockway Bontecou, Page from Dr. Bontecou's Private Teaching Album of Wounded Civil War Soldiers, 1864–65. Albumen silver prints (cartes de visite)

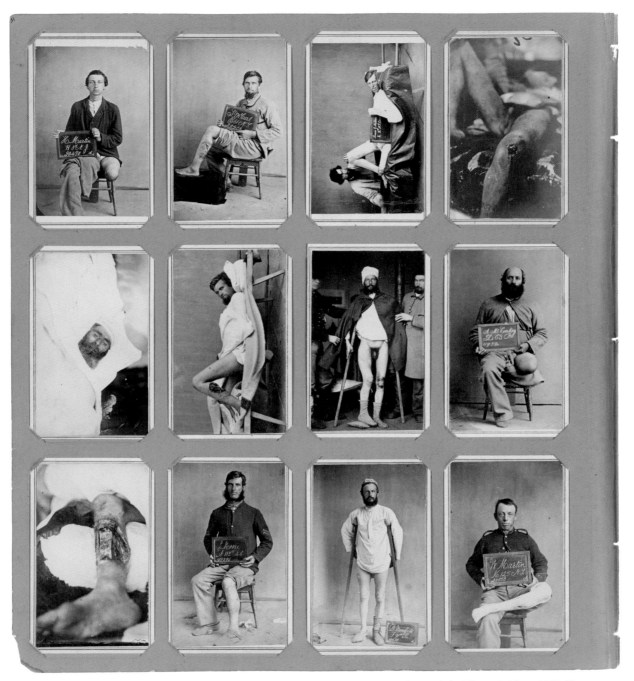

184 Reed Brockway Bontecou, Page from Dr. Bontecou's Private Teaching Album of Wounded Civil War Soldiers, 1864–65.
Albumen silver prints (cartes de visite)

Fig. 38 Thomas C. Roche, Depot Field Hospital, City Point, Virginia, 1865. Albumen silver print. The Metropolitan Museum of Art, Gilman Collection, Purchase, The Horace W. Goldsmith Foundation Gift, through Joyce and Robert Menschel, 2005 (2005.100.95)

a thousand wounded soldiers per day. Figure 38 is a view of a seemingly endless row of large tents at Depot Field Hospital by Thomas C. Roche (1826–1895), a photographer commissioned by Anthony to supply pictures to General Montgomery Meigs, quartermaster general of the Union army. Located at City Point, Virginia, the hospital opened on June 17, 1864. It was set up in seventy-two hours, and received on its first day of operation 3,700 patients from the war front. Within one month it had treated more than 15,000 wounded soldiers, often 5,000 at a time.

When the Civil War began, there were few facilities anywhere in the nation to treat wounded soldiers (pls. 185–87). Both North and South were unprepared to handle what was to come.[198] At the end of 1860, the United States Army Medical Department had only thirty-one surgeons and eighty-four assistant surgeons, twenty-seven of whom resigned to join the Confederacy in 1861. By war's end the Union had

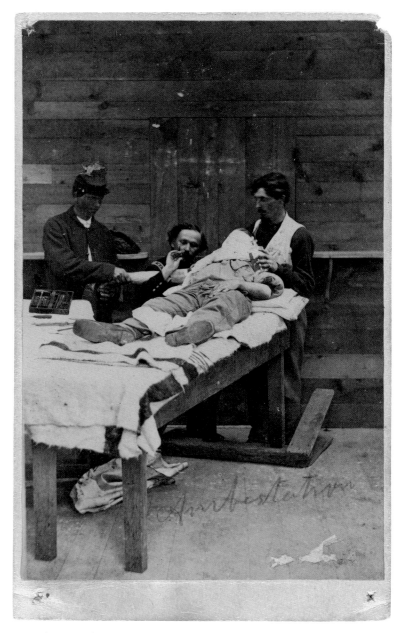

185 Unknown artist, Amputation at Field Hospital, 1861–65. Albumen silver print (carte de visite)

nearly 10,000 working surgeons and assistants. Both the Union and the Confederacy saw the need for large hospitals. Jefferson Davis began construction on five general hospitals near Richmond in 1861; the largest of these, Chimborazo, reportedly treated some 76,000 patients during the war. In the North, construction did not begin until 1862, but in two years President Lincoln had 187 general hospitals built, holding 118,000 beds. These facilities were spread from New Orleans to rural New England and included important hospitals in Virginia, Connecticut, and Rhode Island. The majority were in the District of Columbia, where, Whitman reported, there were within sight of the Capitol "some fifty or sixty such collections or camps, at times holding from fifty to seventy thousand men."¹⁹⁹

The last great battle of the Civil War was the siege of Petersburg, Virginia, a brutal campaign that led to General Lee's surrender on

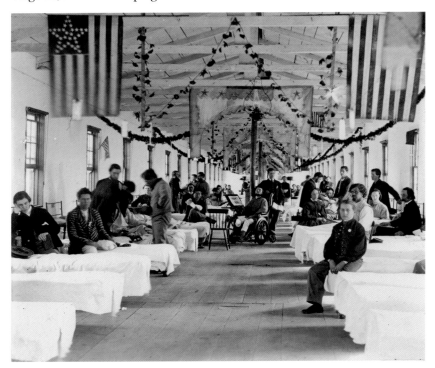

186 Attributed to Reed Brockway Bontecou, Wounded Soldiers on Cots, Possibly at Harewood Hospital, 1865. Albumen silver print (carte de visite)

187 Unknown artist, *Armory Square Hospital, Washington*, 1863–65. Albumen silver print

April 9, 1865. On March 25, Samuel Shoop, a twenty-five-year-old private in Company F of the 200th Pennsylvania Volunteers, received a vicious gunshot wound in the thigh at Fort Stedman, Virginia. He was evacuated to Harewood Hospital, where Dr. Bontecou amputated his leg and then made the photograph seen in plate 173. Under his army jacket, Shoop wears a gown stitched with "H.H.," the initials of the hospital; like most of the surgeon's patients, he holds an identification chalkboard inscribed with his name and company, regiment, and case number, which Bontecou effectively incorporated into his portraits as the best way to keep track of his patients and their photographs. In today's terms, he included the metadata in the image.

Like Samuel Shoop, Private John Parkhurst, from Company E of the Second New York Heavy Artillery, was wounded in the final month of the war, taking a gunshot wound to the head on April 7 at Farmville, Virginia (pl. 189). Bontecou's printed note affixed to the verso of this card-mounted albumen silver print reveals that Parkhurst was fifty years old and that after treatment at Harewood his health progressed favorably. "Doing well," Bontecou observed. The photograph is an excellent example

of how at times the surgeon used enlargements to bring attention to a specific wound and its treatment. In this case, studying his patient from above, he also created a sublime document of medical recovery and human introspection.

Bontecou's portraits of Samuel Shoop and John Parkhurst are not carte-de-visite-format prints, but 5½ × 7½-inch enlargements of the originals. For teaching purposes, the surgeon mounted his photographs of the two soldiers, and hundreds of other enlarged images of patients, on heavy card stock with a gilded oval rule that was designed and sold by standard photography wholesalers for formal portraits (pls. 173, 188–94). The photographs come from another of Bontecou's personal teaching albums that he created for larger public presentations of surgical technique, for which the smaller portraits would have been less effective. To show diagrammatically the paths that bullets took through the soldiers' bodies, Bontecou marked a few of the enlarged prints with red-ink arrows (pl. 190). The dramatic effect of these notations well served the purposes of the doctor as a teacher and graphic artist.

Not all of Bontecou's patients were Union soldiers, nor did they all survive their wounds or his best surgical treatments to relieve them from pain. Twenty-one-year-old Confederate Private Dennis Sullivan, from Company E, Second Virginia Cavalry, died at Harewood Hospital on April 27, 1865 (pl. 188). Bontecou tells his story effectively in the patient history mounted on the verso of the print.

Bontecou produced several thousand negatives of his patients and contributed prints of many of them to the Army Medical Museum, which was founded in Washington in 1862 to "improve the care of the wounded soldier, to teach physicians proper effective therapies, to study wounds, and to publish."[200] In 1863 the museum began to collect photographs that after the war would be put to use as source illustrations for the photomechanical reproductions in *The Medical and Surgical History of the War of the Rebellion*, a six-volume scientific masterpiece released between 1870 and 1888. Considered the greatest medical legacy of the Civil War, the publication analyzes each recorded casualty, the treatment

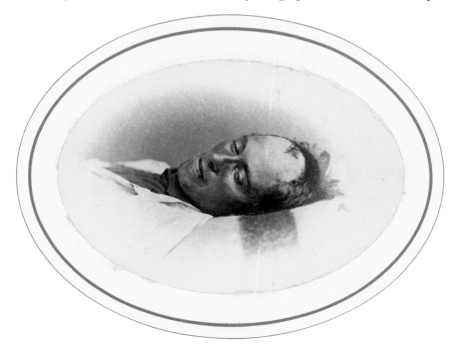

188 Reed Brockway Bontecou, *Private Dennis Sullivan, Company E, Second Virginia Cavalry*, April 1865. Albumen silver print

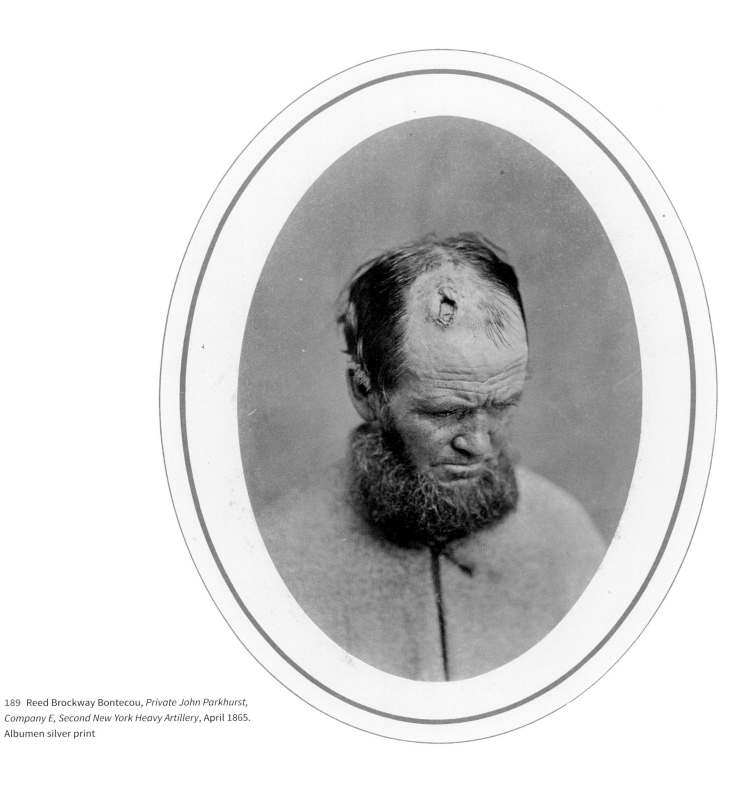

189 Reed Brockway Bontecou, *Private John Parkhurst,
Company E, Second New York Heavy Artillery*, April 1865.
Albumen silver print

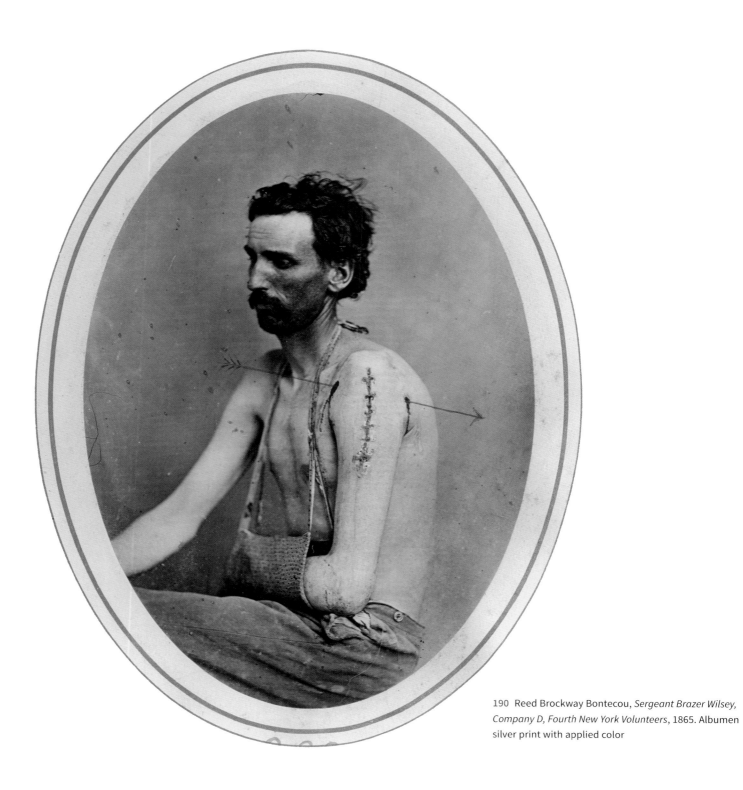

190　Reed Brockway Bontecou, *Sergeant Brazer Wilsey,
Company D, Fourth New York Volunteers*, 1865. Albumen
silver print with applied color

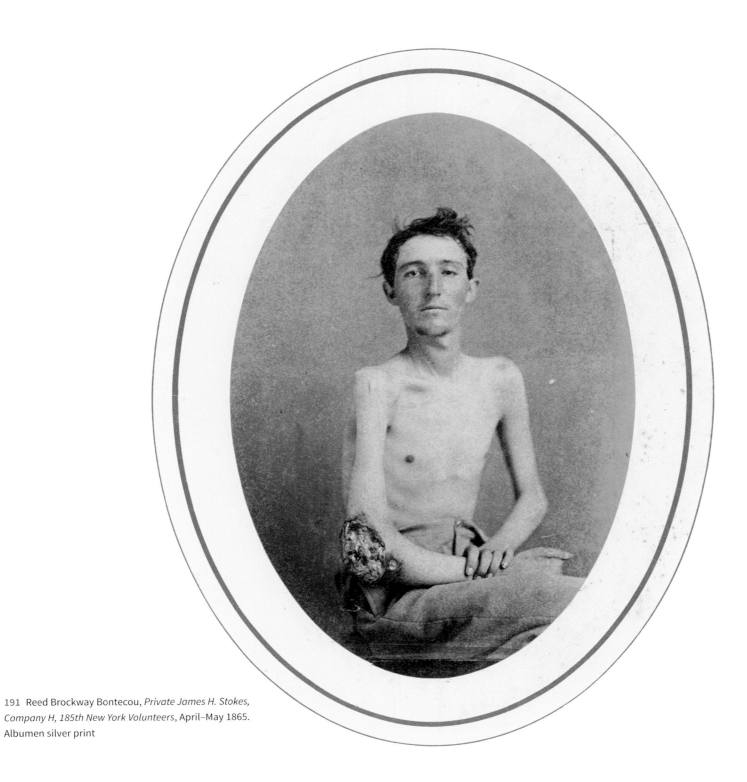

191 Reed Brockway Bontecou, *Private James H. Stokes,*
Company H, 185th New York Volunteers, April–May 1865.
Albumen silver print

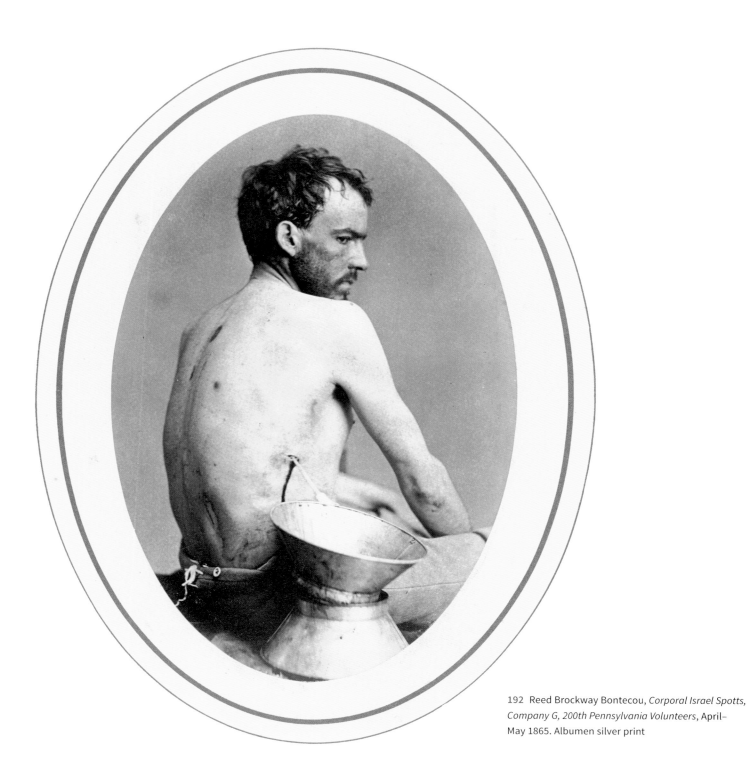

192 Reed Brockway Bontecou, *Corporal Israel Spotts, Company G, 200th Pennsylvania Volunteers*, April–May 1865. Albumen silver print

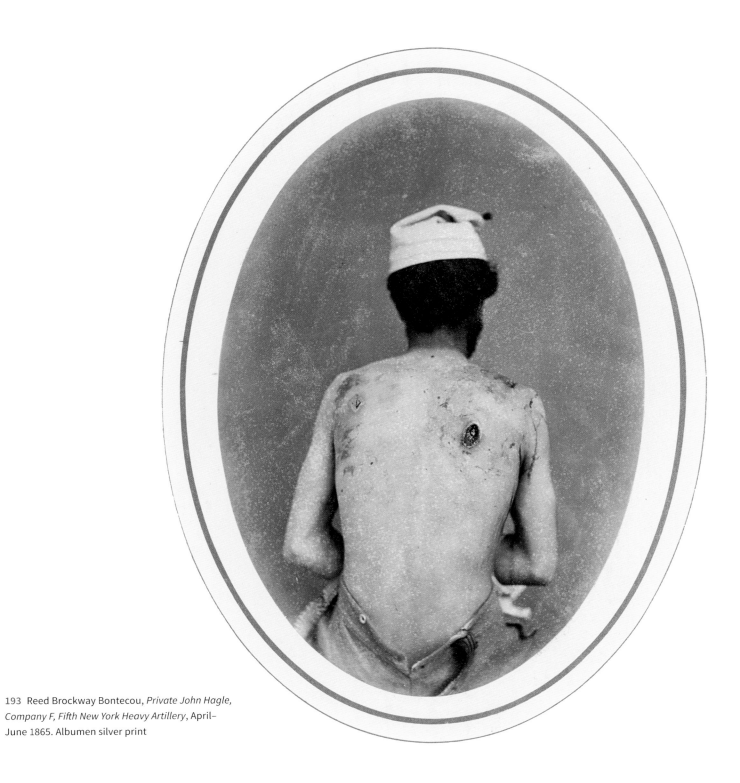

193 Reed Brockway Bontecou, *Private John Hagle,*
Company F, Fifth New York Heavy Artillery, April–
June 1865. Albumen silver print

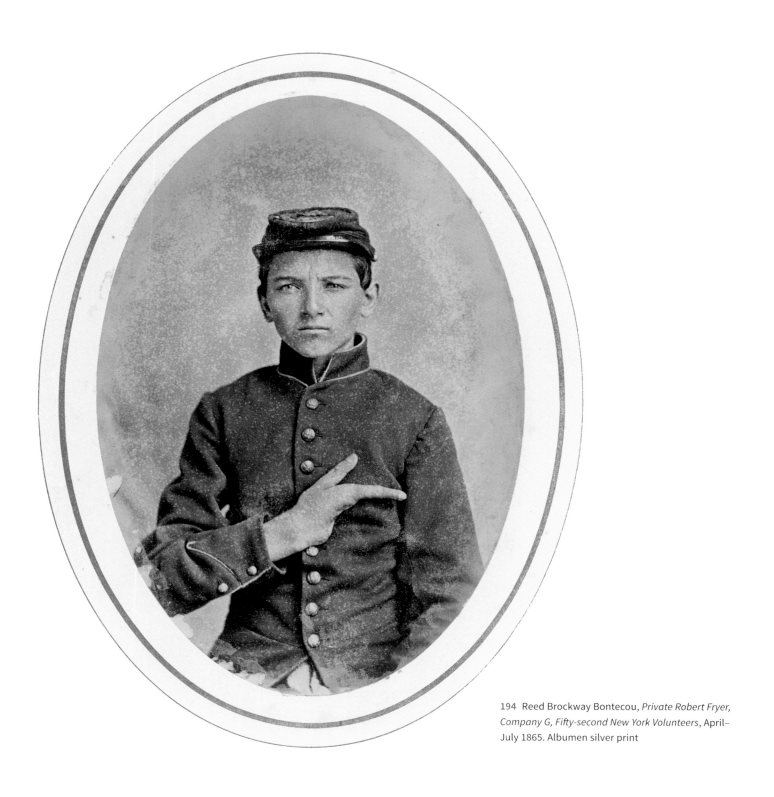

194 Reed Brockway Bontecou, *Private Robert Fryer, Company G, Fifty-second New York Volunteers*, April–July 1865. Albumen silver print

195 William Bell, *Excised Knee Joint. A Round Musket Ball in the Inner Condyle of the Right Femur*, 1866–67. Albumen silver print

the soldier received, and the results of the medical intervention. Bontecou was not the only contributor of photographs to the Army Medical Museum and *The Medical and Surgical History* (plate 195 shows the work of another), but he did supply the most. He was suitably proud of his introduction of photography to the care, understanding, and treatment of patients, and in his later years he observed: "The index of the Surgical History of the War gives me credit as its largest contributor and I was the first to apply Photography to the Military history of the soldier while I was in charge of Harewood, U.S.A. Gen'l Hospital at Washington D.C. in 1864."[201] If the Civil War brought forth a medical revolution in the clinical care of patients, it was Bontecou's humane portraits that led the way.

In his *Memoranda*, Walt Whitman summed up his three years and six hundred visits with wounded and sick patients in Washington hospitals. His words are an apt conclusion to this chapter:

> Those three years I consider the greatest privilege and satisfaction, (with all their feverish excitements and physical deprivations and lamentable sights,) and, of course, the most profound lesson and reminiscence, of my life. . . . It afforded me, too, the perusal of those subtlest, rarest, divinest volumes of Humanity, laid bare in its inmost recesses, and of actual life and death, better than the finest, most labor'd narratives, histories, poems in the libraries.[202]

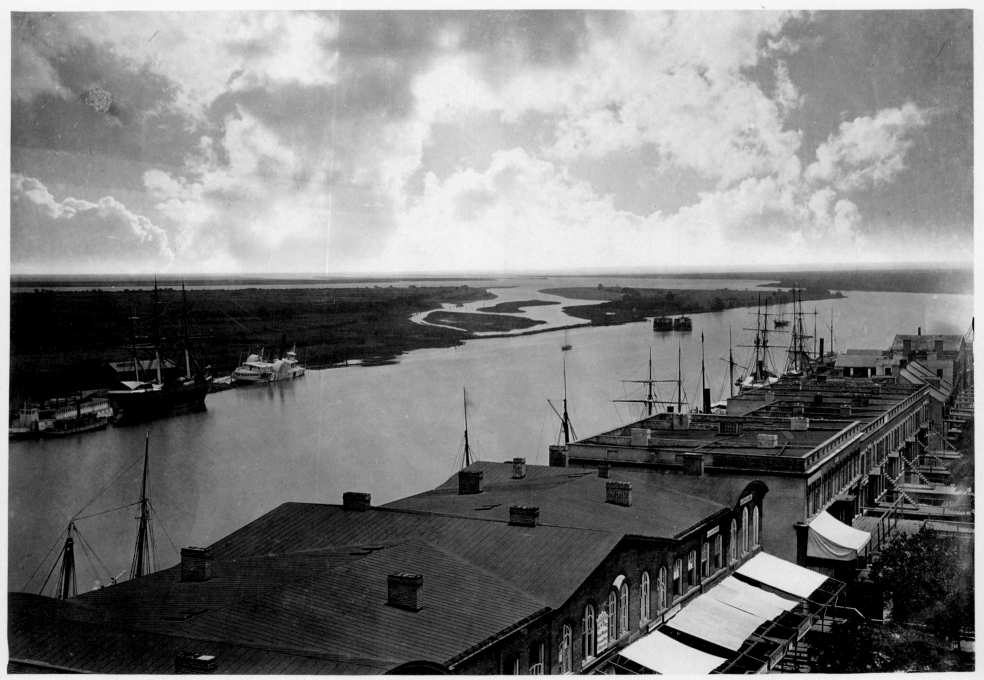

Photo. from nature By. G. N. Barnard.

SAVANAH, GA. N°2.

Barnard and His Views of Sherman's Campaign

In the summer of 1865, after Appomattox and the assassination of President Lincoln, and at approximately the same time that Dr. Bontecou was making portraits and caring for the last wounded soldiers of the war, Alexander Gardner started working on his memoir, *Gardner's Photographic Sketch Book of the War*. As discussed in Chapter Seven, the two-volume publication of original albumen silver prints would be complete in January 1866 and contain one hundred views with extended narrative captions, written by Gardner, accompanying the plates. The book would feature the photographs of eleven artists, including eight by George N. Barnard (assisted by James F. Gibson) from March 1862. After documenting the Confederate defense works at Centreville and the ruins of Mrs. Henry's house along Bull Run, Barnard was by no means through with war photography. But he did no more work for Gardner, as he had found a new employer, the United States Army, and was relocated to the war's western theater.

Yet Barnard would be inspired by his former employer to publish his own Civil War photograph book, *Photographic Views of Sherman's Campaign*. Produced with the support of Major General William Tecumseh Sherman (pl. 217), it follows the progress of his brutal campaign from Tennessee to Georgia, beginning in late summer 1864. Barnard would release his deluxe volume of sixty-one oversize, 10 × 14-inch large-format albumen silver prints in November 1866, ten months after Gardner's *Sketch Book* was published. Together, the two are the foundational publications of nineteenth-century American photography. One is an amalgamation of views by multiple artists made over a period of four years; the other is the work of a single photographer who followed the campaign of one general and his army in the final months of the war—

including Sherman's so-called March to the Sea. The story of Barnard's *Sherman's Campaign* and how different it is from Gardner's *Sketch Book* is a useful lens through which to understand how photography served the purposes of a nation trying to heal itself after four long years of pain.

Little is known about how or where Barnard spent the rest of the summer and the fall of 1862, after his work at Bull Run. It is likely he returned to Oswego, New York, to be with his family after several years in New York City and Washington. Barnard next appears in the historical record in December 1863, when the Topographical Branch of the Army of the Cumberland—essentially a crack team of civil engineers—hired him to manage its photographic operations in Nashville, Tennessee. His principal job was to produce photographic copies of maps and to make panoramas of Knoxville, Chattanooga, and Nashville, where General Grant had moved his headquarters and built a command center for all the activities of the Army of the Tennessee. Nashville was of great personal importance to President Lincoln because it would serve as the Union army's stage for a massive assault on Atlanta, Georgia—after Richmond, the Confederacy's most important and well-fortified city. The captain of the engineers in the Topographical Branch was Orlando M. Poe, who considered photography an invaluable aid to the work of the army and the winning of the war.[203] On December 28, Barnard became one of a large and growing number of official government photographers employed by the United States Army.[204]

He started his work in Nashville copying maps on 12 × 15-inch and 18 × 22-inch glass plates, and making a limited number of studio portraits of high-ranking Union officers; by February 1864 he was photographing scenes of military activity of all varieties in and around Chattanooga, Tennessee, just north of the Georgia border. He also began to execute

196 George N. Barnard, *Savannah, Georgia, No. 2*, 1866. Albumen silver print

for Poe multi-negative topographic panoramas that are among the most ambitious landscape photographs attempted in the Civil War era. Barnard constructed the views incorporating two to seven plates that when printed and mounted together measured from 28 to 100 inches. Examination of these photographic landscapes would inform Grant and Sherman in their imminent battles in southern Tennessee and Georgia.

In May 1864, Sherman began his march on Atlanta, a fierce engagement over inhospitable terrain that lasted into August. At Poe's orders, Barnard was to remain in Nashville until explicitly summoned—a telegram the photographer did not receive for four months, until after Sherman had taken Atlanta on September 2, 1864. Only then did Barnard travel to Georgia to survey with his camera the engineering of the Confederate defenses that ringed the city. Among the first things he photographed in Atlanta were the remains of an ammunition train that Confederate General John Bell Hood exploded in the heart of the city as he and his retreating army were abandoning it (pl. 210). Seen from an elevated vantage, the view of devastation and emptiness is one of the most effective expressions of what was but is no longer. To add gravitas, Barnard has a man—perhaps a soldier—stand in the middle of the destroyed tracks. He is completely dwarfed by the wrecked landscape. The picture explores the topography of pain, suffering, and terror through the refined description of the modern ruin that was rapidly becoming the America South.

Barnard remained in Atlanta for a few months, producing a large body of photographs of the occupied city and the extensive circuit of abandoned forts that had surrounded the Confederate stronghold. As was then his standard procedure, he worked simultaneously with a stereo camera and a 12 × 15-inch view camera. Plate 217 shows a double-page spread of rare half-stereo views of important buildings and streets hours before Sherman ordered the evacuation and razing of central Atlanta. On November 15, the general and his army departed the city, heading east for Savannah. For the first time, Barnard traveled alongside Sherman, but because of the speed of the Confederate army's retreat and thus the rapidity of Sherman's movement, there was little opportunity for Barnard to make any photographs.[205] In addition, there were few major battles or defensive positions to investigate with the camera. The fast-moving

enemy was not really present and had built few or no fortifications for the troops to overrun or for the topographic engineers to study. The troops encountered only civilians, whose homes and commercial buildings they methodically destroyed.

Barnard arrived with the army in Savannah on December 21, 1864, and immediately set to work documenting the city. He remained there for a month. For unknown reasons, he did not then produce a single negative in Savannah that he would use in *Sherman's Campaign*: all five of the photographs of the city in the book date from 1866 (pl. 196). Once settled in the coastal city, Barnard sent Anthony a selection of the negatives he had made after he left Chattanooga. This included stereo and large-format views of Atlanta, and possibly of Savannah as well. The negatives arrived by ship safely in New York, and reproductions appeared as early as January 7, 1865, as wood engravings in *Harper's Weekly*.

Poe did not authorize Barnard to follow Sherman, who left Savannah for Columbia, the capital of South Carolina. Instead, Poe ordered his photographer to New York for a short leave to purchase photographic supplies. Barnard returned to the South in March 1865 to photograph the ruins of Charleston, which had been partially destroyed by fire. Again, he made stereo and large-format views of residential and commercial ruins. He also photographed Fort Sumter, where the war had begun four years earlier, and the ruins of Columbia (fig. 39). Like Atlanta, Columbia had been almost entirely destroyed by fires probably triggered by Sherman's army. After Appomattox, Poe sent Barnard to Washington, where he printed negatives for the government for the next several months. He completed his work for the army on June 30, 1865, and was mustered out. He deposited all but a few of his negatives from eighteen months of inspired picture-making with the federal government.

With the Civil War over, Barnard's services as a photographer were no longer needed. Or so it seemed at first. Then he saw a copy of Gardner's *Sketch Book*. It did not take him long to recognize the great opportunity to capitalize on what was missing, the western and far southern theaters of the war. In a March 1866 letter, he proposed a book of photographs to his former supervisor, Orlando Poe, who had been promoted to general:

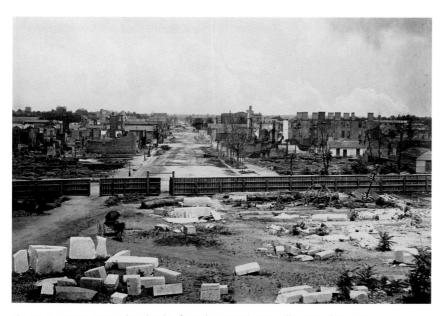

Fig. 39 George N. Barnard, *Columbia from the Capitol*, 1865. Albumen silver print. The Metropolitan Museum of Art, Pfeiffer and Rogers Funds, 1970 (1970.525.53)

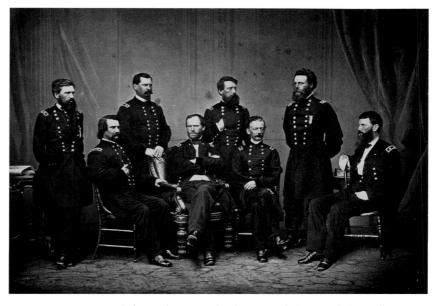

Fig. 40 George N. Barnard after Mathew B. Brady, *Sherman and His Generals*, 1865. Albumen silver print. The Metropolitan Museum of Art, Pfeiffer and Rogers Funds, 1970 (1970.525.1)

I am just now thinking of getting up a set of Photographic views illustrating Gen. Sherman's operations and Grand March through Ga. commencing at Chattanooga.

What I now think of doing is to go to Chattanooga and from there to Savannah and make all views which would be of any historical interest. I want about sixty or sixty five views in all the size of the Atlanta photos, 12 × 15 [inches. I will] print and mount them on a thick kind of paper, and neatly bind them in Book form.[206]

From the start, Barnard knew he needed unrestricted access to the large-format negatives he had submitted to the government, and more important, he wanted to revisit the battlefields and construct new photographs of subjects he had not recorded during the war. Nowhere in his book is there an explanation of which views are wartime scenes from fall 1864 and which are postwar scenes from summer 1866 (pls. 199, 200).

Scaffolding, neat piles of bricks, and other signs of building reconstruction in the 1866 photographs provide useful clues to historians trying to establish firm dates for the negatives. At times, even the images without ruins are datable. Like Barnard's March 1862 photographs of Bull Run that Gardner included in the *Sketch Book*, many of the postwar pictures have a distinctive tranquillity that is generally lacking in the earlier work.

After writing and receiving approval from General Sherman for the personal use of his government photographs (and a few maps), Barnard released a prospectus for the volume, which he mailed to potential subscribers on April 3, 1866. He would make one hundred copies and sell the book at $100 ($50 cheaper than the *Sketch Book*). Interested parties were asked to respond to E. & H. T. Anthony. With this in place, Barnard returned South in April 1866 to retrace the steps of Sherman's army. The resurvey work took a few months, ending on June 16. Barnard then returned to New York to begin printing the old and new negatives. By early July he had received permission from his former employer Mathew Brady to

Hood's Headquarters

Street in Atlanta

Whitehall St.

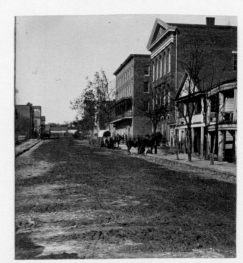

Marietta St.

197 George N. Barnard, *Atlanta*, 1864. Albumen silver prints (half-stereographs) in *A Photographic Album of the Civil War*

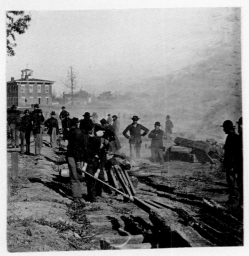

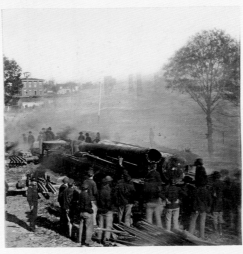

Destroying the railroad before the evacuation

1st Michigan Engineers destroying the R. R.

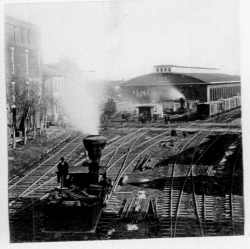

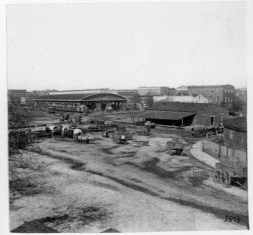

Showing the last train of cars packed to
leave the city before the evacuation.

From the bridge.

Railroad Station

copy and use as the book's first plate a portrait of Sherman and his generals (fig. 40). Brady had made the studio portrait on May 24, 1865, at the time of a thrilling two-day celebration, the Grand Army Review, in which General Sherman led a parade of 65,000 proud soldiers, survivors of the Army of the Tennessee and the Army of Georgia, through the streets of the nation's capital (pls. 224, 225). Alexander Gardner was there to capture the emotional, if orderly, street scene with his stereo camera.

Having obtained the necessary approvals, Barnard and Poe invited the journalist and sketch artist Theodore R. Davis to write an essay supplementing the photographs.[207] Barnard then commenced to do something extraordinary in the annals of nineteenth-century American photography: in the negative printing process, he inserted cloudscapes over his landscape views to add drama to certain pictures.[208] Davis commented on this to Poe: "Barnard has by a new process (double printing) got the most beautiful clouds in his prints, which excel any thing I have ever seen in the way of photographs."[209] The clouds appear in a third of the photographs in *Sherman's Campaign* (pls. 196, 197). For artistic rather than documentary reasons, Barnard printed the same cloud negatives above more than one landscape view. And he experimented with different skies above the same landscape. There seems little rhyme or reason why one negative received a specific type of cloud study and other negatives received none at all. What does seem likely is that Barnard used his favorite clouds for his favorite negatives without much concern for historical consistency. A survey of loose plates and intact albums confirms that, perhaps because of negative breakage (among other reasons), there are small variations from set to set.

With the negative printing complete, Barnard released to his subscribers the book itself, four maps, and the text by Davis, which was set in letterpress and printed in a separate volume.[210] This last decision—not to bind the text into the volume of photographs—produced a very clean and modern-looking book.[211] It was an aesthetic decision that significantly distinguishes the publication from Gardner's. In the *Sketch Book*, a long, often subjective text precedes each plate and provides a narrative against which the reader is asked to interpret the photographs; in *Sherman's Campaign*, the photographs live independently and flow one to the next in an uninterrupted, natural progression. The only writing on the pages

is Barnard's minute picture credit, and a concise title placed below the albumen silver prints in the center of the page. The design and overall conceptual effect are familiar to today's viewers. *Sherman's Campaign* resembles as much a contemporary book of art photographs as it does an exemplar from the nineteenth century. This may explain why so few devoted Civil War collectors find Barnard's photographs and his striking album of much interest and, to the contrary, why so many art collectors interested in photographic aesthetics find it exceptional.

Sherman's Campaign presents a suite of photographs made during and after the war as an act of storytelling and remembering, and in this regard the images in the book play a role that painting in the nineteenth century, not photography, traditionally served. With their saturated skies and highly aestheticized compositions, Barnard's photographs are more than simple records of the war (pl. 198). They are the personal reflections of a highly effective picture-maker intent on creating powerful graphic compositions. By freeing the pictures from any real attempt at reporting on the overall events of Sherman's March, Barnard succeeded in doing something profound: he made art out of war.

The thirty-page booklet by Theodore Davis that accompanied *Sherman's Campaign* begins with a one-paragraph introduction by Barnard that merits quoting in full, as it explains why the photographer felt obliged to revisit sites after the war.

The rapid movement of Sherman's army during the active campaign rendered it impossible to obtain at the time a complete series of photographs which should illustrate the principal events and most interesting localities. Since the close of the war the collection has been completed. It contains scenes of historical interest in Tennessee, Georgia, and the Carolinas; photographic glimpses of important strategic positions; field-fortifications, with their rude but effective obstructions; and the great bridges, built by the army in an almost incredibly short space of time.

G. N. B.[212]

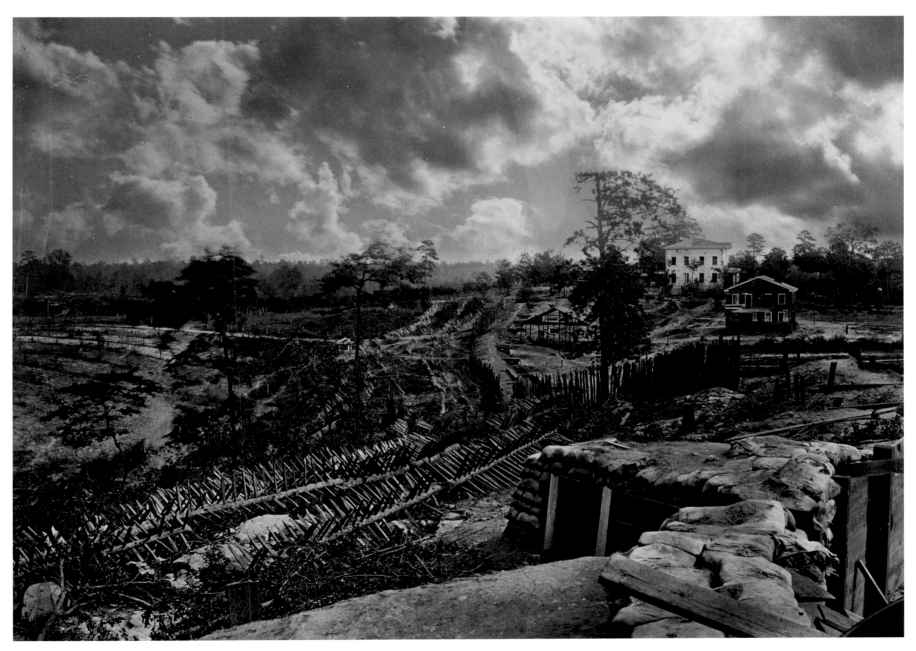

198 George N. Barnard, *Rebel Works in Front of Atlanta, Georgia, No. 1*, 1864. Albumen silver print

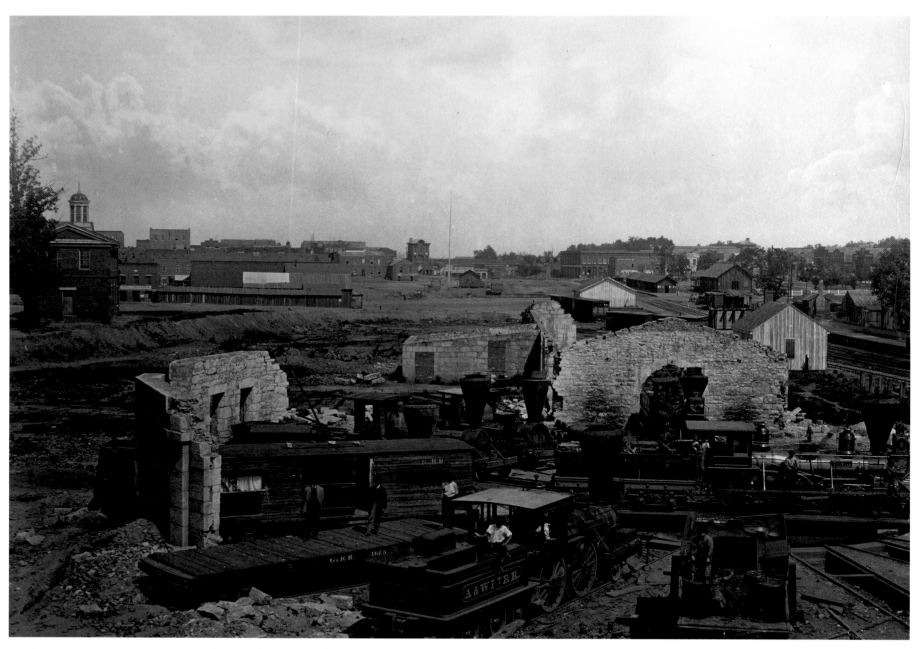

199 George N. Barnard, *City of Atlanta, Georgia, No. 1*, 1866. Albumen silver print

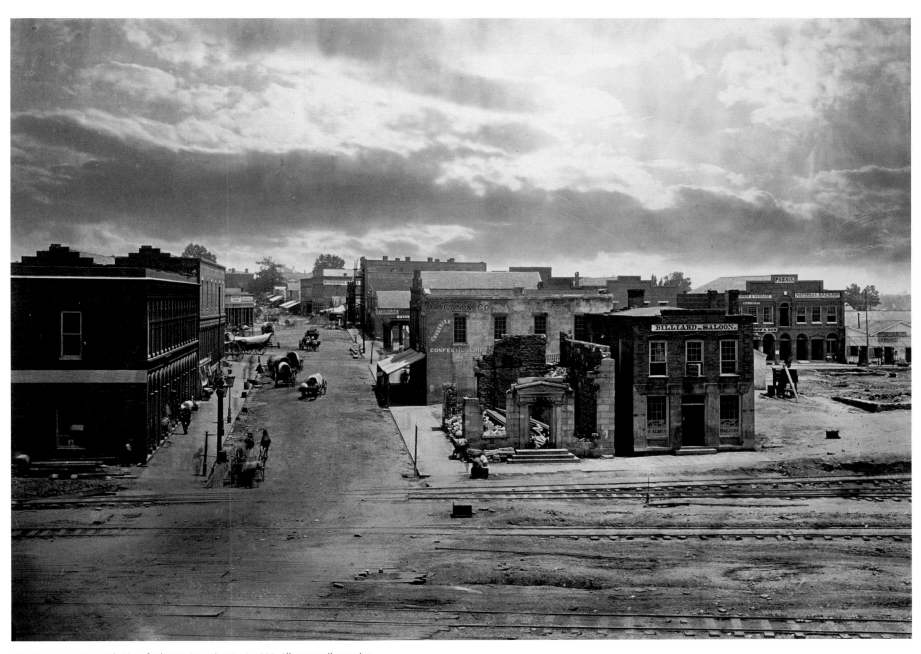

200 George N. Barnard, *City of Atlanta, Georgia, No. 2*, 1866. Albumen silver print

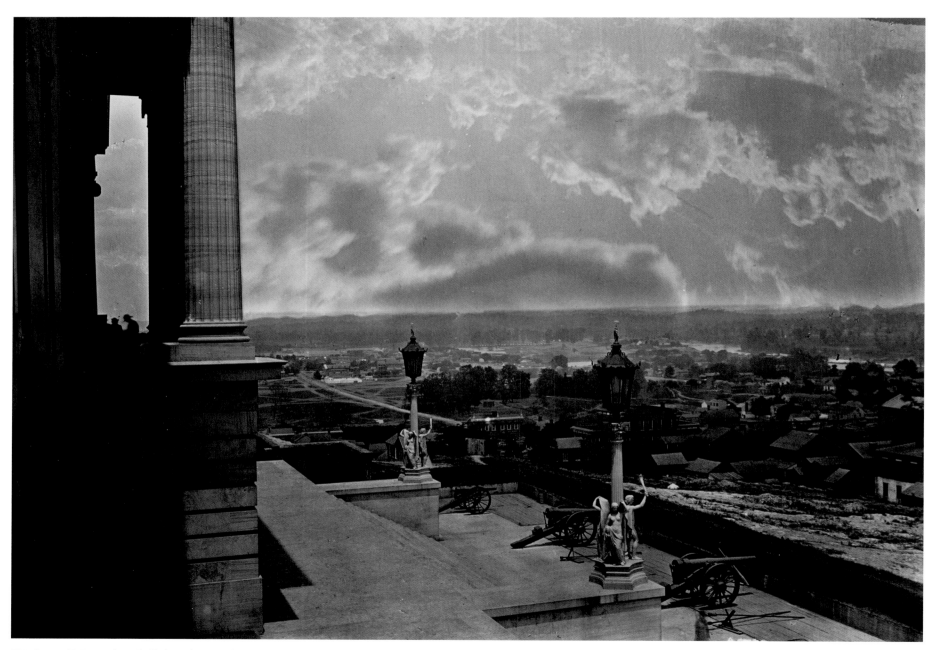

201 George N. Barnard, *Nashville from the Capitol*, 1864. Albumen silver print

As noted previously, Barnard opens his book with a kind of frontispiece, a copy print of Mathew Brady's formal portrait *Sherman and His Generals* (fig. 40).[213] The book's narrative starts with two photographs that establish Nashville as the point of departure for Sherman's campaign (pl. 201). Both show the Tennessee State Capitol. Known by the Union army from 1862 to 1865 as "Fortress Andrew Johnson," it was, according to Theodore Davis's text, the only fortified state capitol, Confederate or Union. Barnard uses a straightforward view of the Capitol with an army encampment at its base to set up a landscape of the city that takes a glancing look at three war cannons flanking ornate lampposts. The view sweeps across rooftops west to the Cumberland River and beyond. In the sky are a few scattered clouds that add a bit of drama to the otherwise languorous scene.

202 George N. Barnard, *Trestle Bridge at Whiteside*, 1864. Albumen silver print

Davis furnishes background commentary on the following four plates, all studies of (or from) a wartime engineering marvel: a five-tier wooden railroad bridge in the Raccoon Range near Chattanooga (pl. 202). Whiteside is a small town on Running Water Creek, a tributary of the Tennessee River. The bridge cuts across two large mountains and was a key link between Nashville and Chattanooga. The original masonry bridge built across the creek was destroyed in the summer of 1863 by Confederate troops shortly before the Battle of Chickamauga. According to Davis, the Union army rebuilt the bridge in the fall of 1863 in forty days, at an expense of $95,000. The lumber came from trees harvested on the hillsides; the labor from the First Michigan Engineers and Mechanics, assisted by the United States Military Railroad Construction Corps; and the know-how from Orlando Poe. Critical to the success of Sherman's campaign to take Atlanta, the five-hundred-foot-long bridge soared ninety-five feet above the creek bed and is considered one of the greatest feats of military engineering during the Civil War. As Davis wrote, "It was not a

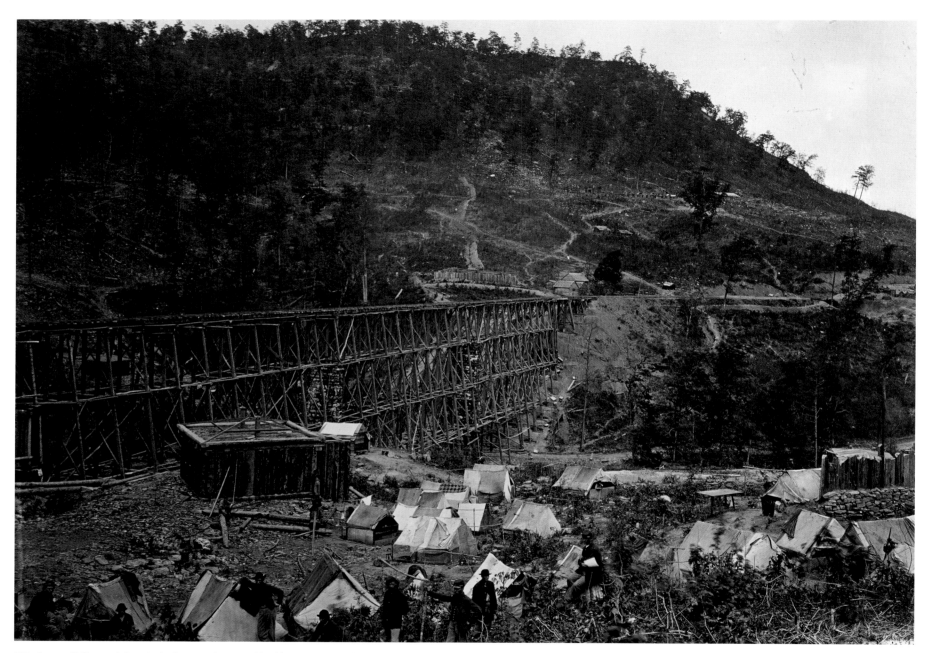

203 George N. Barnard, *Pass in the Raccoon Range, Whiteside, No. 1*, 1864. Albumen silver print

204 George N. Barnard, *Pass in the Raccoon Range, Whiteside, No. 2*, 1864. Albumen silver print

205 George N. Barnard, *Chattanooga Valley from Lookout Mountain*, 1864 or 1866.
Albumen silver print

that artists in other media have used to engage viewers, who can, by sympathetic replacement, imagine themselves unmediated witnesses of the scene.

By the time Barnard set out for Atlanta in September 1864, he was a seasoned panoramist. Here in the field, though, he was somewhat restricted by the terrain. Rather than fight nature, he embraced the vertiginous landscape that Davis termed "picturesquely wild."[215] Barnard climbed the hillside and set up his camera at the exact elevation of the railroad tracks, then created a two-part image looking across and down the valley (pls. 203, 204). Plates 6 and 7 of *Sherman's Campaign* are separate in the book, but together form a 29-inch-wide panorama.[216] On the mountain opposite is a half-denuded hillside—a testament to the amount of tree cutting required to construct the ambitious railroad bridge. In the foreground of both photographs, soldiers pose near their tents. These were the simple field dwellings of the men charged with protecting both sides of the bridge. Davis noted the ragtag nature of their accommodations, which he described as "the snug army homes of the bridge guard [that] form the picturesque foreground of the picture."[217]

Sherman's Campaign continues with studies of the capture of Chattanooga, the "Gateway to the Lower South," and the future site of the general's advance supply base for the attack on Atlanta. Barnard includes views of sites heavily fought over but not well known, such as Mission Ridge and Orchard Knob, and also heavily fortified Lookout Mountain.

difficult task to find in our army of volunteers men who could construct anything from a watch to a locomotive. Great bridges were rapidly rebuilt with no other tools than the ax and auger, convenient forests furnishing the timber."[214] In one of the photographs, a soldier sits to the left of a remaining masonry pier, camouflaged among the fallen timbers just above the water's surface. He is a substitute for the picture maker. Overwhelmed by the scale of the bridge, the man contemplates the scene. It would be Barnard's first of many uses of a figure in the landscape—a pictorial device

He featured not one but two similar views from Lookout Mountain gazing down into the Chattanooga Valley at the curve of the river, plowed fields, and the town of Chattanooga beyond (pl. 204). Each shows what the art historian Keith Davis characterizes as the artist's "deft orchestration of painterly motifs . . . [that share] a marked similarity in structure and content with Thomas Cole's noted painting *The Oxbow*" (fig. 41).[218] Substituting the Tennessee River for the upper Connecticut, Barnard makes many of the same compositional and cultural observations in his photograph, which links the uncivilized, raw wooded hillside to the civilized landscape, complete with planted fields, a community of houses, and an oxbow. Noteworthy is the absence of any military equipment or effect: no tents, cannons, bridges, earthworks, rifle pits, or shattered tree limbs. There are no soldiers in this theater, just pure landscape. *Chattanooga Valley from Lookout Mountain* demonstrates Barnard's belief that his work far exceeded the role of note taker, documentarian, topographer's aide, or federal servant. If the picture itself fails to tell the story of the fight to control Lookout Mountain and the strategically important city that lies in its shadow, it succeeds in all other measures. Theodore Davis certainly believed so, and he amplified Barnard's elegiac view with a lengthy, position-by-position analysis of how Sherman won the mountain and the town below.

Lest there be any doubt about Barnard's artistic intentions, he next presents a photograph of Lu-La Lake at Lookout Mountain, one of the purest nature studies made before, during, or after the Civil War (pl. 206). Again, no signs of military purpose, just beauty—something lost during the war that Barnard in 1866 went out of his way to incorporate into his publication. As Davis notes:

> Tul-lu-la lake, a picturesque basin among the rocks of Lookout Mountain, still retains its Indian name, the translation of which is, the lake among the mountains. The waters of this Indian mirror are as pure and clear as possible. If we may believe the Indian legends, it possesses peculiar properties for healing other ills than those of the body. It is certainly the favorite resort for "swain and lass" of the country near.

Fig. 41 Thomas Cole, *View from Mount Holyoke, Northampton, Massachusetts, after a Thunderstorm—The Oxbow*, 1836. Oil on canvas. The Metropolitan Museum of Art, Gift of Mrs. Russell Sage, 1908 (08.228)

> Near the lake are huge boulders deeply covered with moss of a great variety of color and quality, surpassing anything of the kind that may be found in our more northern wilds.[219]

After the "Battle above the Clouds," as the fight for Lookout Mountain in late November 1863 became known, the Confederate army retreated to Dalton, Georgia. There the troops remained in a strong, fortified position throughout the winter, until the opening of the spring 1864 campaign.[220] Barnard follows Sherman's progress with four grim views of the battleground of Resaca, Georgia, and another three studies of Ringgold and Buzzard Roost (pl. 207; fig. 42).[221] The Resaca photographs lack any explicit human incident—all military activity is implied. Made in 1866, they rely on broken and leafless trees to illustrate the story of the battle on May 13–15, 1864, which was essentially fought to a draw, neither side declaring victory. Barnard uses nature allegorically (perhaps biblically): at Lu-La Lake, he suggests a glimpse of paradise,

206 George N. Barnard, *Lu-La Lake, Lookout Mountain*, 1864 or 1866. Albumen silver print

207 George N. Barnard, *Battle Ground of Resaca, Georgia, No. 2*, 1866. Albumen silver print

208 George N. Barnard, *Scene of General McPherson's Death*, 1864 or 1866. Albumen silver print

of the garden of Eden; at Resaca, of hell, or at least Eden after the fall of man, represented by trampled earth and dead and shattered trees. In *Battle Ground of Resaca, Georgia, No. 2*, Barnard conceives and executes an image worthy of comparison to the best of Gardner's views of the Gettysburg dead (pls. 101, 102), a photograph that is, nevertheless, dissimilar in its pictorial strategy and effect. Again, no sign of the 160,000 soldiers who fought at Resaca, or the 7,000 to 8,000 who died there. The Confederate army retreated once more after the battle, and Sherman moved a step closer to his goal, the taking of Atlanta. The next eleven photographs, all made in 1866, are workmanlike studies of a succession of battlefields and their defenses that Sherman and his army fought through on their way to Atlanta. This includes scenes along the Etawah River, at Allatoona, New Hope Church, Pine Mountain, Kennesaw Mountain, and along the Chattahoochee River just a few miles from Atlanta.

Soon after the Confederate forces abandoned Atlanta on September 1, 1864, Poe wired Barnard to leave his base in Nashville and go to the evacuated city. On his way there, Barnard stopped to make photographs at an otherwise unremarkable location on the outskirts of Atlanta. He would use a pair of wagon wheels, a few cannonballs, ammunition shells, and parts of a horse's skeleton—vertebrae, a skull, and other bones—in an unsuccessful attempt to hallow the ground where, on July 22, 1864, Union General James Birdseye McPherson was shot off his mount near the woods seen in plate 208.[222] First in his West Point class of 1853, and much admired and trusted by Sherman, McPherson was the only commander of a federal army during the Civil War to die in battle. Almost immediately after his death, several of the general's top officers marked the spot where he died, carving his name and death date into the smaller tree, and nailing to it a wooden marker with the same notations. The photographs were suitable for a quick sketch of the site where a great general had died, but they did not meet Barnard's aesthetic criteria, and he returned to the location in either November 1864 or May 1866 to make the photograph shown here. He constructed an image as a painter might, by manipulating the bones, trimming the foliage, and removing any distracting details that could interfere with the psychological meaning of a proper memorial portrait. With the crude marker lost (so, too, the

Fig. 42 George N. Barnard, *Battle Ground of Resaca, Georgia, No. 1*, 1866. Albumen silver print. The Metropolitan Museum of Art, Pfeiffer and Rogers Funds, 1970 (1970.525.19)

wagon wheels) and the carving virtually invisible, the screen of trees became a simple but useful backdrop, a curtain for this minimal landscape of life and death.

After *Scene of General McPherson's Death*, Barnard presents eleven views of the destruction of Atlanta, half made during the war, half in 1866 (pls. 198–200, 209, 210). Collectively, the Atlanta series remains among the most celebrated by any nineteenth-century American photographer. Plate 198, *Rebel Works in Front of Atlanta, Georgia, No. 1*, 1864, is among the most frequently cited and reproduced of all Barnard's war photographs. The subject is an abandoned Confederate fort with rows of chevaux-de-frise running through the landscape. As he did in a third of the photographs in *Sherman's Campaign*, Barnard used two negatives to produce the print: one for the landscape, one for the sky.[223] For this image he chose a favorite sky photograph of his, and lopped off the top of the tree in the central foreground. The powerful effect seems to have inspired

209 George N. Barnard, *Rebel Works in Front of Atlanta, Georgia, No. 5*, 1866. Albumen silver print

210 George N. Barnard, *Destruction of Hood's Ordnance Train*, 1864. Albumen silver print

211 George N. Barnard, *Ruins in Charleston, South Carolina*, 1865. Albumen silver print

212 George N. Barnard, *Ruins of the Rail Road Depot, Charleston, South Carolina*, 1865. Albumen silver print

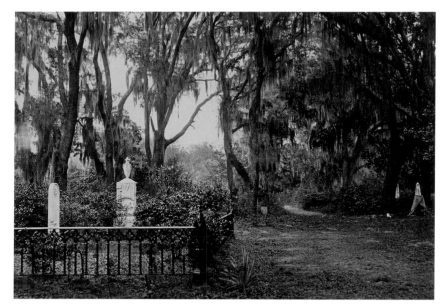

Fig. 43 George N. Barnard, *Buen-Ventura, Savannah, Georgia*, 1866. Albumen silver print.
The Metropolitan Museum of Art, Pfeiffer and Rogers Funds, 1970 (1970.525.48)

the set designers of many Civil War motion pictures, from *Gone with the Wind* (1939) to the present.

Sherman and his generals amassed some 100,000 men for the attack on Atlanta; General Joseph Johnston, the Confederate commander, had 44,000 men to defend the city. Despite this imbalance, it took Sherman forty days to claim Atlanta. Johnston's success was due in part to the Confederates' well-constructed defensive positions, seen in plate 209 below a cloud-filled sky. In the foreground Barnard incorporates a tripod of rifles with bayonets and a single canteen to provide useful "color" to an otherwise barren landscape of denuded fields and defensive works leading into the distance. Several plates later is *City of Atlanta, Georgia, No. 2*, an 1866 view of the confluence of Peachtree and Whitehall streets from the same elevated vantage point Barnard had used in 1864 for his stereo view (pls. 197, 200). Looking directly down the street beneath another dramatic sky, the camera records the movement of wagons and other traffic passing intact commercial buildings and the ruins of the

neoclassical bank. In this odd postwar urban landscape, which evokes a studio back lot, it seems clear that Sherman's men specifically targeted the Georgia Railroad Bank but protected the lucky billiards parlor and saloon next door.

The Atlanta photographs document the razing of the city enacted by Poe under strict orders from Sherman. Theodore Davis comments in his essay:

> General O. M. Poe, to whom was intrusted the duty of completing the destruction inaugurated by [Confederate General] Hood, executed his orders to the entire satisfaction of General Sherman. The tools for the destruction of the railroad iron were invented by General Poe. By the use of these simple tools the iron was rendered entirely unserviceable without calling on the men for the severe labor usual upon the destruction of roads.[224]

Poe targeted the city's commercial buildings, weapons factories, mills, and other nonresidential buildings that Sherman wanted destroyed as part of his scorched-earth campaign. Poe's soldiers did that and more after November 12, when the order was placed. By evening two nights later, the city was engulfed by fire and the central business district nearly obliterated. Poe observed in a diary entry: "Work of destruction of Rail Road and depots in Atlanta going on . . . Much destruction of private property by unauthorized persons to the great scandal of our Army, and marked detriment to its discipline."[225]

The final quarter of Barnard's book presents five views of Savannah and ten of South Carolina. In Savannah, Barnard focused on sections of the city that had been spared destruction (pl. 196). From an aerie in the cupola of the customhouse, he made two photographs—not a panorama but a pair of images to which he added cloud-filled skies from other negatives. In *Savannah, Georgia, No. 2*, he built a magnificent diagonal composition that features the wide Savannah River and the meandering line of marshlands that meet the sea at the horizon. The photograph balances the commerce of ships on the far bank of the river with the awnings shading the entrances to marine shops that had reopened for

business after the war. This 1866 photograph is a clear depiction of Southern commerce at the beginning of Reconstruction.

Of perhaps more symbolic value is Barnard's view of Bonaventure Cemetery, a burial ground that had opened in 1850 on the outskirts of Savannah (fig. 43). Here he added to his photographic harvest an image of absolutely no military value, except by association. Looking down an alley of moss-draped oaks on the grounds of what had been a plantation, Barnard adds a touch of romantic melancholy to his enterprise. Although it does not appear at the end of the book—Barnard had to close the volume with views of Charleston, South Carolina—it is likely the last photograph he made for *Sherman's Campaign*, before heading to New York on the steamer *Missouri* on June 16, 1866.

Barnard concludes his book with a pair of March 1865 views of the ruins of Charleston (pl. 211, 212).[226] The final plate is of the Northeastern Railroad depot, which had been destroyed not by Sherman, but by retreating Confederate troops, who torched the city during their evacuation on the night of February 17, 1865. An explosion of gunpowder in the depot killed 150 residents and ignited a fire that swept across the city. In the foreground stand a fragment of brick wall and the ruins of a chimney spire; in the middle distance a crushed-metal relic litters an otherwise well-swept street; in the background is all that remains of the depot—a row and a half of masonry arches receding into the distance. The effect is dramatic, and ancient: a modern view of classical ruins one might find on the Appian Way leading to Rome. It is a fitting close to the first monograph in American photography.

SURRAT. BOOTH. HAROLD.

War Department, Washington, April 20, 1865,

 # $100,000 REWARD!

THE MURDERER

Of our late beloved President, Abraham Lincoln,

IS STILL AT LARGE.

$50,000 REWARD

Will be paid by this Department for his apprehension, in addition to any reward offered by
Municipal Authorities or State Executives.

$25,000 REWARD

Will be paid for the apprehension of JOHN H. SURRATT, one of Booth's Accomplices.

$25,000 REWARD

Will be paid for the apprehension of David C. Harold, another of Booth's accomplices.

LIBERAL REWARDS will be paid for any information that shall conduce to the arrest of either of the above-
named criminals, or their accomplices.

All persons harboring or secreting the said persons, or either of them, or aiding or assisting their concealment or
escape, will be treated as accomplices in the murder of the President and the attempted assassination of the Secretary of
State, and shall be subject to trial before a Military Commission and the punishment of DEATH.

Let the stain of innocent blood be removed from the land by the arrest and punishment of the murderers.

All good citizens are exhorted to aid public justice on this occasion. Every man should consider his own conscience
charged with this solemn duty, and rest neither night nor day until it be accomplished.

EDWIN M. STANTON, Secretary of War.

DESCRIPTIONS.—BOOTH is Five Feet 7 or 8 inches high, slender build, high forehead, black hair, black eyes, and
wears a heavy black moustache.

JOHN H. SURRAT is about 5 feet, 9 inches. Hair rather thin and dark; eyes rather light; no beard. Would
weigh 145 or 150 pounds. Complexion rather pale and clear, with color in his cheeks. Wore light clothes of fine
quality. Shoulders square; cheek bones rather prominent; chin narrow; ears projecting at the top; forehead rather
low and square, but broad. Parts his hair on the right side; neck rather long. His lips are firmly set. A slim man.

DAVID C. HAROLD is five feet six inches high, hair dark, eyes dark, eyebrows rather heavy, full face, nose short,
hand short and fleshy, feet small, instep high, round bodied, naturally quick and active, slightly closes his eyes when
looking at a person.

NOTICE.—In addition to the above, State and other authorities have offered rewards amounting to almost one hun-
dred thousand dollars, making an aggregate of about TWO HUNDRED THOUSAND DOLLARS.

War's End and Lincoln's Assassination

General William Tecumseh Sherman and his army had taken Atlanta, then Savannah, and then, on February 18, 1865, Charleston, where the war had begun four years earlier. By then, the Confederate states were struggling to survive and Lincoln's secretary of state, William Seward, and Confederate commissioners were meeting to develop a peace agreement. They failed. General Lee knew it was only a matter of time before his defenses at Petersburg, Virginia, were breached, and the capital at Richmond left vulnerable to attack from the south. On April 2, Lee telegraphed Jefferson Davis to abandon the capital and seek safety in the countryside. Davis left that night on the Richmond & Danville Railroad for Greensboro, North Carolina. On his way out of Richmond, he ordered the destruction of the city and the bridges leading to it. Davis and the Confederate leadership would be on the run for a month, until his capture on May 10, 1865, near Irwinville, Georgia.

Lee and what remained of his devoted Army of Northern Virginia retreated westward, into rural Appomattox County, Virginia. General Grant followed in quick pursuit with General Philip Henry Sheridan's cavalry leading the way. After numerous minor engagements, the opposing armies met near the town of Appomattox Court House on April 9, 1865. That afternoon, Lee surrendered to Grant his army, then consisting of approximately 27,000 exhausted and starving men. He had secured from Grant parole for all his soldiers, who would be given Union rations and allowed to return home to their families unmolested by the federals. The meeting took place in the residence of Wilmer McLean, a merchant from Manassas who had moved to Appomattox Court House in 1862 after the First Battle of Bull Run. He had wanted nothing to do with war, and yet,

as historians have noted, it had started in his front yard and ended in his front parlor.

— ✦✦✦ —

As soon as he heard that Lee had left Appomattox and returned to Richmond on April 15, 1865, Mathew Brady headed there with his camera equipment. The Lees' Franklin Street residence had survived the fires that had devastated many of the commercial sections of the city. Through the kindness of a Confederate colonel and Mrs. Lee, Brady received permission to photograph the general on April 16. To many, Brady's picture of Lee on his back porch, holding his hat, is one of the most reflective and thoughtful wartime portraits (pl. 214). Brady exposed a total of six plates, five with Lee seated, sometimes with his eldest son, Custis. The finest is the single standing portrait: the fifty-eight-year-old Confederate general poses in the uniform he had worn at the surrender. It would be Brady's last wartime photograph.

Ever the opportunist, Brady made sure the press knew he had scooped his competitors. *The Richmond Whig* published a short puff piece on April 21: "General Lee and staff—or rather those who accompanied him to Richmond—were yesterday photographed in a group by Mr. Brady, of New York. Six different sittings were then taken of General Lee, each in a different posture, and all were pronounced admirable pictures."[227] J. R. Hamilton, a *New York Times* correspondent in Richmond, filed a more complete story on April 23 that the newspaper published a week later:

Gen. R. E. LEE still remains in this city, and keeps himself so secluded that nobody would suppose, unless so informed, that he is still among us. Few, I believe, have ventured to

213 Unknown maker, Broadside for the Capture of John Wilkes Booth, John Surratt, and David Herold, April 20 1865. Ink on paper with albumen silver prints

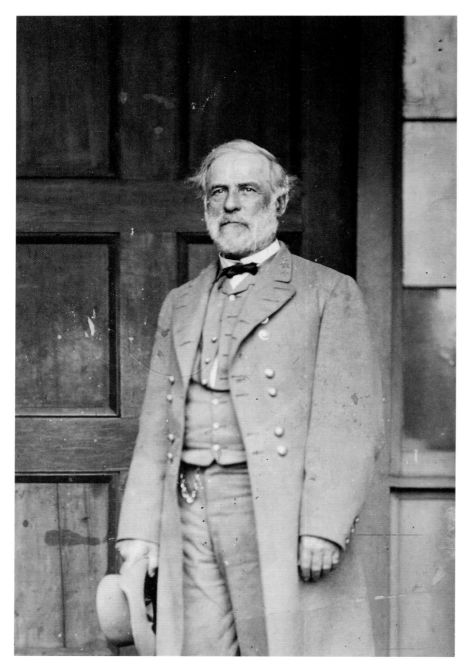

intrude upon his privacy, beyond the circle of his own friends; but one Northern gentlemen was necessarily bound to call upon him in the ordinary pursuit of his business. I yesterday met Mr. BRADY, the celebrated photographer of New-York, who had just been favored with an interview by the General, and had taken splendid cabinet portraits of him and all his staff. It will doubtless add an interesting item to his already splendid gallery of notabilities. Mr. BRADY says the General received him with the utmost affability and cordiality of manner.[228]

Two views from April 3, 1865, of Confederate dead in Petersburg, Virginia, reveal the intensity of the war's last great battle and the sophistication and complexity of late-war stereo photography (pls. 215, 216). Thomas C. Roche arrived on the scene one day after Union forces took Confederate Fort Mahone. A former employee of Brady's and an operator for Edward Anthony, Roche understood the poetics of the stereo medium and photographed from an extremely close and low vantage point, as if he were a soldier fighting hand-to-hand in the trenches. The visual effect of these penetrating photographs through the stereoscope is as shocking as that of Gardner's views of the dead of Antietam and O'Sullivan's at Gettysburg. Both stereos are in the series "Photographic History, The War for the Union," on the bright yellow card mounts designed by E. & H. T. Anthony to appeal to memorabilia collectors after the war. The publisher's caption on the verso of plate 215 typifies the extended narratives found on late-war stereo views:

> Rebel Artillery Soldiers, killed in the Trenches of Fort Mahone, called by the Soldiers "Fort Damnation," at the storming of Petersburgh [*sic*], Va., April 2d, 1865. The one in the foreground has U. S. belts on, probably taken from a Union Soldier prisoner, his uniform is grey cloth trimmed with red. This view was taken the morning after the fight.

214 Mathew B. Brady, *General Robert E. Lee*, April 16, 1865. Albumen silver print

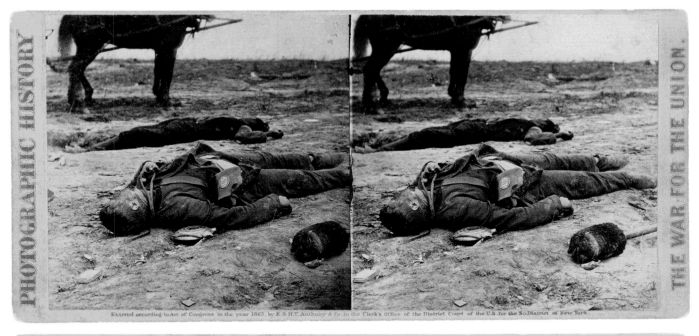

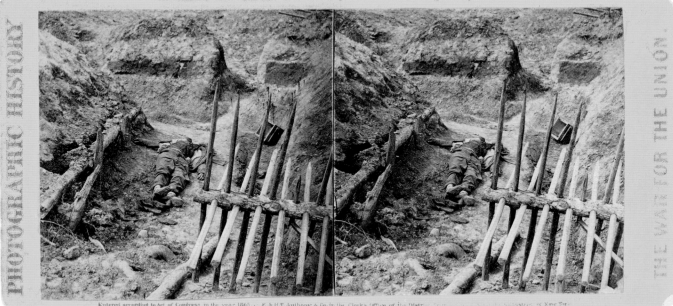

215 Thomas C. Roche, *Rebel Artillery Soldiers, Killed in the Trenches of Fort Mahone, Called by the Soldiers "Fort Damnation," at the Storming of Petersburg, Virginia*, April 3, 1865. Albumen silver print (stereograph)

216 Thomas C. Roche, *Covered Ways Inside the Rebel Fort Mahone, Called by the Soldiers "Fort Damnation," Petersburg, Virginia*, April 3, 1865. Albumen silver print (stereograph)

Anthony does not comment on the other figure, who faces the opposite direction. Upon close inspection it becomes clear he is a civilian, not a Confederate artilleryman. And he is African-American. The "corpse" was a teamster, alive and free, and the photographer's field assistant.[229]

Alexander Gardner, John Reekie, and other members of Gardner's corps of photographers were the first to document Richmond after its evacuation by the Confederate government. Gardner had not been in the field with his cameras since leaving Gettysburg in July 1863. He arrived in Richmond on April 6 and worked for five days producing dozens of stereo and large-format views of the destroyed bridges across the James River and in the twenty square blocks of the city that came to be known as the "Burnt District." Gardner featured four photographs in his *Sketch Book*, among them *Ruins of Arsenal, Richmond, Virginia* (pl. 90). The masterpiece from the series is *Ruins of Gallego Flour Mills, Richmond* (pl. 219), a two-part urban panorama of the charred remains of the Gallego Mills, which did not appear in the *Sketch Book*. Over time, however, the photograph has become an iconic image of the fall of the Confederacy and the utter devastation of the Civil War.

Gardner arrived in Richmond two days after President Lincoln, who had traveled there with his son Tad for a two-day walking tour of the captured city. It was Tad's twelfth birthday, and as soon as he and his father landed in the city, they were immediately recognized and surrounded by thousands of former slaves. Admiral David D. Porter, who accompanied Lincoln, wrote that "no electric wire could have carried the news of the President's arrival sooner than it was circulated through Richmond. As far as the eye could see the streets were alive with negroes and poor whites rushing in our direction, and the crowd increased so fast that I had to surround the President with the sailors with fixed bayonets to keep them off. . . . They all wanted to shake hands with Mr. Lincoln or his coat tail or even to kneel down and kiss his boots!"[230] The last gestures upset the president, and he encouraged the individuals to stand: "Don't kneel to me. That is not right. You must kneel only to God, and thank him for your freedom. Liberty is your birthright. God gave it to you as he gave it to others, and it is a sin that you have been deprived of it for so many years."[231]

—◆◆◆—

On April 14, 1865, ten days after his emotional arrival in Richmond, and five days after Lee's surrender to Grant at Appomattox, President Lincoln took his wife out for a night of theater to celebrate the final days of the Civil War.[232] Laura Keene was starring in a hit British comedy, *Our American Cousin*; the show at Ford's Theatre was billed as a "Benefit and Last Night." During the third act, John Wilkes Booth, who had performed frequently in the house, gained access to Lincoln's private box and shot him in the back of the head. Booth then jumped to the stage, breaking his leg, but he still made a quick getaway. The president would die early the following morning.

Within twenty-four hours, secret service director Colonel Lafayette Baker had acquired cartes de visite of Booth and two of his accomplices. Baker and the District police secured Booth's photograph by searching the actor's room at the National Hotel; they found a photograph of John Surratt, a suspect in the simultaneous plot to kill Secretary of State William Seward, in the Washington boardinghouse run by his mother, Mary Surratt (soon to be indicted as a fellow conspirator); and they retrieved David Herold's photograph from his mother's portrait album. The secret service had not caught the conspirators, but it had collected their likenesses. With the portraits in hand, Colonel Baker visited the government's most trusted photographer, Alexander Gardner, and requested immediate copies for police distribution. On April 20, six days after the murder, Baker released a bill for the capture of Booth, John Surratt, and Herold that was the first broadside in the United States illustrated with photographs (pl. 213). On the Wanted poster, Edwin M. Stanton, secretary of war, offered a $100,000 reward for "THE MURDERER of our late beloved President, Abraham Lincoln."[233]

The carte-de-visite portraits combined with the descriptions of the alleged conspirators proved invaluable to the militia. A week after the poster hit the streets, Booth and Herold were recognized by a division of the Sixteenth New York Cavalry. When soldiers cornered the two men in a barn near Port Royal, Virginia, the commanding officer, Lieutenant Edward Doherty, demanded the assassins' unconditional surrender. Herold complied; Booth refused. Two detectives accompanying the cavalry then set fire to the barn. Booth was shot as he attempted to escape, and he died three hours later. After a two-month military trial, Herold and

three other conspirators were hanged on July 7 at the Old Arsenal Penitentiary in Washington.[234]

Lincoln's assassination immediately generated a variety of photographs that, along with R. B. Bontecou's medical portraits, are the last images of the Civil War. Among the first to appear were new portraits of government and military leaders such as William Tecumseh Sherman, who sits stern-faced for a Brady carte de visite wearing a mourning armband (pl. 217). Around the time of Lincoln's funeral tour (April 21–May 3), enterprising vendors produced mourning corsages featuring black silk ribbons adorned with small circular tintype portraits of the president (pl. 218). The unknown corsage maker whose work is shown here copied a portrait from February 9, 1864, that Anthony Berger had made of Lincoln in Brady's Washington gallery.

Alexander Gardner's long-term relationship with the federal government and the Army of the Potomac gave him unparalleled access to subjects that not even Mathew Brady could attain. Gardner made the staged formal portrait *Planning the Capture of Booth* in his own gallery (pl. 220). Colonel Lafayette Baker sits with Lieutenant Colonel Everton J. Conger standing on his left and Lieutenant Luther B. Baker (his cousin); they study maps of the area where Booth was believed to be hiding in Maryland or Virginia. The portrait, in wood-engraving form, illustrates a long article published in the May 13, 1865, issue of *Harper's Weekly*. According to the news story, Conger and Lieutenant Baker found Booth in the barn and demanded

217 Brady & Company, *Major General William Tecumseh Sherman [Wearing Mourning Armband]*, April 1865. Albumen silver print (carte de visite)

218 Unknown maker, Mourning Corsage with Portrait of Abraham Lincoln, April 1865. Black and white silk with tintype set inside brass button

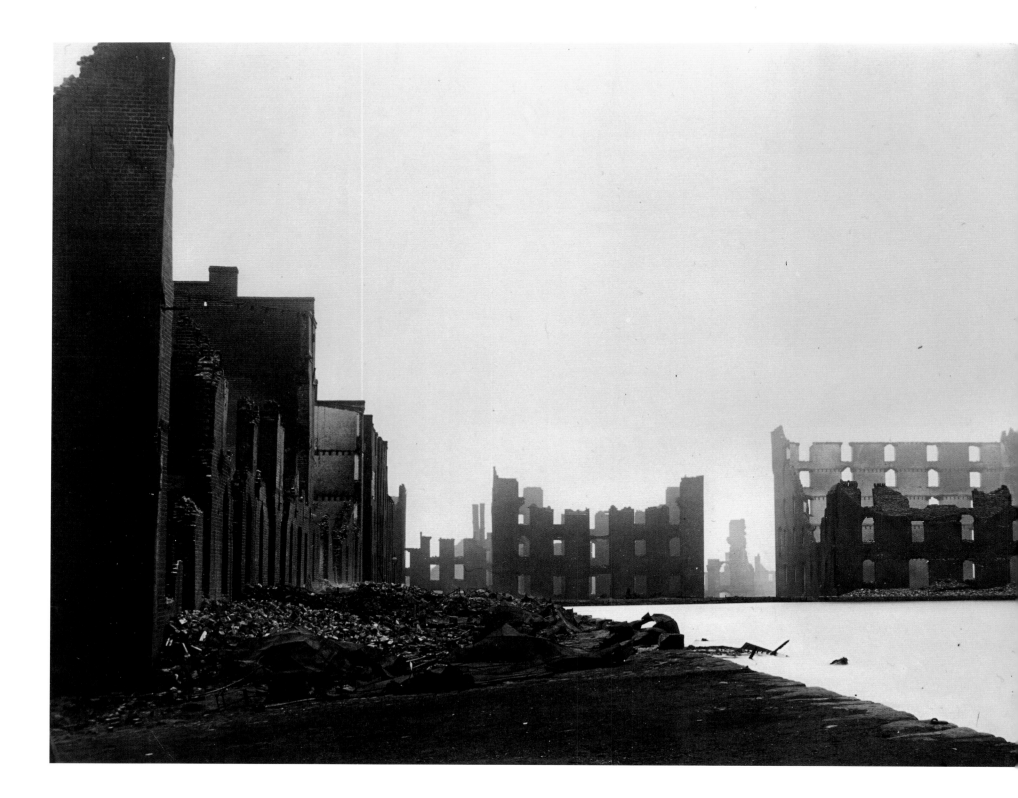

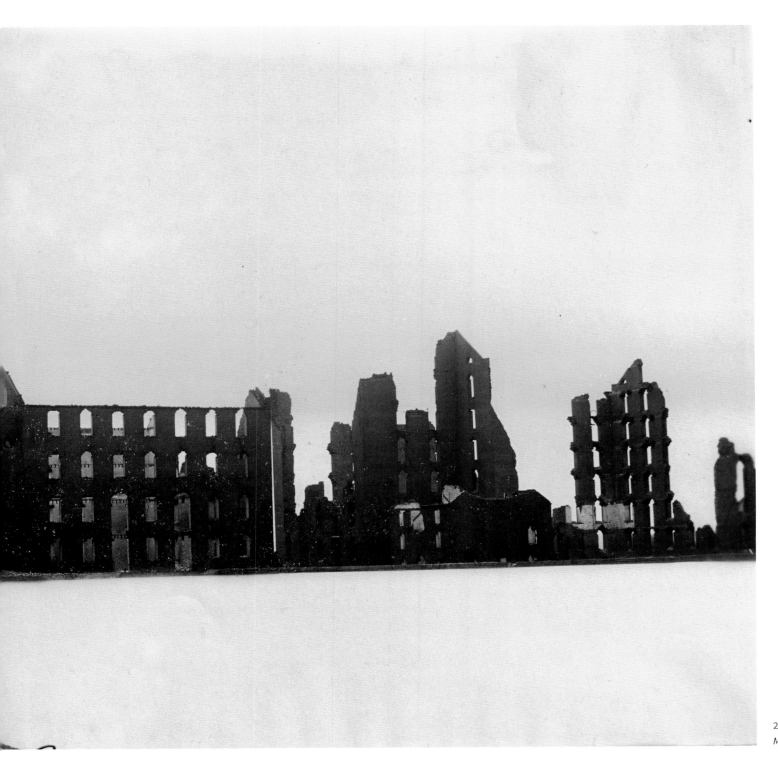

219 Alexander Gardner, *Ruins of Gallego Flour Mills, Richmond*, 1865. Albumen silver prints

220 Alexander Gardner, *Planning the Capture of Booth*, 1865. Albumen silver print

to grow, changing his appearance considerably. His hair had been cut somewhat shorter than he usually wore it."[236] Booth knew from a life on the stage that in the era of photography, hiding one's identity could be critical to escaping one's fate. Considered one of the era's most handsome classical actors, he was billed as a tragedian, and his favorite Shakespearean role was Brutus, the murderer in *Julius Caesar*.

At approximately the same time that Booth shot President Lincoln, Lewis Thornton Powell, a Confederate army deserter who had been wounded at Gettysburg, made an unsuccessful attempt to murder Secretary of State Seward. The son of a Baptist minister from Alabama, Powell (who used the aliases Payne, Paine, Wood, and Hall) was one of the associates of Booth who planned the simultaneous assassinations of Lincoln, Vice President Andrew Johnson, and Seward. A tall, powerful twenty-year-old, Powell broke into Seward's house, struck his son Frederick with the butt of his jammed pistol, brutally stabbed the bedridden politician, and then escaped after stabbing Seward's son Augustus. Four days later, Powell was caught in a sophisticated police dragnet and arrested at the H Street boardinghouse of Mary Surratt. Once again, Colonel Baker required the assistance of Gardner, who made formal portraits of the six presumed conspirators whom the secret service had detained aboard an ironclad monitor docked on the Potomac. On April 27, Gardner produced full-length, profile, and full-face portraits of the conspirators, presaging the pictorial formula later adopted by law enforcement photographers. For these portrait sessions, he brought from his gallery a posing stand—seen beside Powell's left foot in plate 222— and made large-format negatives which he immediately copyrighted and duplicated as mass-produced cartes de visite. Of the ten known photographs of Powell, six show him against a canvas awning on the monitor's deck, the others against the dented gun turret. In this portrait, Powell appears menacingly free of the handcuffs seen in almost all the others; he towers a head above the deck officer, whose weapon seems precariously close to his reach.

Gardner's intimate involvement with the events following Lincoln's assassination would have challenged even the most experienced twenty-first-century journalist. In four months he documented in hundreds of portraits and views one of the most complex

that he surrender. He refused, and when they warned him that soldiers would set fire to the barn, Booth responded: "Well then, my brave boys, prepare a stretcher for me."[235] *Harper's Weekly* also reported a now less familiar piece of information: that Booth had changed his distinctive physiognomy—the one he traded on as a recognized member of America's premier family of actors (pl. 221). "Booth and Harold [*sic*] were dressed in rebel gray uniform. Harold was otherwise not disguised much. Booth's mustache had been cut off, apparently with scissors, and his beard allowed

news stories in American history. The secret service gave him special access and even allowed him to keep all but one of his negatives: a portrait of Booth's corpse. Gardner copyrighted his work and attempted to sell cartes de visite, stereo views, and large-format albumen silver prints of every aspect of the tragedy. During the conspirators' trial, he even experimented with urban landscapes, producing a series of street "snapshots" on May 23 and 24 of more than 150,000 jubilant soldiers who slowly marched up Pennsylvania Avenue as part of the Grand Army Review (pls. 224, 225). Statistics would later reveal that more than four times the number of men who marched in the Grand Army Review had died in the war.

To the sounds of bands playing "When Johnny Comes Marching Home," the Armies of the Potomac, the Tennessee, and Georgia were celebrated in a victory parade marking the official end of the war. Traveling from the newly completed Capitol (seen in the distance in one of the views) to the main reviewing stand in front of the Executive Mansion, row after row of men passed before Gardner's stereo camera, positioned just above their heads. Posted opposite the Willard Hotel, today still standing at Pennsylvania Avenue and 14th Street, Gardner and several assistants worked to document the event with relatively fast small-plate cameras. The resulting views, in which the soldiers and horses are blurred, were taken from the spectators' level rather than from an ideal vantage point, thus anticipating by at least twenty years the contingent look of street photography made with handheld cameras.

Perhaps the most desired commission of the moment was also awarded to Gardner: the right to photograph the hanging of the Lincoln conspirators on July 7, 1865. Exhausted from the war, the American public, however, was less than interested in these last unflinching pictures, and they are, as a result, exceptionally rare. Nonetheless, the photographs of the execution of Mary Surratt, Lewis Powell, David Herold, and George Atzerodt were highly sought after by early collectors of Civil War ephemera in the early 1880s. The large-format photograph formerly in the collection of Frederick Hill Meserve (whose descendants own the carte de visite in plate 226) shows the conspirators on the gallows

221 C. D. Fredricks & Company, *John Wilkes Booth*, ca. 1862. Albumen silver print (carte de visite)

222 Alexander Gardner, *Lewis Payne [Lewis Powell]*, April 27, 1865. Albumen silver print

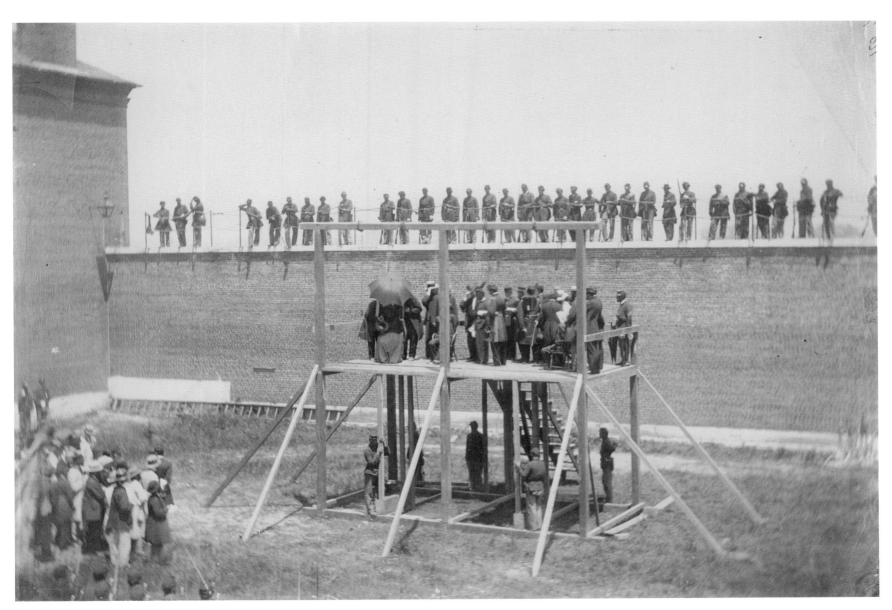

223 Alexander Gardner, *Execution of the Conspirators,* July 7, 1865. Albumen silver print

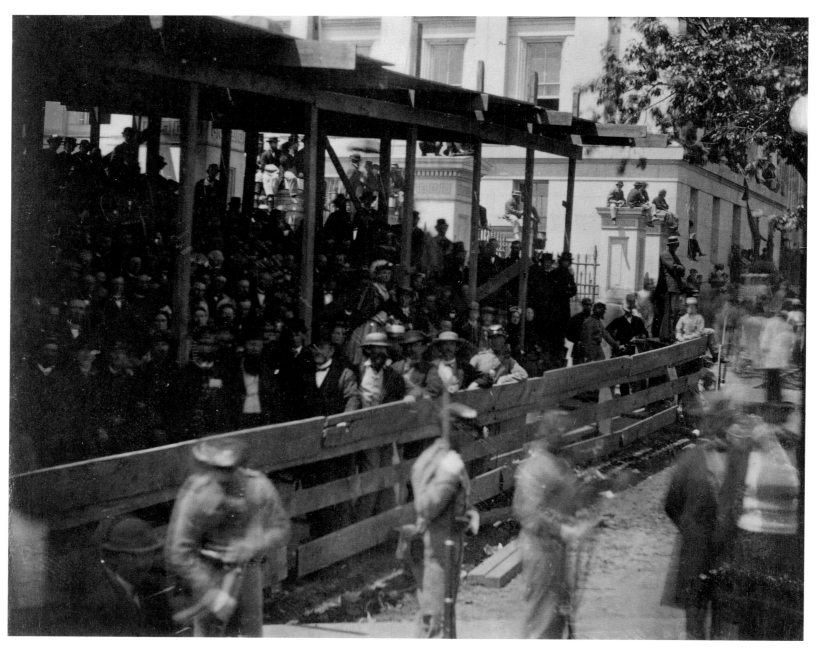

224 Alexander Gardner, Grand Army Review, Washington, D.C., May 23 or 24, 1865. Albumen silver print

225 Alexander Gardner, Grand Army Review, Washington, D.C., May 23 or 24, 1865. Albumen silver print

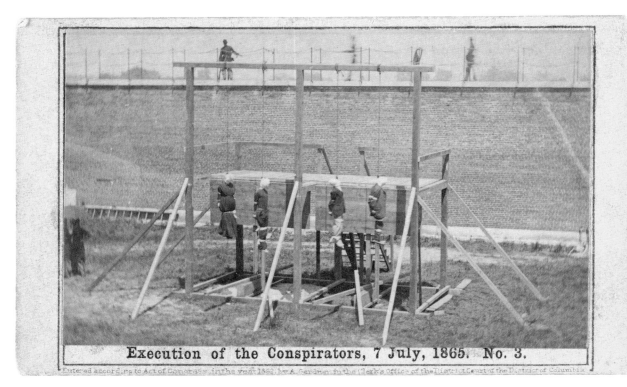

Execution of the Conspirators, 7 July, 1865. No. 3.

Entered according to Act of Congress in the year 1865, by A. Gardner in the Clerk's Office of the District Court of the District of Columbia

226 Alexander Gardner, *Execution of the Conspirators, No. 3,* July 7, 1865. Albumen silver print (carte de visite)

members of the clergy crowd the platform and provide final counsel to the prisoners. Minutes after Gardner made his exposure, soldiers tied and blindfolded the conspirators, and the order was given to knock out the support beams. Gardner proceeded to make several more photographs of the bodies swinging on their ropes before they were cut down and placed in pine coffins (pl. 226). Altogether he made about a dozen carte-de-visite and large-format negatives, prints from which he sold as a sequential "picture story" in his gallery and, by wholesale, through E. & H. T. Anthony in New York. Among the world's first spot-news photographs, they are as unnerving today as they were at the time.

scaffold in the yard of the Old Arsenal Penitentiary (pl. 223). The day of the execution was extremely hot, and a parasol shades Mary Surratt, seated at the far left of the platform. She would be the first woman in the United States to be hanged by the federal government. Two soldiers grasp the narrow beams that hold up the gallows trapdoor. The soldier on the left would later admit he had just vomited, from heat and tension. One noose is visible slightly to the left of Surratt; the other three nooses moved during the exposure and are registered by Gardner's camera as faint blurs. A small group of invited guests huddle at the lower left, and

Mathew Brady took an altogether different path to memorialize the historical moment. Without direct access to the conspirators, their trial, or the hanging itself, he looked within his own archive and drew from it a collection of the gallery's finest portraits of President Lincoln. Brady chose three by Anthony Berger, one by Thomas Le Mere, two by Gardner, and three he had made himself.[237] The earliest dates from February 24, 1861, the last from February 9, 1864. Working with Edward Anthony, his longtime business colleague, Brady made a maquette of eight carte-de-visite portraits, in the center of which he placed a ninth portrait within the silhouette of a stylized cemetery monument (pl. 227). The maquette would be used to generate carte-de-visite copies that E. & H. T. Anthony sold to the grieving public.

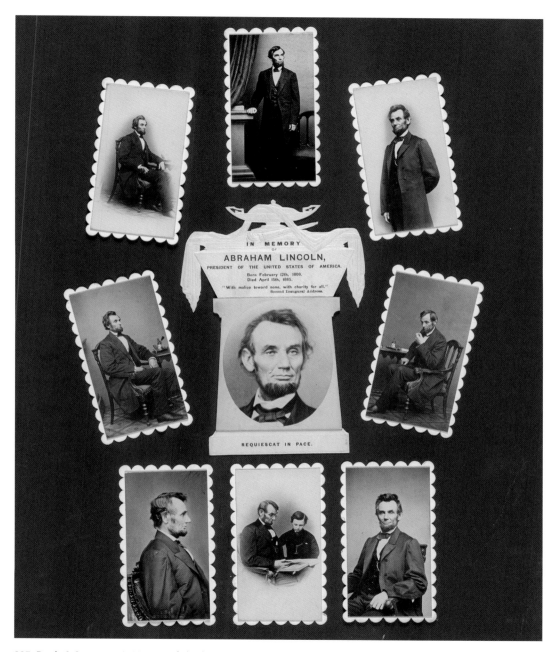

227 Brady & Company, *In Memory of Abraham Lincoln*, 1865. Maquette with albumen silver prints (cartes de visite)

The Slow Recovery

The Civil War was over. And if not whole, the nation was at least reunited, and the slow recovery of Reconstruction could begin. The Thirteenth Amendment to the Constitution, passed in January 1865, outlawed slavery—the first of three amendments that would define national citizenship and give African-American men the right to vote. By the summer of the year, tens of thousands of soldiers were being mustered out and making their way with their companies and regiments back to their homes in Michigan and Mississippi, Virginia and Vermont. With them returned hundreds of photographers who had made their living by following the armies (pl. 229). Their pictures and those by Alexander Gardner, Timothy H. O'Sullivan, Mathew Brady, George N. Barnard, and many others had altered the visual landscape of the country as much as the war had marked the land itself. Some photographers went West, finding jobs with federal expeditions trying to map or otherwise define the landscape of territories not yet states. Some, like Oliver H. Willard, found government work documenting uniforms worn by Union soldiers and officers during the war (pl. 231). Others reestablished portrait businesses in cities and towns throughout the North and South. Barnard moved to Charleston, and A. J. Riddle back to Macon. O'Sullivan and A. J. Russell joined topographic surveys in Colorado, Nevada, and Utah. Brady, the eldest of them all, stayed home, and with difficulty maintained his New York and Washington galleries for years to come.

Gardner and Barnard would produce, respectively, the first anthology and the first monograph in American arts and letters illustrated with original photographs. Many of their original glass negatives, and those

228 Unknown artist, The Wilderness Battlefield, near Spotsylvania, Virginia, 1865 (?).
Albumen silver print

229 Unknown artist, *"Picture Gallery Photographs,"* 1860s. Albumen silver print (carte de visite)

from the Brady studio, would in time enter public collections at the Library of Congress, the National Archives, the United States Military History Institute, the Smithsonian Institution's National Portrait Gallery, and the National Museum of Health and Medicine.[238] Others remain in private collections like those maintained by the Meserve-Kunhardt Foundation in Purchase, New York. These institutions preserve the photographs and permit public access to them via direct transmission of archival materials, but mostly through print publications, motion pictures, and online databases available through their websites. Never before have more Civil War photographs been available for scholarly study. Never have there been more books in print illustrated with photographs about the War Between the States.

Still, there is much to learn about the role of the camera during the Civil War. One day we may know for sure whose copy-camera setup

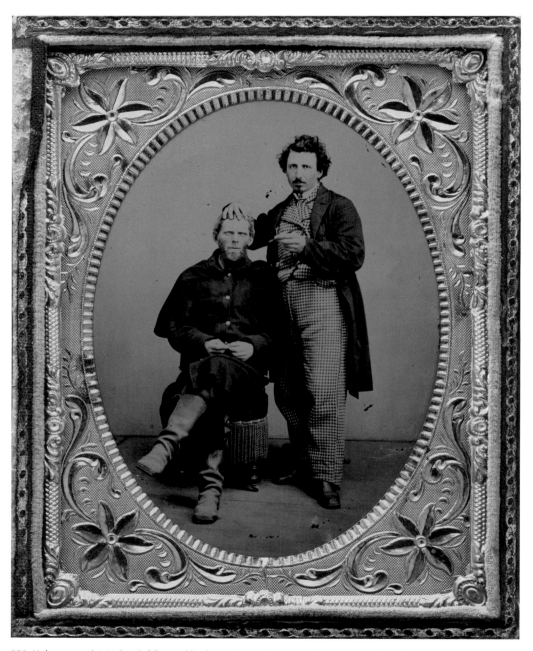

230 Unknown artist, Union Soldier and Barber, 1861–65. Quarter-plate tintype with applied color

Ordnance, Private.

231 Attributed to Oliver H. Willard, *Ordnance, Private*, 1866. Albumen silver print with applied color

232 Unknown artist, The Wilderness Battlefield, near Spotsylvania, Virginia, 1865 (?). Albumen silver print

233 Unknown artist, The Wilderness Battlefield, near Spotsylvania, Virginia, 1865 (?). Albumen silver print

appears in the field at Petersburg in March 1865 (pl. 15). The diagnostic view makes crystal-clear something that words cannot: exactly how field photographers duplicated maps, and how they printed them in the sun right on the spot. At the time of this writing, most authorities attribute the photograph to Alexander Gardner; in the recent past Brady received the credit. Perhaps even before the exhibition that this book accompanies opens to the public, we will learn more about some of the most intriguing field photographs: the macabre studies of skulls and unburied bones discovered by an unknown photographer in the Wilderness battlefield where Robert E. Lee and Ulysses S. Grant had fought to a bloody draw in May 1864 (pls. 228, 232, 233). It seems likely that the photographs date from the immediate postwar period, during cleanup operations, but we cannot state so with certainty.

It is even possible that we will one day discover the name and circumstances of the young man whom C. Burgess of Troy, New York, photographed beside a conspicuously empty studio chair (pl. 234). A pair of worn boots and a soldier's kepi on the seat complete the composition. Is the subject mourning a lost comrade, a brother, his father? Or is he portraying himself as a civilian contemplating the loss of his former self, a Civil War soldier? For now, the mystery seems more beautiful and pleasing than any future clarification could offer.

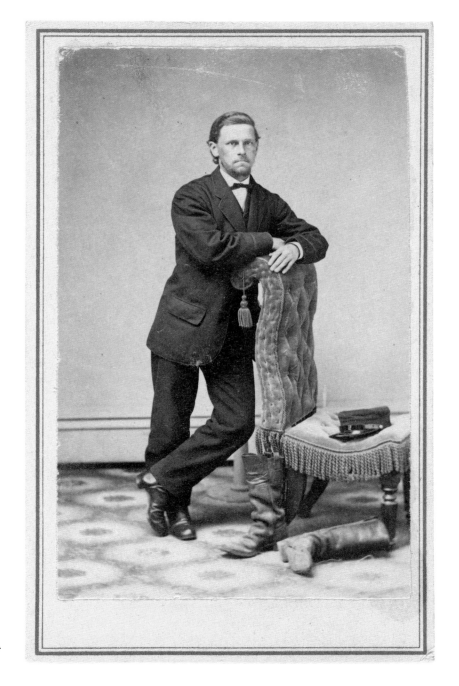

234 C. Burgess, Young Man Standing beside Empty Chair with Kepi and Worn Boots, ca. 1865. Albumen silver print (carte de visite)

NOTES

1. Civil War casualty statistics and recruitment numbers vary from source to source and are still being revised. This book uses generally accepted approximations, and data from specific sources as cited.

2. "Antietam Reproduced," *The New York Times*, October 6, 1862, p. 5.

3. It remains unclear whether or not they had Brady's approval, but Gardner and Gibson filed for and received copyright for their respective photographs of Antietam. In small but legible type, their names appear identifying them as copyright holders on all the Brady studio "album cards" and stereo views of Antietam published over Brady's business imprint.

4. William A. Frassinto, *Antietam: The Photographic Legacy of America's Bloodiest Day* (New York: Charles Scribner's Sons, 1978), p. 18.

5. Other magazines and newspapers covered Brady's exhibition. See also "Scenes on the Battlefield of Antietam," *Harper's Weekly*, October 18, 1862, pp. 664–65.

6. Unfortunately for today's readers, the full review has heretofore not been transcribed in its entirety, or correctly. See www.oldmagazinearticles.com/Mathew_Brady_Civil_War_Photographer_Article for a full transcript.

7. "Brady's Photographs, Pictures of the Dead at Antietam," *The New York Times*, October 20, 1862, p. 5.

8. For detailed information on the family and their military service, see "The Warner Brothers Go to War," *Military Images* 1, no. 1 (July–August 1979), pp. 14–18.

9. The source of the first quotation is Francis Bicknell Carpenter, *The Inner Life of Abraham Lincoln: Six Months at the White House* (Lincoln: University of Nebraska Press, 1995), p. 130. The second quotation is from a telegram sent by Lincoln to Mary Todd Lincoln on October 2, 1862. See Brooks Johnson, *An Enduring Interest: The Photographs of Alexander Gardner* (Norfolk, Va.: The Chrysler Museum, 1991), p. 62. Recent scholarship suggests that the oft-published cipher for the telegram may not be in Lincoln's hand.

10. Alexander Gardner, *Gardner's Photographic Sketch Book of the War* (Washington, D.C.: Philp & Solomons, 1866), text preceding pl. 23. See the one-volume reprint issued by Dover Publications (New York, 1959).

11. Frassinto, *Antietam*, p. 279.

12. See Hirst D. Milhollen and Donald H. Mugridge, "Introduction to the 1961 Microfilm Edition of Selected Civil War Photographs," accessed July 27, 2012, memory.loc.gov/ammem/cwphtml/cwmicro.html. Milhollen and Mugridge were then respectively in the Prints & Photographs Division and the General Reference and Bibliography Division of the Library of Congress.

13. "Brady's Photographs," *The New York Times*, October 20, 1862, p. 5.

14. "Things in New York," *Brother Jonathan*, March 4, 1843, p. 250.

15. Samuel Irenæus Prime, *The Life of Samuel F. B. Morse, LL. D., Inventor of the Electro-magnetic Recording Telegraph* (New York: D. Appleton and Company, 1875), pp. 400–401.

16. See the listing in *New-York City Directory for 1844 & 1845* (New York: John Doggett Jr., 1844), copy in the New-York Historical Society. Brady, who originally crafted jewel and miniature cases, began making daguerreotypes, the first form of photography introduced to the United States, in 1843. See Jeff L. Rosenheim, "'A Palace for the Sun': Early Photography in New York City," in *Art in the Empire City, New York 1825–1861*, ed. Catherine Hoover Voorsanger and John K. Howat, exh. cat. (New York: The Metropolitan Museum of Art, 2000), pp. 227–41.

17. According to Brady's advertisement in *The Independent*, his collection contained "the President [Zachary Taylor] and Cabinet, also the late President Polk and his Cabinet, members of the United States' Senate and House of Representatives, Judges of the Supreme Court at Washington, and many other eminent persons." See "Brady's National Gallery of Daguerreotypes," *The Independent*, November 7, 1850, p. 184.

18. The cost of the volume of twelve portraits was $15.

19. Information in the 1860 United States Census (accessible through ancestry.com) indicates that as of October 18, 1860, Mathew Brady was a resident of the County of Richmond (Staten Island) in the State of New York. He was thirty-five years old, married to Julia Brady (aged twenty-nine), and the two were living in a house valued at $2,500 with Thomas Hagerty (nineteen), Margaret Handy (eight), a cook named Mary Crowley (thirty-five), and a waitress, Jane Little (seventeen). His stated occupation was "Photographist," his place of birth "Ireland." Later in his life Brady claimed that he had been born in Warren County, New York, where, according to the 1830 Federal Census, his parents, Andrew and Julia Brady, immigrants from Ireland, had lived in the town of Hague. This census does not name specific children, but it does confirm that there were eight residents in Brady's father's home: six children (four boys, two girls) under the age of nine, one adult male forty to forty-nine years old, and one adult female thirty to thirty-nine years old. The census states that six of the eight residents were "Aliens."

20. See Mary Panzer, *Mathew Brady and the Image of History*, exh. cat. (Washington, D.C.: Smithsonian Institution Press for the National Portrait Gallery, 1997), p. xviii.

21. See Marcus A. Root, *The Camera and the Pencil; or, The Heliographic Art* (Philadelphia: M. A. Root, 1864; reprint Pawlet, Vt.: Helios, 1971), p. 381.

22. On Queen Victoria, see Eleanor Julian Stanley Long, *Twenty Years at Court, from the Correspondence of the Hon. Eleanor Stanley, Maid of Honour to Her Late Majesty Queen Victoria 1842–1862*, ed. Mrs. Steuart (Beatrice) Erskine (London: Nisbet and Co., 1916), p. 377, quoted in William C. Darrah, *Cartes de Visite in Nineteenth Century Photography* (Gettysburg, Pa.: W. C. Darrah, 1981), p. 6. For the Lincolns as collectors, see Mark E. Neely Jr. and Harold Holzer, *The Lincoln Family Album* (Carbondale: Southern Illinois University Press, 2006).

23. Sadly, none survives—a loss possibly due to the outbreak of the Civil War. See "Daguerreotype Panoramic Views of California," *The Daguerreian Journal*, November 1, 1851, p. 371. For more on the Vance daguerreotypes, see Dolores Kilgo, "Vance's Views in St. Louis: An Update," *The Daguerreian Annual* (Pittsburgh: The Daguerreian Society, 1994), pp. 211–12.

24. Like Brady, Gardner seems to have left the tintype to the practice of the hundreds of itinerant photographers who followed the armies, North and South, and provided welcome picture-making to the soldier intent on posing one more time for an image before

heading off to the next battle. A hallotype is a derivative of the ambrotype process; an ivorytype is a waxed or varnished photographic print, usually with applied color and face-mounted to glass.

25. For full transcripts of this and other Lincoln speeches and public letters quoted here, see Mario M. Cuomo and Harold Holzer, eds., *Lincoln on Democracy* (New York: HarperCollins, 1990), pp. 105–6.

26. In April 1860, to gain political momentum, Lincoln and his party published the full transcripts of the debates with Douglas; see Harold Holzer, ed., *The Lincoln–Douglas Debates: The First Complete, Unexpurgated Text* (New York: HarperCollins, 1993).

27. In October 1859, Henry Ward Beecher had invited Lincoln to New York to speak in his Brooklyn church; Beecher and the Young Men's Republican Union moved the location of the talk to the Cooper Institute to accommodate the anticipated crowd, which numbered some 1,500 people.

28. Cuomo and Holzer, *Lincoln on Democracy*, p. 174.

29. See, among many other reproductions, the cover of *Harper's Weekly*, May 26, 1860.

30. Brady informed a reporter in 1891 that Lincoln had told U.S. Marshal Ward Hill Lamon: "Brady and the Cooper Institute made me President." See George Alfred Townsend, "Still Taking Pictures," *The World*, April 12, 1891, p. 26, accessed August 2, 2012, www.daguerreotypearchive.org/texts/N8910001_BRADY_WORLD_1891-04-12.pdf.

31. The full quotation comes from a letter Lincoln wrote on April 7, 1860, to an H. G. Eastman, who had written the candidate to request a photograph: "Yours of March 18th addressed to me at Chicago, and requesting a photograph is received. I have not a single one now at my control; but I think you can easily get one at New York. While I was there I was taken to one of those places where they get up such things, and I suppose they got my shadow, and can multiply copies indefinitely. Any of

the Republican Club men there can show you the place.... Yours truly, A. Lincoln." See Paul M. Angle and Earl Schenck Miers, [eds.], *The Living Lincoln: The Man and His Times, in His Own Words* (New York: Barnes & Noble, 1992), p. 325. Harvey Gridley Eastman (1832–1878) lived in Poughkeepsie, New York, and ran one of the country's first vocational business schools. Active in the state Republican Party, he was the cousin of George Eastman (1854–1932), the founder, in 1892, of Eastman Kodak Company. H. G. Eastman was also the author of books including *Eastman's Treatise on Counterfeit, Altered, and Spurious Bank Notes, with Unerring Rules for the Detection of Frauds in the Same . . . and Other Valuable Information as to Money, with Hints to Business Success* (St. Louis: N. Niedner, 1859).

32. William Howard Russell, *My Diary North and South* (1863), entry for March 27, 1862, excerpted in Daily Observations from the Civil War, accessed July 29, 2012, http://dotcw.com/category/my-diary-north-and-south-william-howard-russell/.

33. Comparison with a wood engraving of the Confederate vice president that appeared in *Harper's Weekly*, February 23, 1861, suggests that the Stephens photograph is probably a copy of a Brady studio portrait. The illustration is credited in *Harper's* to Brady, and is virtually identical to the portrait in the necklace. The Breckinridge photograph is a copy of a portrait by George W. Minnis of Richmond. See the wood engraving of Breckinridge with attribution in *Harper's Weekly*, February 18, 1865.

34. Senator Hannibal Hamlin of Maine, a committed antislavery advocate, was nominated as Lincoln's running mate.

35. See the address in Cuomo and Holzer, *Lincoln on Democracy*, p. 342.

36. For this letter, see Harold Holzer, ed., *The Lincoln Mailbag: Letters to the President* (New York: Addison-Wesley, 1993), p. 46.

37. For the letter from Lincoln to Grace Bedell,

October 19, 1860, see Roy P. Basler, ed., *The Collected Works of Abraham Lincoln*, 8 vols. (New Brunswick, N.J.: Rutgers University Press, 1953–55), vol. 4, p. 129.

38. John G. Nicolay, quoted in James Mellon, *The Face of Lincoln* (New York: Viking Press, 1979), p. 6.

39. Ten more states would follow: Mississippi, Florida, Alabama, Georgia, and Louisiana in January 1861; Texas in February; Virginia in April; Arkansas and North Carolina in May; and Tennessee on June 8, 1861. In 1863 the Confederacy also claimed Kentucky and Missouri, but these states never officially seceded from the Union.

40. For an in-depth description of Major Robert Anderson's occupation and surrender of Fort Sumter and photographs made there before and after the evacuation, see "The Rebels Shoot First," in Bob Zeller, *The Blue and Gray in Black and White: A History of Civil War Photography* (Westport, Conn., and London: Praeger, 2005), chap. 3.

41. Six days later in New York City, Anderson was greeted with a patriotic hero's parade attended by some 100,000 people who came to see him and the original Fort Sumter flag, which was specially rigged to hang from the equestrian statue of George Washington in Union Square.

42. See Zeller, *Blue and Gray in Black and White*, pp. 42–44, 46, for details about Pelot's career as a photographer and Confederate soldier. Born in Charleston, Pelot was a daguerreotypist in the late 1850s and assistant to Jesse H. Bolles in 1861. After his service in the Confederate army, Pelot moved to Augusta, Georgia, where he operated a portrait gallery for forty years.

43. *The Charleston Daily Courier*, April 16, 1861, quoted in Zeller, *Blue and Gray in Black and White*, p. 42.

44. *The Charleston Mercury*, April 16, 1861, quoted in Zeller, *Blue and Gray in Black and White*, p. 42.

45. Bolles opened an exhibition of these and other photographs (a total of sixteen) on or before April 25. See the advertisement from *The*

Charleston Mercury illustrated in Zeller, *Blue and Gray in Black and White*, p. 43.

46. The same flag appears flying above the sidewheeler seen in plate 33, *Terre-plein and Parapet*, and plate 34, *Hamilton's Floating Battery*. The Confederacy used a number of different flags, the most famous of which was the battle version of the Second National Flag; it featured a blue cross with white stars on a red field—the "Rebel Flag."

47. The album contains several cartes de visite with Anthony backmarks that seem to be copies of the exact full-size prints in the collection of the New-York Historical Society. This suggests the strong possibility that the Historical Society prints with Beauregard's signature, and many others from Charleston, arrived in New York City soon after the battle.

48. The newspaper reported that Osborn had made "twenty-six different views of the fort, internal and external." See *The Charleston Daily Courier*, April 23, 1861, quoted in Zeller, *Blue and Gray in Black and White*, p. 44.

49. Zeller, *Blue and Gray in Black and White*, pp. 44–45.

50. In April 1861, J. D. Edwards, the New Orleans landscapist (see figure 10), made a rare set of field photographs in Pensacola, Florida, of Confederate troops from Louisiana, Mississippi, and Alabama encamped near Fort Pickens, still under federal control. Although he exhibited and offered for sale thirty-nine of these large-format views in his New Orleans gallery the next month, Edwards subsequently abandoned the practice of photography. For more information on him, see Leslie D. Jensen, "Photographer of the Confederacy: J. D. Edwards," in *Shadows of the Storm*, vol. 1 of *The Image of War, 1861–1865*, ed. William C. Davis (Garden City, N.Y.: Doubleday, 1981), pp. 344–63.

51. See Lincoln's April 15, 1861, proclamation in Cuomo and Holzer, *Lincoln on Democracy*, pp. 211–12. On July 4, 1861, Lincoln requested of Congress another 400,000 men and $400 million to go to war against Jefferson

Davis and the Confederate States (ibid., p. 218).

52. Four border states where slavery existed—Missouri, Kentucky, Maryland, and Delaware—threatened to secede but did not.

53. James M. McPherson, introduction to "Hour of Trial," in Cuomo and Holzer, *Lincoln on Democracy*, chap. 5, p. 187.

54. Abraham Lincoln, war message to Congress, July 4, 1861, in Cuomo and Holzer, *Lincoln on Democracy*, p. 223.

55. Andrea L. Volpe, "Cheap Pictures: Cartes de Visite Portrait Photographs and Visual Culture in the United States, 1860–1877" (Ph.D. diss., Rutgers, The State University of New Jersey, 1999; available from UMI), p. 58.

56. The lateral reversal must have bothered many soldiers, who were generally careful to follow correct military procedure as it related to uniforms and weapon placement. See Mark Dunkelman and Michael Winey, "Precious Shadows: The Importance of Photographs to Civil War Soldiers," *Military Images* 16, no. 1 (July–August 1994), pp. 9–10.

57. There were two primary manufacturers of patriotic mats, both based in Waterbury, Connecticut: Scovill Manufacturing Company and Holmes, Booth & Haydens. The former made the most common style, known as "Constitution and Union." As seen in plates 42 and 53, it features: guns with mounted bayonets, a pair of waving flags, and thirteen stars at the top edge; on the left and right sides "CONSTITUTION," "AND UNION"; and on the bottom edge a three-masted gunboat, a cannon, two stacks of cannonballs, and a scroll containing "JULY 4 1776." Curiously, manufacturers during the Civil War era produced patriotic brass mats only for the smaller sixth- and ninth-plate case sizes, not for quarter plates or larger images. The most commonly found mat style from Holmes, Booth & Haydens features the patriotic sentiment "THE UNION NOW AND FOREVER" in a wreath surrounding a drum and a cannon. On top are waving flags and thirteen stars similar to those on the Scovill mat, but without the rifles. For detailed information on Civil War–era case designs, see Paul K. Berg, *Nineteenth Century Photographic Cases and Wall Frames* (Newport Beach, Calif.: Paul K. Berg, 2003), and Paul K. Berg, "Civil War Military and Patriotic Mats for Photographic Cases," *Military Images* 20, no. 4 (January–February 1999), pp. 14–18.

58. Research by the owner of this photograph confirms that in June 1862, Private Bray was wounded in the back of the thigh by grapeshot in a skirmish near the Battle of Seven Pines, Virginia. Disabled from fieldwork, he rejoined his regiment as a nurse and served in this capacity until war's end. George A. Jeffers worked as a daguerreian portraitist, then as an ambrotypist and tintypist, in North and South Carolina from 1851 to 1857. For a history of Jeffers, see Harvey S. Teal, *Partners with the Sun: South Carolina Photographers, 1840–1940* (Columbia: University of South Carolina Press, 2001), pp. 61–62.

59. The term "Union Case" precedes the Civil War by at least three years and refers to the materials of construction, not to any political sympathies.

60. *Memoirs of General William T. Sherman*, 2nd ed. (New York and London: D. Appleton and Company, 1913), vol. 1, p. 195.

61. On April 19, a mob of Confederate sympathizers in Baltimore attacked troops of the Sixth Massachusetts Regiment while they were marching through the city on their way to Washington. The first fatalities of the war after Fort Sumter were four Massachusetts soldiers and some dozen Baltimoreans.

62. According to regimental history, Patten left New York for Washington on the afternoon of April 18, 1861, a day in advance of his regiment.

63. Shaw later became famous for his heroism commanding the Fifty-fourth Massachusetts Infantry of the United States Colored Troops; he died a colonel in 1863 leading his men at the battlefront in South Carolina and was memorialized with them in a large monument in Boston Common designed by Augustus Saint-Gaudens. Shaw is the protagonist of the 1989 film *Glory*. His letter is quoted in John Lockwood and Charles Lockwood, "Letters to New York," *Opinionator* (blog), *The New York Times*, April 25, 2011, http://opinionator.blogs.nytimes.com/2011/04/25/letters-to-new-york/. Francis George Shaw, Robert's father, had moved his family from Boston to Staten Island in 1846.

64. The quantity of different images that survive is significant: 15,000 or more Union covers, approximately 200 Confederate covers. See Bruce Mowday, "Civil War Patriotic Covers," *Military Images* 18, no. 6 (May–June 1997), pp. 19–21.

65. Federal troops captured Davis near Irwinville, Georgia, at dawn on May 10, 1865, a month after the fall of Richmond (April 2), Lee's surrender of his army (April 9), and the assassination of President Lincoln (April 14). The national press responded to the first reports that Davis had tried to escape from the Fourth Michigan Cavalry dressed as a woman. The generally accepted facts are that in the darkness he had hurriedly left his field tent wearing not his own cape, but by mistake his wife Varina's "waterproof" raglan. He also seems to have accepted Varina's offer to use her shawl. Davis wrote after the war: "As I started, my wife thoughtfully threw over my head and shoulders a shawl." Jefferson Davis, *The Rise and Fall of the Confederate Government* (New York and London: Thomas Yoseloff, 1958), vol. 2, pp. 701–2, quoted in Kathleen Collins and Ann Wilsher, "Petticoat Politics: The Capture of Jefferson Davis," *History of Photography* 8, no. 3 (July–September 1984), p. 237. See this article for an analysis of Davis's capture and the production of satirical cartes de visite.

66. *The New York Times*, May 15, 1865, p. 1, quoted in Collins and Wilsher, "Petticoat Politics," p. 238.

67. *Harper's Weekly*, May 27, 1865, p. 323. The suit Davis wore at the time of his capture survives in the Confederate Museum in Richmond, Virginia; the raglan, shawl, and spurs at Beauvoir, the Jefferson Davis house in Biloxi, Mississippi. For modern photographs of the raglan, shawl, and spurs worn by Davis when he was captured, see John Sickles, "The Capture of Jefferson Davis," *Military Images* 28, no. 6 (May–June 2007), pp. 4–19, especially pp. 10–11.

68. See the formal Brady studio portrait of Robert Rathbone standing, in full militia outfit with a sword at his side, in the Prints & Photographs Division of the Library of Congress, negative call number LC-B813-1472A.

69. The parade, on April 19, was photographed extensively, mostly as stereo views. According to Michael J. McAfee, the Seventh New York State Militia did not see action as a regiment, but half of its 1861 members became volunteer officers during the war.

70. Edward and his brother Henry T. Anthony were business partners from 1852; the company name was changed from Edward Anthony to E. & H. T. Anthony by 1862. Anthony as the company's name in this book refers to the firm both before and after 1862.

71. For additional reproductions and analysis of this set of photographs, see Keith F. Davis, *George N. Barnard: Photographer of Sherman's Campaign* (Kansas City, Mo.: Hallmark Cards, 1990), pp. 54–56.

72. *Humphrey's Journal* 13, no. 9 (September 1, 1861), p. 133. Adam Frans van der Meulen (1632–1690), a Flemish painter who specialized in battle scenes, is best known for a series of twenty-three paintings commissioned by King Louis XIV of France and now in the Louvre.

73. George Alfred Townsend, "Still Taking Pictures: Brady, the Grand Old Man of American Photography," *The World*, April 12, 1891, reproduced in Vicki Goldberg, ed., *Photography in Print: Writings from 1816 to the Present*, reprint ed. (Albuquerque: University of New Mexico Press, 1988), p. 205.

74. Ibid.

75. Soon after Fort Sumter, New York state provided at least eighty-four regiments, almost half of the total sent to protect the Union government and

the nation's capital. Most regiments included approximately one thousand men.

76. This author has not seen any prints in the "Illustrations of Camp Life" series with annotations that can help determine which of the three styles of oversize carte-de-visite-format prints is the earliest.

77. Michael J. McAfee, "Fourth Michigan Volunteer Infantry, 1861–1864," *Military Images* 16, no. 3 (November–December 1994), p. 37.

78. In May 1862, in response to Stonewall Jackson's campaign in the Shenandoah Valley, the Twenty-second New York was called to Washington. For more information on the regiment, see Michael J. McAfee, "Uniforms & History: 22nd Regiment National Guard State of New York," *Military Images* 10, no. 3 (November–December 1988), p. 28.

79. For unknown reasons, later in the war Brady and Gardner released very few, if any, of these negatives in other picture formats (carte de visite, album card, stereograph).

80. James F. Gibson started working for Gardner in Brady's Washington gallery by 1860. In 1863 he left Brady to work directly for Gardner, but by September 1864 he had returned to Brady to become a joint owner of the Washington gallery. He remained with Brady until the firm went bankrupt in July 1868.

81. The numbering of the "Brady's Album Gallery" prints is not sequential, and there are large gaps in the series, which includes approximately four hundred photographs. This author's survey of this set of photographs suggests that the same images appear on four different mount types: carte de visite, oversize album card, stereograph, and even large mount. The first three formats feature identical printed captions, titles, and item numbers. The large albumen prints have letterpress titles but are otherwise similar.

82. In some publications, this view of Mrs. Henry's house along Bull Run is attributed to David Woodbury (d. 1866), who, like Barnard, worked for Brady.

83. Stereo views of the same subjects seen in large-format prints credited to Barnard and

Gibson—presumably by prior agreement—credit Barnard exclusively on their mounts. This suggests that Gibson worked for Brady, not Barnard or Anthony, and that Barnard worked for both Brady and Anthony. What is even more confusing is that by September 1863, after Gardner had left Brady and opened his own gallery, these same images appear on a printed checklist for Gardner's stock business. Clearly, these large-format negatives of Bull Run by Barnard and Gibson were no longer in Brady's possession but were then an asset of Gardner's gallery.

84. There is much speculation in the photography literature about why Gardner left Brady. For an excellent, measured analysis, see Zeller, *Blue and Gray in Black and White*, pp. 101–4.

85. Bob Zeller believes Gardner took more than four hundred large-format and stereo negatives. For a detailed discussion, see ibid., chap. 7.

86. The entire contents of Brady's gallery at 785 Broadway in New York City had been mortgaged since early 1861. For information on his finances, see Panzer, *Mathew Brady and the Image of History*.

87. Among a few others, David Woodbury and Anthony Berger would stay with Brady and later accompany him to document the fields of Gettysburg after the battle in July 1863.

88. Gardner, *Sketch Book*, text preceding pl. 46.

89. Ibid., text preceding contents page of vol. 1.

90. William Faulkner, 1956 interview with Jean Stein, published in Philip Gourevitch, ed., *The* Paris Review *Interviews*, vol. 2 (New York: Picador, 2007), pp. 54–55.

91. Gardner even maintained the original negative-numbering system he and Brady had used for the series of small card photographs "Brady's Album Gallery," which stopped production in 1863. After Gardner departed, Brady revised his business plan, and sometime in summer 1863 he resumed distributing Civil War scenes from his Washington gallery and by contract with Anthony; these new photographs have no series designations and often appear with handwritten captions.

92. See William Frassanito, "The Darkroom," *Military Images* 10, no. 6 (May–June 1989), p. 3.

93. The variations in the three plates (21, 22, 65) are as follows. Plate 21: Most sets of the *Sketch Book* show two men conversing at the right edge of Dunker Church at Antietam; in at least one set the camera vantage point is identical but the figures are not present. Plate 22: Most sets show Union soldiers atop a wooden tower, the Elk Ridge signal station, with the flag bearer and a first lieutenant looking off to the viewer's left; in some sets, and from an entirely new vantage point, the flag bearer looks directly at the photographer. This plate is one of only two vertical-format images in the book. The other is plate 74, a view of the Carpenter Gothic–style Poplar Grove Church. Plate 65: The only differences involve the position of the figures approaching the pontoon bridge seen to the left of the large mill. For detailed commentary on the variations, see Marc Daniels, "A Triumph of the Wet Plate: A New Look at Gardner's *Photographic Sketch Book*," *Military Images* 14, no. 2 (September–October 1992), pp. 26–29.

94. For a complete online view of the one hundred plates in the *Sketch Book*, see The Metropolitan Museum of Art's copy via the portal www.metmuseum.org. The accession numbers of the two volumes are 2005.100.502.1 and 2005.100.502.2.

95. Joseph M. Wilson, *A Eulogy on the Life and Character of Alexander Gardner Delivered at a Stated Communication of Lebanon Lodge, No. 7, F.A.A.M., January 19, 1883* (Washington, D.C.: R. Beresford, 1883), quoted in D. Mark Katz, *Witness to an Era: The Life and Photographs of Alexander Gardner* (New York: Viking Penguin, 1991), p. 87.

96. After the war, Pywell went West with Gardner and contributed photographs to numerous government topographic expeditions in the late 1860s and early 1870s.

97. Gardner, *Sketch Book*, text preceding pl. 2.

98. At the end of the war, the United States

Military Railroad Construction Corps released a set of bound albums of Russell's views complete with lengthy titles and inventory numbers. One such album, now in the collection of the Virginia Historical Society, contains 137 large-format albumen silver prints that date from April 1863 to May 1865. All show scenes in Virginia and the District of Columbia.

99. George N. Barnard used this size plate in his fieldwork for the Union army. For copying maps, he used an 18 × 22-inch-format camera.

100. Lincoln announced his intentions to emancipate slaves in "states of rebellion" on September 22, 1862, effective January 1, 1863. For a transcript, see Cuomo and Holzer, *Lincoln on Democracy*, pp. 271–72.

101. Gardner, *Sketch Book*, text preceding pl. 7.

102. E. F. Bleiler, "Introduction to Dover Edition," in Alexander Gardner, *Gardner's Photographic Sketch Book of the Civil War* (New York: Dover Publications, 1959), n.p. Note that the editors at Dover changed the title, inserting "Civil" before "War."

103. Ibid.

104. The other officers present are: Lieutenant Colonel Joseph Dickinson (with straw hat), Count Ferdinand Zeppelin, a visiting Prussian officer (later of airship fame), and Lieutenant Frederick Rosencrantz, a Swedish officer.

105. See Zeller, *Blue and Gray in Black and White*, p. 111.

106. See ibid., p. 104.

107. See *Harper's Weekly*, August 22, 1863, pp. 529, 532–33.

108. Gardner, *Sketch Book*, text preceding pl. 36.

109. Ibid., text preceding pl. 37.

110. See "Group VI: The Rose Farm," in William A. Frassanito, *Gettysburg: A Journey in Time* (New York: Charles Scribner's Sons, 1975), chap. 14, pp. 198–229.

111. Quoted in Charles Hanna, *Gettysburg Medal of Honor Recipients* (Springville, Utah: Bonneville Books, 2010), pp. 253, 254.

112. There is strong circumstantial evidence that Timothy H. O'Sullivan, not Gardner, made

Home of a Rebel Sharpshooter, Gettysburg. In his September 1863 catalogue, Gardner gives credit to O'Sullivan for the large-format glass negative as well as the stereo view made simultaneously. See Frassanito, *Gettysburg*, pp. 186–92.

113. See, among many explications, Susan Sontag, *Regarding the Pain of Others* (New York: Picador, 2004); Anthony W. Lee and Elizabeth Young, *On Alexander Gardner's Photographic Sketch Book of the Civil War* (Berkeley: University of California Press, 2007); Frassanito, *Gettysburg*, part 3, chap. 13; and William A. Frassanito, *Early Photography at Gettysburg* (Gettysburg, Pa.: Thomas Publications, 1995), pp. 241–315.

114. Gardner, *Sketch Book*, text preceding pl. 40.

115. Ibid.

116. Gardner's caption is particularly ambiguous about the allegiance of the soldier. Since he doesn't state otherwise, Gardner leads the reader to believe that the man fought and died for the Union.

117. See Library of Congress negative number LC-B815-251. In his 1863 publication of war views, Gardner gave O'Sullivan's stereo No. 251 the title "Rocks could not save him at the Battle of Gettysburg." See Katz, *Witness to an Era*, p. 288.

118. Gardner, *Sketch Book*, text preceding pl. 41.

119. Frassanito, *Gettysburg*, p. 192. Frassanito also notes that in his *Catalogue of Photographic Incidents of the War* (Washington: H. Polkinhorn, September 1863), Gardner identified O'Sullivan as the cameraman for this photograph.

120. Also in 1936, the photographer Arthur Rothstein moved a cow's skull while working for the Farm Security Administration, a New Deal agency.

121. Sontag, *Regarding the Pain of Others*, p. 53.

122. In April and May 1865, Gardner would produce an extended series of views of the destruction of Richmond, four of which he included in the *Sketch Book*. He credits himself as the cameraman for only one other photograph in the second volume of the *Sketch Book*: plate 65, a landscape view of Jericho Mills and a pontoon bridge across the North Anna River, northwest of Richmond. Recent research confirms that this photograph is from a negative by O'Sullivan, not Gardner. See Library of Congress stereo negative LC-B811-750.

123. Ulysses S. Grant, *Personal Memoirs of U. S. Grant*, vol. 2 (New York: Charles L. Webster, 1886), chap. 55, p. 276.

124. It is interesting to note that Gardner made the plate in the *Sketch Book* from an enlargement from one half of Reekie's stereo view of the collecting of the dead. It and two related negatives survive in the Library of Congress. In one, the knit-capped worker is seen with a shovel working in a background ditch; in the other view, Reekie has moved his camera and looks down on a field of bones and skulls, including the same soldier's leg and boot, perhaps in their "original" location, emerging from the battlefield burial ground.

125. Lee and Young, *On Alexander Gardner's Photographic Sketch Book of the Civil War*, p. 50.

126. Gardner, *Sketch Book*, text preceding pl. 94.

127. According to D. Mark Katz, of the 127 known portraits of Lincoln, Gardner made thirty-seven, more than any other photographer. The earliest are cartes de visite made in Brady's studio on February 24, 1861; the last are proto-snapshots of Lincoln at his second inauguration, on March 4, 1865. See Katz, *Witness to an Era*, p. 107.

128. The quotation is from "Photographic History of the War," a lengthy book advertisement Gardner wrote and circulated through his publisher, Philp & Solomons. The advertisement is transcribed in Katz, *Witness to an Era*, pp. 88–89.

129. The unsigned article, "Gardner's Photographs," also states that Gardner was at work on another book of photographs, *Rays of Sunlight from South America*. This volume would feature a collection of seventy images by the American photographer Henry Moulton that Gardner had printed. The subject was the guano business on the Chincha Islands off the coast of Peru. In the autumn of 1865, a few months before the *Sketch Book* was published, Philp & Solomons released the Peru book, known today in only five copies. A complete set in the collection of the New York Public Library confirms that Gardner applied the same mounting design, typographic style, and artist credit formulation he would use for the Civil War book.

130. For a useful summary of Gardner and his *Sketch Book*, see Anne E. Peterson, "Alexander Gardner in Review," *History of Photography* 34, no. 4 (November 2010), pp. 356–67.

131. See Mark Dunkelman and Michael Winey, "Precious Shadows: The Importance of Photographs to Civil War Soldiers," *Military Images* 16, no. 1 (July–August 1994), pp. 6–13.

132. Ibid., p. 12.

133. Ibid.

134. Ibid., p. 9.

135. "New Year's Day, 1862," *Humphrey's Journal* 13, no. 17 (January 1, 1862), p. 271.

136. For a thorough examination of the subject, see David W. Vaughan, "Georgia History in Pictures: Georgians in Gray, Part I: A Photographic Look at the Empire State's Confederate Soldiers," *The Georgia Historical Quarterly* 89, no. 1 (Spring 2005), pp. 82–110.

137. Union and Confederacy combined, only one in four soldiers died from wounds in battle. The majority died from infections or diseases acquired in camps and hospitals.

138. See the December 26, 1861, letter from the Reverend Mr. Crumley to J. M. Newby, published in the Augusta, Georgia, *Daily Constitutionalist*, January 11, 1862, p. 2, col. 1, transcription accessed August 25, 2012, www.uttyler.edu/vbetts/augusta_const_ja-je_62.htm.

139. Ronald S. Coddington, "Comrades in Arms: *Cartes de Visite* from the Collection of Ronald S. Coddington," *Military Images* 30, no. 1 (July–August 2008), p. 21.

140. See the extensive analysis of the photograph in Keith Bohannon, "More Georgians in Gray," *Military Images* 8, no. 3 (November–December 1986), p. 8.

141. For another half-plate tintype with the same backdrop and draped table, see John Stacey, "Naval Uniforms of the Civil War: Part IV: Enlisted Men of the U.S. Navy," *Military Images* 1, no. 6 (May–June 1980), p. 17. For a useful general reference on Union sailors, see Ron Field, *Bluejackets: Uniforms of the United States Navy in the Civil War Period, 1852–1865* (Atglen, Pa.: Schiffer Military History, 2010).

142. See Roy Mantle, "Proppin' the Prop: A Glimpse of Martial and Patriotic Props Used by Civil War Photographers," *Military Images* 18, no. 2 (September–October 1996), pp. 20–29.

143. Giles (1842–1915) misspells the photographer's name; he was William Bridgers, not Bridges. Text quoted in Philip Katcher and David Scheinmann, "Photography During the Civil War," *Military Images* 2, no. 2 (September–October 1980), p. 12. The memoir source is *Rags and Hope: The Recollections of Val C. Giles, Four Years with Hood's Brigade, Fourth Texas Infantry, 1861–1865*, ed. Mary Lasswell (New York: Coward-McCann, 1961).

144. Walt Whitman, *Specimen Days* (1882), in *Complete Poetry and Collected Prose* (New York: Library of America, 1982), pp. 778–79. Emphasis added.

145. On Zouave companies during the Civil War, see Michael J. McAfee, *Zouaves: The First and the Bravest* (Gettysburg, Pa.: Thomas Publications, 1991); Michael J. McAfee, "What Is a Zouave?," *Military Images* 1, no. 2 (September–October 1979), pp. 14–26; and Michael J. McAfee, "U.S. Army Uniforms of the Civil War: Part VI: Zouaves and Chasseurs," *Military Images* 4, no. 3 (November–December 1982), pp. 10–15.

146. Text quoted in Carol Villa, "Babes in Arms," *Military Images* 4, no. 1 (July–August 1982), p. 8.

147. For a similar field scene, see *Military Images* 8, no. 4 (January–February 1987), p. 13. The editors credit the soldiers to Company D, Ninety-fifth Pennsylvania, "Gosline's Zouaves."

148. Zouave and Chasseur regiments remained active in various state militias throughout the war and long after Appomattox. It is thus quite difficult to determine whether a paper-print portrait of a Zouave soldier dates from the Civil War or after. Most, but likely not all, cased portraits of Zouaves can be safely dated to the war years. According to Michael McAfee, an expert on Zouaves, there were in New York City alone three Zouave regiments active after the war, and seven in the Army of the Potomac.

149. The quotation comes from an unsigned article, possibly written by William Howard Russell, "American Photographs," *The Times* (London), August 30, 1862, p. 11. The article itself was relatively popular and reappears in *The Photographic Journal* (Photographic Society of Great Britain), no. 128 (December 15, 1862), and later in *The Journal of the Photographic Society of London* 8 (1864), p. 185.

150. As mentioned previously, there are far fewer surviving cartes de visite of Southerners, as the paper-print process (involving a collodion glass negative and a positive albumen silver print) was just making headway in the United States at the start of the war. The Union blockade of Confederate ports succeeded in many ways— among other things, it prevented photographers from obtaining sensitized photographic paper, the majority of which was manufactured in New York state.

151. See Bell I. Wiley, *The Life of Billy Yank & The Life of Johnny Reb: The Common Soldier of the Union & The Common Soldier of the Confederacy* (Indianapolis: Bobbs-Merrill, 1952).

152. Although her actual military service record remains uncertain, Frances Clalin Clayton claimed that, under the pseudonym Jack Williams, she fought in Company I of the Fourth Missouri Heavy Artillery and Company A of the Thirteenth Missouri Cavalry.

153. With her friend Olive Gilbert, Sojourner Truth wrote and self-published her autobiography, *The Narrative of Sojourner Truth, a Northern Slave*, in 1850. The income from book sales supported her activities. In 1851, at the Ohio Women's Rights Convention in Akron, she delivered the famous talk on equal rights for women known as "Ain't I a Woman?" For more on her life and work, see the biographies by Carleton Mabee, *Sojourner Truth: Slave, Prophet, Legend* (New York: New York University Press, 1993), and Nell Irvin Painter, *Sojourner Truth: A Life, a Symbol* (New York: W. W. Norton, 1996).

154. Mabee, *Sojourner Truth*, p. 216.

155. "A Typical Negro," *Harper's Weekly*, July 4, 1863, p. 429. The timing of the publication of this "slave to citizen" story was strategic, but not because it appeared the day after Gettysburg. The weekly had to set type before its news editors knew anything about the three-day battle. The only report of what was coming appeared in the column "Domestic Intelligence" (subtitled "The Army of the Potomac," p. 419): "General Lee's whereabouts are unknown, but he is supposed to be in the Shenandoah Valley. A decisive battle is momentarily expected, and General [Joseph] Hooker has placed an embargo upon correspondence until it comes off."

156. McPherson & Oliver made at least three consecutive portraits of Gordon with his shirt lowered; the only differences are a slight shifting of the chin and the angle of the head. One of the two variants of plate 156 appears as an engraving in *Harper's Weekly*. A reproduction also appears on the cover of an antislavery pamphlet by Frances Anne Kemble, *The Views of Judge Woodward and Bishop Hopkins on Negro Slavery at the South* (Philadelphia: Privately printed, [1863]).

157. "A Typical Negro," *Harper's Weekly*, July 4, 1863, p. 429.

158. After Banks arrived in New Orleans in December 1862, he immediately attacked the problem of public education for emancipated slaves. In January 1863 he established free public schools in Louisiana for African-American and white children, and within months 1,422 pupils were enrolled. The teachers were mostly women found through a network of abolitionist and missionary groups from the North. According to the *Report of the Board of Education for Freedmen, Department of the Gulf, for the Year 1864* ([New Orleans: Office of the True Delta, 1865], pp. 16, 21), by the end of 1864, Banks had created ninety-five schools serving 9,571 African-American pupils, approximately half of the juvenile African-American population in the state. The National Freedman's Relief Association dates from at least February 20, 1862. See Kathleen Collins, "Portraits of Slave Children," *History of Photography* 9, no. 3 (July–September 1985), p. 187.

159. After 1831, almost every slave state enacted legislation prohibiting slaves from being taught to read and write. In Louisiana, the law of March 16, 1830, affirmed that "all persons who shall teach, or permit or cause to be taught, any slave in this State, to read or write, shall, on conviction thereof, before any court of competent jurisdiction, be imprisoned not less than one month nor more than twelve months." See Henry A. Bullard and Thomas Curry, comps., *A New Digest of the Statute Laws of the State of Louisiana . . . to the Year 1841, Inclusive* (New Orleans: E. Johns & Co., 1842), vol. 1, pp. 271–72.

160. The only other photographer known to have made portraits of the emancipated slaves was J. E. McClees of Philadelphia.

161. *Harper's Weekly*, January 30, 1864, p. 71.

162. Ibid.

163. According to the historian Kathleen Collins, "These schools were the first in the South to be supported by taxation." See Collins, "Portraits of Slave Children," p. 187.

164. See Mark Dunkelman, *Gettysburg's Unknown Soldier: The Life, Death, and Celebrity of Amos Humiston* (Westport, Conn.: Praeger, 1999). For an exploration of the photograph and the story, see Errol Morris's five-part "Whose Father Was He?," *Opinionator* (blog), *The New York Times*, March 29–April 2, 2009, http://opinionator.blogs.nytimes.com/2009/03/29/whose-father-was-he-part-one/.

165. The carte de visite is in a leather photograph album containing thirty-seven other family portraits and likenesses of Abraham Lincoln in The Metropolitan Museum of Art's collection.

166. "Whose Father Was He?," *The Philadelphia Inquirer*, October 19, 1863, p. 4.

167. See Don Dillon, "Black Troops in the U.S. Military," *Military Images* 2, no. 6 (May–June 1981), pp. 16–24. A small number of African-Americans enlisted as soldiers in the Continental Army during the American Revolution, and many fought in volunteer units, mostly in the navy, during the War of 1812. Overall enlistment for the Union in the Civil War is estimated at 2 million or more; for the Confederacy, 1 to 1.5 million.

168. This was less than the sum received by white soldiers, who were paid $13 per month, with an additional $3.50 clothing allowance. According to the photography historian William Gladstone, "The pay disparity was eliminated [on June 15, 1864, when black and white soldiers] were authorized $16 per month plus clothing allowance." See William Gladstone, "The 29th Connecticut Colored Infantry," *Military Images* 2, no. 6 (May–June 1981), p. 26.

169. Frederick Douglass oration at the Colored National Convention, Cleveland, September 29, 1848, accessed September 1, 2012, www.teachingamericanhistory.org/library/index.asp?document=768.

170. See Michael J. McAfee, "The 108th U.S.C.T.," *Military Images* 25, no. 4 (January–February 2004), pp. 36–37.

171. Ibid., p. 37.

172. The Union imprisoned 214,000 Confederate soldiers; 26,000, or about 12 percent of the population, died. The Confederacy imprisoned approximately the same number, 210,000 Union soldiers, 30,000 of whom died, or about 15 percent. See "In Durance Vile: A Photo Album of P.O.W.'s," *Military Images* 15, no. 4 (January–February 1994), pp. 4–8.

173. See Dennis Babbitt, "Rock Island, Stereo Views of the Illinois Prisoner of War Camp," *Military Images* 15, no. 1 (July–August 1993), pp. 6–10.

174. For the revenue tax on photographs, see the article in *The Philadelphia Photographer* 2, no. 1 (October 1865), pp. 168–69, which summarizes the June 30, 1864, act and its amendment of March 3, 1865: "All sun pictures, including photographs, ambrotypes, and daguerreotypes, are liable to stamp duties, varying in value according to the retail price of the pictures." Failure to apply the stamp involved loss of the photograph and "a penalty of one hundred dollars on any maker or manufacturer of photographs, &c., who shall sell, *expose for sale*, send out, remove, or *deliver* any of the same, before the duty to which they were liable shall have been fully paid by affixing thereon the proper stamps."

175. For comparison, the tax on matches alone (one cent per hundred matches) generated more than $1 million annually. The revenue stamps (proof that the tax had been paid) were supposed to be canceled by proprietors with their initials and the date of sale. Some businesses had a rubber stamp with the date, but most simply initialed the stamps or marked them with an X to cancel them. See David A. Norris, "Revenue Stamps & Civil War Photography," *Military Images* 20, no. 6 (May–June 1999), pp. 13–15.

176. After the war, Wirz was tried and convicted at a military tribunal in Washington, and hanged on November 10, 1865. Alexander Gardner photographed his execution. For related photographs, see Katz, *Witness to an Era*, pp. 195–96.

177. Whitman, *Specimen Days* (1882), in *Complete Poetry and Collected Prose*, p. 265.

178. See Michael J. McAfee, "The Third Regiment, Michigan Volunteer Infantry, 1864–1865," *Military Images* 27, no. 2 (September–October 2005), pp. 32–33.

179. Daniel G. Crotty, *Four Years Campaigning in the Army of the Potomac* (Grand Rapids, Mich.: Dygert Bros. & Co., 1874), p. 57.

180. In 1881, at age fifty-nine, Barton founded the American Red Cross.

181. Statistics on Barton's work with missing soldiers are from the website of the National Museum of Civil War Medicine, accessed September 2, 2012, www.civilwarmed.org/clara-barton-missing-soldiers-office/.

182. See Juanita Leisch, "An Army of Women: A Look at the Non-Uniformed Participants in the Civil War," *Military Images* 21, no. 6 (May–June 2000), pp. 6–11; and Juanita Leisch, *Who Wore What: Women's Wear 1861–1865* (Gettysburg, Pa.: Thomas Publications, 1995).

183. See Roy Nibley, "Miracles of American Spirit," *Military Images* 25, no. 3 (November–December 2003), pp. 15–17.

184. The painting is in the collection of The Metropolitan Museum of Art, Gift of John Stewart Kennedy, 1897 (97.34). See Carrie Rebora Barratt et al., "*Washington Crossing the Delaware*: Restoring an American Masterpiece," *The Metropolitan Museum of Art Bulletin* 69, no. 2 (Fall 2011).

185. In many ways, the quality of the paintings and sculptures on view at the fair and the public's generous response to them led to the creation of The Metropolitan Museum of Art in 1870. Colonel Luigi Palma di Cesnola, the museum's first director, was a decorated Civil War cavalry officer who had been taken prisoner by Confederate forces at the Battle of Aldie in Virginia in June 1863. Gurney also contributed six of the eight original albumen silver prints tipped into the pages of the fair's official publication. See *A Record of the Metropolitan Fair in Aid of the United States Sanitary Commission, Held at New York, in April, 1864* (New York: Hurd and Houghton, 1867).

186. "The Metropolitan Fair . . . ," *The New York Times*, April 9, 1864, p. 8.

187. Gardner, *Sketch Book*, text preceding pl. 36.

188. Plunkett died on March 10, 1885, in his native Massachusetts.

189. Walt Whitman to Louise Whitman, December 29, 1862, in Walt Whitman, *The Wound Dresser: A Series of Letters Written from the Hospitals in Washington During the War of the Rebellion*, ed. Richard Maurice Bucke (Boston: Small, Maynard, 1898), p. 48, accessed September 2, 2012, www.gutenberg.org. At the Battle of Fredericksburg, the Lacy House (known today as Chatham Manor) served as a hospital for the Second Corps of the Union army.

190. Walt Whitman, *Memoranda During the War: Civil War Journals, 1863–1865* (Mineola, N.Y.: Dover Publications, 2010), p. 35.

191. Ibid., p. 1. Some of Whitman's original notebooks survive in the collection of the New York Public Library.

192. Bontecou organized the photographs in his albums anatomically, from top to bottom (head to foot), and then within each area alphabetically by patient. For a complete history of Bontecou and his medical photographs and albums, see Stanley B. Burns, ed., *Shooting Soldiers: Civil War Medical Photography by R. B. Bontecou* (New York: Burns Archive Press, 2011).

193. Ibid., p. 10.

194. Whitman, *Specimen Days* (1882), in *Complete Poetry and Collected Prose*, p. 779.

195. Harewood General Hospital opened in September 1862 and closed on May 20, 1866. Originally built with nine wards containing sixty-three beds each, it could accommodate a total of 945 patients. As the war progressed, Harewood added as many as 312 hospital tents with a capacity of 1,872 beds. According to Charles Smart, *The Medical and Surgical History of the War of the Rebellion*, part 3, vol. 1 (Washington: Government Printing Office, 1888), p. 960, the bed census of December 17, 1864, documented 2,080 beds, with 1,207 occupied.

196. Burns, *Shooting Soldiers*, pp. 34–35.

197. Whitman, *Memoranda During the War*, pp. 21–22.

198. For a discussion of early war medicine, see John Halliday, "Three Hospitals," *Military Images* 18, no. 2 (September–October 1996), pp. 13–17.

199. Whitman, *Memoranda During the War*, p. 33.

200. Burns, *Shooting Soldiers*, p. 16.

201. Ibid., p. 22.

202. Whitman, *Memoranda During the War*, pp. 74–75. Whitman tried but failed to find a publisher for his notes from during and soon after the war. He included some of the material in *Drum-Taps, and Sequel to Drum-Taps* (1865–66), and much of it in *Memoranda During the War* (1875–76), which he had to self-publish. Most of his notes appear in *Specimen Days* (1882).

203. For more on Barnard and his work with Orlando Poe, see Davis, *Barnard: Photographer of Sherman's Campaign*, p. 63.

204. In December 1863 there were photographers employed by the Department of the Treasury, the United States Coast Survey, and the bureau of military railroads, and they would soon be employed by the Army Medical Museum.

205. For details about Barnard's activity during the march to Savannah, see Davis, *Barnard: Photographer of Sherman's Campaign*, p. 89.

206. George N. Barnard to Orlando Poe, March 7, 1866, letter no. 118, O. M. Poe Papers, 1852–1922, Library of Congress Manuscript Division, Washington, D.C., quoted in Davis, *Barnard: Photographer of Sherman's Campaign*, p. 97. In the same letter, Barnard requested the use of a set of maps.

207. See Davis, *Barnard: Photographer of Sherman's Campaign*, pp. 102–3.

208. Combination printing of skies in European photography was not common, but it was often discussed in the American photographic literature of the 1850s–1860s. The most prominent artist to print clouds over his landscapes is Gustave Le Gray (1820–1884); see his *Mediterranean Sea at Sète* (1857) in the collection of The Metropolitan Museum of Art (2005.100.48).

209. Theodore R. Davis to Orlando Poe, September 9, 1866, quoted in Davis, *Barnard: Photographer of Sherman's Campaign*, p. 103.

210. *Sherman's Campaign* soon received reviews and commentaries in *The New York Times* (November 30, 1866), *Harper's Weekly* (December 8, 1866), and *Harper's Monthly* (January 1867).

211. Whether it was Barnard's intention or not, Davis's text is exceptionally difficult to find alongside any intact copy of his book. The Metropolitan Museum of Art has in its

study collection (1970.525 [1–61]) a bound example of Barnard's *Photographic Views of Sherman's Campaign Embracing Scenes of the Occupation of Nashville, the Great Battles around Chattanooga and Lookout Mountain, the Campaign of Atlanta, March to the Sea, and the Great Raid through the Carolinas; from Negatives Taken in the Field by Geo. N. Barnard, Official Photographer of the Military Div. of the Miss.* [New York, 1866] and a 1960s photocopy of the original text by Davis. No recorded copy of *Sherman's Campaign* is known with the maps Barnard had acquired from Poe for the publication.

212. George N. Barnard, "Introduction," in *Photographic Views of Sherman's Campaign, from Negatives Taken in the Field by Geo. N. Barnard . . .* (New York: Wynkoop & Hallenbeck, 1866), n.p., quoted from a photocopy (1960s) in the study collection of the Department of Photographs at The Metropolitan Museum of Art. The original source seems to be the [Thomas Addis] Emmet Collection at the New York Public Library. Theodore Davis, in his unsigned essay "Sherman and His Generals," does not comment on the aesthetics of any particular photograph, but his text proceeds with the sequence of images, which follows the movement of Sherman's army from the occupation of Nashville to the battle for Chattanooga and Lookout Mountain (Tennessee); and from there to the campaign for Atlanta, and on to Savannah, a passage commonly known as the "March to the Sea." Davis's full text appears in the 1977 Dover edition of *Photographic Views of Sherman's Campaign*, with a preface by Beaumont Newhall.

213. At the time of the scheduled sitting, Major General Francis Preston Blair was absent. The studio photographed him separately and later collaged him into the group image. He sits to the far right in the portrait.

214. [Theodore R. Davis], "Sherman and His Generals," in *Photographic Views of Sherman's Campaign*, p. 7.

215. Ibid.

216. See Visual Materials from the O. M. Poe Papers, Library of Congress Manuscript Division, for a panoramic print combining both plates (DLC/PP-1985:644). It is inscribed "No. 33."

217. Davis, "Sherman and His Generals," p. 7.

218. Davis, *Barnard: Photographer of Sherman's Campaign*, p. 174. It seems likely that Barnard had seen Cole's landscape in New York City and been influenced by it, as were so many other artists of the era. The painting was on view at the Artists' Fund Society, 625 Broadway, in its Third Annual Exhibition in November and December 1862. The work received notable commentary in the press, including a review on November 17, 1862, in *The New York Times*, which Barnard would have read. Moreover, the Broadway location was just a few blocks from the Anthonys' retail store, where Barnard worked and conducted his business from 1859 to 1861, in late 1862, and throughout his collaboration with Orlando Poe.

219. Davis, "Sherman and His Generals," p. 12.

220. During the Civil War, it was the custom not to fight actively during the winter months.

221. On the printed mounts in *Sherman's Campaign*, the names Resaca and Savannah appear as "Resacca" and "Savanah."

222. These first photographs—three stereo-format negatives and one 6½ × 8½-inch negative—were released by E. & H. T. Anthony, as announced in the firm's fall 1864 catalogue, and by *Harper's Weekly* as a wood engraving on February 18, 1865. In each, the sign and carvings are clearly visible on the tree. Barnard's essayist Theodore Davis wrote as if he knew firsthand the quality of the man: "It seemed impossible that McPherson was gone. His loss was to these troops as a star torn from the flag. . . . Tears trickled down the cheeks of many a bronzed-faced soldier as the word passed down the line that McPherson was gone." Davis, "Sherman and His Generals," p. 23.

223. The clouds in this 1864 photograph also appear in *Sherman's Campaign*, plate 22, *Battle Ground of Resaca, Georgia, No. 4*, from 1866. A survey of the skies in Barnard's book confirms that in at least one intact album (Hallmark Cards/Nelson Atkins Museum), he used a single cloud negative for four photographs (plates 33, 37, 43, and 49.)

224. Davis, "Sherman and His Generals," p. 28.

225. Diary entry for November 15, 1864, quoted in Davis, *Barnard: Photographer of Sherman's Campaign*, p. 85.

226. Theodore Davis refers to the building as the Wilmington depot.

227. *The Richmond Whig*, April 21, 1865.

228. J. R. Hamilton, "Condition of the Public Mind in Richmond," *The New York Times*, April 30, 1865, p. 2.

229. For a discussion of the photograph, see David Lowe and Philip Shiman, "Substitute for a Corpse," *Civil War Times*, December 2010, p. 41. For an explication of the entire series, see "Group VII: Fort Mahone and Fort Sedgwick," in William A. Frassanito, *Grant and Lee: The Virginia Campaigns, 1864–1865* (New York: Charles Scribner's Sons, 1983), chap. 10, pp. 335–77.

230. Admiral David D. Porter, quoted in "Lincoln's Visit to Richmond," on the National Park Service website for Richmond National Battlefield Park, Virginia, accessed November 4, 2012, nps.gov/rich/historyculture/lincvisit.htm.

231. Ibid.

232. The Fourth Michigan Cavalry would not capture Confederate President Davis until May 10. General Joseph E. Johnston surrendered the last Confederate army under arms on April 26, 1865.

233. For a complete account of Lincoln's assassination and photographs and ephemera related to the trial and execution of the conspirators, see James L. Swanson and Daniel R. Weinberg, *Lincoln's Assassins: Their Trial and Execution: An Illustrated History* (New York: William Morrow, 2006).

234. The story of John Surratt is almost unbelievable. He escaped to England via Canada and eventually settled in Rome. In 1867 a former schoolmate from Maryland recognized Surratt, then a member of the Papal Zouaves, and he was extradited to Washington. In September 1868 the government dropped the charges against him after his trial ended in a hung jury. Surratt retired to Maryland, worked as a clerk, and lived until 1916.

235. "The Assassin's End," *Harper's Weekly*, May 13, 1865, p. 294.

236. Ibid.

237. The Brady studio photographers and dates of the source photographs are as follows, from left to right: Top row: Alexander Gardner, February 24, 1861; Thomas Le Mere, April 17, 1863; Mathew Brady, January 8, 1864. Middle row: Gardner, February 24, 1861; Anthony Berger, February 9, 1864; Brady studio, 1862 (?). Bottom row: Berger, February 9, 1864; Berger, February 9, 1864; Brady, January 8, 1864.

238. For an excellent study of surviving photographic negatives of the Civil War and where they are today, see "The Journey of the Negatives," in Zeller, *Blue and Gray in Black and White*, chap. 12, pp. 189–200.

SELECTED BIBLIOGRAPHY

Angle, Paul M., and Earl Schenck Miers, [eds.]. *The Living Lincoln: The Man and His Times, in His Own Words*. New York: Barnes & Noble Books, 1992.

Barnard, George N. *Photographic Views of Sherman's Campaign Embracing Scenes of the Occupation of Nashville, the Great Battles around Chattanooga and Lookout Mountain, the Campaign of Atlanta, March to the Sea, and the Great Raid through the Carolinas; from Negatives Taken in the Field by Geo. N. Barnard, Official Photographer of the Military Div. of the Miss.* [New York, 1866]. Reprint ed., *Photographic Views of Sherman's Campaign*, including Theodore R. Davis's text, "Sherman and His Generals," and a new preface by Beaumont Newhall. New York: Dover Publications, 1977.

Barnes, Joseph K., ed. *The Medical and Surgical History of the War of the Rebellion*. 6 vols. Washington, D.C.: Government Printing Office, 1870–88.

Basler, Roy P., ed. *The Collected Works of Abraham Lincoln*. 8 vols. New Brunswick, N.J.: Rutgers University Press, 1953–55.

Bengtson, Bradley P., and Julian E. Kuz, eds. *Photographic Atlas of Civil War Injuries*. Grand Rapids, Mich.: Medical Staff Press, 1996.

Berg, Paul K. *19th Century Photographic Cases and Wall Frames*. Huntington Beach, Calif.: Huntington Valley Press, 1995. 2nd ed., 2003.

Burns, Stanley B., ed. *Shooting Soldiers: Civil War Medical Photography by R. B. Bontecou*. New York: Burns Archive Press, 2011.

Carlebach, Michael L. *The Origins of Photojournalism in America*. Washington, D.C.: Smithsonian Institution Press, 1992.

The Civil War. 28 vols. Alexandria, Va.: Time-Life Books, 1987.

Coddington, Ronald S. *Faces of the Civil War: An Album of Union Soldiers and Their Stories*. Baltimore: Johns Hopkins University Press, 2004.

Cuomo, Mario M., and Harold Holzer, eds. *Lincoln on Democracy*. New York: HarperCollins, 1990.

Darrah, William C., *Cartes de Visite in Nineteenth Century Photography*. Gettysburg, Pa.: W. C. Darrah, 1981.

Davis, Keith. *George N. Barnard, Photographer of Sherman's Campaign*. Kansas City, Mo.: Hallmark Cards, Inc., 1990.

[Davis, Theodore R.] *Photographic Views of Sherman's Campaign from Negatives Taken in the Field by Geo. N. Barnard, Official Photographer of the Military Division of the Mississippi*. New York: Wynkoop & Hallenbeck, 1866.

Davis, William C., ed. *The Image of War, 1861–1865*. 6 vols. Garden City, N.Y.: Doubleday, 1981–84.

———, ed. *Touched by Fire: A Photographic Portrait of the Civil War*. 2 vols. Boston: Little, Brown, for the National Historical Society, 1985–86.

Dee, Christine. *"Feel the Bonds That Draw": Images of the Civil War at the Western Reserve Historical Society*. Kent, Ohio: Kent State University Press, 2011.

Dinkins, Greg, ed. *Gettysburg in 3D: A Look Back in Time*. Minneapolis: Voyageur Press, 2009.

Field, Ron. *Bluejackets: Uniforms of the United States Navy in the Civil War Period, 1852–1865*. Atglen, Pa.: Schiffer Books, 2010.

Foote, Shelby. *The Civil War: A Narrative*. 3 vols. New York: Random House, 1958–74.

Frassanito, William A. *Gettysburg: A Journey in Time*. New York: Charles Scribner's Sons, 1975.

———. *Antietam: The Photographic Legacy of America's Bloodiest Day*. New York: Charles Scribner's Sons, 1978.

———. *Grant and Lee: The Virginia Campaigns, 1864–65*. New York: Charles Scribner's Sons, 1983.

———. *Early Photography at Gettysburg*. Gettysburg, Pa.: Thomas Publications, 1995.

Gardner, Alexander. *Gardner's Photographic Sketch Book of the War*. 2 vols. Washington, D.C.: Philp & Solomons, [1866]. Reprint ed., *Gardner's Photographic Sketch Book of the Civil War*, with a new introduction by E. F. Bleiler. Mineola, N.Y.: Dover Publications, 1959.

Gladstone, William A. *United States Colored Troops, 1863–1867*. Gettysburg, Pa.: Thomas Publications, 1990.

Goldberg, Vicki, ed. *Photography in Print: Writings from 1816 to the Present*. New York: Simon and Schuster, 1981. Reprint ed., Albuquerque: University of New Mexico Press, 1988.

Holzer, Harold, ed. *The Lincoln–Douglas Debates: The First Complete, Unexpurgated Text*. New York: HarperCollins, 1993.

———, ed. *The Lincoln Mailbag: Letters to the President*. New York: Addison-Wesley, 1993.

Johnson, Brooks. *An Enduring Interest: The Photographs of Alexander Gardner*. Exh. cat. Norfolk, Va.: The Chrysler Museum, 1991.

Kagan, Neil, ed., and Stephen G. Hyslop. *Eyewitness to the Civil War: The Complete History from Secession to Reconstruction*. Washington, D.C.: National Geographic, 2006.

Katz, D. Mark. *Witness to an Era: The Life and Photographs of Alexander Gardner*. New York: Viking Penguin, 1991.

Kunhardt, Dorothy, and Philip B. Kunhardt. *Mathew Brady and His World . . . from Pictures in the Meserve Collection*. Alexandria, Va.: Time-Life Books, 1977.

Lee, Anthony W., and Elizabeth Young. *On Alexander Gardner's* Photographic Sketch Book *of the Civil War*. Berkeley: University of California Press, 2007.

Leisch, Juanita. *Who Wore What?: Women's Wear 1861–1865*. Gettysburg, Pa.: Thomas Publications, 1995.

Mabee, Carleton. *Sojourner Truth: Slave, Prophet, Legend*. New York: New York University Press, 1993.

McAfee, Michael J. *Zouaves: The First and the Bravest*. Gettysburg, Pa.: Thomas Publications, 1991.

McPherson, James M. *Battle Cry of Freedom: The Civil War Era*. The Oxford History of the United States 6. New York: Oxford University Press, 1988. Rev. ed., 2003.

Mellon, James. *The Face of Lincoln*. New York: Viking Press, 1979.

Meredith, Roy. *Mr. Lincoln's Camera Man: Mathew B. Brady*. New York: Charles Scribner's Sons, 1946. Reprint ed. with corrections, Mineola, N.Y.: Dover Publications, 1974.

Military Images, a bi-monthly magazine. 31 vols. to date. Export, Pa.: David Neville, 2004–. Founded by Harry Roach in 1979 as *Military Images Magazine*.

Miller, Frances Trevelyan, ed. *The Photographic History of the Civil War*. 10 vols. New York: The Review of Reviews/Patriot Publishing Company, 1911. Collector's ed., Norwalk, Conn.: Easton Press, 1995.

Neely, Mark E., Jr., and Harold Holzer. *The Lincoln Family Album*. New York: Doubleday, 1990. Paperback ed., Carbondale: Southern Illinois University Press, 2006.

Painter, Nell Irvin. *Sojourner Truth: A Life, a Symbol*. New York: W. W. Norton, 1996.

Panzer, Mary. *Mathew Brady and the Image of History*. Exh. cat. Washington, D.C.: Smithsonian Institution Press for the National Portrait Gallery, 1997.

A Record of the Metropolitan Fair in Aid of the United States Sanitary Commission, Held at New York, in April, 1864. New York: Hurd and Houghton, 1867.

Robertson, James. *The Untold Civil War: Exploring the Human Side of War.* Edited by Neil Kagan. Washington, D.C.: National Geographic, 2011.

Root, Marcus A. *The Camera and the Pencil; or, The Heliographic Art.* Philadelphia: M. A. Root, 1864. Reprint ed., Pawlet, Vt.: Helios, 1971.

Russell, William Howard. *My Diary North and South.* New York: Harper & Brothers Publishers, 1863.

Sherman, William T. *Memoirs of General William T. Sherman.* 2nd ed. 2 vols. New York and London: D. Appleton and Company, 1913.

Simpson, Brooks D., Stephen W. Sears, and Aaron Sheehan-Dean, eds. *The Civil War: The First Year Told by Those Who Lived It.* New York: The Library of America, 2011.

Sontag, Susan. *Regarding the Pain of Others.* New York: Farrar, Straus & Giroux, 2003.

Sullivan, Constance, ed. *Landscapes of the Civil War: Newly Discovered Photographs from the Medford Historical Society.* New York: Alfred A. Knopf, 1995.

Swanson, James L., and Daniel R. Weinberg. *Lincoln's Assassins: Their Trial and Execution. An Illustrated History.* New York: William Morrow, 2006.

Teal, Harvey S. *Partners with the Sun: South Carolina Photographers 1840–1940.* Columbia: University of South Carolina Press, 2001.

Volpe, Andrea L. "Cheap Pictures: Cartes de Visite Portrait Photographs and Visual Culture in the United States, 1860–1877." Ph.D. diss., Rutgers, The State University of New Jersey, New Brunswick, 1999; available from UMI.

Voorsanger, Catherine Hoover, and John K. Howat, eds. *Art in the Empire City, New York, 1825–1861.* Exh. cat. New York: The Metropolitan Museum of Art, 2000.

Ward, Geoffrey C., Ric Burns, and Ken Burns. *The Civil War: An Illustrated History.* New York: Knopf, 1992.

Whitman, Walt. *Drum-Taps.* New York: N.p., 1865.

———. *Memoranda During the War: Civil War Journals, 1863–1865.* Camden, N.J.: The Author, 1876. Reprint ed., with a new introduction by Bob Blaisdell, Mineola, N.Y.: Dover Publications, 2010.

———. *Specimen Days & Collect.* Philadelphia: David McKay, 1882.

———. *The Wound Dresser: A Series of Letters Written from the Hospitals in Washington During the War of the Rebellion.* Edited by Richard Maurice Bucke. Boston: Small, Maynard & Co., 1898.

Wiley, Bell I. *The Life of Billy Yank & The Life of Johnny Reb: The Common Soldier of the Union & The Common Soldier of the Confederacy.* Indianapolis: Bobbs-Merrill, 1952.

Woodhead, Henry, ed. *Echoes of Glory: Arms and Equipment of the Union; Arms and Equipment of the Confederacy; Illustrated Atlas of the Civil War.* 3 vols. [Alexandria, Va.]: Time-Life Books, 1991.

Zeller, Bob. *The Blue and Gray in Black and White: A History of Civil War Photography.* Westport, Conn., and London: Praeger, 2005.

235 Unknown maker, Mathew B. Brady's Studio Camera and Tripod, 1860s. Wood, glass, metal, cloth

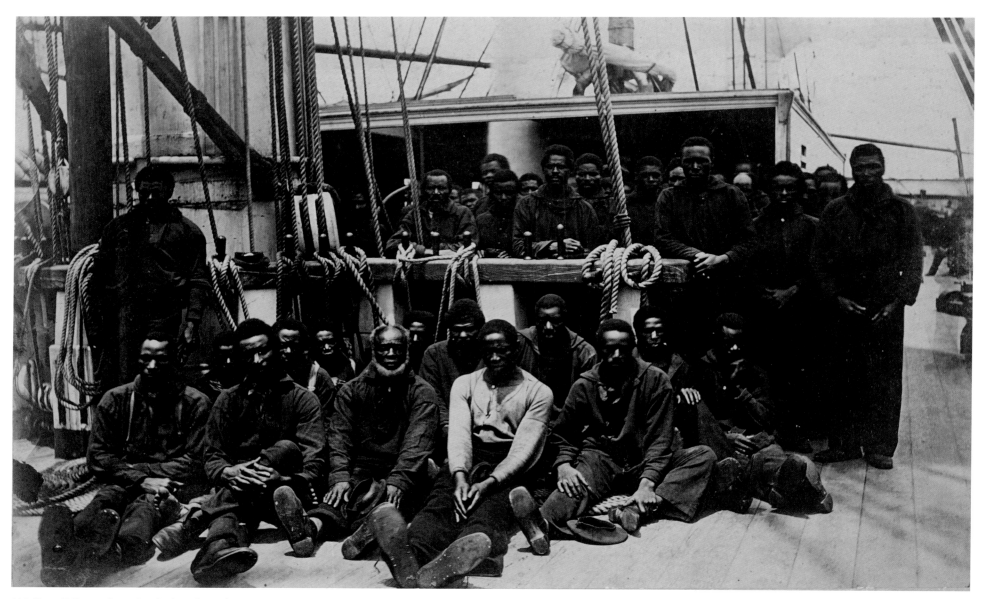

236 Henry P. Moore, *Contrabands aboard U.S. Ship* Vermont, *Port Royal, South Carolina*, October–November 1861. Albumen silver print

CHECKLIST

- Not illustrated
✤ Shown only at The Metropolitan Museum of Art
➥ Shown only in exhibition tour

Plate sizes:

Half plate: 5½ × 4¼ inches
Quarter plate: 4¼ × 3¼ inches
Sixth plate: 3¼ × 2¾ inches
Ninth plate: 2½ × 2 inches

All albumen silver prints are from glass negatives.

1 Andrew Joseph Russell
American, 1830–1902
*End of the Bridge after Burnside's Attack,
Fredericksburg, Virginia*, 1863
Albumen silver print
5⅛ × 8⅛ in. (13.1 × 20.6 cm)
The Metropolitan Museum of Art
Harris Brisbane Dick Fund, 1933
33.65.17

2 Andrew Joseph Russell
American, 1830–1902
*Confederate Method of Destroying Rail Roads at
McCloud Mill, Virginia*, 1863
Albumen silver print
6⅜ × 7¾ in. (16.2 × 19.6 cm)
The Metropolitan Museum of Art
Harris Brisbane Dick Fund, 1933
33.65.175

3 Unknown maker
Game Board with Portraits of President Abraham
Lincoln and Union Generals, 1862
Albumen silver print
8½ × 8⅜ in. (21.6 × 21.4 cm)
Brian D. Caplan Collection

4 Timothy H. O'Sullivan
American, born Ireland, 1840–1882
Alexander Gardner, printer
A Harvest of Death, Gettysburg, July 1863
Plate 36 in Volume 1 of *Gardner's Photographic Sketch
Book of the War*
Albumen silver print
Image: 6⅞ × 8⅞ in. (17.4 × 22.5 cm);
album: 12¾ × 17½ × 2 in. (32.5 × 44.5 × 5 cm)
The Metropolitan Museum of Art
Gilman Collection, Purchase, Ann Tenenbaum and
Thomas H. Lee Gift, 2005
2005.100.502.1

- Timothy H. O'Sullivan
American, born Ireland, 1840–1882
Alexander Gardner, printer
A Harvest of Death, Gettysburg, July 1863
Plate 36 in Volume 1 of *Gardner's Photographic Sketch
Book of the War*
Albumen silver print
7 × 8⅞ in. (17.8 × 22.5 cm)
The Metropolitan Museum of Art
Gilman Collection, Museum Purchase, 2005
2005.100.1201

5 Unknown artist
Union Private with Musket and Pistol, 1861–65
Sixth-plate tintype with applied color
The Metropolitan Museum of Art
The Horace W. Goldsmith Foundation Fund, through
Joyce and Robert Menschel, 2012
2012.76

6 Unknown artist
*Sergeant Alex Rogers with Battle Flag, Eighty-
third Pennsylvania Volunteers, Third Brigade, First
Division, Fifth Corps, Army of the Potomac*, ca. 1863
Albumen silver print (carte de visite)
2¼ × 3½ in. (5.6 × 8.9 cm)
Thomas Harris Collection

7 McPherson & Oliver
Active New Orleans and Baton Rouge, Louisiana, 1860s
William D. McPherson, American, ca. 1833–1867
Oliver, American, active 1860s
Sailors on the Deck of the USS *Hartford*, 1864
Albumen silver print (carte de visite)
2¼ × 3¼ in. (5.6 × 8.4 cm)
Brian D. Caplan Collection

8 Timothy H. O'Sullivan
American, born Ireland, 1840–1882
*Pennsylvania Light Artillery, Battery B, Petersburg,
Virginia*, 1864
Albumen silver print
3 × 7½ in. (7.6 × 18.9 cm)
The Metropolitan Museum of Art
Harris Brisbane Dick Fund, 1933
33.65.241

9 Andrew Joseph Russell
American, 1830–1902
*Bridge on Orange and Alexandria Rail Road,
as Repaired by Army Engineers under Colonel
Herman Haupt*, 1865
Albumen silver print
6¼ × 8⅛ in. (15.8 × 20.6 cm)
The Metropolitan Museum of Art
Harris Brisbane Dick Fund, 1933
33.65.278

10 Unknown artist
*Corporal Hiram Warner, Company C, Second United
States Sharpshooters*, 1861–62
Sixth-plate tintype with applied color
The Metropolitan Museum of Art
The Horace W. Goldsmith Foundation Fund, through
Joyce and Robert Menschel, 2012
2012.78

11 Alexander Gardner
American, born Scotland, 1821–1882
Brady & Company, publisher
Confederate Soldier [on the Battlefield at Antietam],
September 1862
Albumen silver print
2⅜ × 3⅞ in. (6.1 × 9.8 cm)
The Metropolitan Museum of Art
Purchase, Florance Waterbury Bequest, 1970
1970.537.4

12 Mathew B. Brady
American, born Ireland, 1823/24–1896
Self-Portrait, ca. 1860
Albumen silver print (carte de visite)
3½ × 2¼ in. (8.8 × 5.7 cm)
Brian D. Caplan Collection

13 Alexander Gardner
American, born Scotland, 1821–1882
Antietam, September 19, 1862
Albumen silver prints
In *A Photographic Album of the Civil War*, compiled
before 1869, with 348 photographs by Mathew B.
Brady, Brady & Company, George N. Barnard,
Alexander Gardner, James F. Gibson, Timothy H.
O'Sullivan, and others
8¾ × 11 × 4 in. (22.2 × 27.9 × 10.2 cm)
Loewentheil Family Photography Collection

14 Alexander Gardner
American, born Scotland, 1821–1882
The President [Abraham Lincoln], Major General John A. McClernand [right], and E. J. Allen [Allan Pinkerton, left], Chief of the Secret Service of the United States, at Secret Service Department, Headquarters Army of the Potomac, near Antietam, October 4, 1862
Albumen silver print
8⅞ × 7⅛ in. (22.4 × 18 cm)
The Metropolitan Museum of Art
Gilman Collection, Gift of The Howard Gilman Foundation, 2005
2005.100.1221

15 Unknown artist
Attributed to Alexander Gardner, American, born Scotland, 1821–1882
Copying Maps, Photographic Headquarters, Petersburg, Virginia, March 1865
Albumen silver print
7⅜ × 9⅝ in. (18.8 × 24.5 cm)
The Metropolitan Museum of Art
Gilman Collection, Museum Purchase, 2005
2005.100.1236

16 ✥ Alexander Gardner
American, born Scotland, 1821–1882
Antietam Bridge, Maryland, September 1862
Plate 19 in Volume 1 of *Gardner's Photographic Sketch Book of the War*
Albumen silver print
6⅞ × 8⅞ in. (17.5 × 22.6 cm)
Photography Collection, Miriam and Ira D. Wallach Division of Art, Prints and Photographs, The New York Public Library, Astor, Lenox and Tilden Foundations

17 Unknown artist
Confederate Corporal (?) with British Rifle Musket and Bowie Knife, Likely from Georgia, 1861–62 (?)
Sixth-plate ambrotype with applied color
David Wynn Vaughan Collection

18 Unknown artist
Union Soldier with Rifle, 1862
Sixth-plate ruby glass ambrotype with applied color
Brian D. Caplan Collection

19 Unknown artist, after an 1859 ambrotype by H. H. Cole, Peoria, Illinois
Abraham Lincoln Campaign Pin, 1860
Red, white, and blue silk with tintype set inside stamped brass button
7¼ × 2⅝ in. (18.5 × 6.7 cm), Diam. of portrait: 1 in. (2.5 cm)
Brian D. Caplan Collection

20 Porter Photographic Parlors
Active Janesville, Wisconsin, 1860s
Young Woman with Beckers Tabletop Stereoscope, 1864–66
Albumen silver print (carte de visite)
3⅝ × 2 in. (9.1 × 5.2 cm)
Thomas Harris Collection

21 Alexander Gardner
American, born Scotland, 1821–1882
Gardner's Gallery, 7th and D Streets, Washington, D.C., 1864
Albumen silver print
3 × 4⅛ in. (7.6 × 10.6 cm)
The Metropolitan Museum of Art
Gilman Collection, Museum Purchase, 2005
2005.100.1118

22 Mathew B. Brady
American, born Ireland, 1823/24–1896
Edward Anthony, publisher
Abraham Lincoln, February 27, 1860
Albumen silver print (carte de visite)
3⅜ × 2⅛ in. (8.7 × 5.3 cm)
Collection of the Meserve-Kunhardt Foundation

23 Unknown artist, after an 1860 carte de visite by Mathew B. Brady
Front page of *Harper's Weekly*, November 10, 1860
Newspaper with wood engraving
16 × 11¼ in. (40.6 × 28.6 cm)
Brian D. Caplan Collection

24 Unknown artist, after an 1860 carte de visite of Lincoln by Mathew B. Brady
Presidential Campaign Medal with Portraits of Abraham Lincoln and Hannibal Hamlin, 1860
Tintypes in stamped brass medallion
Diam. 1 in. (2.5 cm)
The Metropolitan Museum of Art
Purchase, The Overbrook Foundation Gift, 2012
2012.12

25 Unknown artists
Three Presidential Campaign Medals with Portraits of Stephen A. Douglas and Herschel V. Johnson, John C. Breckinridge and Joseph Lane, and John Bell and Edward Everett, 1860
Tintypes in stamped brass medallions
Diam. 1 in. (2.5 cm)
Brian D. Caplan Collection

● Unknown artist, after an 1864 carte de visite of Lincoln by Thomas Le Mere for Brady & Company
Presidential Campaign Medal with Portraits of Abraham Lincoln and Andrew Johnson, 1864
Tintypes in stamped brass medallion
Diam. 1 in. (2.5 cm)
The Metropolitan Museum of Art
Purchase, The Overbrook Foundation Gift, 2012
2012.13

26 Mathew B. Brady
American, born Ireland, 1823/24–1896
Edward Anthony, publisher
Jefferson Davis, 1858–60
Albumen silver print (carte de visite)
3⅜ × 2¼ in. (8.5 × 5.6 cm)
Brian D. Caplan Collection

27 Unknown maker, after photographs by Mathew B. Brady and others
Political Necklace with Portraits of Confederate States of America President Jefferson Davis, Vice President Alexander H. Stephens, and Secretary of War John C. Breckinridge, 1861–65
Albumen silver prints set in carved vegetable ivory (tagua nut) disks, with modern stringing
L. 11⅞ in. (30 cm), Diam. of portraits ½ in. (1.2 cm)
Brian D. Caplan Collection

28 William Marsh
American, active Springfield, Illinois, 1850s–60s
Abraham Lincoln, May 20, 1860
Salted paper print from glass negative
7⅞ × 5¾ in. (19.9 × 14.5 cm)
The Metropolitan Museum of Art
Gilman Collection, Purchase, Joyce F. Menschel Gift, 2005
2005.100.89

29 Attributed to Alma A. Pelot
American, active Charleston, South Carolina, 1850s–60s
Terre-plein off the Gorge, Fort Sumter, April 15, 1861
Albumen silver print
5⅜ × 7⅜ in. (13.5 × 18.6 cm)
Collection of The New-York Historical Society

30 Attributed to Alma A. Pelot
American, active Charleston, South Carolina, 1850s–60s
Western Barracks and Parade, Fort Sumter, April 15, 1861
Albumen silver print
5⅜ × 7¼ in. (13.5 × 18.5 cm)
Collection of The New-York Historical Society

31 Unknown artist
Soldier's Kepi with First National Flag of the Confederacy, April 1861
Ninth-plate ruby glass ambrotype with applied color
David Wynn Vaughan Collection

32 Attributed to Alma A. Pelot
American, active Charleston, South Carolina, 1850s–60s
Interior Face of Gorge, Fort Sumter, April 15, 1861
Albumen silver print
5¼ × 7¼ in. (13.3 × 18.5 cm)
Collection of The New-York Historical Society

33 Attributed to Alma A. Pelot
American, active Charleston, South Carolina, 1850s–60s
Terre-plein and Parapet, Fort Sumter, April 15, 1861
Albumen silver print
5⅜ × 7⅜ in. (13.5 × 18.7 cm)
Collection of The New-York Historical Society

34 Attributed to Alma A. Pelot and Jesse H. Bolles
Americans, active Charleston, South Carolina,
1850s–60s
Edward Anthony, publisher
*Hamilton's Floating Battery Moored at the End of
Sullivan's Island the Night Before They Opened Fire
upon Fort Sumter*, April 1861
Albumen silver print (carte de visite)
2⅛ × 3¼ in. (5.3 × 8.3 cm)
From *The Evacuation of Fort Sumter*, April 1861
Album with 16 albumen silver print cartes de visite
5 × 3¾ × 1 in. (12.6 × 9.4 × 2.5 cm)
The Metropolitan Museum of Art
Gilman Collection, Museum Purchase, 2005
2005.100.1174.4

35 Osborn's Gallery
J. M. Osborn, American, active Charleston,
South Carolina, 1850s–60s
Salient with North-west Casemates, Fort Sumter,
April 1861
Albumen silver print (carte de visite)
2⅜ × 2⅞ in. (6 × 7.3 cm)
From *The Evacuation of Fort Sumter*, April 1861
Album with 16 albumen silver print cartes de visite
5 × 3¾ × 1 in. (12.6 × 9.4 × 2.5 cm)
The Metropolitan Museum of Art
Gilman Collection, Museum Purchase, 2005
2005.100.1174.15

• Attributed to Alma A. Pelot and Jesse H. Bolles
Americans, active Charleston, South Carolina,
1850s–60s
J. M. Osborn, Osborn's Gallery
American, active Charleston, South Carolina, 1850s–60s
Edward Anthony, publisher
The Evacuation of Fort Sumter, April 1861
Album with 16 albumen silver print cartes de visite
5 × 3¾ × 1 in. (12.6 × 9.4 × 2.5 cm)
The Metropolitan Museum of Art
Gilman Collection, Museum Purchase, 2005
2005.100.1174

36 George S. Cook
American, 1819–1902
Young Boy in Zouave Outfit, with Drum, 1861–65
Sixth-plate ambrotype with applied color
Brian D. Caplan Collection

37 Henry P. Moore
American, 1833–1911
*Negroes (Gwine to de Field), Hopkinson's Plantation,
Edisto Island, South Carolina*, 1862
Albumen silver print
6 × 8 in. (15.2 × 20.4 cm)
The Metropolitan Museum of Art
Gilman Collection, Museum Purchase, 2005
2005.100.1137

38 George N. Barnard
American, 1819–1902
Bonaventure Cemetery, Four Miles from Savannah, 1866
Albumen silver print
13⅜ × 10⅜ in. (34 × 26.4 cm)
The Metropolitan Museum of Art
Gilman Collection, Purchase, Ann Tenenbaum and
Thomas H. Lee Gift, 2005
2005.100.281

39 Unknown artist
*Private James House with Fighting Knife, Sixteenth
Georgia Cavalry Battalion, Army of Tennessee*,
1861–62 (?)
Sixth-plate ruby glass ambrotype
David Wynn Vaughan Collection

40 Herrick & Dirr
Active Vicksburg, Mississippi, 1860s
Henry J. Herrick, American, born Canada,
active 1850s–60s
A. J. Dirr, American, active 1860s
*Private Abram Beach Reading, Company A,
"Vicksburg Southrons," Twenty-first Mississippi
Infantry*, 1861–before June 29, 1862
Albumen silver print (carte de visite)
3⅝ × 2¼ in. (9.2 × 5.8 cm)
David Wynn Vaughan Collection

41 A. J. Riddle
American, 1828–1897
Confederate Captain and Manservant, 1864
Albumen silver print (carte de visite)
3⅜ × 2¼ in. (8.7 × 5.6 cm)
David Wynn Vaughan Collection

42 Unknown artist
Union Private, Standing, with Rifle Musket, 1861–65
Sixth-plate tintype with applied color
Collection of Philip and Jennifer Maritz

43 Unknown artist
Active Georgia, 1860s
*Thomas Mickleberry Merritt [left] and Unknown
Fellow Officer, Company G, Second Georgia Cavalry
Regiment*, 1862–63
Albumen silver print (carte de visite)
2⅛ × 3⅜ in. (5.4 × 8.6 cm)
David Wynn Vaughan Collection

44 Charles Henry Lanneau
Active Columbus and Greenville, South Carolina,
1850–63
*Private Ezekiel Taylor Bray, Company A, "Madison
County Greys," Sixteenth Regiment, Georgia Volunteer
Infantry, "Sallie Twiggs Regiment," Army of Northern
Virginia*, 1863
Sixth-plate ruby glass ambrotype
David Wynn Vaughan Collection

45 Charles Henry Lanneau
Active Columbus and Greenville, South Carolina,
1850–63
*Fincher Brothers, Company I, "Zollicoffer Rifles,"
Forty-third Regiment, Georgia Volunteer Infantry,
Army of Tennessee*, 1863
Sixth-plate ambrotype with applied color
David Wynn Vaughan Collection

46 Unknown artist
*Union Officer in Dress Coat and Plumed Hat, with
Rifle and Sword Bayonet*, 1861–65
Sixth-plate ambrotype with applied color
Collection of Philip and Jennifer Maritz

47 Unknown artist
*Confederate Soldier with Handgun in Belt, Holding
Bowie Knife*, 1861–62
Sixth-plate ruby glass ambrotype with applied color
David Wynn Vaughan Collection

48 Unknown artist
*Confederate Sergeant, Standing, with Large Bowie
Knife and Rifle*, 1861–65
Sixth-plate ruby glass ambrotype with applied color
David Wynn Vaughan Collection

49 Unknown artist
*Union Cavalry Soldier, Seated, with Sword and
Handgun*, 1861–65
Sixth-plate tintype with applied color
The Metropolitan Museum of Art
The Horace W. Goldsmith Foundation Fund, through
Joyce and Robert Menschel, 2012
2012.79

50 Unknown artist
Union Cavalry Officer Holding Sword, 1861–65
Quarter-plate tintype with applied color
Collection of Philip and Jennifer Maritz

51 Unknown artist
*Private Benjamin Franklin Ammons, Company L,
First Tennessee Regiment Heavy Artillery*, 1861–63
Quarter-plate ambrotype with applied color
David Wynn Vaughan Collection

52 Unknown artist
Confederate Sergeant in Slouch Hat, 1861–62
Sixth-plate ambrotype with applied color
David Wynn Vaughan Jr. Collection

53 Unknown artist
*Union Infantry Soldier, Seated, with Handgun in
Belt*, 1861–65
Sixth-plate tintype with applied color
Collection of Philip and Jennifer Maritz

54 Unknown artist
Confederate Private in Double-breasted Jacket, 1861–65
Ninth-plate ambrotype with applied color
David Wynn Vaughan Collection

55 Unknown artist
*Confederate Corporal, Seated in Gothic Revival
Chair*, 1861–65
Ninth-plate ruby glass ambrotype with applied color
David Wynn Vaughan Collection

56 Unknown artist
Union Soldier with Black Collar, 1861–65
Sixth-plate ruby glass ambrotype with applied color
Collection of Philip and Jennifer Maritz

57 Unknown artist
Union Officer Standing at Attention, 1861–65
Quarter-plate ruby glass ambrotype with applied color
The Metropolitan Museum of Art
Anonymous Gift, 2012
2012.504

58 Unknown artist
Union Soldier Holding Rifle, with Photographer's
Posing Stand, 1861–65
Quarter-plate ruby glass ambrotype with applied color
The Metropolitan Museum of Art
The Horace W. Goldsmith Foundation Fund, through
Joyce and Robert Menschel, 2011
2011.474

59 Unknown artist
Woman Holding Cased Portraits of Civil War
Soldiers, 1861–65
Sixth-plate tintype with applied color
Jane Van N. Turano-Thompson Collection

60 Unknown maker
War! War! War!, April 1861
Ink on paper (broadside)
9⅜ × 12¾ in. (23.8 × 32.3 cm)
Brian D. Caplan Collection

61 Unknown artist
*March from Annapolis to Washington, Robert C.
Rathbone, Sergeant Major, Seventh Regiment,
New York State Militia*, April 24, 1861
Albumen silver print (carte de visite)
3½ × 2⅛ in. (8.9 × 5.4 cm)
Michael J. McAfee Collection

62 Charles Wheeler
American, active New York City, 1860s
"I wish I was in Dixie," 1863
Albumen silver print (carte de visite)
3⅜ × 2½ in. (8.6 × 6.2 cm)
Brian D. Caplan Collection

63 Kellogg Brothers
Active Hartford, Connecticut, 1860s–70s
E. P., C. P., and William Kellogg, Americans,
active 1860s–70s
"How do You Like it, Jefferson D.?," 1865
Albumen silver print (carte de visite)
3½ × 2⅛ in. (9 × 5.5 cm)
Brian D. Caplan Collection

64 Unknown maker
Jeff Davis "Taking" Washington, 1861–65
Ink on paper (printed mailing envelope)
3 × 5⅜ in. (7.7 × 13.8 cm)
Brian D. Caplan Collection

65 George N. Barnard
American, 1819–1902
Ruins of Mrs. Henry's House, Battlefield of Bull Run,
March 1862
Albumen silver print
6¼ × 8¼ in. (15.9 × 20.9 cm)
The Metropolitan Museum of Art
Harris Brisbane Dick Fund, 1933
33.65.106

66 Mathew B. Brady
American, born Ireland, 1823/24–1896
Arlington Heights, Virginia, July 16, 1861
Albumen silver print
3⅝ × 2¾ in. (9.1 × 7 cm)
Michael J. McAfee Collection

67 Unknown artist
Edward Anthony, publisher
Scene in the Fortifications at Camp Essex [Maryland],
1861
Albumen silver print (stereograph)
3 × 6⅛ in. (7.5 × 15.5 cm)
Private collection, Courtesy William L. Schaeffer

68 Attributed to George Stacy
American, active New York City
Camp Hamilton near Fortress Monroe, Virginia,
1861 (?)
Albumen silver print (stereograph)
3 × 5½ in. (7.7 × 14.1 cm)
Brian D. Caplan Collection

69 Mathew B. Brady
American, born Ireland, 1823/24–1896
Camp Scene with Soldiers of the Twenty-second
New York State Militia, Harpers Ferry, Virginia, 1862
Albumen silver print (carte de visite)
3⅜ × 2¼ in. (8.7 × 5.8 cm)
Thomas Harris Collection

70 Mathew B. Brady
American, born Ireland, 1823/24–1896
*Richard L. Cramer, Company I, Fourth Michigan
Volunteer Infantry*, 1861
Albumen silver print
3½ × 2½ in. (8.9 × 6.4 cm)
Michael J. McAfee Collection

71 Mathew B. Brady
American, born Ireland, 1823/24–1896
*Camp Sprague. First Rhode Island Regiment.
Company D [Washington, D.C.]*, before July 16, 1861
Albumen silver print
11 × 14⅝ in. (27.9 × 37 cm)
Brian D. Caplan Collection

72 Mathew B. Brady
American, born Ireland, 1823/24–1896
*Camp Brightwood near Washington. Second Rhode
Island. Colonel Frank Wheaton*, 1862
Albumen silver print
10 × 14 in. (25.4 × 35.6 cm)
Brian D. Caplan Collection

73 George N. Barnard
American, 1819–1902
James F. Gibson
American, born 1828/29
Brady & Company, publisher
Fortifications, Manassas, March 1862
Albumen silver print
7⅜ × 9¼ in. (18.7 × 23.4 cm)
The Metropolitan Museum of Art
Gilman Collection, Museum Purchase, 2005
2005.100.1133

74 George N. Barnard
American, 1819–1902
James F. Gibson
American, born 1828/29
Brady & Company, publisher
Stone Church, Centreville, Virginia, March 1862
Albumen silver print (carte de visite)
2¼ × 3¾ in. (5.6 × 9.4 cm)
W. Bruce and Delaney H. Lundberg Collection

75 ✛ George N. Barnard
American, 1819–1902
James F. Gibson
American, born 1828/29
Alexander Gardner, printer
Stone Church, Centreville, Virginia, March 1862
Plate 4 in Volume 1 of *Gardner's Photographic Sketch
Book of the War*
Albumen silver print
6⅞ × 9 in. (17.6 × 22.8 cm)
Photography Collection, Miriam and Ira D. Wallach
Division of Art, Prints and Photographs, The New York
Public Library, Astor, Lenox and Tilden Foundations

76 Alexander Gardner
American, born Scotland, 1821–1882
James F. Gibson
American, born 1828/29
Peninsular Campaign, May 1862
Albumen silver prints
In *A Photographic Album of the Civil War*, compiled
before 1869, with 348 photographs by Mathew B.
Brady, Brady & Company, George N. Barnard,
Alexander Gardner, James F. Gibson, Timothy H.
O'Sullivan, and others
8¾ × 11 × 4 in. (22.2 × 27.9 × 10.2 cm)
Loewentheil Family Photography Collection

77 George N. Barnard
American, 1819–1902
Quaker Gun, Centreville, Virginia, March 1862
Albumen silver print
3¼ × 3¾ in. (8.1 × 9.4 cm)
The Metropolitan Museum of Art
Gilman Collection, Museum Purchase, 2005
2005.100.1232

78 Charles DeForest Fredricks
American, 1823–1894
General George McClellan, 1862 (?)
Albumen silver print (carte de visite)
3⅝ × 2⅛ in. (9.1 × 5.4 cm)
Thomas Harris Collection

79 ✣ Alexander Gardner
American, born Scotland, 1821–1882
Studying the Art of War, Fairfax Court-House [Virginia], June 1863
Plate 45 in Volume 1 of *Gardner's Photographic Sketch Book of the War*
Albumen silver print
6⅞ × 8⅞ in. (17.4 × 22.4 cm)
Photography Collection, Miriam and Ira D. Wallach Division of Art, Prints and Photographs, The New York Public Library, Astor, Lenox and Tilden Foundations

80 ✣ Timothy H. O'Sullivan
American, born Ireland, 1840–1882
Alexander Gardner, printer
Provost Marshal's Office, Aquia Creek, Virginia, February 1863
Plate 46 in Volume 1 of *Gardner's Photographic Sketch Book of the War*
Albumen silver print
6⅞ × 9 in. (17.3 × 22.7 cm)
Photography Collection, Miriam and Ira D. Wallach Division of Art, Prints and Photographs, The New York Public Library, Astor, Lenox and Tilden Foundations

81 Timothy H. O'Sullivan
American, born Ireland, 1840–1882
Alexander Gardner, printer
Quarters of Men in Fort Sedgwick, Generally Known as Fort Hell, May 1865
Plate 83 in Volume 2 of *Gardner's Photographic Sketch Book of the War*
Albumen silver print
6¾ × 8⅞ in. (17.2 × 22.4 cm)
The Museum of Modern Art, New York
Anonymous Gift, 34.1941.83

82 Andrew Joseph Russell
American, 1830–1902
Slave Pen, Alexandria, Virginia, 1863
Albumen silver print
10⅛ × 14⅜ in. (25.6 × 36.5 cm)
The Metropolitan Museum of Art
Gilman Collection, Purchase, The Horace W. Goldsmith Foundation Gift, through Joyce and Robert Menschel, 2005
2005.100.91

83 Brady & Company
Active 1840s–80s
E. & H. T. Anthony & Company, publisher
Slave Pen, Alexandria, Virginia, 1862
Albumen silver print (stereograph)
3⅛ × 6¼ in. (8 × 16 cm)
The Metropolitan Museum of Art
The Horace W. Goldsmith Foundation Fund, through Joyce and Robert Menschel, 2011
2011.476

84 Andrew Joseph Russell
American, 1830–1902
Rebel Caisson Destroyed by Federal Shells, May 3, 1863
Albumen silver print
9⅜ × 12⅞ in. (23.7 × 32.8 cm)
Private collection, Courtesy William L. Schaeffer

85 Andrew Joseph Russell
American, 1830–1902
Wood Choppers' Huts in a Virginia Forest, ca. 1863
Albumen silver print
9⅜ × 12⅞ in. (23.9 × 32.8 cm)
Private collection, Courtesy William L. Schaeffer

86 Andrew Joseph Russell
American, 1830–1902
Street Scene, Culpeper [Virginia], March 1864
Albumen silver print
10⅛ × 13⅛ in. (25.7 × 33.3 cm)
Private collection, Courtesy William L. Schaeffer

87 Andrew Joseph Russell
American, 1830–1902
Government Coal Wharf, Alexandria, Virginia, ca. 1863
Albumen silver print
9 × 12⅞ in. (22.9 × 32.8 cm)
Private collection, Courtesy William L. Schaeffer

88 ✣ George N. Barnard
American, 1819–1902
James F. Gibson
American, born 1828/29
Alexander Gardner, printer
Ruins of Stone Bridge, Bull Run, Virginia, March 1862
Plate 7 in Volume 1 of *Gardner's Photographic Sketch Book of the War*
Albumen silver print
7 × 8⅞ in. (17.7 × 22.6 cm)
Photography Collection, Miriam and Ira D. Wallach Division of Art, Prints and Photographs, The New York Public Library, Astor, Lenox and Tilden Foundations

89 ✣ Timothy H. O'Sullivan
American, born Ireland, 1840–1882
Alexander Gardner, printer
View on the Appomattox River, near Campbell's Bridge, Petersburg, Virginia, May 1865
Plate 82 in Volume 2 of *Gardner's Photographic Sketch Book of the War*
Albumen silver print
6⅞ × 8⅞ in. (17.4 × 22.4 cm)
Photography Collection, Miriam and Ira D. Wallach Division of Art, Prints and Photographs, The New York Public Library, Astor, Lenox and Tilden Foundations

90 Alexander Gardner
American, born Scotland, 1821–1882
Ruins of Arsenal, Richmond, Virginia, April 1865
Plate 91 in Volume 2 of *Gardner's Photographic Sketch Book of the War*
Albumen silver print
Image: 6⅞ × 8¾ in. (17.4 × 22.1 cm);
album: 12¾ × 17½ × 2 in. (32.5 × 44.5 × 5 cm)
The Metropolitan Museum of Art
Gilman Collection, Purchase, Ann Tenenbaum and Thomas H. Lee Gift, 2005
2005.100.502

91 ✣ Alexander Gardner or Timothy H. O'Sullivan
American, born Scotland, 1821–1882
American, born Ireland, 1840–1882
Unfit for Service at the Battle-field of Gettysburg, July 6, 1863
Albumen silver print
6½ × 9 in. (16.6 × 23 cm)
Collection of The New-York Historical Society

92 Brady & Company
American, 1840s–80s
E. & H. T. Anthony & Company, publisher
Rebel Prisoners, Gettysburg, July 1863
Albumen silver print (stereograph)
3⅛ × 6¼ in. (8 × 15.9 cm)
Michael J. McAfee Collection

93 Mathew B. Brady
American, born Ireland, 1823/24–1896
Wheat-Field in Which General Reynolds Was Shot, July 1863
[Mathew B. Brady Looking toward McPherson's Woods, from the Wheatfield, Gettysburg, Pennsylvania]
Albumen silver prints (panorama)
6⅛ × 16⅛ in. (15.7 × 40.9 cm)
The Metropolitan Museum of Art
Harris Brisbane Dick Fund, 1933
33.65.352 and 33.65.391

94 Alexander Gardner
American, born Scotland, 1821–1882
Execution of Lincoln Assassination Conspirators, After the Trap Sprung, July 7, 1865
Albumen silver print
Image: 6⅝ × 9½ in. (16.8 × 24.2 cm);
album: 11⅜ × 15¾ × 2¾ in. (28.9 × 40 × 7 cm)
Collection of The New-York Historical Society

95 ✣ John Wood
American, active 1860s
James F. Gibson
American, born 1828/29
Alexander Gardner, printer
Battery No. 4, near Yorktown, Virginia, May 1862
Plate 14 in Volume 1 of *Gardner's Photographic Sketch Book of the War*
Albumen silver print
6⅞ × 8⅞ in. (17.5 × 22.5 cm)
Photography Collection, Miriam and Ira D. Wallach Division of Art, Prints and Photographs, The New York Public Library, Astor, Lenox and Tilden Foundations

96 John Wood
American, active 1860s
James F. Gibson
American, born 1828/29
Alexander Gardner, printer
Inspection of Troops at Cumberland Landing,
Pamunkey, Virginia, May 1862
Plate 16 in Volume 1 of *Gardner's Photographic Sketch*
Book of the War
Albumen silver print
7 × 9 in. (17.7 × 22.9 cm)
The Museum of Modern Art, New York
Anonymous Gift, 34.1941.16

97 ✣ Alexander Gardner
American, born Scotland, 1821–1882
What Do I Want, John Henry? Warrenton, Virginia,
November 1862
Plate 27 in Volume 1 of *Gardner's Photographic Sketch*
Book of the War
Albumen silver print
6⅞ × 8⅞ in. (17.4 × 22.6 cm)
Photography Collection, Miriam and Ira D. Wallach
Division of Art, Prints and Photographs, The New York
Public Library, Astor, Lenox and Tilden Foundations

98 ✣ Alexander Gardner
American, born Scotland, 1821–1882
Guides to the Army of the Potomac, Berlin, Virginia,
October 1862
Plate 28 in Volume 1 of *Gardner's Photographic Sketch*
Book of the War
Albumen silver print on printed mount
7 × 9 in. (17.7 × 22.9 cm)
Rare Book Division, The New York Public Library,
Astor, Lenox and Tilden Foundations

99 Timothy H. O'Sullivan
American, born Ireland, 1840–1882
Alexander Gardner, printer
A Harvest of Death, Gettysburg, July 1863
Plate 36 in Volume 1 of *Gardner's Photographic Sketch*
Book of the War
Albumen silver print
Image: 6⅞ × 8⅞ in. (17.4 × 22.5 cm);
album: 12¾ × 17½ × 2 in. (32.5 × 44.5 × 5 cm)
The Metropolitan Museum of Art
Gilman Collection, Purchase, Ann Tenenbaum and
Thomas H. Lee Gift, 2005
2005.100.502.1

100 Timothy H. O'Sullivan
American, born Ireland, 1840–1882
Alexander Gardner, printer
Field Where General Reynolds Fell, Gettysburg, July 1863
Plate 37 in Volume 1 of *Gardner's Photographic Sketch*
Book of the War
Albumen silver print in full-leather album
Image: 7 × 9 in. (17.8 × 22.7 cm);
album: 12¾ × 17½ × 2 in. (32.5 × 44.5 × 5 cm)
The Metropolitan Museum of Art
Gilman Collection, Purchase, Ann Tenenbaum and
Thomas H. Lee Gift, 2005
2005.100.502.1

101 ✣ Alexander Gardner
American, born Scotland, 1821–1882
A Sharpshooter's Last Sleep, Gettysburg, July 1863
Plate 40 in Volume 1 of *Gardner's Photographic Sketch*
Book of the War
Albumen silver print
7 × 9 in. (17.7 × 22.9 cm)
Rare Book Division, The New York Public Library,
Astor, Lenox and Tilden Foundations

102 Alexander Gardner
American, born Scotland, 1821–1882
Home of a Rebel Sharpshooter, Gettysburg, July 1863
Plate 41 in Volume 1 of *Gardner's Photographic Sketch*
Book of the War
Albumen silver print
7 × 9 in. (17.8 × 22.9 cm)
The Museum of Modern Art, New York
Anonymous Gift, 34.1941.41

103 Timothy H. O'Sullivan
American, born Ireland, 1840–1882
Alexander Gardner, printer
Pontoon Boat, February 1864
Plate 58 in Volume 2 of *Gardner's Photographic Sketch*
Book of the War
Albumen silver print
6¾ × 8⅞ in. (17.2 × 22.5 cm)
The Museum of Modern Art, New York
Anonymous Gift, 34.1941.58

104 ✣ Timothy H. O'Sullivan
American, born Ireland, 1840–1882
Alexander Gardner, printer
Chesterfield Bridge, North Anna, Virginia, May 1864
Plate 66 in Volume 2 of *Gardner's Photographic Sketch*
Book of the War
Albumen silver print
6⅞ × 8⅞ in. (17.4 × 22.5 cm)
Photography Collection, Miriam and Ira D. Wallach
Division of Art, Prints and Photographs, The New York
Public Library, Astor, Lenox and Tilden Foundations

105 ✣ David Knox
American, active 1860s
Alexander Gardner, printer
Battery Wagon, Front of Petersburg, September 1864
Plate 73 in Volume 2 of *Gardner's Photographic Sketch*
Book of the War
Albumen silver print
6⅞ × 8⅞ in. (17.4 × 22.6 cm)
Photography Collection, Miriam and Ira D. Wallach
Division of Art, Prints and Photographs, The New York
Public Library, Astor, Lenox and Tilden Foundations

106 ✣ David Knox
American, active 1860s
Alexander Gardner, printer
Mortar Dictator, Front of Petersburg, October 1864
Plate 75 in Volume 2 of *Gardner's Photographic Sketch*
Book of the War
Albumen silver print
6⅞ × 8⅞ in. (17.4 × 22.6 cm)
Rare Book Division, The New York Public Library,
Astor, Lenox and Tilden Foundations

107 ✣ John Reekie
American, active 1860s
Alexander Gardner, printer
Extreme Line of Confederate Works, Cold Harbor,
Virginia, April 1865
Plate 96 in Volume 2 of *Gardner's Photographic Sketch*
Book of the War
Albumen silver print
6⅞ × 9 in. (17.3 × 22.8 cm)
Photography Collection, Miriam and Ira D. Wallach
Division of Art, Prints and Photographs, The New York
Public Library, Astor, Lenox and Tilden Foundations

108 ✣ John Reekie
American, active 1860s
Alexander Gardner, printer
A Burial Party, Cold Harbor, Virginia, April 1865
Plate 94 in Volume 2 of *Gardner's Photographic Sketch*
Book of the War
Albumen silver print
6⅞ × 9 in. (17.6 × 22.8 cm)
Photography Collection, Miriam and Ira D. Wallach
Division of Art, Prints and Photographs, The New York
Public Library, Astor, Lenox and Tilden Foundations

109 Bonsall & Gibson
Active 1860s
Isaac H. Bonsall, American, 1833–1909
Gibson, active Ohio and Tennessee, 1860s
"Headquarters for Photographs," ca. 1863
Quarter-plate ambrotype
Jane Van N. Turano-Thompson Collection

110 Unknown artist
Union Drummer with Drum and Sticks, 1861–65
Sixth-plate ambrotype with applied color
Jane Van N. Turano-Thompson Collection

111 Unknown artist
Union Soldiers, Seated, with Handguns, 1861–65
Sixth-plate tintype with applied color
Brian D. Caplan Collection

112 Unknown artist (left)
Union Soldier in Dress Coat, Seated, before Painted Backdrop, 1861–65
Sixth-plate ruby glass ambrotype with applied color
Unknown artist (right)
Union Soldier in Winter Overcoat, Standing, in Full Marching Order, 1861–65
Sixth-plate tintype with applied color
Collection of Philip and Jennifer Maritz

113 Unknown artist
William Houston House, Cavalry Battalion, Army of Tennessee, 1862–65
Half-plate ambrotype
David Wynn Vaughan Collection

114 Unknown artist
The Pattillo Brothers (Benjamin, George, James, and John), Company K, "Henry Volunteers," Twenty-second Regiment, Georgia Volunteer Infantry, 1861–63
Quarter-plate ruby glass ambrotype with applied color
David Wynn Vaughan Collection

115 Unknown artist
Union Infantry Soldiers in Frock Coats, Standing, with Rifles, 1861–65
Quarter-plate ruby glass ambrotype with applied color
Collection of Philip and Jennifer Maritz

116 Unknown artist
Private Thomas Gaston Wood, Drummer, Company H, "Walton Infantry," Eleventh Regiment, Georgia Volunteer Infantry, 1861
Ninth-plate tintype with applied color
David Wynn Vaughan Collection

117 Unknown artist
Private George M. Harper, Company A, "Cutts's Battery," Eleventh Battalion, Georgia Volunteer Artillery, 1861–62
Sixth-plate ambrotype with applied color
David Wynn Vaughan Collection

118 Unknown artist
Sergeant Nathaniel Edward Gardner, "Cobb's Legion Cavalry," Company B, "Fulton Dragoons," Army of Tennessee, 1861–65
Half-plate ambrotype with applied color
David Wynn Vaughan Collection

119 Unknown artist
James A. Holeman, Company A, "Roxboro Grays," Twenty-fourth North Carolina Infantry Regiment, Army of Northern Virginia, 1861–62
Half-plate ambrotype with applied color
David Wynn Vaughan Collection

120 Unknown artist
Lieutenant William O. Fontaine, Company I, Twentieth Texas Infantry, 1862–65
Half-plate tintype with applied color
David Wynn Vaughan Collection

121 Unknown artist
Union Officer and Private, Standing at Attention, with Sword and Rifle with Fixed Bayonet, 1861–65
Quarter-plate tintype with applied color
The Metropolitan Museum of Art
The Horace W. Goldsmith Foundation Fund, through Joyce and Robert Menschel, 2012
2012.74

122 Unknown artist
Union Sailor in Peacoat and Hat, before Nautical Backdrop, 1861–65
Half-plate tintype with applied color
W. Bruce and Delaney H. Lundberg Collection

123 Unknown artist
Captain Charles A. and Sergeant John M. Hawkins, Company E, "Tom Cobb Infantry," Thirty-eighth Regiment, Georgia Volunteer Infantry, 1861–62
Quarter-plate ambrotype with applied color
David Wynn Vaughan Collection

124 Unknown artist
Private Thomas Holeman, Company C, "The Secession Guards," Thirteenth Tennessee Infantry, 1861–62
Half-plate tintype with applied color
David Wynn Vaughan Collection

125 Unknown artist
Union Private with Stenciled Canteen, 1861–65
Ninth-plate ruby glass ambrotype with applied color
David Wynn Vaughan Collection

126 Unknown artist
Union Sergeant John Emery, 1861–65
Sixth-plate tintype with applied color
The Metropolitan Museum of Art
The Horace W. Goldsmith Foundation Fund, through Joyce and Robert Menschel, 2012
2012.73

127 Unknown artist
Union Soldiers Sitting on Bench, Playing Cards, 1861–65
Sixth-plate tintype with applied color
The Metropolitan Museum of Art
The Horace W. Goldsmith Foundation Fund, through Joyce and Robert Menschel, 2012
2012.72

128 Joseph Carr Moulton (left)
American, 1824–1914
Union Sergeant with "WG" Breastplate, 1861–65
Sixth-plate ambrotype
Unknown artist (right)
Union Private with Musket, 1861–65
Sixth-plate ambrotype with applied color
Collection of Philip and Jennifer Maritz

129 Unknown artist
Private James Malcolm Hart, Crenshaw's Virginia Battery, 1862–65
Sixth-plate ruby glass ambrotype with applied color
David Wynn Vaughan Collection

130 Unknown artist
Union Infantry Soldier Wearing Light-Colored Overcoat with Short Cape, 1861–65
Sixth-plate ambrotype with applied color
Collection of Philip and Jennifer Maritz

131 Unknown makers
Civil War Portrait Lockets, 1860s
Tintypes and albumen silver prints in brass, glass, and shell enclosures
Varying dimensions: Diam. ½ to 1⅝ in. (1.4 to 4 cm)
Brian D. Caplan Collection

132 Unknown artist
Young Boy Dressed in Zouave Outfit, with Father, 1861–65
Quarter-plate ambrotype with applied color
Brian D. Caplan Collection

133 Unknown maker
Young's Steam Print (Philadelphia?), publisher
Attention!! Recruits Wanted to Fill Up Company C. Col. D. B. Birney's Zouave Regiment, 1861
Ink on paper (broadside)
19 × 13⅛ in. (48.3 × 33.3 cm)
Brian D. Caplan Collection

• Unknown maker
Wanted Immediately! 45 Good Horsemen, 1861–63
Ink on paper (broadside)
9¼ × 12 in. (23.5 × 30.4 cm)
Brian D. Caplan Collection

• Unknown maker
Thomas J. Griffiths, Book and Job Printer, Utica, New York, printer
Rally! Your Country Calls! $225 Bounty!!, 1862
Ink on paper (broadside)
37⅞ × 26¼ in. (96.3 × 66.8 cm)
Brian D. Caplan Collection

• Unknown maker
Commercial Printing House, Boston, printer
Heavy Artillery, Now Is the Time to Enlist, 1863
Ink on paper (broadside)
43⅛ × 29⅜ in. (109.4 × 74.7 cm)
Brian D. Caplan Collection

134 Unknown artist
Union Private, Eleventh New York Infantry (First Fire Zouaves), May–June 1861
Sixth-plate ruby ambrotype with applied color
Michael J. McAfee Collection

135 Unknown artist
Union Private, New York Zouaves, Wearing Knapsack with Blanket Roll, 1860–61
Quarter-plate ambrotype with applied color
Michael J. McAfee Collection

136 Unknown artist
Pennsylvania Zouave Soldiers in Field, 1861–65
Sixth-plate tintype
Thomas Harris Collection

137 Benjamin F. Reimer
American, 1826–1899
Union Zouave Soldier in Dark Blue Jacket and Light
Blue Pants, 1861–65
Albumen silver print with applied color
7¼ × 5¼ in. (18.5 × 13.4 cm)
Brian D. Caplan Collection

138 Unknown artist
Union Zouave Soldier in Dark Blue and Red Jacket,
and Red Pants, 1861–65
Albumen silver print with applied color
7⅜ × 5⅜ in. (18.7 × 13.5 cm)
Brian D. Caplan Collection

139 George W. Wertz, Kansas City Photograph Rooms
American, active Kansas City, Missouri, 1860s
*Private William Henry Lord, Company I, Eleventh
Kansas Volunteer Cavalry*, 1863–65
Albumen silver print (carte de visite)
3¼ × 2¼ in. (8.4 × 5.6 cm)
W. Bruce and Delaney H. Lundberg Collection

140 Attributed to McPherson & Oliver
Active New Orleans and Baton Rouge, Louisiana, 1860s
William D. McPherson, American, ca. 1833–1867
Oliver, American, active 1860s
Iron Clad Essex, *Baton Rouge, Louisiana*, May 1863
Albumen silver print (carte de visite)
2⅛ × 3⅜ in. (5.5 × 8.7 cm)
Private collection, Courtesy William L. Schaeffer

141 George W. Armstead
American, 1833–1912
Active Corinth, Mississippi, 1860s
*Frank Wyatt, One of General Dodge's Band, Corinth,
Mississippi*, September 18, 1863
Albumen silver print (carte de visite)
3½ × 2⅛ in. (9 × 5.4 cm)
Thomas Harris Collection

142 Tappin's Photograph Art Gallery
T. S. Tappin, American, active Noblesville, Indiana,
1860s
Union Cavalry Soldier with Pistol in Holster, 1861–65
Albumen silver print (carte de visite)
3⅝ × 2¼ in. (9.3 × 5.7 cm)
Private collection, Courtesy William L. Schaeffer

143 Unknown makers
Three Civil War Pocket Photograph Albums, 1861–65
*Photograph Album of the 102nd New York Volunteer
Infantry*
Paper and leather case with 12 albumen silver prints
(cartes de visite)
*Photograph Album of Captain W. S. Potter, Fifty-ninth
Regiment, Massachusetts Volunteers*
Paper and leather case with 3 albumen silver prints
(cartes de visite)
"Soldiers Photograph Album"
Paper and leather case with gilt embossing,
with 6 albumen silver prints (cartes de visite)
4 × 3 × 1 in.; 4⅛ × 3 × ½ in.; 4¼ × 3 × ½ in.
(10.2 × 7.6 × 2.5 cm; 10.5 × 7.6 × 1.3 cm;
10.8 × 7.6 × 1.3 cm;)
Michael J. McAfee Collection

144 Brady & Company
Active 1840s–80s
General Ulysses S. Grant, ca. 1864
Albumen silver print (carte de visite)
3½ × 2¼ in. (9 × 5.6 cm)
Brian D. Caplan Collection

145 Charles DeForest Fredricks
American, 1823–1894
Rear Admiral David Farragut, 1864
Albumen silver print (carte de visite)
3⅝ × 2⅛ in. (9.1 × 5.4 cm)
Thomas Harris Collection

146 Brady & Company
Active 1840s–80s
General George Custer, 1864–66
Albumen silver print (carte de visite)
4 × 2½ in. (10.2 × 6.4 cm)
Brian D. Caplan Collection

147 Unknown artist
Union Officer Asleep in Studio Chair, 1861–65
Albumen silver print (carte de visite)
3½ × 2⅛ in. (8.9 × 5.4 cm)
Michael J. McAfee Collection

148 Richard A. Lewis
American, born England, 1820–1891
John L. Burns, "Hero of Gettysburg," 1863–65
Albumen silver print (carte de visite)
3¾ × 2⅛ in. (9.5 × 5.4 cm)
Brian D. Caplan Collection

149 Morse & Peaslee, Gallery of the Cumberland
Active Nashville, Tennessee, 1861–65
A. S. Morse, American, ca. 1830–ca. 1922
William A. Peaslee, American, born ca. 1826
*Sergeant John Lincoln Clem, the Drummer Boy of
Chickamauga*, ca. 1864
Albumen silver print (carte de visite)
3½ × 2⅛ in. (8.9 × 5.4 cm)
Thomas Harris Collection

150 Unknown artist
Active 1860s
*Alfred A. Stratton, Company G, 147th New York
Volunteers, Wounded at Petersburg, Virginia*, 1865–69
Albumen silver print (carte de visite)
3½ × 2⅛ in. (8.9 × 5.4 cm)
Thomas Harris Collection

151 Samuel Masury
American, 1818–1874
Frances Clalin Clayton, 1864–66
Albumen silver print (carte de visite)
3¾ × 2¼ in. (9.4 × 5.6 cm)
Buck Zaidel Collection

152 Hall & Company's Photograph Gallery
Active Nashville, Tennessee, 1860s
*Alonzo H. Sterrett, Late Adjutant, Fortieth U.S.
Infantry*, July 27, 1865
Albumen silver print (carte de visite)
3½ × 2⅛ in. (8.9 × 5.5 cm)
Thomas Harris Collection

153 N. A. & R. A. Moore
Active Hartford, Connecticut, 1854–65
Nelson August Moore, American, 1824–1902
Roswell Allen Moore, American, 1832–1907
Union Soldier, Possibly in the Sixteenth Connecticut
Regiment, Standing with Rifle before Painted
Backdrop with Tented Encampment, 1862–65
Albumen silver print (carte de visite)
3½ × 2¼ in. (8.8 × 5.8 cm)
Buck Zaidel Collection

154 N. A. & R. A. Moore
Active Hartford, Connecticut, 1854–65
Nelson August Moore, American, 1824–1902
Roswell Allen Moore, American, 1832–1907
Union Soldier, Possibly in the Sixteenth Connecticut
Regiment, Standing before Painted Backdrop with
Tented Encampment, 1862–65
3⅜ × 2⅛ in. (8.5 × 5.5 cm)
Albumen silver print (carte de visite) with applied color
Buck Zaidel Collection

155 Unknown artist
*Sojourner Truth, "I Sell the Shadow to Support
the Substance,"* 1864
Albumen silver print (carte de visite)
3⅜ × 2⅛ in. (8.5 × 5.4 cm)
Thomas Harris Collection

156 Attributed to McPherson & Oliver
Active New Orleans and Baton Rouge, Louisiana, 1860s
William D. McPherson, American, ca. 1833–1867
Oliver, American, active 1860s
Gordon, a Runaway Mississippi Slave, or
"The Scourged Back," March–April 1863
Albumen silver print (carte de visite)
3⅜ × 2⅛ in. (8.7 × 5.5 cm)
International Center of Photography
Purchase, with funds provided by the ICP
Acquisitions Committee, 2003
183.2003

157 Myron H. Kimball
American, 1827–after 1908
*Emancipated Slaves Brought from Louisiana by
Colonel George H. Hanks*, December 1863
Albumen silver print
5¼ × 7¼ in. (13.2 × 18.3 cm)
The Metropolitan Museum of Art
Gilman Collection, Purchase, The Horace W.
Goldsmith Foundation Gift, through Joyce and
Robert Menschel, 2005
2005.100.92

158 Charles Paxson
American, active New York City, 1860s
*Learning Is Wealth. Wilson, Charley, Rebecca &
Rosa, Slaves from New Orleans*, 1863
Albumen silver print (carte de visite)
3¼ × 2⅛ in. (8.4 × 5.3 cm)
Thomas Harris Collection

159 Charles Paxson
American, active New York City, 1860s
Wilson. Branded Slave from New Orleans, 1863
Albumen silver print (carte de visite)
3¼ × 2⅛ in. (8.4 × 5.3 cm)
Private collection, Courtesy William L. Schaeffer

160 Charles Paxson
American, active New York City, 1860s
"Oh! How I Love the Old Flag." Rebecca, a Slave Girl from New Orleans, 1863
Albumen silver print (carte de visite)
3¼ × 2⅛ in. (8.3 × 5.4 cm)
Thomas Harris Collection

161 Charles Paxson
American, active New York City, 1860s
Our Protection. Rosa, Charley, Rebecca. Slave Children from New Orleans, 1863
Albumen silver print (carte de visite)
3¼ × 2 in. (8.3 × 5.2 cm)
Thomas Harris Collection

162 Wenderoth, Taylor & Brown, after an ambrotype by an unknown artist
Active Philadelphia, 1860s
Frank, Frederick & Alice. "The Children of the Battle Field," 1863
Albumen silver print (carte de visite)
3½ × 2¼ in. (8.9 × 5.8 cm)
The Metropolitan Museum of Art
Gift of Eva Kasiska, 1947
47.46.44

163 Attributed to Andrew Joseph Russell
American, 1830–1902
Laborers at Quartermaster's Wharf, Alexandria, Virginia, 1863–65
Albumen silver print
5¼ × 8 in. (13.2 × 20.2 cm)
The Metropolitan Museum of Art
Harris Brisbane Dick Fund, 1933
33.65.40

164 Thomas C. Roche
American, 1826–1895
Ordnance Wharf, City Point, Virginia, 1865
Albumen silver print
8½ × 10 in. (21.7 × 25.5 cm)
The Metropolitan Museum of Art
Gilman Collection, Purchase, The Horace W. Goldsmith Foundation Gift, through Joyce and Robert Menschel, 2005
2005.100.94

• Thomas C. Roche
American, 1826–1895
Ordnance Wharf, City Point, Virginia, 1865
Collodion glass negative
8½ × 10⅛ in. (21.6 × 25.6 cm)
The Metropolitan Museum of Art
Gilman Collection, Purchase, The Horace W. Goldsmith Foundation Gift, through Joyce and Robert Menschel, 2005
2005.100.787

165 Thomas C. Roche
American, 1826–1895
E. & H. T. Anthony & Company, publisher
Camp Dinner, 1861–65
Albumen silver print (stereograph)
2⅞ × 5⅞ in. (7.4 × 14.8 cm)
Brian D. Caplan Collection

166 Attributed to McPherson & Oliver
Active New Orleans and Baton Rouge, Louisiana, 1860s
William D. McPherson, American, ca. 1833–1867
Oliver, American, active 1860s
Our Scouts and Guides in 1863 in Baton Rouge, Louisiana, 1863
Albumen silver print (carte de visite)
3⅜ × 2¼ in. (8.7 × 5.6 cm)
Private collection, Courtesy William L. Schaeffer

167 Gayford & Speidel
Active Rock Island, Illinois, 1860s
Alfred B. Gayford, American, active 1850s–80s
Conrad Speidel, American, active 1858–88
Private Christopher Anderson, Company F, 108th Regiment, U.S. Colored Infantry, January–May 1865
3½ × 2⅛ in. (8.8 × 5.4 cm)
Albumen silver print (carte de visite)
Thomas Harris Collection

168 Gayford & Speidel
Active Rock Island, Illinois, 1860s
Alfred B. Gayford, American, active 1850s–80s
Conrad Speidel, American, active 1858–88
Private Gid White, Company F, 108th Regiment, U.S. Colored Infantry, January–May 1865
3⅜ × 2⅛ in. (8.7 × 5.5 cm)
Albumen silver print (carte de visite)
Thomas Harris Collection

169 Gayford & Speidel
Active Rock Island, Illinois, 1860s
Alfred B. Gayford, American, active 1850s–80s
Conrad Speidel, American, active 1858–88
Private Louis Troutman, Company F, 108th Regiment, U.S. Colored Infantry, January–May 1865
3½ × 2⅛ in. (8.8 × 5.4 cm)
Albumen silver print (carte de visite)
Thomas Harris Collection

170 A. J. Riddle
American, 1828–1897
Issuing Rations to Thirty-three Thousand Prisoners. View from the Main Gate, Andersonville Prison, Georgia, August 17, 1864
Albumen silver print
3⅛ × 4¾ in. (8 × 12.1 cm)
Collection of The New-York Historical Society

171 A. J. Riddle
American, 1828–1897
Thirty-three Thousand Prisoners in Bastile. Southwest View of Stockade, Showing the Dead Line, Andersonville Prison, Georgia, August 17, 1864
Albumen silver print
3⅛ × 4¾ in. (8 × 12.1 cm)
Collection of The New-York Historical Society

172 J. W. Jones
American, active Orange, Massachusetts, 1860s
Emaciated Union Soldier Liberated from Andersonville Prison, 1865
Albumen silver print (carte de visite)
3½ × 2⅛ in. (9 × 5.5 cm)
Brian D. Caplan Collection

173 Reed Brockway Bontecou
American, 1824–1907
Private Samuel Shoop, Company F, 200th Pennsylvania Infantry, April–May 1865
Albumen silver print
7½ × 5⅛ in. (18.9 × 13.1 cm)
The Metropolitan Museum of Art
Gift of Stanley B. Burns, M.D. and The Burns Archive, 1992
1992.5134

174 Unknown artist
Active 1860s
Anna Etheridge, after May 30, 1863–65
Albumen silver print (carte de visite)
3⅜ × 2⅛ in. (8.7 × 5.3 cm)
Michael J. McAfee Collection

175 Brady & Company
Active 1840s–80s
Relics of Andersonville Prison, June 1866
Albumen silver print
8¾ × 7⅜ in. (22.1 × 18.8 cm)
The Metropolitan Museum of Art
Gilman Collection, Purchase, Joseph M. Cohen Gift, 2005
2005.100.98

176 Unknown artist
Patriotic Young Woman Holding Flag, 1861–65
Albumen silver print (carte de visite)
3⅜ × 2¼ in. (8.7 × 5.6 cm)
Brian D. Caplan Collection

177 J. Gurney & Son
Active New York City, 1850s–74
Jeremiah Gurney, American, 1812–1895
Disabled Union Soldiers Posed in Aid of the U.S. Sanitary Commission at the New York Metropolitan Fair, April 1864
Albumen silver print (carte de visite)
3½ × 2¼ in. (8.9 × 5.6 cm)
Private collection, Courtesy William L. Schaeffer

178 Reed Brockway Bontecou
American, 1824–1907
A Morning's Work, 1865
Albumen silver print (carte de visite)
2¼ × 3¾ in. (5.8 × 9.4 cm)
Collection of Stanley B. Burns, M.D.

179 Reed Brockway Bontecou
American, 1824–1907
Union Private John Parmenter, Company G, Sixty-seventh Pennsylvania Volunteers, June 21, 1865
Albumen silver print (carte de visite)
2¼ × 3⅝ in. (5.7 × 9.1 cm)
Collection of Stanley B. Burns, M.D.

180 Reed Brockway Bontecou
American, 1824–1907
Amputated Leg of Private George S. Shelton, Company J, Thirty-sixth Wisconsin Volunteers, 1864–65
Albumen silver print (carte de visite)
3¾ × 2¼ in. (9.4 × 5.6 cm)
Collection of Stanley B. Burns, M.D.

181 Reed Brockway Bontecou
American, 1824–1907
Page from Dr. Bontecou's Private Teaching Album of Wounded Civil War Soldiers: Primarily Hand Wounds, 1864–65
Albumen silver prints (cartes de visite)
13 × 12 in. (33 × 30.5 cm)
Collection of Stanley B. Burns, M.D.

182 Reed Brockway Bontecou
American, 1824–1907
Page from Dr. Bontecou's Private Teaching Album of Wounded Civil War Soldiers: Primarily Arm Wounds, 1864–65
Albumen silver prints (cartes de visite)
13 × 12 in. (33 × 30.5 cm)
Collection of Stanley B. Burns, M.D.

183 Reed Brockway Bontecou
American, 1824–1907
Page from Dr. Bontecou's Private Teaching Album of Wounded Civil War Soldiers: Primarily Chest and Mid-Body Wounds, 1864–65
Albumen silver prints (cartes de visite)
13 × 12 in. (33 × 30.5 cm)
Collection of Stanley B. Burns, M.D.

184 Reed Brockway Bontecou
American, 1824–1907
Page from Dr. Bontecou's Private Teaching Album of Wounded Civil War Soldiers: Primarily Lower Leg Wounds, 1864–65
Albumen silver prints (cartes de visite)
13 × 12 in. (33 × 30.5 cm)
Collection of Stanley B. Burns, M.D.

185 Unknown artist
Amputation at Field Hospital, 1861–65
Albumen silver print (carte de visite)
3⅝ × 2¼ in. (9.3 × 5.8 cm)
W. Bruce and Delaney H. Lundberg Collection

186 Attributed to Reed Brockway Bontecou
American, 1824–1907
Wounded Soldiers on Cots, Possibly at Harewood Hospital, 1865
Albumen silver print (carte de visite)
3¾ × 2¼ in. (9.4 × 5.7 cm)
Thomas Harris Collection

187 Unknown artist, formerly attributed to Mathew B. Brady
Armory Square Hospital, Washington, 1863–65
Albumen silver print
6⅞ × 7⅞ in. (17.3 × 20 cm)
The Metropolitan Museum of Art
Harris Brisbane Dick Fund, 1933
33.65.307

188 Reed Brockway Bontecou
American, 1824–1907
Private Dennis Sullivan, Company E, Second Virginia Cavalry, April 1865
Albumen silver print
5⅛ × 7½ in. (13.1 × 18.9 cm)
The Metropolitan Museum of Art
Gift of Stanley B. Burns, M.D. and The Burns Archive, 1992
1992.5139

189 Reed Brockway Bontecou
American, 1824–1907
Private John Parkhurst, Company E, Second New York Heavy Artillery, April 1865
Albumen silver print
7½ × 5⅛ in. (18.9 × 13.1 cm)
The Metropolitan Museum of Art
Gift of Stanley B. Burns, M.D. and The Burns Archive, 1992
1992.5131

190 Reed Brockway Bontecou
American, 1824–1907
Sergeant Brazer Wilsey, Company D, Fourth New York Volunteers, 1865
Albumen silver print with applied color
7½ × 5⅜ in. (19 × 13.5 cm)
Collection of Stanley B. Burns, M.D.

• Reed Brockway Bontecou
American, 1824–1907
Private Jacob F. Simmons, Company H, Eighty-second Pennsylvania Volunteers, April–May 1865
Albumen silver print with applied color
7⅜ × 5⅛ in. (18.7 × 13 cm)
The Metropolitan Museum of Art
Gift of Stanley B. Burns, M.D. and The Burns Archive, 1992
1992.5135

191 Reed Brockway Bontecou
American, 1824–1907
Private James H. Stokes, Company H, 185th New York Volunteers, April–May 1865
Albumen silver print
7⅜ × 5⅛ in. (18.8 × 13 cm)
The Metropolitan Museum of Art
Gift of Stanley B. Burns, M.D. and The Burns Archive, 1992
1992.5137

192 Reed Brockway Bontecou
American, 1824–1907
Corporal Israel Spotts, Company G, 200th Pennsylvania Volunteers, April–May 1865
Albumen silver print
7½ × 5⅛ in. (18.9 × 13.1 cm)
The Metropolitan Museum of Art
Gift of Stanley B. Burns, M.D. and The Burns Archive, 1992
1992.5136

193 Reed Brockway Bontecou
American, 1824–1907
Private John Hagle, Company F, Fifth New York Heavy Artillery, April–June 1865
Albumen silver print
7½ × 5⅛ in. (18.9 × 13.1 cm)
Collection of Stanley B. Burns, M.D.

194 Reed Brockway Bontecou
American, 1824–1907
Private Robert Fryer, Company G, Fifty-second New York Volunteers, April–July 1865
Albumen silver print
7½ × 5⅛ in. (18.9 × 13.1 cm)
Collection of Stanley B. Burns, M.D.

195 William Bell
American, born Great Britain, 1831–1910
Excised Knee Joint. A Round Musket Ball in the Inner Condyle of the Right Femur, 1866–67
[Private Gardiner Lewis, Company B, Nineteenth Indiana Volunteers]
No. 104 from a series published by the Surgeon General's Office, Army Medical Museum
Albumen silver print
7½ × 6 in. (19 × 15.3 cm)
The Metropolitan Museum of Art
Purchase, The Horace W. Goldsmith Foundation Gift, through Joyce and Robert Menschel, 1986
1986.1197

196 George N. Barnard
American, 1819–1902
Savannah, Georgia, No. 2, 1866
Plate 50 in *Photographic Views of Sherman's
Campaign*, 1866
Albumen silver print
10 × 14¼ in. (25.5 × 36.1 cm)
The Metropolitan Museum of Art
The Horace W. Goldsmith Foundation Fund, through
Joyce and Robert Menschel, 2012
2012.19

197 George N. Barnard
American, 1819–1902
Atlanta, 1864
Albumen silver prints (half-stereographs)
In *A Photographic Album of the Civil War*, compiled
before 1869, with 348 photographs by Mathew B.
Brady, Brady & Company, George N. Barnard,
Alexander Gardner, James F. Gibson, Timothy H.
O'Sullivan, and others
8¾ × 11 × 4 in. (22.2 × 27.9 × 10.2 cm)
Loewentheil Family Photography Collection

198 George N. Barnard
American, 1819–1902
Rebel Works in Front of Atlanta, Georgia, No. 1, 1864
Plate 39 in *Photographic Views of Sherman's
Campaign*, 1866
Albumen silver print
10 × 14 in. (25.5 × 35.5 cm)
The Museum of Modern Art, New York
Acquired by exchange with the Library of Congress,
409.1969.39

199 George N. Barnard
American, 1819–1902
City of Atlanta, Georgia, No. 1, 1866
Plate 45 in *Photographic Views of Sherman's
Campaign*, 1866
Albumen silver print
10⅛ × 14⅛ in. (25.6 × 36 cm)
The Museum of Modern Art, New York
Acquired by exchange with the Library of Congress,
409.1969.45

200. → George N. Barnard
American, 1819–1902
City of Atlanta, Georgia, No. 2, 1866
Plate 46 in *Photographic Views of Sherman's
Campaign*, 1866
Albumen silver print
10⅛ × 14 in. (25.6 × 35.5 cm)
The Metropolitan Museum of Art
Pfeiffer and Rogers Funds, 1970
1970.525

201 George N. Barnard
American, 1819–1902
Nashville from the Capitol, 1864
Plate 3 in *Photographic Views of Sherman's Campaign*,
1866
Albumen silver print
10 × 14⅛ in. (25.4 × 35.9 cm)
The Museum of Modern Art, New York
Acquired by exchange with the Library of Congress,
409.1969.3

202 George N. Barnard
American, 1819–1902
Trestle Bridge at Whiteside, 1864
Plate 4 in *Photographic Views of Sherman's Campaign*,
1866
Albumen silver print
10⅛ × 14⅛ in. (25.6 × 35.9 cm)
The Museum of Modern Art, New York
Acquired by exchange with the Library of Congress,
409.1969.4

203 George N. Barnard
American, 1819–1902
Pass in the Raccoon Range, Whiteside, No. 1, 1864
Plate 6 in *Photographic Views of Sherman's Campaign*,
1866
Albumen silver print
10⅛ × 14⅛ in. (25.6 × 35.9 cm)
The Museum of Modern Art, New York
Acquired by exchange with the Library of Congress,
409.1969.6

204 George N. Barnard
American, 1819–1902
Pass in the Raccoon Range, Whiteside, No. 2, 1864
Plate 7 in *Photographic Views of Sherman's Campaign*,
1866
Albumen silver print
10⅛ × 14⅛ in. (25.6 × 35.9 cm)
The Museum of Modern Art, New York
Acquired by exchange with the Library of Congress,
409.1969.7

205 George N. Barnard
American, 1819–1902
Chattanooga Valley from Lookout Mountain,
1864 or 1866
Plate 13 in *Photographic Views of Sherman's
Campaign*, 1866
Albumen silver print
10⅛ × 14⅛ in. (25.7 × 35.9 cm)
The Museum of Modern Art, New York
Acquired by exchange with the Library of Congress,
409.1969.13

206. → George N. Barnard
American, 1819–1902
Lu-La Lake, Lookout Mountain, 1864 or 1866
Plate 15 in *Photographic Views of Sherman's
Campaign*, 1866
Albumen silver print
10⅛ × 14⅛ in. (25.6 × 35.9 cm)
The Metropolitan Museum of Art
Pfeiffer and Rogers Funds, 1970
1970.525

207 George N. Barnard
American, 1819–1902
Battle Ground of Resaca, Georgia, No. 2, 1866
Plate 20 in *Photographic Views of Sherman's
Campaign*, 1866
Albumen silver print
10⅛ × 14⅛ in. (25.7 × 35.9 cm)
The Museum of Modern Art, New York
Acquired by exchange with the Library of Congress,
409.1969.20

208 George N. Barnard
American, 1819–1902
Scene of General McPherson's Death, 1864 or 1866
Plate 35 in *Photographic Views of Sherman's
Campaign*, 1866
Album with 61 albumen silver prints
Image: 10 × 14¼ in. (25.4 × 36.1 cm);
album: 16¾ × 20⅞ × 3 in. (42.5 × 53 × 7.5 cm)
The Metropolitan Museum of Art
Pfeiffer and Rogers Funds, 1970
1970.525

209 George N. Barnard
American, 1819–1902
Rebel Works in Front of Atlanta, Georgia, No. 5, 1866
Plate 43 in *Photographic Views of Sherman's
Campaign*, 1866
Albumen silver print
10⅛ × 14⅛ in. (25.6 × 36 cm)
W. Bruce and Delaney H. Lundberg Collection

210 George N. Barnard
American, 1819–1902
Destruction of Hood's Ordnance Train, 1864
Plate 44 in *Photographic Views of Sherman's
Campaign*, 1866
Albumen silver print
10 × 14 in. (25.5 × 35.7 cm)
W. Bruce and Delaney H. Lundberg Collection

211 George N. Barnard
American, 1819–1902
Ruins in Charleston, South Carolina, 1865
Plate 60 in *Photographic Views of Sherman's
Campaign*, 1866
Albumen silver print
10⅛ × 14⅛ in. (25.6 × 35.8 cm)
W. Bruce and Delaney H. Lundberg Collection

212 George N. Barnard
American, 1819–1902
Ruins of the Rail Road Depot, Charleston, South Carolina, 1865
Plate 61 in *Photographic Views of Sherman's Campaign*, 1866
Albumen silver print
10⅛ × 14⅛ in. (25.6 × 36 cm)
The Museum of Modern Art, New York
Acquired by exchange with the Library of Congress, 409.1969.61

213 Unknown maker (broadside)
Alexander Gardner (copy photographs of original carte-de-visite portraits)
American, born Scotland, 1840–1882
Silsbee, Case & Company (portrait of Booth)
Unknown artists (portraits of Surratt and Herold)
Broadside for the Capture of John Wilkes Booth, John Surratt, and David Herold, April 20, 1865
Ink on paper (broadside) with albumen silver prints
Images: 3⅜ × 2⅛ in. (8.6 × 5.4 cm) each; sheet: 23⅞ × 12⅜ in. (60.5 × 31.3 cm)
The Metropolitan Museum of Art
Gilman Collection, Purchase, The Horace W. Goldsmith Foundation Gift, through Joyce and Robert Menschel, 2005
2005.100.96

214 Mathew B. Brady
American, born Ireland, 1823/24–1896
General Robert E. Lee, April 16, 1865
Albumen silver print
5½ × 3⅝ in. (14 × 9.3 cm)
The Metropolitan Museum of Art
Gilman Collection, Museum Purchase, 2005
2005.100.1213

215 Thomas C. Roche
American, 1826–1895
E. & H. T. Anthony & Company, publisher
Selden & Ennis, Richmond, Virginia, vendor
Rebel Artillery Soldiers, Killed in the Trenches of Fort Mahone, Called by the Soldiers "Fort Damnation," at the Storming of Petersburg, Virginia, April 3, 1865
Albumen silver print (stereograph)
3⅛ × 6¼ in. (8 × 16 cm)
Private collection, Courtesy William L. Schaeffer

216 Thomas C. Roche
American, 1826–1895
Covered Ways Inside the Rebel Fort Mahone, Called by the Soldiers "Fort Damnation," Petersburg, Virginia, April 3, 1865
Albumen silver print (stereograph)
3⅛ × 6 in. (7.8 × 15.3 cm)
Private collection, Courtesy William L. Schaeffer

217 Brady & Company
Active 1840s–80s
Major General William Tecumseh Sherman [Wearing Mourning Armband], April 1865
Albumen silver print (carte de visite)
3⅜ × 2⅛ in. (8.5 × 5.4 cm)
Thomas Harris Collection

218 Unknown maker, after a carte de visite by Anthony Berger for Brady & Company
Mourning Corsage with Portrait of Abraham Lincoln, April 1865
Black and white silk with tintype set inside brass button
7⅞ × 3½ in. (20 × 9 cm), Diam. of portrait: ¾ in. (2 cm)
Thomas Harris Collection

219 Alexander Gardner
American, born Scotland, 1821–1882
Ruins of Gallego Flour Mills, Richmond, 1865
Albumen silver prints (panorama)
6⅜ × 14½ in. (16.3 × 36.9 cm)
The Metropolitan Museum of Art
Harris Brisbane Dick Fund, 1933
33.65.11 and 33.65.226

220 Alexander Gardner
American, born Scotland, 1821–1882
Planning the Capture of Booth, 1865
[Colonel Lafayette C. Baker, Chief of the Secret Service; Lieutenant Luther B. Baker, left; and Lieutenant Colonel Everton J. Conger, right]
Albumen silver print
10⅝ × 9⅝ in. (27.1 × 24.5 cm)
The Metropolitan Museum of Art
Gilman Collection, Purchase, Ann Tenenbaum and Thomas H. Lee Gift, 2005
2005.100.1223

221 C. D. Fredricks & Company
Active 1850s–60s
Charles DeForest Fredricks, American, 1823–1894
John Wilkes Booth, ca. 1862
Albumen silver print (carte de visite)
3⅝ × 2⅛ in. (9.1 × 5.4 cm)
Collection of the Meserve-Kunhardt Foundation

222 Alexander Gardner
American, born Scotland, 1821–1882
Lewis Payne [Lewis Powell], April 27, 1865
Albumen silver print
8⅞ × 6⅞ in. (22.4 × 17.4 cm)
The Metropolitan Museum of Art
Gilman Collection, Purchase, The Horace W. Goldsmith Foundation Gift, through Joyce and Robert Menschel, 2005
2005.100.97

223 Alexander Gardner
American, born Scotland, 1821–1882
Execution of the Conspirators, July 7, 1865
Albumen silver print
6⅝ × 9½ in. (16.8 × 24.2 cm)
The Metropolitan Museum of Art
Gilman Collection, Purchase, The Horace W. Goldsmith Foundation Gift, through Joyce and Robert Menschel, 2005
2005.100.251

224 Alexander Gardner
American, born Scotland, 1821–1882
Grand Army Review, Pennsylvania Avenue, Washington, D.C., May 23 or 24, 1865
Albumen silver print
3½ × 3⅞ in. (8.8 × 9.9 cm)
The Metropolitan Museum of Art
Gilman Collection, Museum Purchase, 2005
2005.100.1193

• Alexander Gardner
American, born Scotland, 1821–1882
Grand Army Review, Washington, D.C., May 23 or 24, 1865
Albumen silver print
3¼ × 4 in. (8.2 × 10 cm)
The Metropolitan Museum of Art
Gilman Collection, Museum Purchase, 2005
2005.100.1197

225 Alexander Gardner
American, born Scotland, 1821–1882
Grand Army Review, Pennsylvania Avenue, Washington, D.C., May 23 or 24, 1865
Albumen silver print
3⅜ × 4 in. (8.5 × 10.1 cm)
The Metropolitan Museum of Art
Gilman Collection, Museum Purchase, 2005
2005.100.1196

226 Alexander Gardner
American, born Scotland, 1821–1882
Execution of the Conspirators, No. 3, July 7, 1865
Albumen silver print (carte de visite)
2⅛ × 3⅜ in. (5.4 × 8.7 cm)
Collection of the Meserve-Kunhardt Foundation

227 Brady & Company
Active 1840s–80s
Mathew B. Brady, American, born Ireland, 1823/24–1896
Alexander Gardner, American, born Scotland, 1821–1882
Anthony Berger, American, active 1860s
Thomas Le Mere, American, active 1860s
E. & H. T. Anthony & Company, publisher
In Memory of Abraham Lincoln, 1865
Maquette with albumen silver prints (cartes de visite)
14½ × 11⅞ in. (36.8 × 30.1 cm)
Loewentheil Family Photography Collection

• Brady & Company
Active 1840s–80s
Mathew B. Brady, American, born Ireland, 1823/24–1896
E. & H. T. Anthony & Company, publisher
In Memory of Abraham Lincoln, 1865
Albumen silver print (carte de visite)
3⅜ × 2⅛ in. (8.5 × 5.3 cm)
W. Bruce and Delaney H. Lundberg Collection

228 Unknown artist, formerly attributed to Alexander Gardner
The Wilderness Battlefield: Confederate Entrenchments across Orange Plank Road, near Spotsylvania, Virginia, 1865 (?)
Albumen silver print
4⅞ × 3⅛ in. (12.3 × 7.8 cm)
The Metropolitan Museum of Art
Gilman Collection, Purchase, The Horace W. Goldsmith Foundation Gift, through Joyce and Robert Menschel, 2005
2005.100.944.22

229 Unknown artist
"Picture Gallery Photographs," 1860s
Albumen silver print (carte de visite)
2⅛ × 3¾ in. (5.5 × 9.4 cm)
Thomas Harris Collection

230 Unknown artist
Union Soldier and Barber, 1861–65
Quarter-plate tintype with applied color
The Metropolitan Museum of Art
The Horace W. Goldsmith Foundation Fund, through
Joyce and Robert Menschel, 2012
2012.326

231 Attributed to Oliver H. Willard
American, died 1875
Ordnance, Private, 1866
Albumen silver print with applied color
8 × 5⅞ in. (20.2 × 15 cm)
The Metropolitan Museum of Art
The Horace W. Goldsmith Foundation Fund, through
Joyce and Robert Menschel, 2010
2010.37

• Attributed to Oliver H. Willard
American, died 1875
Artillery, Quartermaster Sergeant, 1866
Albumen silver print with applied color
8 × 5⅞ in. (20.3 × 14.8 cm)
The Metropolitan Museum of Art
The Horace W. Goldsmith Foundation Fund, through
Joyce and Robert Menschel, 2010
2010.34

• Attributed to Oliver H. Willard
American, died 1875
Fatigue, Marching Order, 1866
Albumen silver print with applied color
7⅞ × 5⅞ in. (20.1 × 15 cm)
The Metropolitan Museum of Art
The Horace W. Goldsmith Foundation Fund, through
Joyce and Robert Menschel, 2010
2010.38

• Attributed to Oliver H. Willard
American, died 1875
Artillery, Musician, 1866
Albumen silver print with applied color
7⅞ × 5⅞ in. (19.9 × 14.9 cm)
The Metropolitan Museum of Art
The Horace W. Goldsmith Foundation Fund, through
Joyce and Robert Menschel, 2010
2010.35

• Attributed to Oliver H. Willard
American, died 1875
Light Artillery, Sergeant Major, 1866
Albumen silver print with applied color
8 × 6 in. (20.3 × 15.2 cm)
The Metropolitan Museum of Art
Purchase, Saundra B. Lane Gift, in honor of
Charles Isaacs, 2010
2010.36

232 Unknown artist, formerly attributed to
Alexander Gardner
The Wilderness Battlefield: Skulls and Bones of Dead
Soldiers on South Side of Orange Plank Road, near
Spotsylvania, Virginia, 1865 (?)
Albumen silver print
4⅞ × 3⅜ in. (12.5 × 8.6 cm)
The Metropolitan Museum of Art
Gilman Collection, Purchase, The Horace W.
Goldsmith Foundation Gift, through Joyce and
Robert Menschel, 2005
2005.100.944.18

233 Unknown artist, formerly attributed to
Alexander Gardner
The Wilderness Battlefield: Skulls and Bones of
Dead Soldiers North of Orange Plank Road, near
Spotsylvania, Virginia, 1865 (?)
Albumen silver print
5 × 3⅛ in. (12.7 × 7.9 cm)
The Metropolitan Museum of Art
Gilman Collection, Museum Purchase, 2005
2005.100.1255

234 C. (Charles?) Burgess
American, active Troy and Schenectady, New York,
1860s–80s
Young Man Standing beside Empty Chair with Kepi
and Worn Boots, ca. 1865
Albumen silver print (carte de visite)
3⅜ × 2⅛ in. (8.6 × 5.4 cm)
Buck Zaidel Collection

235 Unknown maker
Mathew B. Brady's Studio Camera and Tripod, 1860s
Wooden camera, lens, tripod
H. 59⅞, W. 24, D. 16⅛ in. (152 × 61 × 41 cm)
Loewentheil Family Photography Collection

236 Henry P. Moore
American, 1833–1911
Contrabands aboard U.S. Ship Vermont, *Port Royal,
South Carolina,* October–November 1861
Albumen silver print
5⅛ × 8¼ in. (12.9 × 20.8 cm)
The Metropolitan Museum of Art
Gilman Collection, Gift of The Howard Gilman
Foundation, 2005
2005.100.897

237 Attributed to Tyson Brothers
Active 1860s
Isaac G. Tyson, American, 1833–1913
Charles J. Tyson, American, 1838–1906
Procession of Troops and Civilians on the Way
to Dedication of Soldiers National Cemetery,
Gettysburg, Pennsylvania, November 19, 1863
Albumen silver print
6⅞ × 8¼ in. (17.6 × 20.8 cm)
The Metropolitan Museum of Art
Harris Brisbane Dick Fund, 1933
33.65.174

238 Alexander Gardner
American, born Scotland, 1821–1882
*Brigadier General Gustavus A. DeRussy and Staff on
Steps of Arlington House, Arlington, Virginia,* May 1864
Albumen silver print
6¾ × 9 in. (17.2 × 23 cm)
The Metropolitan Museum of Art
A. Hyatt Mayor Purchase Fund, Marjorie Phelps Starr
Bequest, 1986
1986.1166.2

239 Timothy H. O'Sullivan
American, born Ireland, 1840–1882
*General Grant's Council of War, Massaponax Church,
Virginia,* May 21, 1864
Albumen silver print
3⅜ × 4¼ in. (8.7 × 10.8 cm)
The Metropolitan Museum of Art
The Elisha Whittelsey Collection, The Elisha
Whittelsey Fund, 1986
1986.1027

240 Alexander Gardner
American, born Scotland, 1821–1882
*Ruins of Richmond & Petersburg Rail Road Bridge,
Richmond, Virginia,* April 1865
Albumen silver print
6⅜ × 8⅜ in. (16.3 × 21.4 cm)
The Metropolitan Museum of Art
Harris Brisbane Dick Fund, 1933
33.65.22

• Unknown maker
Photographer's Studio Posing Stand, 1850s–60s
Iron
H. 42½, W. 24, D. 19¾ in. (108 × 61 × 50 cm)
The Metropolitan Museum of Art
Department of Photographs
Purchase, 2004

• ✦ Attributed to Ernest Vogt
American, active 1860s
Side Drum, ca. 1864
Wood, calfskin, rope
H. 15⅜ in. (39.1 cm), Diam. 17 in. (43.1 cm)
The Metropolitan Museum of Art
The Crosby Brown Collection of Musical
Instruments, 1889
89.4.2162

237 Attributed to Tyson Brothers, Procession of Troops and Civilians on the Way to Dedication of Soldiers National Cemetery,
Gettysburg, Pennsylvania, November 19, 1863. Albumen silver print

ACKNOWLEDGMENTS

Large traveling museum shows depend on the expertise and cooperation of hundreds of individuals. None has been more important to *Photography and the American Civil War* than the nineteen private collectors and public institutions whose photographs are featured in this exhibition and publication. Their willingness to open their homes and archives to a curator on a long march through the interconnected fields of nineteenth-century American photography and Civil War history has made the last five years of research among the most rewarding in his career. Their loans to the Metropolitan, the Gibbes Museum in Charleston, and the New Orleans Museum of Art and their advice and counsel demonstrate a generosity that the author hopes this catalogue might repay in some way. The following collectors and institutions deserve to be thanked individually:

Stanley B. Burns
Brian D. Caplan
Tina Freeman
Thomas Harris
Stephan Loewentheil
W. Bruce and Delaney H. Lundberg
Michael J. McAfee

Philip and Jennifer Maritz
Stephen Sherrill
Jane Van N. Turano-Thompson
David Wynn Vaughan
David Wynn Vaughan Jr.
Buck Zaidel
Private collector

The International Center of Photography: Brian Wallis and Erin Barnett
The Meserve-Kunhardt Foundation: Peter W. Kunhardt Jr. and
 James Jordan
The Museum of Modern Art: Sarah Hermanson Meister, Drew Sawyer,
 and Lee Ann Daffner
The New-York Historical Society: Marilyn Kushner
The New York Public Library: Stephen Pinson and David Lowe, Michael
 Inman, Matthew Knutzen, Erin Murphy, and Deborah Straussman

A large number of Civil War collectors, historians, and photography dealers shared their knowledge and professional contacts. The author owes a debt of gratitude again to the lenders listed above, and to:

Denise Bethel
Frish Brandt
Ken Burns
Rick Carlile
Henry Deeks
Tina Freeman
Greg French
Victor Germack
Donald Heald
Harold Holzer
John Ibson
Jeffrey Kraus
John Lawrence

Mack Lee
Russell Lord
Michael Medhurst
Lynn Novick
Gilles Peress
Anne Peterson
Jeremy Rowe
William L. Schaeffer
Charles Schwartz
George Whitely
David Winter
Bob Zeller

At the Metropolitan, Jennifer Russell and Martha Deese in the Office of the Director led the effort to secure venues for the exhibition and to manage the Museum's tour contracts with partners in Charleston and New Orleans. Carrie Rebora Barratt and Christine Coulson provided counsel and friendship that kept the exhibition and the curator on track. Nina McN. Diefenbach, Sarah Higby, and their colleagues in the Development Office solicited support from corporations and foundations. Aileen Chuk, Nina S. Maruca, and Willa Cox in the Office of the Registrar ably organized the collection, transportation, and return of works lent to the Museum. They were assisted in the Department of Photographs by Anna Wall, collections management associate. Without Anna's unflagging attention to details

relating to the loan paperwork, this exhibition and publication would not be a reality.

Nora Kennedy, Elisabeth Barro, Katherine Sanderson, and Georgia Southworth, the Metropolitan's expert team of photograph conservators, provided treatment of the original photographs—works in the Museum's collection and in private collections. Rachel Mustalish and Valerie Faivre conserved the paper mounts for selected works in the exhibition. Intern Margaret Wessling also helped prepare photographs for exhibition.

Other colleagues in the Department of Photographs brought the show to life. In addition to those already mentioned, the following have earned sincere thanks: Malcolm Daniel, Mia Fineman, Douglas Eklund, Meredith Friedman, Karan Rinaldo, Laura T. Harris, Myriam Rocconi, Mazie Harris, Shana Lopes, and Joy Kerveillant. Predrag Dimitrijevic and Ryan Franklin merit special recognition for their expertise in designing the large frames and small picture mounts, and then installing the complex exhibition. As she has for many years, Jeanne Savitt, the department's long-term volunteer, assisted with every aspect of this exhibition from start to finish.

Eileen Travell in the Metropolitan's Photograph Studio tirelessly managed the unusually difficult job of photographing each work of art in the Museum's collection featured here, and almost every photograph lent by private collectors. Jack Melton of Atlanta furnished reproductions of the twenty-five photographs in David Wynn Vaughan's superb collection. The stunning images in this book testify to these two artists' well-honed skills and to those of unnamed photographers who performed the same role for the other institutional lenders.

Mark Polizzotti, the Metropolitan's Publisher and Editor in Chief, supported the publication from the project's inception and chose the book's generous page format. He and his talented team—Michael Sittenfeld, Gwen Roginsky, and Peter Antony—provided excellent advice and encouragement during the writing and page design process, and then during the printing itself. Douglas Malicki supervised the internal production necessary to keep the process flowing smoothly and efficiently. Jane S. Tai sourced reproductions and permissions. Jean Wagner verified references and compiled the bibliography. Sue Burke prepared the index.

A small number of unnamed individuals (drafted without fair compensation to read early versions of the manuscript) gave of their time and expert advice. Their notes and responses were crucial to the book. So, too, was the essential first reading of each chapter offered by Kellye Rosenheim, whose comments refined a text then in a most undeveloped stage. Thanks go to Anna Jardine, who copyedited the manuscript. Her patience with the author is appreciated more than words can express.

Laura Lindgren, the book designer, arranged the pictures and the text and made this the beautiful book it is. She selected the type fonts, sized the photographs, and designed the book's jacket as well as the interior. Periodically, she even indulged the author's desire to believe he had an eye for page layout.

Michael Lapthorn designed the exhibition, Connie Norkin the graphics. Their sympathetic response to months of curatorial what-ifs ensured the success of the show's concept and the visitor experience. Linda Sylling and Patricia A. Gilkison oversaw the installation. Taylor Miller and his team constructed the galleries. Paco Link, together with colleagues in the Digital Media Department, produced the stereograph feature. Frederick Sager and his installers constructed the elegant mounts for the ambrotypes and tintypes. Jed Bark of Bark Frameworks made the distinctive mounts for the cartes de visite and most of the exhibition frames. Pamela T. Barr edited the wall texts and labels. Harold Holzer and Egle Žygas encouraged the press and bloggers to find their way to the exhibition; Christopher A. Noey produced a dynamic audio guide; and dozens of colleagues in the Education Department created exciting programs for Museum visitors. And finally, Thomas P. Campbell, the Museum's Director, offered to move *Photography and the American Civil War* to the special exhibition galleries so that it could reach its full potential and a larger audience.

To these individuals and to Julia and Phoebe Rosenheim, and again to Kellye Rosenheim, who has had to live with the Civil War and with him all these years, the author extends his profound thanks.

Jeff L. Rosenheim
December 2012

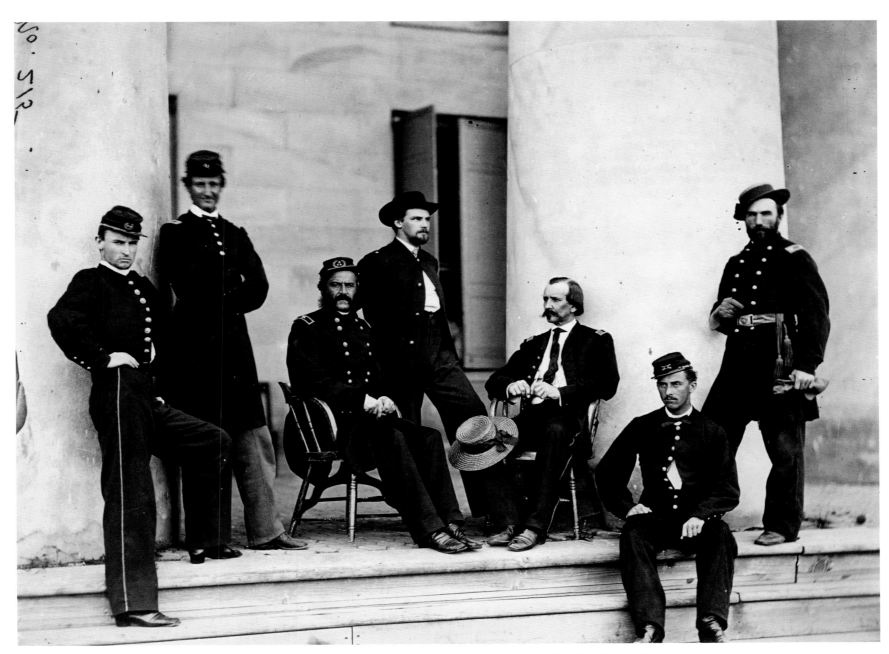

238　Alexander Gardner, *Brigadier General Gustavus A. DeRussy and Staff on Steps of Arlington House, Arlington, Virginia*, May 1864. Albumen silver print

239 Timothy H. O'Sullivan, *General Grant's Council of War, Massaponax Church, Virginia*, May 21, 1864. Albumen silver print

INDEX

240 Alexander Gardner, *Ruins of Richmond & Petersburg Rail Road Bridge, Richmond, Virginia*, April 1865. Albumen silver print